HINDU ART

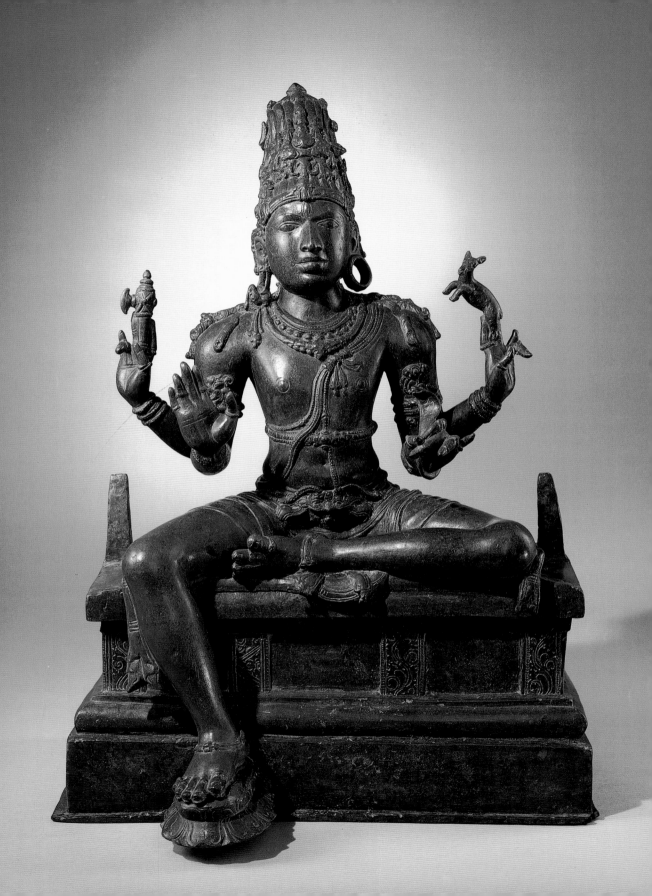

HINDU ART

T. Richard Blurton

HARVARD UNIVERSITY PRESS
CAMBRIDGE, MASSACHUSETTS
1993

For Martin
and in memory of
John Walter Atherton Hussey (1909–1985)
Dean of Chichester 1955–1977

Copyright © 1992 Trustees of the British Museum
All Rights Reserved
Printed in Singapore
10 9 8 7 6 5
Library of Congress Cataloguing-in-Publication Data
Blurton, T. Richard
 Hindu art / T. Richard Blurton.
 p. cm.
 Includes bibliographical references and index.
 ISBN 0–674–39188–8 (cl)
 ISBN 0–674–39189–6 (pbk)
 1. Art. Hindu. 1. Title.
N8195.AdB58 1993
704.9'48945–dc20
 92–11157
 CIP

Designed by Behram Kapadia

Phototypeset by Southern Positive and Negatives (SPAN), Lingfield, Surrey
Printed in Singapore

Frontispiece Shiva Vishapaharana, South India. *c.*940–950 AD. The South Indian tradition of bronze casting is one of the finest in the world, excelling in the technique of lost wax production. In this magisterial Chola-period four-armed processional image, the god Shiva is shown both as an all-powerful deity and as a protector of his devotees.

Front cover Shiva and Parvati seated on a terrace, Jaipur. *c.*1800 AD. Garlanded with skulls, wreathed in snakes and with a multi-headed serpent in his hair, Shiva turns tenderly towards his consort, Parvati. They sit against a bolster of exquisite crimson and gold stuff, set before a dark night sky tinged only with the faintest gilding of the clouds. Shiva as the defeater of the elephant-demon wears its skin wrapped around his loins – the eyes and ears of the flayed animal are seen at the base of the skull-garland. The two deities are shown on the skin of a tiger, the seat of ascetics. The river Ganges, flowing from the hair of Shiva, cascades down beside them, past the diminutive figure of the bull mount of the god. The lustre of the painting is added to by the use of iridescent beetle wings which are inlaid into elements of the jewellery which the two gods wear.

Back cover: The temple dedicated to Shiva as Mukteshvara, at Bhuvaneshvar, Orissa. Late 10th century AD. Bhuvaneshvar contains an astonishing array of medieval Hindu temples, many of them intact and some still in worship. At the Mukteshvara, the classic Orissa temple unit is clear: a hall with porches and a pyramidal roof is followed by a tower (*shikhara*) which is crowned by a flat circular slab with a pot finial. The whole is set within an enclosure entered by a gate (above the striding figure, centre). Close beside the temple is a tank where ritual ablutions can be performed. Further shrines cluster around the temple.

CONTENTS

NOTE

All authors who write about India are faced with a dilemma as to spelling and word usage. Indian languages use a number of letters which do not figure in English – for instance, there are two forms of 'sh', and a number of letters have a separate existence when aspirated. Philologists have devised methods for correctly representing these sounds. However, to the layman outside India these differences seem minor and the use of the diacritical marks to indicate them, complicated. Therefore in this volume, in the cause of greater clarity, they have been dispensed with – thus, Shiva, rather than Siva with a diacritical mark over the capital 'S'.

Place names are also problematic as they often exist in a variety of forms: for example, Kashi, Benares, Varanasi, all for the same city on the banks of the Ganges. I have tried to use the names which are most easily pronounced and most commonly found. This has, however, meant that I have not been consistent, sometimes using an old name, sometimes a new one. The Indian forms are used when the context demands it; when speaking generally of the river Ganges, the Anglicized version is used, but when reference is made to the god of the river, the Sanskrit Ganga is used.

Words in modern Hindi which are Sanskrit in origin often drop the final 'a' that frequently appears in the older language. When dealing with today's practice, I have used the modern form – thus *prasad*, rather than *prasada*. When Indian language terms are used, they appear in italics, unless they are proper nouns, or now exist in the Oxford English Dictionary – thus, yogi, but *abhisheka*. Indian language terms where pluralised appear with a final 's' – thus *avataras*. The letter 'w' does not appear in Indian languages, with the result that this letter and 'v' are sometimes interchangeable – Wima or Vima. A Glossary of Indian language terms appears at the end of the book.

The word 'India' is often used in its general sense to refer to the whole Indian subcontinent. This does not imply a lack of acknowledgement of modern boundaries, but only a desire for simplicity. The term 'medieval' is used to refer to the long period between the end of Gupta rule (6th century) and the contact with Europe in the 17th and 18th centuries; it has no chronological connection with the medieval period in Europe. The terms 'Vaishnava' and 'Shaiva' are the adjectives from the gods Vishnu and Shiva.

Most objects illustrated are from the collections of the British Museum, while field shots are generally the author's. (Full illustration acknowledgements are given on p. 236.)

Hindu art – like most things in India – is vast. This book only covers a fraction of what might be said; there are undoubtedly many lacunae.

AUTHOR'S
ACKNOWLEDGEMENTS

Any author incurs obligations, and in the present instance, there have been many. Firstly, I wish to record my debt to the Vijayanagara Research Project, a remarkable inter-disciplinary undertaking based in the south Indian state of Karnataka, and run by Dr. George Michell and Dr. John Fritz, in collaboration with the Indian authorities. The three years spent working on the Project have had a profound effect on my understanding of Indian civilisation. It also enabled me to witness, in the surrounding countryside of the great ruined city, that potent interpenetration of tradition and contemporaneity which is such a striking feature of Hinduism. For this opportunity, I shall always be grateful.

The idea of this book came from Celia Clear at British Museum Press, and I am in her debt for the faith she placed in it. From the beginning Dr. Jessica Rawson, Keeper of the Department of Oriental Antiquities, was similarly supportive. Further, she read early versions of the chapters, as did her husband John, whose editorial skills I was greatly in need of; I am very grateful to them both. Within the museum it is a pleasure to acknowledge help from many quarters. Wladimir Zwalf, despite his own publication activities, generously answered many queries, invariably opening up new understanding of ancient Indian religion, or providing hard-to-come-by bibliographical information. Robert Knox read the early chapters and provided information on the prehistory of the subcontinent to which I would not otherwise have had access. Dr. Anne Farrer and Jessica Harrison-Hall helped and encouraged with matters photographic; the latter also kindly read the text. The photography of items in the collections of the British Museum has been carried out by Dave Gowers and John Williams – my thanks to them both. Ann Searight has provided the plan and maps, dealing with the mass of unusual Indian names with aplomb. To my other colleagues in the department who on occasions have shielded me from the fury of everyday museum work, I am deeply grateful. Elsewhere in the museum, I am pleased to acknowledge John Reeve and Shelby Mamdani in the Education Department – both of whom read my draft and provided useful comments. Conversations with Joe Cribb of the Department of Coins and Medals, concerning the early depictions of deities on coins, have been much valued.

Beyond the museum, the many discussions with Dr. Henry Ginsburg (British Library), Professor Anna Dallapiccola (University of Heidelberg/Edinburgh), Dr. George Michell, Arthur Duff, Dr. Francesca Fremantle and Professor Carla Sinopoli (University of Wisconsin) have been enormously fruitful; frequent queries have been answered and they all read all or part of the text. To these friends my debt is very considerable. In India, my thanks are due to Dr. R. Nagaswamy (Madras) and Foy Nissen (Bombay) for cheerfully answering a barrage of questions. The British Council in India, especially the local staff, have invariably made my visits to the subcontinent easier and more productive than they might otherwise have been – I am in their debt.

At British Museum Press my first editor, Teresa Francis, encouraged me; it was, however, Carolyn Jones who, with a remarkable patience and forebearance, has managed to get all the various parts of the book from me and, eventually, within time. My debt to her is difficult to quantify. The hard work and calm sense of Susanna Friedman, Assistant Production Manager, has also been much appreciated.

Finally, to my parents and family whom I have seen much less of while struggling with this book, I offer my regrets, but hope that they will find the result at least satisfactory. However, the greatest debt is acknowledged in the dedication – without them, there would have been nothing.

Shri Virupaksha

INTRODUCTION

Hindu art is the product of one of the world's great religions. The range of the art of Hinduism, in terms of date, region and character, is very great. The material examined in this book covers at least two thousand years, and is drawn from the whole of South Asia – the modern countries of India, Pakistan, Sri Lanka, Nepal, Bangladesh and Afghanistan (see map on p. 16). Hinduism has influenced, or continues to influence, all of these countries in what is generally referred to as the Indian subcontinent. Today, the modern country of India is home to the majority of the world's Hindus. However, Hindus are also found in the many parts of the world where Indians have settled, especially during the diaspora of the last two centuries.

All Hindu art, along with the religious art of other cultures, grapples with a fundamental difficulty. How does the artist show the divine in concrete form, when there is no known form from which to model? In the final analysis religious art can only suggest or point the way towards the divine, which is ultimately unknowable. This sense of the unimaginable nature of the deity is especially strong in Hinduism. It is not uncommon for a deity to be defined in terms of negatives – that which the deity is not – because the positives are unknown and beyond comprehension.

Different artistic traditions in India dealt with this problem in different ways. For many Hindus, their art is primarily devotional, encouraging them to acknowledge the presence of a god or gods. Thus some examples are narrative and representational with the divine shown in human, or superhuman, likeness. Other traditions emphasise abstract or symbolic concepts of the deity. The idea that the gods are ever-present and eternal has encouraged the idea that they can be manifest in many different forms. This concept has a long history in Hinduism. For this reason, and because the divine is indefinable, any one thing can be viewed as the temporal residence, body or symbol of the deity, just as well as anything else. To the

9

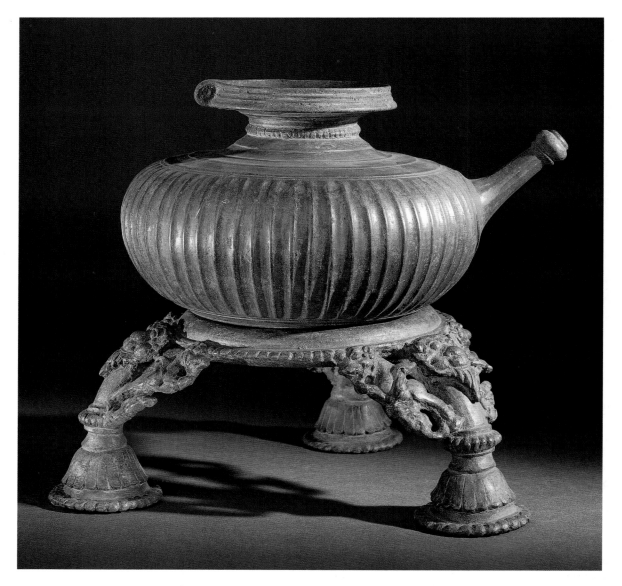

1 Ritual tripod and ewer. Deccan. Bronze. Period of the Western Gangas. *c.*1000 AD. Indian temples and domestic shrines require certain vessels and utensils for the performance of ritual. Early examples, such as these, are rare, and indicate their Deccan origin by the prancing lions which connect the ring of the tripod to the feet.

devotee, a heap of stones decorated with sacred vermilion stripes may thus be just as evocative of the god as a likeness in human form displaying the most exquisite and refined courtly taste.

Almost all Indian art has, until recently, been religious in inspiration and function. All Indian religions share features in common, and they have often flourished side by side. It may consequently be invalid to divide Indian art into 'Hindu art', 'Jain art' or 'Buddhist art'. These are distinctions which a non-Westernised Indian might find curious – these different and man-made categories all concern the gods, after all. Thus the same crafts-man would carve an image of Shiva just as readily as he would one of a Jain saint, and this irrespective of his own beliefs. These distinctions are more typical of European thinking, and European attempts to bring order and

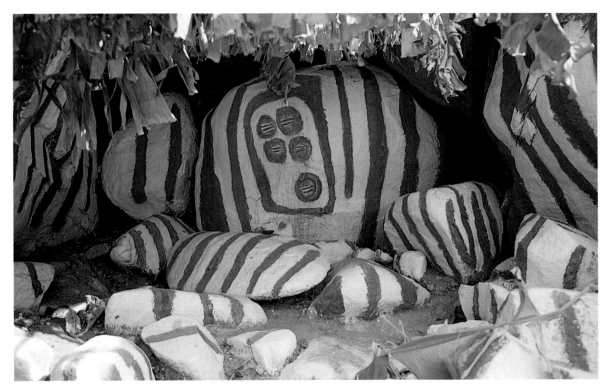

understanding to a body of material which may actually be without order.

Thus, Hindu art may not be stylistically different from Jain art produced at the same time. What will be different is the content and the way in which the content is made clear to the viewer – that is, the iconography. Therefore, although the idea of 'Hindu art' is artificial, it is one that can usefully be taken up to introduce a large part of the artistic activity of the Indian subcontinent. For, since the decline of Buddhism in the medieval period, Hinduism has been, and continues to be, the dominant religious force in the area.

As Hinduism and its art is little known outside the countries of its practice, it is necessary to provide detailed information on the deities, their histories and legends – and also their functions. This book aims to be an introduction to this subject. A knowledge of this context within which Hindu divinities operate makes it possible to approach Hindu art from a point of view that is not merely aesthetic. This is not to deny that Hindus have always responded to conventional beauty. However, it is also true that the most efficacious and most popular icons of the deities are not necessarily the most beautiful ones. An aesthetic approach is, therefore, not sufficient on its own.

Hindu art can be defined as the sculpture, painting and ritual objects used in the service of the many Hindu gods and goddesses. Hindu sculpture is produced for two different reasons: either as an image of the god for veneration in a temple or on a domestic altar, or carved to cover the exterior walls of temples or portable shrines, illustrating to devotees the

2 Rural shrine in Bellary District, Karnataka. Modern. As in countless other small shrines throughout rural India, the deity here is worshipped in an aniconic form, as a painted stone. The red and white stripes mark the sacred nature of the location, a common device seen particularly in the Deccan and South India.

legends of the deities and the eternal truths behind them. In both of these categories the sculpture was always conceived of as something more than just decoration.

Hindu painting was also very often displayed in the shrine of the god. Sadly the climatic conditions of India have caused paintings on cloth and wood to decay rapidly. Wall-paintings, always an important component in Indian temples, have also survived poorly. Where they do survive, they have often – with only one or two outstanding exceptions – been re-painted or are the products only of the last few hundred years. Fortunately for our view of Indian painting, sacred texts written on palm-leaf (or latterly on paper) and used in worship and in religious instruction, were frequently illustrated. These have survived better, and many examples are recorded, especially from the last four hundred years. Paintings on paper which are used in story-telling have also come down to us; the legends of epic heroes have usually provided the subject for these. 3, 10

11

Lastly there are ritual objects, perhaps less obviously 'art' from a European standpoint, but nevertheless of the greatest interest as many of them are exquisitely and beautifully produced. This category includes such things as holy water vessels, lamps, incense-burners, spoons, trays, palanquins, candelabras, chariots and umbrellas. As Hindu rituals have become more complex this type of object – made of bronze, ivory, wood or textiles – has become more specialised and elaborate. This very large category of material varies greatly by region and by cult. 1

13, 30, 142

The origins of Hinduism are unknown. However, some elements probably go back to the prehistoric past. Some features from this very early phase seem to have been assimilated by the Indo-Aryans, a group of conquering peoples who entered India probably during the middle of the second millennium BC. Both the prehistoric and the Indo-Aryan strands will be examined in greater detail later. However, Hinduism has developed greatly since those times, and has reacted to both internal and external pressures. These have included the development of new cults and practices within Hinduism, and the appearance from outside India of often hostile faiths which have threatened the continuance of the old religion.

Hinduism is not the result of one major revelation granted to one prophet. In this it is different from both Christianity and Islam, where divine revelations to individual seers have provided the basis for most future development. Because of this lack of a central figure who has propounded basic tenets of belief, no need has been felt for a strictly-defined creed. After all, etymologically Hinduism is but the 'religion of the Indians'. The two words, Hindu and India, have the same origin in the Greek word for the river Indus which flows across the plains of the northwestern subcontinent. The absence of an absolute creed has meant that Hindus have never found it interesting to insist that their view was necessarily the only one. Similarly they have never insisted that further spiritual experiences or visions of the divine might not yet await the devotee. The Hindu concept of a varied and continuing revelation of sacred truth has produced a religion of great flexibility, allowing the existence of many different schools and sects. This has been an important feature for a religion which has often been under threat from foreign rulers,

some of whom have tried to impose their own beliefs on the Hindus. Hinduism has repeatedly shown itself capable of absorbing outside and competing elements, thus to some extent neutralising them.

The strong emotional connection between the very land of India, and Hinduism, makes some knowledge of the geography of the subcontinent necessary. The section which follows briefly introduces this to the reader, who will be further aided by the maps on pp. 16, 228 and 229.

The Geography of India

Geologically India is a land of four basic units: the mountain chains of the north; the great river valleys which extend southwards from the mountains; the high central plateau of the Deccan; and the coastal plains of the far south (see map p. 16).

The Himalayas are the major chain in a series of mountains which mark the northern extent of the Indian subcontinent. They contain the highest peaks in the world and retain a strong hold on the Indian imagination. Repeatedly in Hindu art these peaks are imagined as the home of the gods, and a number of important pilgrimage centres are located there. The major passes leading out of India both to the West and to China are situated in the northwestern sector of this mountain zone. It has been through these passes that armies have repeatedly entered India, and exports have left it.

The rivers Indus, Ganges and Jumna run southwards out of the Himalayas and provide, in their broad valleys, fertile lands for a substantial proportion of the 850 million people of modern India. Certainly for the last two thousand years this part of India has been one of the most populated in the subcontinent. Along these rivers and their tributaries are located important cities such as Lahore, New Delhi, Allahabad, Patna and Calcutta. Also in this riverine area are located ancient religious centres such as Mathura and Benares.

As the Ganges flows eastwards across the northern plains many other rivers join it, such as the Jumna and the Gumti. Eventually it empties into the Bay of Bengal through a huge delta. This continues to expand as fertile silts, brought down from the mountains by the monsoon rains, are deposited. To the west of the Ganges system are other rivers which also originate in the northern mountains. These rivers include the five which water the Punjab, all of which eventually join the Indus to flow into the Arabian Sea. Dividing the Punjab river system from the Ganges system is an area of desert, the Thar. To the north of the Punjab are valleys in the foothills of the Himalayas, and the Hindu Kush mountains. These include the valleys of Kabul, Swat and Kashmir.

South of the immense river plains is the central Indian plateau known as the Deccan. The northern limit of this upland area is marked by the Vindhya mountains. In antiquity there were few routes through these inhospitable, densely forested hills. Some of the oldest tribal inhabitants of India have been pushed into these remote forest areas by the successive waves of invaders who crowded into the fertile lands of northern India.

The Deccan uplands are separated from the sea on both the east and the west by a plain of varying width. The change in level from coastal plain to

55

3 Krishna lifting up Mount Govardhan. Bikaner, western India. *c.*1690. The cowherd god is depicted effortlessly lifting up the mountain to shelter his followers from the storm of the god Indra, seen in the upper right of the painting on his elephant mount, Airavata. The naturalistic details of the foreground – including a cow giving birth – are beautifully recorded.

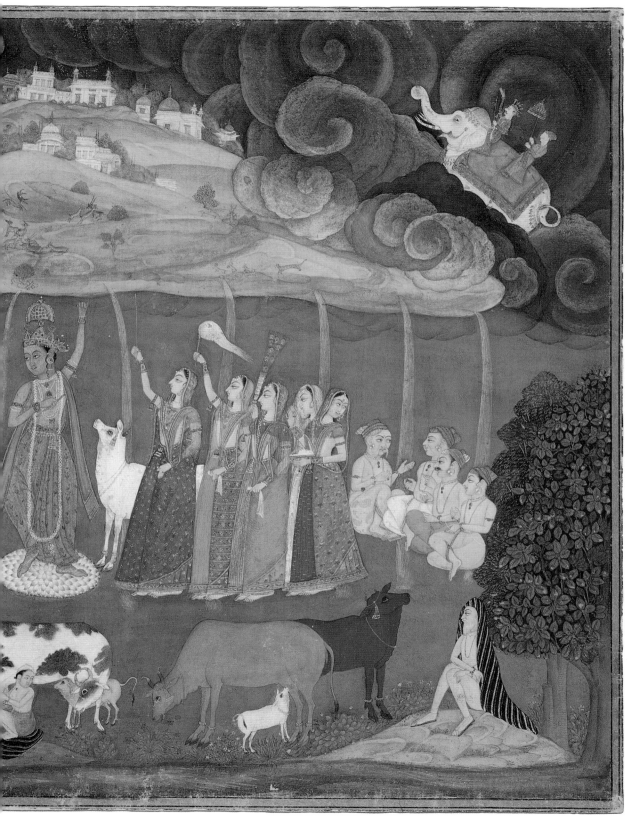

15

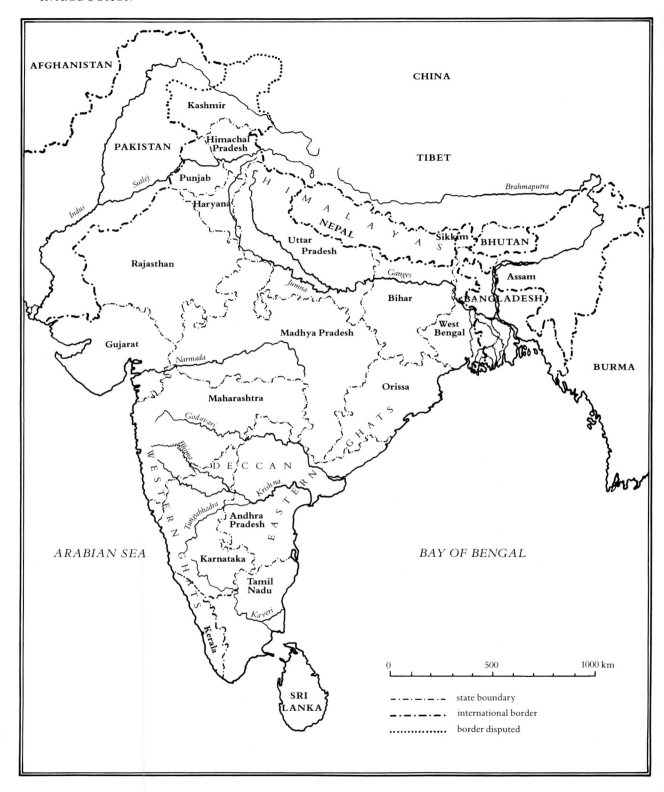

AFGHANISTAN

CHINA

Kashmir

PAKISTAN

TIBET

Himachal
Pradesh

Sutlej

Punjab

Indus

Brahmaputra

Haryana

H I M A L A Y A S

NEPAL

Sikkim

BHUTAN

Uttar
Pradesh

Assam

Ganges

Rajasthan

Jumna

Bihar

BANGLADESH

West
Bengal

Madhya Pradesh

Gujarat

Orissa

BURMA

Narmada

Maharashtra

Godavari

Bhima

D E C C A N

G H A T S

Krishna

W E S T E R N G H A T S

Tungabhadra

Andhra
Pradesh

E A S T E R N

ARABIAN SEA

BAY OF BENGAL

Karnataka

Tamil
Nadu

Kerala

Kaveri

| 0 | 500 | 1000 km |

SRI
LANKA

–·–·–·–·– state boundary

–·–·–·–·– international border

············ border disputed

upland plateau results in a series of step-like ascents known as the Ghats (literally 'steps'). These are most pronounced on the western coast, where they rise dramatically from the narrow and lush coastal lowlands. To the east the Ghats are somewhat less pronounced. Most of the major rivers of the Deccan flow eastwards from the high western Ghats and drain into the Bay of Bengal. Although they provide areas of great fertility, much of the interior of the Deccan is rugged and poorly-watered.

In the far south the eastern Ghats peter out, while those to the west become even higher, though restricted to the coastal region. The result is that the southern-most part of India is generally open, flat and well-watered. Consequently it is highly fertile and has for many centuries been densely populated. This area is a zone of tropical flora and fauna. It is only accessible from the north; because of this and because of the distances involved, it has been somewhat cut off from the events of the Indo-Gangetic plains. Historically the south has been more culturally conservative than the rest of the subcontinent due to its isolation from regions which have been the first recipients of overland extra-Indian influences.

The languages of Hinduism

The languages of the prehistoric populations of India are unknown. The inhabitants of the great Indus Valley cities, such as Mohenjo-daro and Kalibangan (*c.*2500–2000 BC), used a script made up of a large number of different characters. Unfortunately this script has never been deciphered. The difficulty of its decipherment has been compounded because surviving inscriptions are found only on seals and seal impressions. On these short inscriptions it is rare for more than ten characters to be found together. From such a very small base it is difficult to build up a picture of this language and its script. All that can be said with any degree of confidence is that this previous language probably had some influence upon the language which finally became Sanskrit, the *lingua franca* of Hinduism.

The main linguistic strand which made up early Sanskrit is, however, not Indian in origin. This early strand was the language of the Indo-Aryans who conquered northwestern India in the second millennium BC. Their language in its turn belonged to a much larger family, the Indo-European group. Not only does neighbouring Persian belong to this group but so also do Greek, Latin and indeed most of the languages of Europe. The modern languages of northern India, such as Gujarati, Hindi and Bengali, are all descended to a greater or lesser extent from Sanskrit.

The earliest form of Sanskrit was used by the first Indo-Aryan settlers in northern India to transmit orally their religious lore and myths. These were only written down much later and are known today as the Vedas. The earliest and most important of the four Vedas is the collection of prayers and invocations, known as the *Rig Veda*. This was probably largely complete by *c.*1300 BC. Sanskrit has changed considerably since those earliest days, with the result that some of the texts of the Vedas are now abstruse and difficult to understand. From the Vedic period onwards, and certainly since before the beginning of the Christian era, Sanskrit was the language of religion. It retains that position to this day, largely because it is

4 *Opposite* Map of India showing major physical features, modern international frontiers, and state boundaries inside present-day India.

the language in which most of the religious texts have been written, from the Vedas onwards. Indeed, for this reason it is often honoured today as possessing an inherent sacred power. Often a single syllable or group of syllables is considered powerful as the *mantra* or sacred invocation specific to particular gods.

The languages of south India are not connected to Sanskrit and are not part of the Indo-European family of languages. These southern languages (the major ones are Tamil, Malayalam, Kannada and Telugu) all belong to the linguistic family known to philologists as Dravidian. These languages are unconnected structurally to Sanskrit, though a substantial number of Sanskrit words, especially sacred and philosophical terms, now appear in them. Further, as Sanskrit is the language of religion, it has been taught, used and respected to a much greater degree than one would expect for a foreign language. The analogy with medieval Latin is close.

Both northern (Indo-Aryan) and southern (Dravidian) languages are today written in alphabetic scripts which, ultimately, go back to the script, Brahmi, used for the earliest surviving inscriptions in India. Brahmi itself was adapted, some time before the third century BC, probably from a Semitic script which became known in India and Sri Lanka as a result of growing commercial links with the west. The script used for some of the northern Indian languages has provided the base from which scripts used in Central Asia, and also in Tibet, have been developed. Meanwhile the southern scripts, which are recognisable on account of their more circular form, have provided the models for scripts in Southeast Asia, such as Burmese, Thai and Cambodian.

Tribal India

A further contribution to the development of Hinduism is found in the tribal populations of India, some of whom are neither Dravidian nor Indo-Aryan in origin. Ethnically, they represent the very oldest groups who today live in India. Despite centuries of political and economic suppression, forced to live in the most difficult and marginal parts of the country, they still make up a significant proportion of the total population of India.

The process of invasion and settlement by the Indo-Aryans took many generations. However, eventually sufficient tracts of forest were cleared to enable colonisation of the northern river plains. They also mastered the routes through the Vindhya mountains. Thus Indo-Aryan civilisation was spread throughout much of central and southern India. Certainly by the beginning of the Christian era this civilisation included urban settlements as well as settled agricultural life in many parts of the subcontinent. Any groups which did not become absorbed by the Indo-Aryan advance were slowly forced into more and more remote areas of the country; especially the more barren and rugged parts of upland central India. Typically these groups were nomads or hunters, gaining their livelihood from the forests. If their modern descendants, such as the Gonds, Bhils and Toda, are anything to go by, they found the restraints of settled life contemptible. The disdain which was felt between the two groups was further enhanced by differences in physical type.

Tribal life was thus different economically and culturally. Linguistically the differences were also marked, with some tribal languages being neither Indo-Aryan nor Dravidian. However, despite all these dissimilarities, it is clear that the contact between the tribal forest-dwellers, and the farmers and city-dwellers, has been very considerable. This is nowhere more certain than in matters of religion and art.

Tribal cults are usually connected with the forests or the rugged open lands where these groups are located. They include the veneration of natural forces, such as the monsoon rains and the great trees of the forests, as well as of specific animals. Some of these animal cults are totems associated with specific clans or families. The fact that Vedic religion (the religion of the early Indo-Aryans) contains few, if any, animal deities, but that later Hinduism has many, suggests the extent to which these tribal cults may have contributed to the emergence of Hinduism. The mythology of the major Hindu god Vishnu, for instance, not only contains figures who symbolise the eternal verities, but also includes fierce and powerful animal deities, such as Narasimha. In extreme cases they require blood offerings and their origins are almost certainly to be found in the tribal, and not the orthodox Hindu, world.

The religious and artistic ideas of the Indian tribal groups have for many centuries acted as a rich reservoir from which settled orthodox Hindu society has drawn. Sometimes ideas and practices have 'leaked' into the mainstream, while on other occasions the process has been more obvious. A contemporary example of the latter is the way in which many modern Indian artists have deliberately looked to tribal art for inspiration. Painters such as the Bengali Jamini Roy have regarded tribal life as the repository of unadulterated, primitive and incontrovertibly indigenous Indian culture. They have seen it as surviving only because pushed to the extremities of later Indian civilisation. There, tribal life and tribal art have been much less affected by the ideas of later residents, whether they be Muslim or British. These notions taken up by artists such as Roy are, it is true, inextricably linked with ideas of nationalism and the search for artistic identity. Nevertheless, there is undoubted truth in the romantic concept that the traditionally most unregarded and marginalised groups in Indian society have been, over a very long time, amongst the most culturally influential in the development of Indian, and specifically Hindu, culture.

I

HINDUISM

In this section we shall examine first the religious art of the Indus Valley civilisation, and second the religion of the Indo-Aryans and their successors and its influence on the development of a specifically Hindu art.

The best documented of all the prehistoric cultures of India is that which grew up in the Indus Valley between *c*.2500–2000 BC. It is known to archaeologists either as the Indus Valley, or the Harappan, civilisation – Harappa being one of its most important city settlements. Many sites of this sophisticated urban culture have been excavated. As a result some attempt can be made to understand its religion and its art. This is important in the present context as some elements seem to foreshadow Hinduism; thus we can legitimately look here for examples of the precursors of Hindu art. It would, however, be unwise to see Harappan religion as anything so definite as early Hinduism. Despite much excavation work little is yet known about the beliefs of the prehistoric inhabitants of the subcontinent. The greatest city sites are those of Mohenjo-daro, Harappa, Ganweriwala Thar and Kalibangan, but there were countless smaller sites, all the products of a remarkably homogenous society. Their presumed religious art is represented today by only a small amount of surviving material, the most important of which are seals, a few miniature stone sculptures and a very large number of terracotta figurines.

The seals, mostly made of steatite, generally bear an inscription of several characters of the still unread Indus Valley script. Usually an animal is also depicted, or more rarely a human figure or group of figures involved in some activity which scholars today interpret as religious; its precise meaning, though, is not known. Frequently the animals are shown standing before an object which may be a manger or perhaps a standard. Considering their use it seems likely that these animals – rhinoceros, elephant, and above all, bull – were thought to possess suitable power to guard that which was being sealed. The fact that the bull in later Hinduism

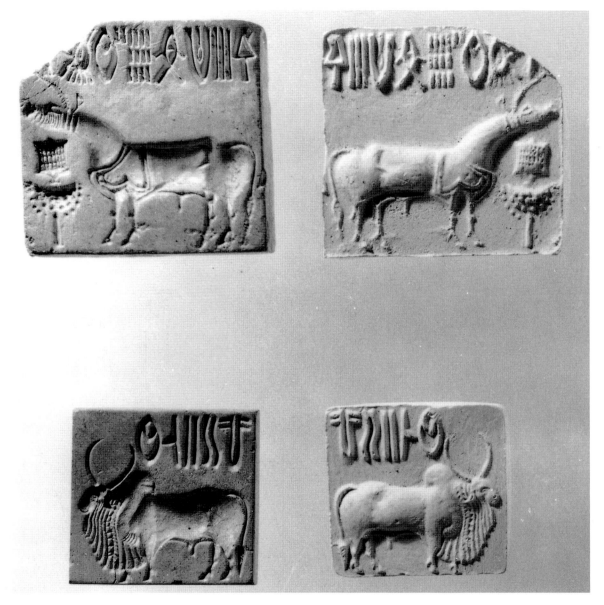

is accorded such an important position (it is the animal mount of the Hindu god Shiva), perhaps indicates some continuity of religious ideas between the two periods. Other more direct evidence of continuity is probably seen in the small group of seals on which human figures are depicted. One remarkable example shows a figure who displays many of the attributes which are later associated with the god Shiva. The figure on the seal is three-headed, and is seated cross-legged as an ascetic (or yogi), is surrounded by animals and is shown with erect penis. This 'prehistory' for the cult of Shiva is further suggested by the find at Mohenjo-daro of a small object explained by the excavator as a *linga*, the phallic pillar which is still

5 Two Indus Valley seals (left) with impressions. *c.*2500–2000 BC. From Mohenjo-daro. The naturalistic and confident manner in which the brahminy bull, with its heavy dewlap and prominent hump, is depicted, is typical of the lapidary skill of the Indus Valley stone-cutters.

6 *Below* Fragmentary terra-cotta figurine from Sheri Khan Tarakai, Bannu District, North West Frontier Province, Pakistan. 5th/4th millennium BC. This fragment of a painted female figurine is typical of South Asian prehistoric terracottas in the exaggerated way in which the beasts are modelled. This seems to emphasise the fertility aspect of this presumed mother goddess image.

7 *Below right* Terracotta sculpture of a female figure perhaps pregnant. *c.*2000–2500 BC. Mohenjo-daro. Fragmentary figurines such as this one are found at many prehistoric sites in India. It is assumed that they depict fertility goddesses.

today the most common form in which Shiva is depicted. Another seal which shows a row of female figures has been connected with the later Hindu cult of the Seven Mothers, the *saptamatrikas* (see p. 165). The 106 standard of miniature sculpting represented by these seals is very high, and suggests that the artists were drawing on an established tradition. Few earlier seals survive, however, and most of those which do bear geometric rather than figural designs. The Indus Valley seals are probably the greatest artistic achievement of the prehistoric period in India. Our knowledge of the religious ideas behind these images will, however, continue to be limited until the Indus Valley script is deciphered.

The amount of surviving stone or bronze sculpture is restricted to a handful of small pieces. Further, with the exception of the small stone items which may be *lingas*, the religious nature of the sculpture is in doubt.

However, in the field of small-scale terracotta sculpture a very large number of examples survive. Some of these are of animals – possibly votive offerings for a deity – but the largest single group is of human figurines. Very often these are of females, thought to be representations of a Mother Goddess. This identification is based on the exaggerated reproductive features (hips, vulva, breasts) which are frequently shown on them. Unlike the making of seals, the production of such terracotta figurines has a long documented history in India, prior to the Indus Valley period. Examples

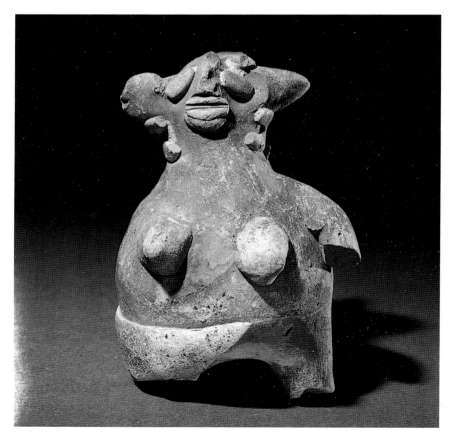

from sites in Baluchistan (Mehrgarh) and the North West Frontier Province (Sheri Khan Tarakai) date to the fifth and fourth millennium BC.

This long tradition of terracotta figurines continues up to the present day in India. Votive offerings as well as shrine figures of the deities are still sculpted in clay throughout Hindu India. The ancient examples use a variety of construction methods: hand-modelling, coiling, pinching and smoothing. More recent examples also make use of wheel-made and moulded elements.

8 Contemporary terracotta figurines. Chhota Udaipur, eastern Gujarat. The domes are considered residences for the deity, while the horses are for night-time travel through the forests. Small saucer lamps are seen in the foreground.

It has been assumed in the past that the arrival in northern India of the nomadic, horse-riding and chariot-driving Indo-Aryans caused the downfall of the Indus Valley civilisation. It now seems unlikely that there was such an absolute link between the two events. For, while there was a general decline from an urban style of life, some Indus Valley sites did continue, apparently without a catastrophic break of the type caused by an invasion. Other city sites do, though, appear to have come to a sudden end. This period in the history of India is extremely obscure, and our knowledge of the arrival and dispersal through northern India of the Indo-Aryans is almost non-existent. The only substantial source is the Vedas, the sacred lore of the Indo-Aryans. Any historical information preserved there is, however, mentioned only in passing. This lore, which was originally orally transmitted and only written down much later, was certainly never intended to be used as history. Further, it has proved notoriously difficult to allocate any archaeological material to the Indo-Aryans as they advanced and settled in northern India during the second millennium BC. We do know something of Vedic religion, as recorded in the Vedas, but of Vedic religious art, we can say little, for nothing survives which we can unequivocally identify with these early inhabitants of northern India.

It is, though, important to say something about Vedic religion, because the four Vedas have always been considered the foundation upon which all later Hindu activity has been based. Objectively the connection between modern Hinduism and the Vedas is not great. Few of the deities honoured in the Vedas became the major gods of Hinduism. Slowly these older gods, with only a few exceptions, lost their popularity. However, there is traditionally a strong feeling of the continuity of Hindu belief from the days of the Vedic sages right up to the present day.

The four Vedas are a collection of hymns, invocations, prayers and magic formulae. They are, in chronological order, the *Rig Veda*, the *Sama Veda*, the *Yajur Veda* and the *Atharva Veda*. The compilation of the *Rig Veda* into recognisable parts probably began around 1500 BC. This collecting together (the collections are known as *samhitas*) was based on material which reflects events several hundred years even before this. The deities mentioned are of a recognisably Indo-European type, and thus share features with the deities of other Indo-European peoples such as the Persians, the Greeks and the Romans. This connection is clear in the prominence given to male deities of the skies and the heavens, such as Indra (god of the storms), Surya (god of the sun) and Varuna (god of rain and the waters). The hymns in the first of the Vedas – the *Rig Veda* – survive in a sublime and powerful literary form, though exact meanings are often difficult to determine. There is almost none of the sweetness of expression when addressing the divine, nor the emphasis on fertility, which are such features of later, fully-established Hinduism. The *Sama Veda* is mostly made up of transposed sections of the *Rig Veda*, while the *Yajur Veda* is specifically concerned with the correct way of performing the sacrifice required by the deities. The last Veda, the *Atharva*, is more magical in tone, and already displays elements which are not specifically Indo-Aryan, but which may reflect an accommodation into the developing Vedic tradition of pre-Aryan beliefs.

3, 9

131

Sacrifice was a major component of Vedic religious activity and it has continued to be important in Hinduism, though over the centuries it has been tempered by the growth of a more pacific devotionalism. However, it is noteworthy that of the few Vedic gods to have survived from antiquity to the present day, the god of the sacrificial fire, Agni, is prominent. His presence is still invoked at times of religious solemnity when a sacred fire is lit, such as during the marriage ceremony. The antiquity of this cult is clear from the closeness of the name Agni to the Latin word for 'fire', *ignis*; they share a common Indo-European root.

Another feature of the Vedas is the importance placed upon the office of the sacrificial expert, the *brahmana*. (This term has been Anglicised as 'brahmin' and will be used in this incorrect, but more familiar form from now onwards.) This position was maintained, father to son, as only the brahmins were learned in the correct way in which to carry out the sacrifice. This lore concerned the correct performance of the sacrifices and became increasingly complicated. Its performance was conceived of as the way in which cosmic order could be preserved. The actions of Vedic sacrifice came to be regarded as symbols of universal creation.

Thus in Indo-Aryan society, the brahmins maintained themselves in the position of the highest status – they were the intermediaries between men and the plane of cosmic activity. The other main categories into which society was divided were the warriors (*kshatriyas*), the artisans and traders (*vaishyas*), the agriculturalists (*shudras*) and those who were outside even the lowest in the hierarchy, the outcasts. It is likely that this last group was made up of peoples subjugated by the advancing Indo-Aryans and then relegated to this inferior position. These caste categories have continued in traditional Indian society up to the present day, though enormously subdivided and elaborated. Tribal groups were always considered by orthodox Hindus as being beyond the categorisation of caste.

Between the end of the period of the compilation of the last parts of the Vedas (*c.*600 BC) and the first examples of unequivocally Hindu art, there is a further period of historical and cultural uncertainty. Our major source is again not art historical nor archaeological, but textual. It is only at the end of this period, with the appearance of the first monuments of the Buddhists and the Jains, that we have something more concrete than religious and philosophical texts. The texts which chronologically follow the Vedas include the *Brahmanas*, the *Upanishads* and the *Puranas*. Also emerging from an originally oral tradition during the latter part of the first millennium BC are the two great epics of India, the *Mahabharata* and the *Ramayana*. All of this written material – especially the epics and the *Puranas* – is important in the study of Hindu art because it provided artists with an immense body of material upon which to draw. The written word, always regarded in India as possessing an inherently mystical quality, thus gradually became the bedrock upon which so much later belief and iconography developed.

These texts are of different types. Thus, the *Brahmanas* deal largely with the ritual performance of the sacrifice and its effects. The *Upanishads* are later in date and are much more philosophical in content. They are concerned with the practice of asceticism and with philosophical speculation. The authors of the *Upanishads* grappled with ideas which attempted

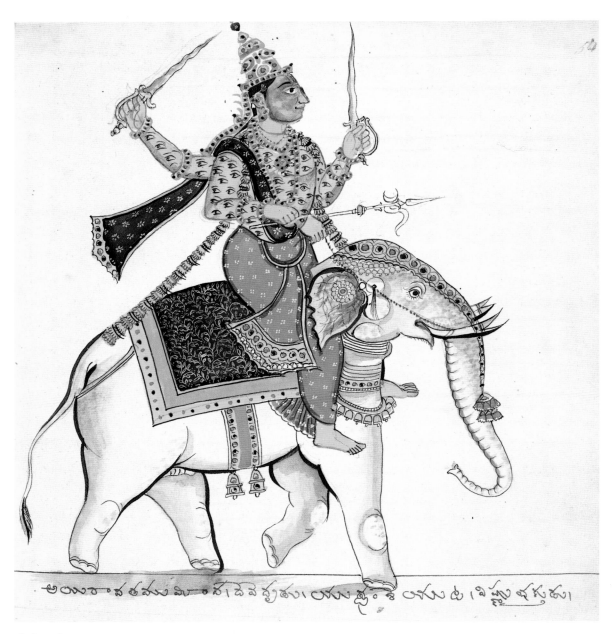

అయిరావతము మీ ... ని దేవేంద్రుండు. యసు ఖం.ఓ యసు ఢి (విష్ణు ధనుడు)

9 Indra riding on Airavata. South India, probably Tanjore. On European paper, watermarked 1820. Indra is one of the few gods whose worship survives from the Vedic period. His cult has not, however, remained unchanged, and he is shown here as a minor deity – one of the Eight Guardians of Space, the *ashtadikpalas*.

10 The marriage of Krishna. Page from an illustrated manuscript of the 10th century Vaishnava text, the *Bhagavata Purana*. Western India. *c*.1500 AD. The 10th canto of the *Bhagavata Purana* deals with the life of Krishna, especially the episodes concerned with his love for the milkmaids. In this painting the blue-skinned god celebrates his marriage before a sacrificial fire, into which an offering is being poured by a brahmin.

11 Register from a scroll-painting illustrating the enthronement of Rama at Ayodhya. Probably from Bankura District, West Bengal. 19th century. We know of an Indian tradition of epic story-telling using painted scrolls as illustrations from the time of Patanjali (1st/2nd century BC) who speaks of it in his grammar. This tradition still continues in several parts of India. The register illustrated is from the end of the *Ramayana*. Rama and Sita are enthroned; to the left, Lakshmana and Hanuman offer obeisance.

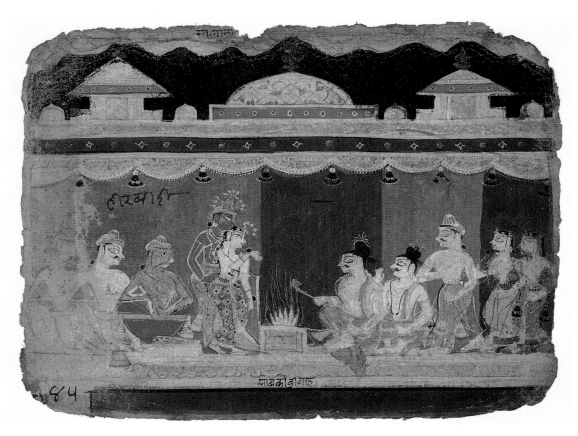

सीतावास

लीरबाई

४५ सीबकीबीबाह

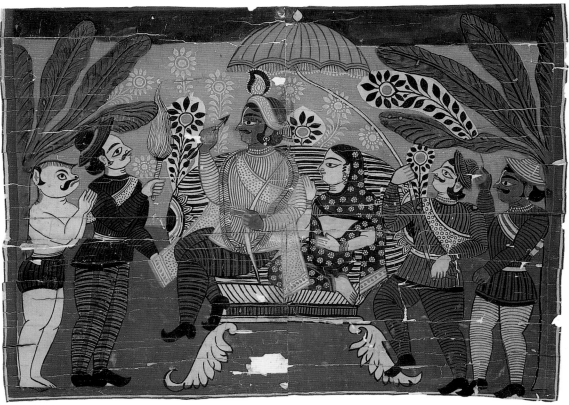

to connect humanity with what they felt to be the underlying universal principle, or Brahman. They suggested that, beyond even the gods, there existed an impersonal, and ultimately unknowable, controlling force. Scholars have noted in this type of speculation a parallel to the metaphysical investigations of the sectarian groups already beginning to break away during the Upanishadic period from the orthodox religion based on brahmanical sacrifice as laid down in the Vedas. These sects included the Buddhists, the Ajivikas and the Jains. It is certainly true that in the last half of the first millennium BC, religious questioning of great variety existed in northern India. This was frequently characterised by a turning from extrovert mythological deliberations to somewhat introverted philosophical theorising. The *Upanishads* are typical of this intellectual movement.

The *Puranas* – later in date – are altogether more accessible. They are concerned with the legends of the gods, and detail exhaustively the myths of divine creation, battle and destruction. They are generally more narrative and less speculative in nature than the earlier texts. Some of them speak only of one particular deity, and thus present a partisan viewpoint. 127

Finally the epics, also initially products of the late centuries BC, have provided Indian artists with countless subjects upon which to draw. The most important are the *Mahabharata* and the *Ramayana*. The former is enormously long and is mostly earlier than much of the somewhat shorter *Ramayana*. Today the *Mahabharata* is especially remembered for the section known as the *Bhagavad Gita* ('The Song of the Lord'), which although only a very small section of the whole, has frequently been depicted in Indian paintings and prints. Here we encounter the popular god Krishna in disguise as a charioteer, offering advice to the hero Arjuna on one's duty in life. This pivotal exchange between the deity and the hero takes place on the eve of the battle of Kurukshetra, which is the climax of the whole immense epic. The human duty outlined in this important text is the need to follow one's destiny as laid down by one's birth and station. Duty fulfilled, without attachment to the consequences, is thus of greater importance than one's own wishes. It is a great statement for the persistence of the *status quo* and has had a profound influence on the development of Hindu civilisation.

The *Ramayana* also provided a mass of narrative matter for both the Indian painter and sculptor. The epic tells of King Rama, his wife Sita and his brother Lakshmana. Early in the epic Sita is abducted by Ravana, the king of the island of Lanka; the majority of the rest of the epic is concerned with her rescue. In their many adventures Rama and Lakshmana are greatly aided by Hanuman, the war-leader of the monkeys. The episodes in which he features are some of the most entertaining and attractive. Like all true epics, the *Ramayana* was originally orally transmitted and is made up of a number of different strands which became part of it at different times. These varying layers of the story brought with them particular aspects of the Hinduism of the day. This process of accumulation has been continuing well into the historical period. In the text we can see, for instance, how Rama became increasingly recognised as a form of the god Vishnu, and less as merely an important martial king (for Rama as an incarnation of Vishnu, see pp. 129–32). 11

79, 140

Other early Indian religions

At the time of the compilation of the *Upanishads*, other sages and philosophers flourished, especially in the area of eastern India which today forms the states of Bengal and Bihar. By the sixth century BC this region had become the most important area of civilised settlement in India. It was here that the historical figure of the Buddha was born as Prince Siddhartha, in the sixth century BC. Here he practised his ministry, dying in *c*.480 BC. A contemporary of the Buddha, also from this same part of eastern India, was Mahavira, the founder of Jainism. There were also other philosophers and enquirers around whom disciples gathered, just as they did around the now more famous founders of Buddhism and Jainism. However, few other names have come down to us because these other philosophical and religious traditions have not survived, and the memory of their founders has largely been lost. Both the Buddha and Mahavira questioned the stranglehold which the brahmins maintained over all religious activity. They called into doubt the rigidity of the caste system, and thus the basis of brahmin power. They also queried the use of sacrifice as a viable way of communicating with the divine. However, like all other Indian religions – including Hinduism – they did accept the concept of the transmigration of the soul, and the idea of *karma*. This last idea is one of the most important in Indian philosophy. The belief is, first, that time is cyclical, second, that all beings are involved in a continuous round of endless existences one after the other of varying quality, and third, that the quality of these countless existences is determined, prior to birth, by the deeds – good and bad – of our previous lives. The goal is therefore to escape from the infinite round of existences. This can be done either by slowly working through the many levels of existence, (always subject to falling backwards just as much as advancing) or by cutting through all the bonds which hold us to the wheel of existence. The goal of either course is the state of liberation (*moksha*), where human concerns no longer impinge. Concepts such as these are present in the three great religions of Indian origin: Hinduism, Buddhism and Jainism.

Buddhism has evolved just as much as Hinduism, and it is now difficult to be certain what exactly was taught by the historical figure known as the Buddha (the 'Enlightened One'). It is clear, though, that he abandoned the orthodox religious and philosophical ideas based on sacrifice and supplication, as laid down by the brahmins. He propounded his own system, based on the insight he had gained while engaged in the meditation which resulted in his enlightenment. This experience of enlightenment took place at Bodh Gaya in Bihar. Here the Buddha, seated beneath a pipal tree, entered a state of profound concentration from which he emerged understanding the nature of human existence. Following this experience, he taught that human existence is suffering, for it always ends in decay and death; that suffering is caused by desire; that desire (and thus suffering) could be eliminated by non-attachment; and that non-attachment could be achieved through following specific rules of human behaviour. This doctrine and the rules for right conduct were laid out in the Buddha's first sermon, delivered at Sarnath, near Benares.

One of the notable features of Buddhism during its 2500 years of history has been its ability to develop new concepts. Probably the most important of these changes was the emergence of the doctrines which have since become known as the Mahayana. It was these doctrines which were especially popular during the spread of Buddhism from northern India to Central Asia, China and Tibet, and they are still to be found there. The Mahayana first developed, however, in India from the first centuries AD onwards. Its exponents taught that, just as the historical Buddha had been able to gain enlightenment, and thus enter Nirvana (the liberation of extinction), so it was likely that there had been others who had previously achieved the same state. There were also clearly going to be others in the future who would also gain Buddhahood, for this was the goal of all that the historical Buddha had taught. Thus there developed the idea that not only had there been many Buddhas in the past, but that there would be many more in the future. The corollary of this was that there were many individuals who were in various stages on the way towards Buddhahood and enlightenment. Those who were but one stage before Buddhahood, were called bodhisattvas ('those containing the essence of Enlightenment'), and it is around these that a theistic cult developed. They were regarded as beneficent and approachable, unlike the historical Buddha who had passed beyond human ken following his entry into Nirvana.

The effect of Mahayana Buddhism on the development of Hinduism has been considerable. During the early centuries AD the cults of the great Hindu gods which are examined in the next three chapters were developing. It is during exactly this period that the cults of the bodhisattvas were also gaining prominence and popularity. Thus, it is not surprising to find, for instance, that the imagery of Avalokiteshvara, the Bodhisattva of Compassion, has many features in common with that of the Hindu god Shiva. Both wear the matted and piled-up hair of the Indian ascetic, both are shown with an antelope skin thrown over the shoulder, and Avalokiteshvara, just as Shiva, is sometimes shown carrying a trident. The name of the bodhisattva is also noteworthy, for in the Hinduism of the medieval and later periods, the use of the suffix 'ishvara' (Lord) invariably implies a Shaiva affiliation.

Further, with its emphasis on the devotional worship of deities, Mahayana Buddhism prepared the way for the eventual merging of the popular, non-monastic forms of Buddhism with Hinduism, and the inclusion in Hinduism of Buddhist ideas and practices. The cult of the bodhisattvas had in most parts of India combined with the cults of deities in the Hindu pantheon before the end of the first millennium AD. The Buddha himself was eventually listed as one of the incarnations of the Hindu god Vishnu.

90

The process of the development of theistic cults was, therefore, the same one, operating at the same time and in the same place. Today it is difficult to disentangle in the two surviving religions what owes its origins to Buddhism or to Hinduism. A case in point is the mystical doctrine of the tantras, which were elaborated in the second half of the first millennium AD. The concept behind these tantric texts is that supernatural powers can be gained through practising extreme acts of austerity, and sometimes

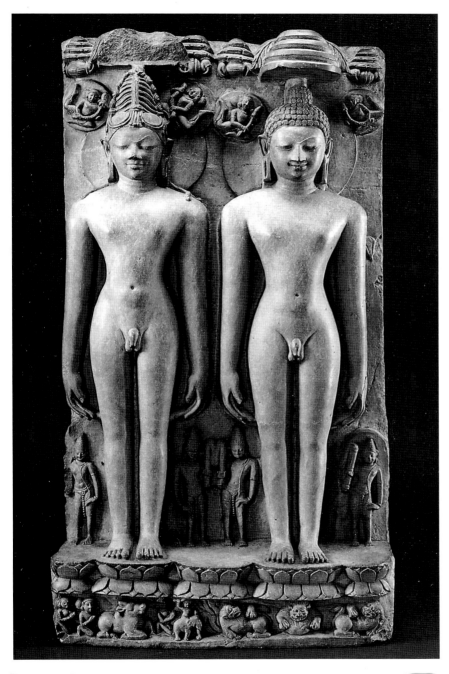

12 The *tirthankaras* Rishabha-deva (left) and Mahavira. Schist. Orissa. Eastern Ganga period, 11th century. The first and last of the Jain teachers (*tirthankaras*) are depicted in this fragment of temple sculpture from eastern India. As is consistent with Jain iconography, the upright and naked figures have broad shoulders and narrow waists. The ascetic nature of Rishabhadeva is suggested by his piled-up and matted hair. The parasols above their heads (one is now broken) indicate the royal nature of the two figures.

behaving in a highly unconventional manner to demonstrate the illusory nature of existence. This path was dangerous and difficult, but the powers thus gained could then be used by an adept to short cut the endless rebirths of karmic existence. Thus liberation – *nirvana* for the Buddhist, and *moksha* for the Hindu – could be achieved in the short passage of one lifetime.

Jainism, the religion founded by Mahavira (the 'Great Hero'), has had a

different career to that of Buddhism. Unlike the Buddhists, the Jains seem to have stayed close to the doctrines of their founder. The development of further doctrines, which has been such a feature of Buddhism, has never been a serious component of Jainism. The most provoking split the Jains have experienced has been whether monks should or should not wear clothes; doctrine has remained remarkably constant. This insistence on the original message, with only passing acknowledgement to the attractions of theism, may well explain why Jainism has never been a movement of mass appeal. This doubtless also explains why Jainism has never spread outside the confines of India. In India itself, the Jains have on occasions been powerful and important, but for centuries now they have been restricted largely to western India (Gujarat and Rajasthan) and the southern Deccan (the area north of Mysore). The emphasis on the important Jain principle of non-violence (*ahimsa*), in the teachings of Mahatma Gandhi, is perhaps connected with the Gujarati origin of his family.

Like Hindus and Buddhists, the Jains believe in *karma*, and in an eternal series of rebirths. Escape from this cycle can, it is taught, only be achieved through the dissipation of negative *karma* accumulated from previous births. This is achieved by following a code of behaviour of considerable austerity. Ideally, to accomplish this one must join a band of wandering monks or nuns. Each individual gives up all possessions, denies all the pleasures and comforts of the world, regularly fasts for long periods, begging for what food is taken, and undergoing various austerities. The sanctity of all life, including the very smallest insect, has always been stressed, with the result that Jains practise vegetarianism of a severe kind. They often even eschew root crops because of the possibility of killing small grubs while extracting the tubers from the soil. In western India the Jain practices of vegetarianism and pacifism have had a profound effect on the cult of Vishnu.

Mahavira took an uncompromising stand on the unimportance of the gods, just as was the case in early Buddhism. However, unlike Buddhism, Jainism has on the whole maintained the basically atheistic and austerely negative tenor of the early teachings. It is true though that Jains honour, even worship, Mahavira, as they do also his perceived twenty-three predecessors. All these previous sages have, it is believed, brought the Jain message to the world during different cycles. They are known collectively as the twenty-four *tirthankaras* (the 'ford-crossers'). They are differentiated in a Jain temple by slight variations in their iconography. The most notable of these differences concerns the immediate predecessor of Mahavira, Parshvanatha – the only one of the *tirthankaras* other than Mahavira for whom there exists any historical evidence. He is recognised by the rearing cobra hood which protects his head.

Common features found throughout Hinduism

We have now examined various elements which contributed in larger or smaller ways to the making of Hinduism and its art. This has included the Indus Valley civilisation, the texts of the Indo-Aryans (the Vedas), the ideas of the sages who produced the *Upanishads*, and finally (in brief) the

doctrines of the Buddhists and the Jains. All of these have provided features which eventually entered into mainstream Hinduism. In the remaining part of this chapter some common characteristics which are found throughout Hinduism will be introduced. These are all elements which have had an influence on the art of Hinduism – an art which is first and foremost a functional art.

Although philosophical speculation has always been a part of Hinduism, Hindus have never absolutely rejected the centrality of the gods, or a god, however impersonal. This is clearly demonstrated in artistic activity where the depiction of the deities is traditionally the single most important subject for the artist. Images of the gods are seen everywhere in India. They populate the land almost as profusely as do the humans. In this obsession with imaging the gods, Hinduism differs importantly from both Buddhism and Jainism. The importance of the gods to the Hindus is incontrovertible. This is especially so in the Hinduism of the majority and is even so when, as often happens, a devotee gives one god pre-eminence and worships that deity in preference to others.

Most Hindu religious activity identifies the practitioner as belonging to one or other of the three major groupings in Hinduism. These groupings are based on the central gods of the Hindu pantheon – Shiva, Vishnu and the Great Goddess (also known as Devi, 'goddess'). Although they are three in number, they are in no way a trinity in the Christian sense. Sometimes, though, devotees will insist that behind even these beings, there is an overarching and impersonal Principle. This is a re-statement of the old idea of the indefinable and unknowable Brahman, first developed in the *Upanishads*. This principal is sometimes personified as the god Brahma, and is identified as a creator god. However, historically there has been no substantial cult of this indefinable power, and this doctrine has had little effect on Hindu art. Each of the major deities will be the subject of one of the following chapters. Despite having evolved from very different roots, and possessing very different characters, as Hindu deities they do all demonstrate certain features in common.

Gods in many forms

Today we can isolate these three great deities to whom most other deities in Hinduism have some relationship. This has not, however, always been the case. It is clear that over long periods of time, Hindu cults exhibit a tendency to move from multiplicity and variety, towards unity. Thus many different cults tend to converge, eventually appearing as a single deity. This tendency largely explains why Shiva, Vishnu and Devi have such well-developed personalities and cults. For instance, the god known today as Shiva, seems to be made up of a number of originally different divine characters. To the devotee this variety implies the all-pervasive nature of the god. To an outsider it may also suggest the way in which separate cults have joined to become one cult. The Hindu god Shiva certainly contains elements of the Vedic god Rudra as well as elements of a non-Vedic fertility god, and a god of the cremation ground – to name but three from a mix of great complexity. In two of these forms he has a human shape, while in the other he appears only as a phallic pillar. Here is a further

characteristic of Hindu deities: they can be worshipped in both iconic and 39, 40
aniconic forms.

Vishnu similarly demonstrates variety – so much so that there is a
canonical list of the ten most important forms, the *dashavataras*, all quite
separate and having their own mythologies. There are also many lesser
forms. These different forms, or *avataras*, are usually translated as
'incarnations', though the word literally means 'descent'. This literal
translation suggests the way in which they are thought to operate. They are
regarded as forms of the god manifesting themselves ('descending') to
mankind at times of great need. The nature of these incarnations differs
greatly. Some of them have animal and some have human forms; some are 72, 82
aggressive and some pacific. This variety again suggests that there has been
some gathering together of varying cults with tribal, rural and urban input.
The ninth *avatara*, the Buddha, is even an historical figure. This last 90
example shows how the system can accommodate new entries. Regional
variety can also be catered for in this system, as a local holy man can be
listed as one of the *avataras* in place of one of the other less popular
incarnations.

Hindu gods worshipped in shrines
Hindu deities are usually worshipped in man-made structures – everything
from two stone slabs leant together in a forest shrine, to a built temple of
subtle design and exuberant decoration. The many features of a typical
temple are delineated in Chapter 2.

The space where the god is enshrined in a Hindu temple is usually not
large, though it is the essential part of the whole edifice. Not much space

13 Painting of a procession from a Shiva temple. Tamil Nadu, South India. First decades of the 19th century. This painting, part of a series of fourteen, shows processional images (from left to right) of Ganesha, Murugan (flanked by his two wives) and Shiva with Parvati. Carried on platforms rather than on their usual animal mounts, these images are probably proceeding from the temple to the nearby temple tank. The raft on which the tank procession takes place becomes their *vahana* (see fig. 27). Over each of the deities is a parasol, the emblem of royalty (see fig. 27).

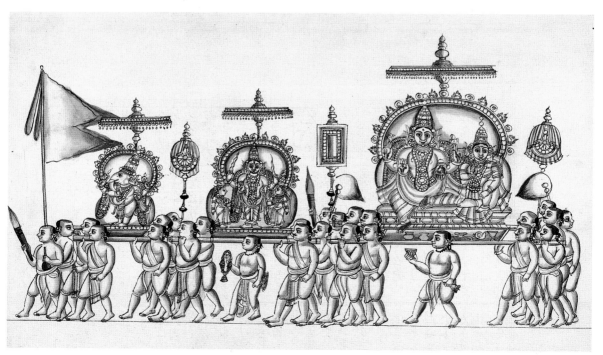

other than this is required, for temples do not need congregational spaces, unlike Christian churches. They do, however, need space for the rituals of the cult, which generally take place at the threshold between the chamber where the deity is enthroned and the outer world. Theoretically the ritual is a sacrifice, as was the case in Vedic times. However, today the sacrificial element has almost been lost, with the result that the worship is made up of offerings to the god, prayers made, and the chance to view the deity (*darshan*). The making of eye contact with the god is considered especially auspicious, and is the culmination of any visit to the temple. The desire for *darshan* produces a brand of rapt devotionalism of a type which is almost unimagined in Europe today. The focus of this devotion can just as easily be one of the great gods, or one of their local forms, or perhaps one of the revered mystics or saints of previous times.

Another spatial requirement in a Hindu temple is room for processions to take place. Processions honouring a deity are an important part of temple activity, and generally they move from the inner and darkest part, to the most open and outer part of the temple. Such processions are particularly apparent at festival times, when the god may be brought out of the temple complex itself and paraded through the streets, before returning to the innermost confines where the shrine is located. The retinue of the god in procession will be full of lesser gods and their human attendants carrying their emblems and their lamps.

13, 25
133

Pilgrimage

The time of the festivals may also coincide with pilgrimage to a particular temple – this is another important feature in Hinduism and one which is often shown in painting. Since the first building of railways in India in the

14 Painting of the temple of Jagannatha at Puri, Orissa. 19th/early 20th century. This type of distinctive painting has been produced at Puri for at least two centuries, doubtless for much longer. Purchased by pilgrims as mementos, the paintings show the Jagannatha temple in plan, elevation and section. Located centrally are the gods of the Puri triad (see pp. 135–8) with the temple tower above them. Elsewhere are marked various of the local spots of sacred geography.

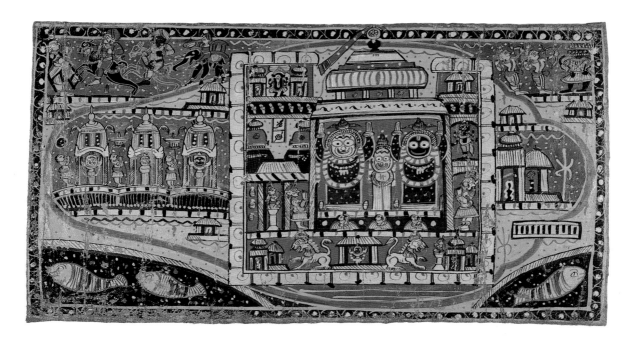

15 *Opposite* Small image of Durga killing the Buffalo Demon. Brass and silver. South India, perhaps Mysore District. 18th/19th century. This exquisite and diminutive image of the powerful goddess (see pp. 168–71) is typical of icons used in domestic shrines. Distinctive southern features include the mask-like face of the lion with bulging eyes, the tall crown of the goddess, the five-headed cobra which protects the deity, and the lion mask (*kirttimukha*) at the top of the framing arch, from whose mouth garlands spew.

middle of the nineteenth century, pilgrimage has become even more popular because of the comparative ease with which it has become possible to travel the length and breadth of India. It is not unusual now to encounter large groups of pilgrims on the move during agriculturally slack periods of the year. They will visit as many sacred sites as they can during their tour either by bus or by train. Usually a pilgrim to a shrine will carry away with him some holy souvenir – often a picture of the god of the particular temple. In the past this would have been a painting, though today it is more likely to be a print.

Pilgrimage can also be concerned with death. Cremation is the preferred form of disposing of the dead for most Hindus, and to be cremated at an auspicious place is desired by all. The banks of a river – above all the banks of the Ganges at Benares – are the most auspicious. Thus, to be there already at the fateful moment means that elderly people – especially widows from traditional households – may make one last pilgrimage, when all family obligations have been honoured and all human ties have been cut. To die and be cremated at a holy place will help towards a better future in the life to come.

Pilgrimage has been an important way for cults to spread. The present popularity of the Vishnu shrine at Tirupati north of Madras is a case in point. Because the act of making the pilgrimage is considered highly efficacious, the shrine now attracts devotees from all over India. The god is considered to answer all boons requested of him. The variations in the nomenclature of the god is some indication of his popularity – he is Venkateshvara in the south and Balaji in the north. The rise to prominence of this cult probably coincides with the establishment nearby at Chandragiri of a palace of the late Vijayanagara kings. Indeed, although the original temple may be late Chola in date, the majority of the structures date to the Vijayanagara period (fourteenth–sixteenth centuries AD) and later. Here, the power of the god and the power of the Rajas became interconnected.

Devotionalism

Devotionalism, as demonstrated by pilgrimage, is today a very strong element in Hinduism and its roots can be traced back to the sixth and seventh centuries AD. In south India at this time itinerant devotees travelled from shrine to shrine singing the praises of the god and abandoning themselves to his worship. These hymns of adoration have been collected together and form a large literature of devotional poetry. Further, the inspired saints who gave their lives to the worship of the deity through their compositions and recitations, have themselves become the objects of veneration and love. This devotional element in Hinduism, for many centuries now pan-Indian, is known by the Sanskrit word, *bhakti*. It has profoundly shifted the emphasis in Hinduism away from ritual and sacrifice, towards love and surrender to the god. These qualities are today especially noted in the worship of Krishna (one of the *avataras* of Vishnu), but over the centuries most deities have received the love and devotion which is at the core of *bhakti*.

Because of its non-Vedic origins, *bhakti* has often been regarded with

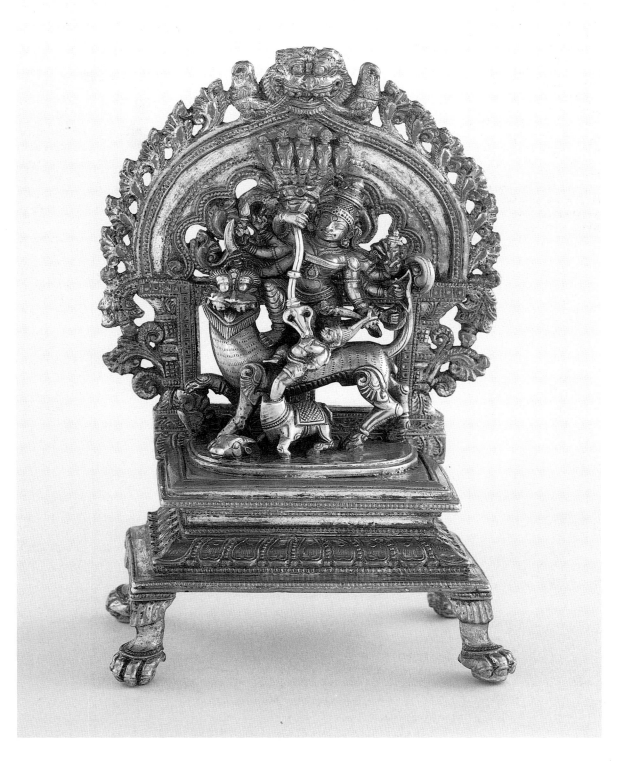

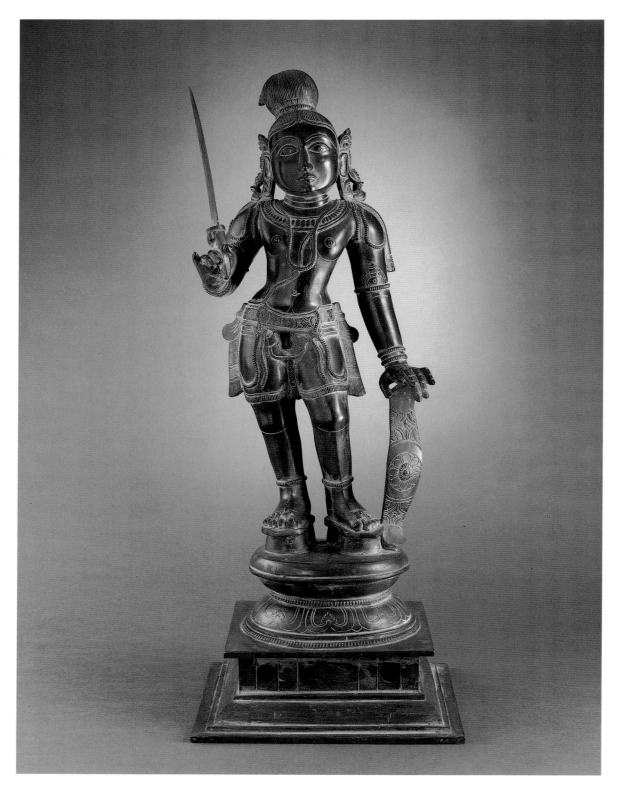

suspicion by the brahmins. It has further caused alarm amongst the religious experts because the rapt and loving devotion, with its hymn-singing and recitations, has usually by-passed the intermediary of the brahmins. Often, therefore, *bhakti* cults have emerged from non-orthodox groups, and have been a means for non-brahmanical groups to have direct access to the deity. This has been important because, until recently, low caste groups were often excluded from orthodox temples; *darshan* and its blessing was thus not available to them. It is therefore not surprising that the immense literature of *bhakti* has invariably been composed in the vernacular tongues; it is now to be found in all regions of India.

The effect of *bhakti* on Indian religious literature has been fundamental. A similar effect is seen in the visual arts. First, the cults required the representation of the new intermediaries – the saints – to be produced. The number of sculptures and paintings of figures such as the South Indian saints the *alvars* and the *nayanmars*, the Bengali saint Chaitanya or the Marathi saint Tukaram, is immense. Regional cults of poet-saints and their depiction in art, are known from all over the subcontinent. However, the requirement for images of the deities who were the objects of the veneration of these saints was probably even more substantial. Thus were produced paintings and sculptures of great tenderness, full of the intense feeling of the cult. This is particularly true of examples to be used in the privacy of domestic shrines. The emotion of *bhakti* has been a spur to the production of some of the finest Indian religious art.

16 *Opposite* Processional bronze image of the saint Tirumangai Alvar. South India. 18th/19th century. The south Indian singer-saints who praised the name of Vishnu are known as the *alvars*; the Shaiva equiva- lent are the *nayanmars*. Tirumangai (probably active in the late 8th century AD) was renowned initially as a dacoit – hence the sword and shield he carried – but later renounced this life in favour of one of devotion to Vishnu, whose name he praised in a prolific outpouring of devotional poetry.

2

THE TEMPLE

from a temple. Sandstone.
Western India, probably
northern Gujarat. Solanki
period, 11th century. Already
in the collection of the British
Museum before 1835 (the
exact accession date is
unknown), this column base
is typical of temples built
during the Solanki period,
such as the sun temple at
Modhera (see figs. 31 and
123). The positioning of
beautiful female figures at the
base of the column fulfils the
same auspiciously supportive
role as did the *shalabhanjika* at
Sanchi (see fig. 103) a
thousand years previously.

The actual soil of India is thought by many to be the body, or residence of the divinity, especially in its feminine manifestation. The idea that a deity can be resident in the very landscape of the country is discussed on pages 154–156. However, this identification of the land of India with the sacred makes it unsurprising that the whole terrain of the subcontinent is covered with the habitations of the gods – their temples. Despite the incursion of other religions, India is still a country of temples and shrines, and wherever you travel, the gods of Hinduism are present. In most temples they are imaged, either in paintings or in sculpture. Most of the sculpture that is illustrated in this book comes from temples or from smaller domestic shrines which mirror temple shrines. In the past, most artists would have gained their livelihood by working in the service of a temple, or working for a patron whose requirements were mainly religious. Painters were employed to decorate the outer areas of a temple compound, often with the cycles of legends of the deity of the temple. Sculptors used their skills in a similar manner, carving elaborately figured columns, walls and roof structures on the outer edges of the temple. They also sculpted the icon of the god (if of stone) or cast it (if of bronze); this was placed in the interior of the otherwise plain sanctuary. As the temple, in its architecture, decoration and ritual, has been the primary location where Hindu art has flourished, some general information about Hindu temples is necessary. This chapter will examine these categories of architecture, decoration and ritual in greater detail, and will place some of the major temple traditions within basic chronological and regional frameworks. A more systematic listing will, however, be found in Chapter 6.

Today in the major cities of India the temple does not have the important physical position that it has had traditionally. This is not least because the four great cities of contemporary India – Bombay, Madras, Calcutta and New Delhi – were all founded and laid out by Europeans.

17

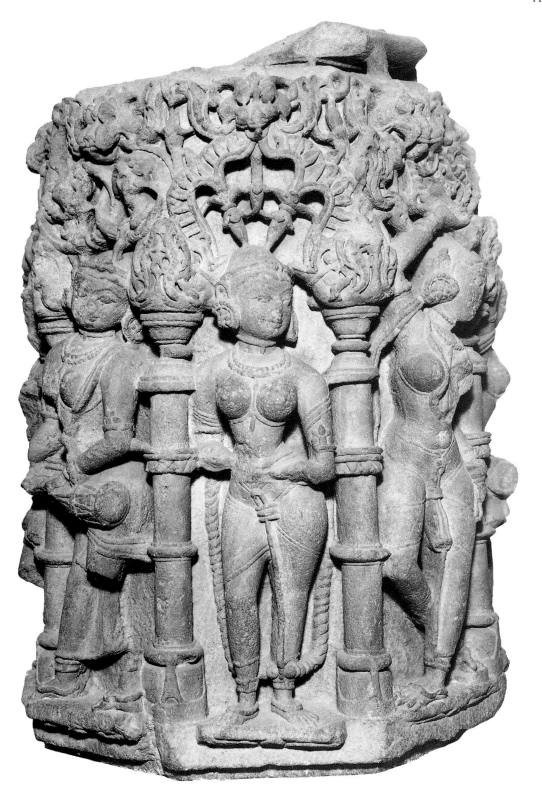

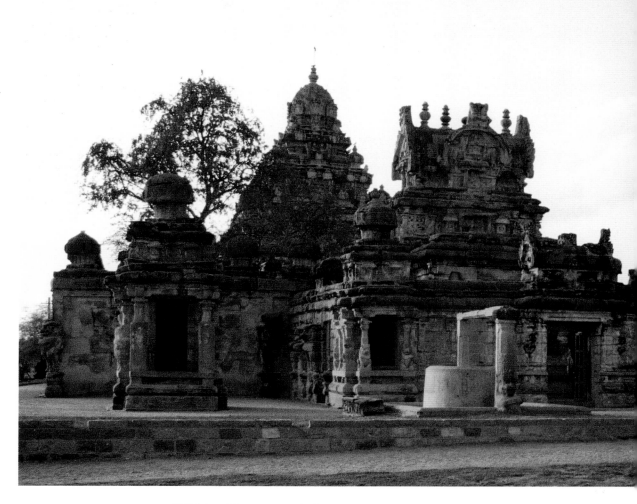

Within this context it is not surprising that the temple should have a
subsidiary position in these cities and the smaller towns which imitate their
western layout. Further, there is now immense pressure on space in Indian
cities, with the result that urban temples usually have to be built away from
the main streets, above shops or down side-streets. This situation produces
a greater dependence on domestic shrines, which in some urban households
are elaborate.

However, although the great cities dominate political and business life,
the majority of the population of India is still rural, or is resident in small
towns. In the countryside, the temple still acts as the religious and social
focus for the inhabitants, especially at the time of festivals. The temple is
often the oldest building in the town, and is frequently decorated with
sculpture and brightly-coloured paintings. However, today temples are
also constructed of concrete and reinforced steel, as well as the traditional
stone and brick. The use of permanent materials in the past marked out the
temple as separate from other buildings. Secular structures were built of

18 The Kailasanatha temple at Kanchipuram, Tamil Nadu. Mostly built during the reign of the Pallava king Rajasimha I (*c.*700–728 AD). Here, in one of the earliest free-standing temples in the Tamil country, the form is set for succeeding southern temples. In the foreground is the enclosure wall, entered by a tiered gateway (*gopura*). Beyond this is the pyramidal tower (*vimana*) which rises above the image of the god, in this instance a *linga*. A *bilva* tree, sacred to Shiva, is seen growing in the courtyard (left).

more transient materials such as wood and plaster. It was only in the sixteenth century, influenced at least partly by Islamic traditions, that more permanent materials were used for buildings such as palaces, which thus survive to this day. Free-standing Hindu temples survive, however, from a millennium earlier. Temples are usually easily recognisable because different architectural styles are used in religious as opposed to secular architecture. Generally speaking, temple architects used post and beam architecture without true vaulting; dry-stone construction technique was the norm with mortar rarely used. Very occasionally true vaulting was used in temples, though most religious architects considered it unstable, believing an arch held in place by compression to be inherently weak. Much more common was corbelled vaulting, in which technique Indian temple architects excelled. Ceilings are usually constructed of flat slabs of stone laid between pillars. In contrast to such conservative construction techniques, architects have for the last five hundred years designed secular buildings with both vaulted and trabeate elements. It has therefore not been

through lack of skill that the old techniques have been followed, but because of the religious necessity to follow tradition. Throughout the subcontinent, climate has affected temple architecture, sometimes dramatically. For instance, the temples of the southwest coast of India (South Kanara and Kerala) where there are huge rainfalls during the monsoon, have substantial wooden overhanging eaves. Similarly, in the Kulu valley in the foothills of the Himalayas, overhanging eaves protect against snowfall.

The rest of this chapter is divided into two sections, one theoretical, the other practical. The first and smaller section examines the ideas preserved in texts and in tradition concerning the architectural and cosmological theories behind the construction of an Indian temple. The second section will provide a practical understanding of the workings of a Hindu temple. This will be done partly through the device of making an imaginary visit to an unspecified (though typical) temple, describing what a pilgrim would see and experience, progressing from the outer gate to the inner sanctuary.

The theory of the Hindu temple

The design and construction of Hindu temples is theoretically determined by texts called *shastras*. They are invoked as the link between current activity and ancient tradition. They have come down to us in written form, mostly in Sanskrit, though many are doubtless based on earlier oral traditions. As a huge literary genre the *shastras* cover many different activities, not just the construction of sacred buildings. They describe the correct and most auspicious way to perform, according to tradition, a large range of activities. The earliest *shastras* date to the late centuries BC/early centuries AD. Examples include treatises on warfare, cooking, making love (the most renowned in this category is the *Kama Sutra*), playing music, or poetics. The *shastras* dealing with sculpture are the *shilpashastras*, those concerned with architecture are the *vastushastras*. These *vastushastras* were written in various of the different regions of India. Thus, in western India a text entitled the *Aparajitaprichchha* has been influential, while in Kerala (southwest India), the *Tantrasamuchchaya* has been the preferred text. Also from the south are the *Mayamata*, and the immense compilation, the *Manasara*, both of which have had currency throughout Hindu India.

Shastras are particularly recorded in areas of human activity where ritual activity was required. This fact explains the terminological language of the texts, which is frequently now obscure. Sometimes they were written as guides, but more often they seem to have been written as idealised descriptions, after the activity had taken place; in the case of architecture, after construction. Indeed, the unlikelihood that they were actually manuals of everyday practice, has caused the scholar D. D. Kosambi (1965) to say in frustration, 'The traditional Sanskrit books on architecture and iconography are contradicted by the specimens actually found.' This is an extreme statement, as the theory and the practice have some coincidence, though rarely a very exact one. Another scholar, T. S. Maxwell (1989), in an attempt to understand the more subtle purpose of these texts says, 'Their purpose was, rather, to preserve what could be remembered of

former traditions and recent conventions and to discuss such obviously associated issues as aesthetic theory.'

The *vastushastra* texts were, of course, written by the literate brahmin class, rather than by craftsmen. The authors were already one step away from the everyday activity and problems of building; 'spectators', as Maxwell calls them, concerned more with the symbolism of architecture and the ritual uses to which the finished product was to be put by them, rather than with the nitty-gritty of construction. The *shastras* tell us today what was considered traditional lore at a particular time in the past, not what was actually used as a blueprint by masons, carpenters and architects. The upper caste, the brahmins, had a general theoretical overview of temple construction and would have conducted the many rituals required during the process of construction. The brahmins were both the readers and the writers of the *shastras*. However, the two middle castes – the *kshatriyas* (rulers and warriors – and usually also the patrons), and the

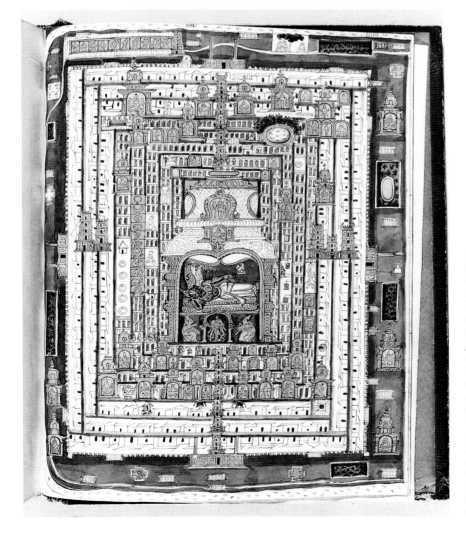

19 Schematic painting of the temple of Vishnu Ranganatha at Shrirangam, Tamil Nadu. South Indian, probably Tanjore. *c.*1820. The series of enclosing walls are entered through towered gateways, *gopuras*, halfway along each enclosure (see also fig. 29). Inner courts, meanwhile, are filled with small shrines dedicated to minor gods and saints. The central shrine where the god is depicted is fittingly large and impressive. It is, however, actually much smaller than many of the other structures. Its size in the painting is determined by its importance, not its real dimensions.

20 Small Shiva shrine (1.22m tall). Red sandstone. Western part of Central India. 18th century. Inside the shrine is a Shiva *linga*, while in the lintel above the door is a diminutive figure of Ganesha, whose auspicious image is so often seen above doorways. The tower or *shikhara* is typical of north Indian temple architecture. The central tower element is repeated in miniature, both at the corners and in the centre of each face. A late date for the shrine is suggested by the panels of floral decoration flanking the doorway; these are derived from Mughal decorative schemes.

vaishyas (craftsmen) – were more concerned with the everyday activity at the building site.

Hinduism inherited from Vedic religion a belief in the importance of correctly performed ritual undertaken by specialists – the brahmins. In the earliest Vedic period this ritual revolved around the sacrifice (see pp. 24–5) and the later Vedic texts (such as the *Brahmanas*) are filled with minutely detailed instructions on how the sacrifice should be correctly carried out. The exact performance of the sacrificial rituals ensured the success of the rite. When temples began to be built and the cult changed from one of sacrifice to one of worship and supplication (see p. 35), the idea of correctly performed ritual was probably extended to include not only the observance, but the building in which it took place. It was realised that the residence of the god needed to be built in a ritually correct way. Crudely speaking, if the builders followed the rules which were laid down, the god

21 Part of the complex of nine Shiva temples at Alampur, Andhra Pradesh. All built during the 7th and 8th centuries (early Chalukya period). Dominating the enclosure is the *shikhara* of one of the temples. The *shikhara*, or convex-sided tower, is capped by a large circular ribbed element, the *amalaka*. Although occurring here at Alampur in the Deccan, the *shikhara* is primarily a northern architectural feature. In the foreground are two open-columned halls (*mandapas*).

would be pleased to take up residence in the new abode – the temple. If they did not do so, the deity would be displeased, and the point of building the structure – ensuring access to the divinity – would be negated.

A common idea found in the *vastushastras* is the concept that the temple should be a representation of the cosmos, symbolically and in miniature. This idea may have developed from the transference of cosmic notions in Vedic sacrificial ritual celebrated in the open air to the temple, where the ritual took place within a permanent structure.

Thus, just as cosmic diagrams (*mandalas*) were painted as two-dimensional representations of the cosmos with the deity and his palace at the centre, so the temple was regarded as a three-dimensional *mandala*, illustrating the same universe. In both the *mandala* and the temple the deity occupies the centre. This central sanctuary chamber is the *garbhagriha*, literally the 'womb-chamber'. Like a king surrounded by his court, the god

in the temple is surrounded by his retinue. These are arranged in decreasing order of precedence as one moves away from the image of the divinity: his consort nearest, then his mount (usually a real or mythological animal), the other, usually subsidiary, deities in his group, the deities who stand guard over the eight directions (*ashtadikpalas*), the gods of the planets (*navagrahas*), the saints who have lovingly laboured in the service of the god, the various local folk deities and lastly and thus farthest from the sanctuary, the sacred plants associated with the cult. The heavenly situation is as consciously graded hierarchically as is Hindu society. 16 36

In Hindu cosmology, the centre of the Universe is conceived of as a mountain, Meru. From the base of Mount Meru, the continents spread out in all directions, with India to the south. Meru is considered to be the home of the gods, ruled over by Indra. This mountain home is equated with the Himalayas, and in simulation of this, the sanctuary of an Indian temple invariably has a tower superstructure placed above the sanctuary; the Sanskrit term for this tower-element is *shikhara*. The god in the innermost part of the temple is thus placed within a cave-like or womb-like chamber; the tower immediately above imitates the peaks of the Himalayas. Although all the gods are thought to live on Mount Meru, it is Shiva above all who is associated with the mountains. His consort is Parvati, whose name literally means 'daughter of the mountains', and their home is Mount Kailasa, on the borders of Tibet and India. Vishnu similarly has a mountain home, located on the flanks of the mythical Mount Meru – Vaikuntha. 20, 21

The presence of the god in a shrine is auspicious and desirable. As the gods can be both benevolent and malevolent, it is important to ensure that they are pleased to reside in one particular place. It follows that the most select place should be chosen for a temple. This is specifically suggested in a text quoted by the great Indologist, Stella Kramrisch (1946), in her pioneering study *The Hindu Temple*. In this *Purana* it states that 'The gods always play where groves are near rivers, mountains and springs, and in towns with pleasure gardens'. The emphasis on water is important, and if a river is not available, a tank should be provided. Auspicious river locations for temples include the junction (*sangam*) of two or more rivers (as at Allahabad), an island in the middle of a river (such as the Omkareshvara temple in the Narmada south of Indore) or the point where a river turns to the north (*uttaravahini*, as at Benares). To further add to the allure of a particular site, the location should be ritually prepared to ensure that the god is pleased to be temporarily manifest in that place. Rites of consecration carried out by brahmins are listed in the *shastra* literature. They include the placing of a foundation deposit prior to commencement of building, right through to rites for the placement of the final anchoring stone elements which crown the *shikhara* – these are the ribbed and fruit-like *amalakas*, above which is the final pot-shaped finial, *kalasha*. These, traditionally, are all necessary elements in the correct construction of a temple. 21

Early Hindu temples

It is clear from the Vedas, and also from the archaeological record, that the Indo-Aryans did not build permanent structures for the practice of their

religious rites. Their main sacred activity was sacrifice, and this was carried out in the open air. The pastoral and nomadic economy of at least the early Indo-Aryans also militated against the building of durable structures. It was only in the heterodox cults of Buddhism and Jainism (see Chapter 1) which first flourished in eastern India of the fifth century BC that religious structures began to be built. These were initially the solid burial mounds (*stupas*) in which the ashes of the Buddha were buried. Such structures must have first been built soon after the death of the Buddha in *c*.480 BC, but using wood and other impermanent materials for the crowning elements of the *stupa*, and for the railings placed around the drum. The only other structures associated with early Buddhism were the railings placed around sacred trees, similar to the ones placed around the *stupa*. In a Buddhist context, railings around a tree and offerings placed before it symbolised the Bodhi tree, the tree beneath which the Buddha achieved enlightenment. However, this use of tree symbolism certainly reflects a much earlier tree-cult associated with the nature-spirits, the *yakshas* (feminine, *yakshis*). In this context it is interesting to note that excavation inside the temple at Gudimallam (see p. 78ff.) has unearthed fragments of just such a railing from around the image of Shiva standing before the *linga*. This is dated to the second or first century BC, and is of the same type as those seen in Buddhist reliefs, where they enclose the Bodhi tree. The surrounding temple at Gudimallam is of the ninth century AD and later. The railings found around the image may, however, suggest the way in which early Hindu shrines were constructed.

The earliest recorded stone *stupas* were those built at Bharhut (second century BC) and at Sanchi (second century BC, and following centuries). It is at such sites, probably on the margins of the existing sacred spaces, that the first shrine structures must have been built. The change to the construction of large numbers of individual shrines seems particularly understandable in the first half of the first millennium AD when Mahayana Buddhism (see Chapter 1) was gaining ground against the earlier forms of Buddhism. The Mahayana, with its emphasis on devotionalism, had a much greater requirement for a place to worship a divine figure than did the earlier Buddhist sects, where the place of the individual and his personal meditation was given much greater importance. The first shrines would have been built of wood and have thus not survived; the next stage is represented by shrines which, although built of stone, imitate wooden structures. Such shrines are repeatedly found in the Buddhist architecture of Gandhara (modern northwestern Pakistan), dated to the second and third centuries AD.

Although no incontrovertible archaeological evidence for permanent non-Buddhist religious structures (in the form of floor-plans or cult objects) exists prior to the first centuries AD, there is epigraphic evidence which is very suggestive. An inscription recovered from the wall of a well at Ghosundi, in Rajasthan, speaks of a royal donation for the construction of a shrine. Although vague in some respects, it specifically mentions an enclosing wall built around stone objects of worship 'for the divinities Sankarshana-Vasudeva who are unconquered and are lords of all' (Banerjea, 1956, p. 91). Both the divine names are connected with the god

Vishnu (see Chapter 4), and the conclusion is inescapable that some sort of structure was built here to honour non-Buddhist deities in the first century BC. Unfortunately, the text is not specific enough to indicate the nature of the construction beyond the fact that there was an encircling wall. Precisely how the gods were honoured and whether it was in an enclosed building is not known. Similar in implication is the fragmentary inscription from Vidisha (old Bhilsa), in the modern state of Madhya Pradesh (see map on p. 228); it doubtless came originally from the nearby ruins of Besnagar. The inscription is from the shaft of a column and states that 'this Garuda column of the excellent temple of the Bhagvat was erected by Gautamiputra' (Banerjea, 1956, p. 92). This evidence linking a column topped with a figure of Garuda (the hawk mount of Vishnu) and temples dedicated to Bhagvat (literally 'the Lord', but almost certainly referring to Vishnu) is important. It provides a link with the more famous and still-standing column at Besnagar which is dated to the second century BC. The inscription on this column also records the erection of a Garuda pillar, just like the fragmentary inscription from Vidisha. Presumably the pillar on which the inscription survives is the Garuda pillar, though there is today no figure of a hawk on top of the column. While mentioning the name of the donor and of the deity to whom the column was dedicated, the inscription does not speak of a temple. The Vidisha fragment does fill this gap though, as it suggests that the column would have been placed in front of the shrine – just as tradition still demands. Further, there is tantalising evidence near to the column of an elliptical structure which could well have been the temple in front of which the column was erected. These inscriptions, then, provide suggestions for the existence of early shrines or temples, suggestions which are substantiated by the later archaeological evidence from Mathura. This includes the so-called Mora Well inscription, which records the installation in a temple of statues of the Five Heroes of the Vrishni clan, figures whose identities are usually taken to be Sankarshana, Vasudeva, Pradyumna, Samba and Aniruddha – all names connected with Vishnu.

The extent to which early temple structures were influenced by cultures further to the west is a question which is unresolved. The earliest temples in India which are non-Buddhist and for which there is archaeological – as opposed to only epigraphical – evidence, belong to the first centuries AD, and are located in northern India, at Mathura. The shrine at Mat just outside Mathura was probably royal and dynastic in character, rather than public and devotional. In this respect it is anomalous in the Indian context, as with only a few exceptions there are no comparative structures elsewhere in the subcontinent. Mathura was the capital of the Kushan kings in the first centuries AD and, as their empire also included the Hellenized parts of Afghanistan and Iran, it is likely that dynastic shrines such as the one at Mat had more in common with similar structures in western, rather than southern Asia. The Kushan dynastic shrine at Surkh Kotal in Afghanistan offers an obvious comparison.

Also recorded from Mathura, from the early Kushan levels excavated at Sonkh (late first/early second century AD), are the remains of an apsidal temple. The sculptural evidence suggests that it was dedicated to a *naga* (serpent) cult. A yet earlier temple was located beneath, but there is no

22

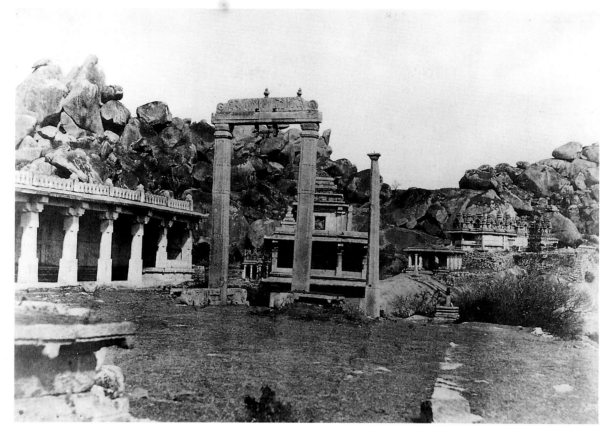

evidence of the nature of the cult. The presence of a *naga* cult at such an early period is an important piece of evidence because of the known antiquity of these cults elsewhere. They were apparently already in place during the first centuries of Buddhism and Jainism. In the first sculptural records of Buddhism, and in the textual record of the Jataka tales, they occur frequently. Early on in the spread of the new philosophies, the *naga* cults were incorporated into both Buddhism and Jainism (see pp. 29–32). Despite this, one can justifiably regard the *naga* cults, along with the similar cults of the mischievous *gana*, and the popular and frequently imaged tree-spirits (the *yakshas* and the *yakshis*), as the earliest cults of what was later to become Hinduism. Not only are they one of the earliest cults, but one of the most long-standing, for they still have many adherents throughout the subcontinent. Such cults as these, altered through contact with the Vedic tradition, and leavened by juxtaposition with Buddhism and Jainism, led to the evolution of historical Hinduism.

Having surveyed some of the archaeological evidence for early shrines, we can suggest that constructed temples emerged in response to various stimuli. These include the following: cult requirements – the move from sacrifice to devotion; religious history – the beginning of shrine building in the Buddhist (and perhaps also in the Jain) communities; international contacts – the uniting of northern India under the rule of a dynasty, part of

22 Photograph of a medieval temple group at Chitradurga, central Karnataka. Photographed in the 1850s, this salted print belongs to the first decade of photography in India. The idea of a single standing column in front of the shrine is of great antiquity. This example probably supported lamps. The free-standing arch close by is a swing, used at festivals for the entertainment of the deity.

whose territories had been previously ruled by Hellenized western Asians with a tradition of temple-building; and indigenous traditions – the local free-standing architecture in wood, which does not survive, but which is mirrored in a long series of Buddhist and Hindu rock-cut temples.

In this last category, the earliest of the decorated rock-cut temples – the Lomas Rishi cave – is dated to the third century BC, and is located in the Barabar Hills of Bihar. This cave bears no inscription, but a nearby example records the gift of the cave to the heterodox sect of the Ajivikas, by the king Ashoka in the third century BC. These rock-cut shrines are probably the first in the long series which continues for over a thousand years throughout India. During this period they grow in size and daring, eventually producing a structure of the sophistication and complexity of the Kailasanatha temple at Ellora, in the western Ghats (see map for 135 location, and below for further discussion). Many architectural features of the earliest shrines, such as the ribbed and vaulted ceilings of the shrine chambers, and the reliefs of building façades which decorate the portals, indicate a thorough-going knowledge of construction in wood. These features are clearly seen at sites such as Bhaja (second/first centuries BC) and Karle (first century AD).

The earliest free-standing temples which have survived only date from the period of the Gupta rulers of northern India (fourth–sixth centuries AD). Rock-cut architecture continued, often in conjunction with the building of free-standing structures, as at the sites around modern Vidisha: Udayagiri (rock-cut and Hindu); Besnagar (Hindu inscriptions, see above); and Sanchi (free-standing temples). At Sanchi a small Buddhist temple of the very early fifth century built of stone is recorded (temple 17), though the archaeological record suggests that earlier apsidal temples were located here. Meanwhile, at Bhitargaon, a Hindu temple of a slightly later date, built of brick and decorated with terracotta panels, survives. There are other examples of this early period, such as the temples at Tigawa, Nachna and Bhumara, though all of them are now restored. Although small in size compared to later structures, these early temples are recognisable as the antecedents of the later medieval Hindu temples. They display some or all of the following features: they are axially arranged with columned porches, are raised up on platforms with mouldings and have elaborately decorated doorways complete with guarding figures who possess magical qualities. Some probably had tower superstructures, like the later temples. Bhitargaon alone still has some surviving indication of this; temple 17 at Sanchi and the Kankali-Devi temple at Tigawa almost certainly had no tower. Approximately fifty years later than Bhitargaon is the renowned *dash-avatara* temple at Deogarh (*c.*500 AD), which also has remnants of a *shikhara*. More remarkable here are the three panels of sculpture which are located on the side walls of the outside of the sanctum; they are all Vaishnava in subject and illustrate that elusive Gupta quality which combines both vigour and refinement.

These early temple structures belong to the north Indian tradition; in the Deccan, a rock-cut tradition of Hindu architecture is recorded at sites such as Badami during the sixth century. The late centuries of the first 118, 13 millennium, however, saw the flourishing of a Deccan style of constructed

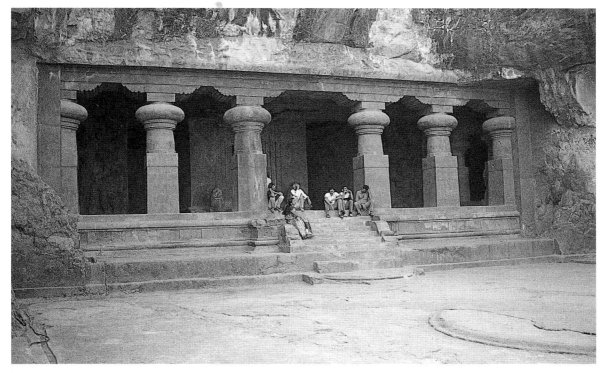

temples associated with the kings of the Early Chalukya dynasty. The
21 major sites include Aihole, Pattadakal, Alampur, as well as Badami (see
map on p. 229). Generally speaking, the early northern style of temple is
here expanded so that the sanctuary appears at the end of a series of
chambers, which start part-open and end in the sanctum, enclosed and
dark. This sequence is one which succeeding centuries saw consistently
developed, so that the numbers of intermediary chambers in front of the
sanctum increased, as did their size. The early Deccan temples are still small,
though decorated with sculpture of great accomplishment.

In the western Ghats, from Bombay to Ellora (see map), the same period
witnessed the excavation of both Buddhist and Hindu rock-cut temples. Of
23 these, the outstanding Hindu examples are on the island of Elephanta and
the Kailasanatha at Ellora – both dedicated to Shiva (see pp. 213–6). The
135 Ellora temple is remarkable because it is not made up of a cave-like shrine
excavated into the cliff-face like so many other excavated temples, but has
been cut out, from above, and is thus free-standing. As a bravura archi-
tectural and political statement it has few equals anywhere in the world.

Further south, in Andhra Pradesh, at the site of Nagarjunakonda in the
Krishna valley (see map on p. 229), free-standing shrines developed to
contain cult images in line with the practices both of Hinduism and the
emerging Mahayana school of Buddhism. These are dated to the third and
fourth centuries AD and thus provide evidence for the earliest Hindu
temples in southern India. Further, a number of these temple ruins have
yielded dated inscriptions. Temples at Nagarjunakonda were built both by
Buddhists and by Hindus, the temples of the latter being mostly Shaiva

23 The rock-cut temple at
Elephanta. 6th century AD.
This excavated shrine was
probably built by kings of
the Kalachuri dynasty. It is
situated on an island in the
modern harbour of Bombay.
The illustration shows the
exterior of the side chapel;
the location of the main cult
icons – the three-headed
image of Shiva, and a *linga* –
is in an excavated cave to
the right of the court. The
massive cushion capitals, and
the pillars of square section,
are also seen at other cave
sites in the Western Ghats.

(where it is possible to make an identification). At least one temple has been identified as Vaishnava (the god was worshipped in his eight-armed form, and his temple is dated by an inscription to 278 AD), and one also as dedicated to the Mother Goddess. A large sculpture of Devi was also discovered during the investigation of the site. Excavations at Nagarjuna-konda (still mostly unpublished) were carried out prior to the flooding of the valley of the Krishna River on account of a hydro-electric project. While this means that most of the site is now lost, it has also meant that considerable excavation was carried out prior to the inundation. Amongst both the Buddhist and Hindu temples were apsidal structures, which provided space for the ritual of walking around the cult object – circumambulation. Although only conjectural, it seems likely that this feature developed in Hindu shrines from the Buddhist practice of walking around an enshrined *stupa*, which being round would automatically suggest the construction of an apsidal building. We only know of these early examples of south Indian temples from the archaeological and epigraphic record: there are no surviving standing structures. Although a few lineal descendants of apsidal temples are known in early Hindu architecture (for instance, at Chezarla, Ter and most impressively at the 'Durga' temple at Aihole), the apsidal temple was not a form which remained popular in Hindu temple architecture beyond the end of the first millennium AD. In rock-cut form and further south, it is seen in the seventh century at the Sahadeva monolith at Mahabalipuram (see below).

From the excavation of one of the Shiva temples at Nagarjunakonda, where the inscription records the name of the god as Mahadeva (The Great God) Pushpabhadraswami, the following features are recorded: the erection of a flag-pillar (*dhvajastambha*) in the temple court, a practice recorded from the earlier inscriptions at Besnagar (see above), and one that it is still current today; the inscription on the *dhvajastambha*, which provides a date for its erection of 342; the placing of the temple within a walled court (*prakara*), entered by gates flanked by bastions – again a feature seen in the later temple tradition; the presence in the *prakara* of subsidiary shrines; and the alignment of the temple towards the river Krishna, where an impressively large flight of steps (*ghats*) on the edge of the water was uncovered by the excavators. These would have provided the necessary facilities for ritual ablutions. This temple shared some of these features with other of the sacred structures recorded at the site. Stone images of Karttikeya were recovered from two other shrines, while an inscription referring to a second Shiva temple came from a third excavated shrine – also located on the waterfront like the Pushpabhadraswami temple. This archaeological and epigraphic evidence for the construction of Hindu temples at Nagarjunakonda is dealt with in some detail here because of its early date and its infrequent appearance in the literature.

The later rock-cut architecture of southern India is recorded at sites throughout the Tamil country, such as Tiruchirapalli (old Trichinopoly) and Kalugumalai. It is, however, best-known from one of the earliest sites, the Pallava port of Mahabalipuram, south of Madras. Shrines here are both 108, 13 cut into the rock to form caves, and also cut free-standing from the rock. These are dated to the late seventh century AD, while at the same site in the

next century, the constructed temple known as the Shore Temple, begins
the series of magnificent south Indian stone-built temples of the Pallava
18 kings. These include the Kailasanatha and the Vaikunthaperumal temples
(respectively Shaiva and Vaishnava) constructed at their capital, Kanchi-
puram. Here shrines with ambulatory walkways and pyramidal roof-
structures are situated in courts, the walls of which contain small subsidiary
shrines. Entrance to the court is through a towered gate. This tradition,
under their successors, the Cholas, blossomed into what many consider the
136 classic style of southern temple architecture. The greatest patrons in this
expanded, imperial style were the Chola kings Rajaraja I (985–1016) and
his son Rajendra I (1012–1044). (See Chapter 6.)

Northern and Southern styles of temple

To a large extent the temple architectures of north and south India have
retained their own traditions. Considering the vast expanse of the sub-
continent this is not surprising. The differences of space and of style are at
least as great as those between say, a church in Italy and one in Scotland.
The racial, linguistic and climatic differences between the north and the
south of the subcontinent are also considerable; the basic religious tenets
which inform the structures remain the same. Not surprisingly, in the
Deccan at sites such as Pattadakal, midway between north and south, the
two basic styles are found at the same location. Undoubtedly there was
stylistic interchange between one area to the other. The northern and
southern styles are known respectively as *nagara* and *dravida*.

In the north, the history of the development of temples is less certain
than in the south, as warfare has greatly reduced the quantity of surviving
examples. The important temples which attracted huge numbers of
pilgrims and thus wealth, also attracted the attentions of the invaders of
northern India. The great temples at Somnath, Mathura and Benares, to
name only three of the more famous, were sacked during successive waves
of Muslim incursion into the subcontinent, from the early eleventh century
onwards. Thus, we are generally left with only the less important or
remote regional examples from which to form judgements. In this context
134 the large complex of still-standing temples at Khajuraho in central India is
all the more remarkable – exceptional not only from an aesthetic point of
view, but also because a large group of substantial temples survive in such a
fine state. In contrast with this situation, large numbers of temples survive
in the Deccan and above all in southern India from the eighth century
onwards. Also, it is not only the central structure of these southern temples
which survives, but also many of the subsidiary buildings. This architec-
tural context is generally missing in northern India. In the south there are
many temples with still-flourishing cults which were founded in the latter
part of the first millennium AD. Such a degree of religious continuity is rare
in the north of India. Only in the foothills of the Himalayas, for instance in
lowland Nepal, and in Kulu are such traditions maintained, though on a
smaller scale.

Despite this situation, the north has primacy by several centuries in the
matter of the earliest surviving free-standing Hindu structures (see previous

section of this chapter). From the fifth century onwards, the northern style was distinguished by a number of identifiable features. Most immediately obvious is the form of the tower over the sanctum (*shikhara*). This is 21 generally tall, and sometimes has a slightly convex outline. In the south, by contrast, the superstructure is flatter and smaller – pyramidal, rather than tower-like; here it is known as *vimana*. The continuation of the niches and 18 offsets of the temple wall straight up into the tower of the *shikhara* is another northern feature. The gateways of northern and southern temples are also substantially different – those in the north tend to be less pronounced, the *shikhara* being the most important element. In the south the gateway (*gopura*) was substantial from the Pallava period (seventh/ eighth century onwards) with a tower-like superstructure capped with a barrel-vaulted element. In the later periods this part of the temple architecture became increasingly pronounced, so that from the Vijaya-nagara period (fourteenth–sixteenth century) onwards, the *gopura* becomes 29 the visually dominating feature, often embellished with plaster sculpture, frequently brightly painted. This trend reached its most striking form in the Nayaka period, following the disintegration of the Vijayanagara empire in the sixteenth century. The development of series of *gopuras*, one beyond the other, is seen most clearly at sites in Tamil Nadu such as the Ranganatha temple at Shrirangam, the Arunachaleshvara at Tiruvan- 19 namalai, and the famous Minakshi-Sundareshvara at Madurai (see map on p. 229). Such south Indian temples built (or certainly expanded) from the sixteenth century onwards tend to display another typically southern attribute – gigantism. In the north, where religious divisions between Hindus, Muslims and Sikhs have been greater, the confidence of the southern builders has not been matched. Sacred complexes of the Nayaka period in southern India, with their enclosure walls one within the other, and their towering and coloured *gopuras*, are urban units in their own right. Such temples employ immense numbers of staff, and indirectly fuel large quantities of money into the local economy. It should come as no surprise that the temple of Venkateshvara at Tirupati (see p. 147), is reliably regarded as the wealthiest and most charitable temple in India.

The practice of the Hindu temple

At this point it is useful to consider the reasons that Hindus come to temples at all. Worship before a deity is probably carried out for one or more of four reasons: desire for well-being; desire for power over others; fear of the power of the deity; and pure devotion. The first three reasons imply some sort of contract, and worship certainly includes the making of offerings, and usually the expectation of something received in return. Offerings will include flowers, incense, fruits, clarified butter and money, and in the case of some cults, blood offerings. Such gifts to the deity will be used for the decoration or delight of the god, or for the upkeep of the temple and its officiants. However, food or flower offerings will usually be returned to the offerer as *prasad* (see p. 73). The fourth reason for visiting a temple – pure devotion – also generates offerings, given out of a sense of love for the deity.

In return for offerings, the devotee receives two things – one spiritual and intangible, *darshan*; the other physical and tangible, *prasad*. *Darshan* is the experience of seeing and making contact with the deity imaged in the temple sanctum. The most important and auspicious part of the representation of the god is the eyes. It is through the eyes that the human and the divine communicate, and the desire of devotees when they visit the temple is to make contact this way. There is a certain privacy in this communication, as each worshipper can feel that it is only with them that the deity is silently but intently communing. In modern Hinduism the eyes of new images are usually added separately, and often in the form of metal plates. Only with the installation of the eyes, according to the fixed rites, does the image become fit habitation for the god. The eyes are usually large in proportion to the rest of the body. Grander, and of a different material, they are immediately visible to the devotee who seeks *darshan*. *Darshan* has a significant effect on the temple plan, with the result that from the point where the worshipper crosses the threshold of the temple complex, the architecture will channel him towards the culmination of the visit – the 'taking of *darshan*'. The axiality of the temple plan is therefore a vital element, as it draws the attention of the worshipper towards the image of the deity.

A temple is usually not just one building, but a complex made up of a number of different units. The overall design is sometimes difficult to understand, especially for the first-time visitor. Changes of direction, as well as changes from light to darkness as one progresses towards the image of the deity, can be disorientating. Seen from above, however, the overall unity of the building plan becomes clearer. Generally speaking, the temple will be separate from the settlement in which it is located. This separateness is usually indicated by an enclosing wall, or a series of them, one within the other. Set into the outer wall are gateways, often built halfway along the length. Within the walls, the building containing the sanctuary will be centrally situated and recognisable because of the tower-like *shikhara* or the pyramidal *vimana* superstructure, mentioned above. The space between the sanctuary and the outer wall forms a courtyard, but is filled to a greater or lesser degree with other structures. Some of them are connected to each other by open or closed corridors, and may include minor shrines, music and dancing pavilions, verandahs, flag-posts, office buildings and pilgrim accommodation. It is this accumulation of structures nestling around the central shrine which gives many Hindu temples their confusing layout. The secondary structures are often built in different styles, reflecting differences both in time and patronage. In this respect, the analogy with a medieval European cathedral may be helpful. Amongst this apparent chaos, the important facts to note are that the worshipper enters from the farthest point and progresses from open, decorated, light space to closed, undecorated, dark space. Further, the deity in the sanctuary will usually be located in a straight line from the worshipper as he enters the temple compound, though to reach the sanctum it is necessary to move around the sacred space in an ever-decreasing, but always clockwise, circular direction. To process towards the god in an anti-clockwise direction is inauspicious, and disrespectful.

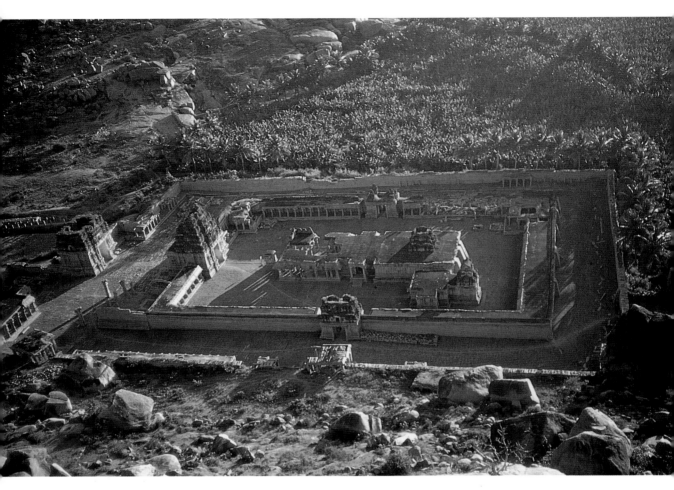

24 The Tiruvengalanatha temple at Vijayanagara, Karnataka. 16th century. This view of the great Vishnu temple in the Sacred Centre at Vijayanagara is taken from the top of nearby Matanga Hill. Despite its ruined state, the layout is still clearly visible, with enclosure walls, towered gateways, inner courtyard, central shrine and subsidiary shrine dedicated to the consort of the deity. At the far left, and beyond the *gopura*, is the beginning of the chariot street, now abandoned and used for agriculture.

The walls of the main shrine are distinguished by the use of recessed niches framed by protruding pilasters. This gives a markedly stepped outline to many temple plans, and in practice allows for the placement of sculpture in the niches on the exterior face of the shrine building. The niche 144 flanked by pilasters, topped by a roof element, becomes a basic element in temple design. Not only is it used around the outside of the shrine walls, but it is also repeated in decreasing size as part of the superstructure. The idea of repeating architectural parts to build up the whole structure is seen in both the northern and southern traditions. In the north, the main tower of the *shikhara* is frequently flanked by smaller, but identical, towers one 134 above the other. There may sometimes be three or four diminutions of size from the topmost to the lowest. Usually each decrease in size is offset by an increase in number. Thus, there is one large central tower; the next group are smaller, but four in number, one for each side of the central tower; the next group are smaller again but eight in number – and so on. In the southern style, the *vimana* is frequently made up of rows of individual pavilions, three-dimensional versions of the niches which decorate the 136 lowest storey. Again, the upper pavilions are proportionately smaller than

the lower ones. The very top of the *shikhara* or *vimana*, in both the traditions, is marked by a stone cap which, when in place, holds the superstructure solid on account of the immense downward thrust of its weight.

Visiting a temple

No two temples are the same, but certain standard elements can be listed. This fact is used here to give an idea of the way in which the different units of a Hindu temple fit together, and how it operates in daily life. On the whole, because traditions have survived better in the south than in the north, the following descriptions owe more to Deccan or south Indian examples of temples, than to northern ones.

Local topography inevitably determines the exact layout of individual temples, but many share a common form of approach by means of a long avenue. This provides space for the activities which are connected with the temple, but which take place outside its confines. Along its length are located the shops which provide necessities for visitors to the shrine: the offerings of flowers, incense, coconuts, fruits and lamps; the devotional literature which explains the mythology of the deity and lays down the

25 Painting of a chariot festival. Kathmandu valley, Nepal. First half of the 19th century; on paper watermarked 1821. In Nepal, as in many other parts of the subcontinent, the image of the god is carried out of the temple on elaborate chariots at festival time. In this painting, the distinctive tiered tower of a Nepalese temple is replicated in the chariot. The deity here honoured is probably Bhairava, shown as a mask (see also fig. 52). The smaller chariot carries an image of his consort.

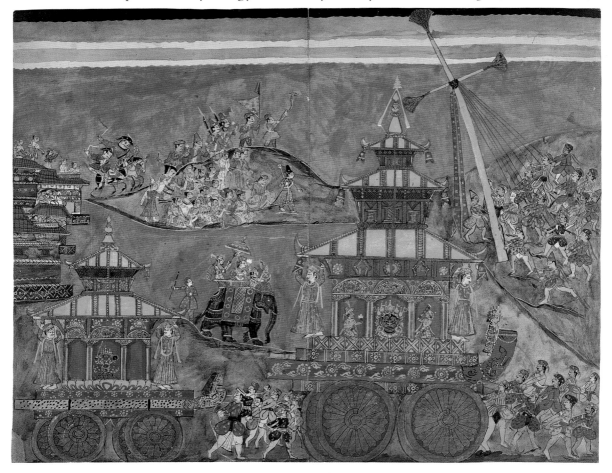

26 The lower structure and framework for a festival chariot. Karnataka. 20th century. Festival chariots, of which this is a small example, are drawn on solid wheels above which is a solid base, elaborately carved (see also fig. 25). Above this again is a less substantial structure, the roof element of which is often extended and dramatically decorated with brightly coloured textiles (see fig. 28). This illustration shows the chariot frame only, parked in its shelter between festivals.

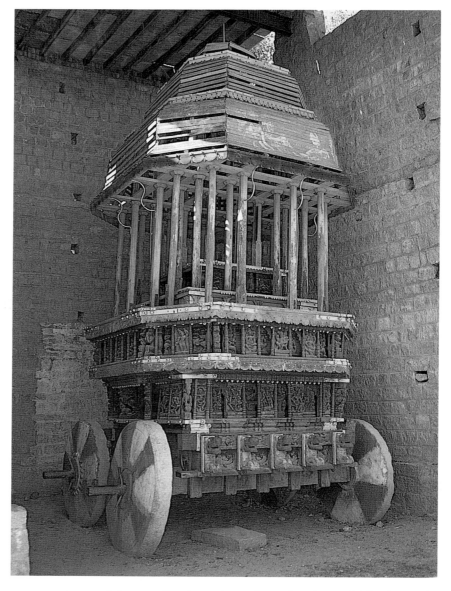

vows to be used in supplication; the coloured prints which show the legends of the deity (particularly any special connections between the god and the locality); the bangles, bought by women so that they appear as beautiful as possible before the god; and the everyday supplies of food and clothing which are bought by pilgrims as they travel from one sacred spot to the next. The location in a town of a major temple will mean that many people will be provided with employment, especially those close to the approach avenue leading to the temple. They will provide services not only for pilgrims, but also for the cult. These providers include garland-makers, musical instrument-makers, actors, image-makers, producers of clarified butter for lamps, incense merchants, wholesale food-sellers, makers of

62, 99

85

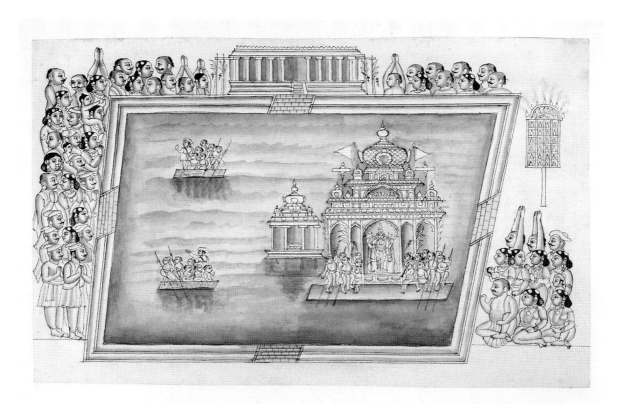

vibhuti (the powder used for head and body markings), water–carriers, and hoteliers, to name only some. At the time of a festival huge sums of money will pass through the town, especially in the quarter around the temple.

The street leading to the temple is also the space where the processional icon of the god is brought from the temple at the time of festivals. The image of the god which is worshipped in the temple sanctuary never moves from that location. Therefore at festivals when an image of the god leaves the temple for processions, the icon carried out is one that is kept solely for processional use; this is the *utsava murti*. The image of the god goes in procession down the temple approach street, either carried on poles on the shoulders of devotees, in a palanquin or, more spectacularly, in a wooden chariot (*ratha*) dragged down the street by bands of worshippers. It is on account of this method of carrying the god that the approach street is usually referred to as the chariot-street. The lower parts of these chariots, including the wheels, are made of wood, and are kept from year to year. They are carved with lively scenes from the mythology of the deity. The upper parts are of bamboo and cloth and are rebuilt at each festival. The cloth elements are frequently painted, again with episodes from the life of the god and his saints. The processional image of the god is enthroned and attended by brahmins on the top of the wooden chariot platform, while above it sways the bamboo and cloth superstructure. One of the most famous chariot festivals is held annually in honour of the god Jagannatha (see p. 135ff.) at Puri, in Orissa (see map on p. 228). However, the practice

27 Painting of a tank festival. Tamil Nadu, South India. First two decades of the 19th century. In this painting the god Vishnu is depicted during a night–time festival; note the multiple lamp on the right side of the painting. The special festival image of the god has been placed on a raft which is poled around the tank by brahmins, while others stand before him playing musical instruments or with flywhisks. Devotees in the crowd are shown with arms raised or palms joined in adoration.

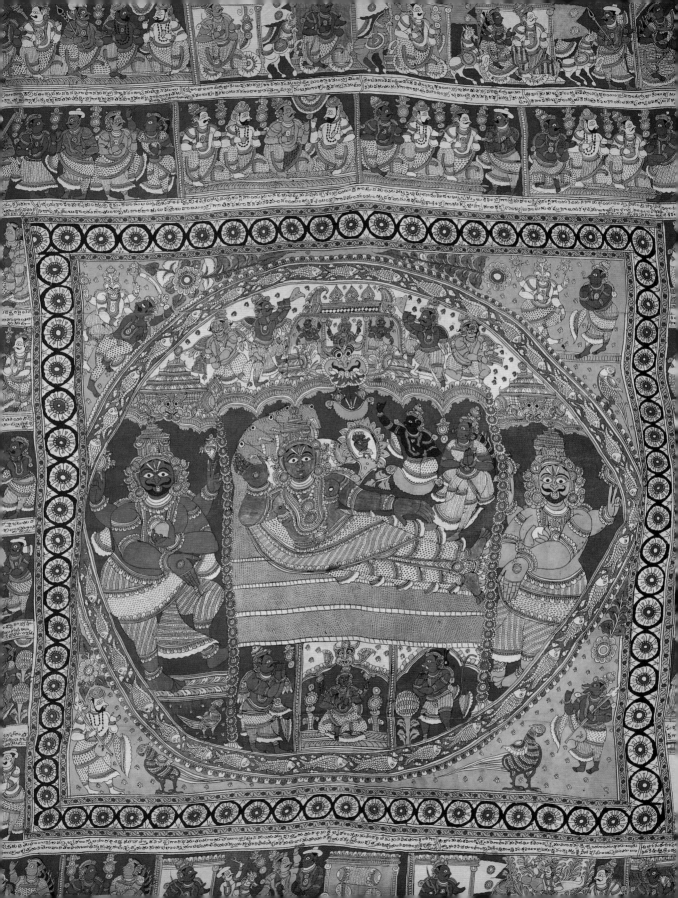

28 *Opposite* Large painted cloth, *kalamkari*, probably from southern Andhra Pradesh. *c.*1900. Today large free-hand paintings on cloth such as this one are associated with the town of Kalahasti. However, until this century their production was more widespread. In the central medallion, Vishnu is shown lying on the serpent Ananta, whose five heads rear up protectively above the blue-skinned god. On either side are guardian *dvarapala* figures, while in registers on either side are scenes from the epics, captioned in the local vernacular, Telugu. Huge painted cloths such as this one are used to decorate the upper parts of festival chariots (see fig. 26).

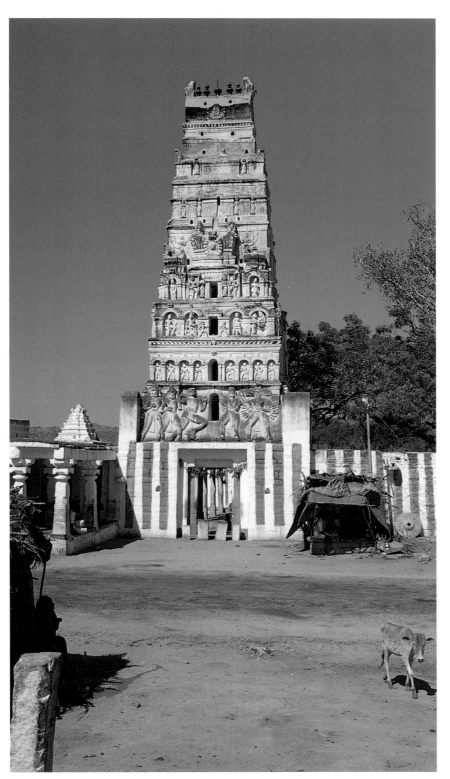

29 *Gopura* or towered gateway. 17th century or later. Tondapadi, Anantapur District, western Andhra Pradesh. This small *gopura* is representative of the typical gateway to south Indian temples. The upper storeys recede in size, but also accommodate registers for sculpture. Like most examples, this *gopura* is terminated by a barrel-vaulted structure crowned with horn-like elements. The vertical red and white stripes of the enclosure wall are a common device used to delimit the sacred space. The pillared structure to the left of the gate is where offerings and sacred souvenirs may be purchased.

of chariot festivals is known in many other parts of the subcontinent – in Nepal, Bengal (where the chariots are more like portable temples), and throughout central and southern India.

Passing down the chariot-street (*rathapatha*), past the shops selling religious souvenirs, and towards the temple gates, the pilgrim will frequently find on one side a stepped, rectangular tank. Here devotees wash before entering the temple precincts. In the *Vishnudharmottara*, an early *shastra* text, it specifically states that 'In places without tanks, gods are not present. A temple therefore should be built where there is a pond on the left or in front, not otherwise'. The tank may thus be either specially constructed or be merely an area of open water. In many temples it is the focus of an annual festival when the image of the deity is brought out from within the temple, and is floated around the tank, often at night. The excavators of the second–fourth century AD site of Nagarjunakonda in Andhra Pradesh (see p. 53 and map on p. 229), have identified a stepped tank close to one of the Shiva temples as a tank for such festivals. The continuity of this tradition is demonstrated by the description of a tank festival in central India by E. M. Forster, in 1921. This example, recorded in his book of reminiscences of India *The Hill of Devi*, is of a type where clay images of the deity, or of items associated with it, are taken to a tank to be submerged in the waters at the end of a festival. The festival which Forster witnessed was Gokul Ashtami, celebrating the birth of Krishna. However, elsewhere in India – in Maharashtra and in Bengal – festivals end with similar rituals of submersion. These two other examples are associated respectively with Ganesha, and with Durga.

Near the main entrance to the temple, both inside and outside, there are often a cluster of small subsidiary shrines which worshippers pass. Here visitors offer garlands and incense, on their way into the temple. The gods honoured here are often guardian figures suitable for an entrance. However, they will usually be of the 'family' or in some way connected with the main deity of the temple. Also found both inside and outside the temple walls are tall pillars, often encased in metal sheets (in the richest temples of gold or silver), and decorated with repoussé designs. These are used as flag-standards (*dhvajastambhas*) or lamp-standards (*dipastambhas*). Some of these were originally located outside the main building, but later became engulfed within the expanding structures of the growing complex.

At the end of the chariot-street, the entrance into the temple compound is marked by a gate. The style of these structures varies according to region and time, but they are often impressive. The southern variety (*gopuras*) are renowned for their size and the elaboration of the painted stucco sculpture with which they are covered. There is often more than a single gateway, but the major one will be the one connected to the chariot-street. In this case the gateway will stand across the axis of the chariot-street outside the temple and the sanctuary within.

Passing through the gateway, the visitor moves from the territory of man to that of the gods, passing the shrines of divinities who guard the auspiciousness and strength of the temple. Facing the visitor approaching the gate, it is common to find sculptures of door-guardians (*dvarapalas*). They are depicted as male warriors, and carry weapons or emblems indica-

31 *Opposite* The tank at the Surya temple at Modhera, northern Gujarat. Begun in the early 11th century. The visually dramatic tank, with its many series of steps, prepared the visitor for similarly elaborate designs inside the *mandapa* (seen at the top of the steps) and the temple beyond (not visible in this photograph, but see fig. 123). The column bases in the *mandapa* are of the same type as the one in fig. 17.

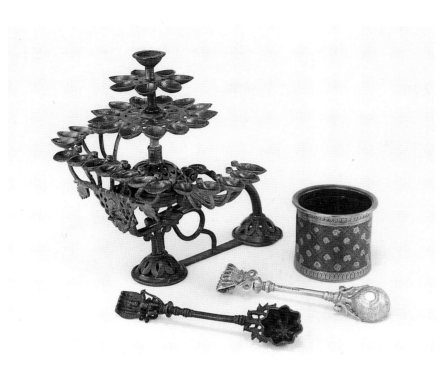

30 Group of ritual metalwork: multiple lamp (perhaps from Maharashtra); cylindrical metal vessel (north India); spoons (south India). All 18th or 19th century. Multiple lamps are used in the ritual of *arati*, when an image is honoured with light (see p. 74). The vessel is made using both copper and brass, the so-called Ganga–Yamuna technique. It is used to hold water dispensed to devotees when they leave the temple sanctuary. The spoons used for this ritual are of the type illustrated here.

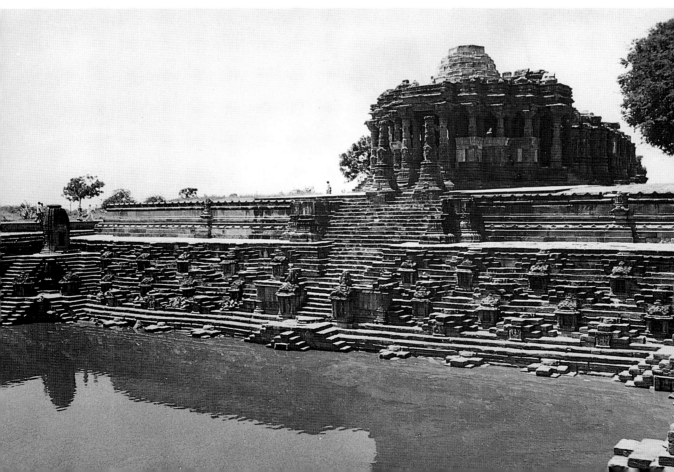

32 Door-guardian (*dvarapala*) at the Brihadishvara temple at Tanjore, Tamil Nadu. Chola period *c*.1100–1110. In India all temple doorways are protected by the presence of some powerful or auspicious figure, such as these twin warrior figures.

tive of the sectarian affiliation of the temple. Thus, at the entrance to a Vishnu temple, the guardians will carry one of the weapons of Vishnu, the club (*gada*). Passing into the gateway itself, the visitor frequently sees sculptures of the goddesses of the two most sacred rivers of India, Ganga and Yamuna. Also an habitual presence at this point is elephant-headed Ganesha (see p. 102ff.), in his role as the Lord of Openings, and Beginnings. He needs to be acknowledged at the outset because he has the power to cause the rest of the visit to succeed or to malfunction. He oversees not only beginnings, but also obstacles – their imposition as well as their removal.

33

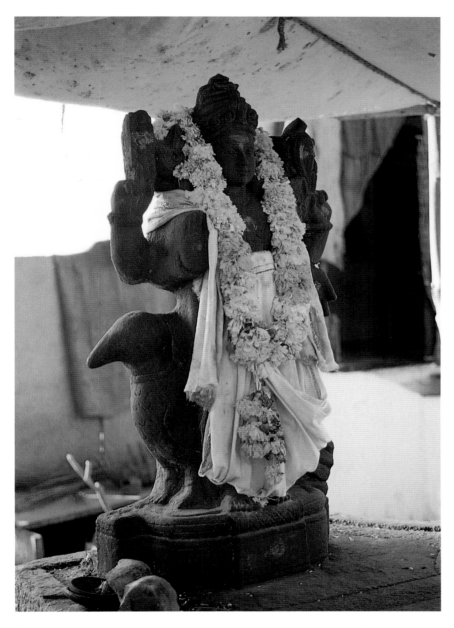

33 *Opposite* Doorway figure of the deified Ganges, Ganga. Venkataramana temple at Tadapatri, Andhra Pradesh. Mid-16th century. The figure of Ganga in the entranceway guarantees the auspiciousness of the temple visitor's experience within the temple compound. Her mount is the mythical water beast, *makara*, and her beneficent fruitfulness is indicated not only by her voluptuous bodily form, but also by the scrolling creeper which springs from her upheld hand. In this characteristic, she is the descendant of the dryads of early Buddhist sculpture (see fig. 103).

34 Stone sculpture of the planetary deity Shani (Saturn). Ramalingeshvara temple at Tadapatri, Andhra Pradesh. Temple constructed early 16th century or later. This sculpture of Shani is located just outside the *gopura* of the earliest of the two Vijayanagara-period temples at Tadapatri (for the other, see figs. 33, 35 and 36). The image is garlanded with the ubiquitous marigolds, and is also clothed and depicted riding on his bird mount, the crow. The placing of planetary deities at the doorway is another way of ensuring the auspiciousness of the sacred location within.

Other oft-encountered deities here at the entrance are Hanuman and Virabhadra, both gods who can fiercely defend the gate against enemies.

Once inside the temple wall, and having paid respects at the shrines in the gateway, the visitor can move towards taking *darshan* of the deity. The space inside the compound often appears cluttered with smaller buildings grouped around the main shrine, which is still some way off but probably visible. Whatever occupies the intermediate space, the most important function that the worshipper must fulfil before approaching the divinity is the performance of the clockwise circular walk around the shrine (this is

technically known as circumambulation, or in Sanskrit, *pradakshina*). If the temple has many enclosing walls, the opportunities for *pradakshina* increase – devout visitors to the temple will process around all the walkways, one within the other, and complete the sequence by walking around the main building or cluster of buildings at the centre of the compound. As the rite of circumambulation is performed, the smaller shrines of the various associated deities can be honoured in the same way. The logical and emotional culmination of the circumambulation is the 'view' of the god, *darshan*. During *pradakshina* of the main shrine building, the 'view' of the deity will be presaged by attendance at a niche containing an image of the deity, which is situated on the outer wall of the shrine, the farthest point axially from the entrance to the sanctum. This niche, or *devakoshtha*, is located at the nearest point on the outside, to the icon of the deity within. The diminutive image of the god is usually smeared with coloured powder, and may also have small lamps and flowers placed in front of it.

Around the inner face of the compound wall, a colonnade containing temple offices, pilgrim accommodation and the shrines of the lesser deities is often situated. Amongst the offices will be storehouses where the precious items needed in the service of the god are kept. These include not only the implements used in worship, such as water vessels, lamps, incense burners and lustration spoons, but also the jewelled clothing worn by the deity. The latter will be changed according to the time of day, or year. Perhaps slung between columns or locked away are the large drums and bells which are used to announce the movement of the god from the main shrine. Other instruments used in temple ritual include the oboe-like *shahnai*, whose braying and exciting tones are heard at most religious events when the god travels in procession. If the temple is wealthy, there will be musicians who are attached to the shrine, whose sole duty it is to play for the pleasure of the deity, and to accompany him as he travels through his domain. Also stored in this outer part of the temple will be the various transport items required by the god. These include chariots and palanquins, as well as wooden representations of the animal on which the god rides – his *vahana*. Thus if it is a Shiva-temple, the animal will be a bull, if a Vishnu-temple, it will be the hawk, Garuda. If the temple is a large one and has a tradition of sumptuous festivals it may possess temple elephants. It is in this outer, though still sacred, area that they will be lodged, and here also that the howdah and other elephant trappings will be stored. Although not as elaborately decorated as the halls immediately surrounding the temple, the outer colonnades often have fine sculpture decorating the stone columns and beams, and the walls and the ceilings may also bear wall-paintings which illustrate the legends of the deity.

In the outer part of the temple compound the snake deities (*nagas*) are worshipped. Their images are often propped up against a tree or close to a well in the courtyard. Here offerings of water are poured over their images and they are anointed with coloured powders. These are deities whose ancient cults are found both out in the fields and also within the temple confines. Their phallic shape obviously links them with Shiva, but the *naga*-stones are found in many temples irrespective of sectarian affiliation.

Other shrines found in the courtyard of a temple might include ones

dedicated to the Nine Planets (*navagrahas*), or to saints especially associated with the shrine. These saints may have performed some special service to the god, or performed some outstanding austerity. Such figures during their lifetimes are frequently the objects of moral uncertainty or even ridicule. It is only in afterlife that they can be safely incorporated into the fold of orthodoxy through the establishment of their own cult, subsidiary to that of the great god. Other shrines laid out in the colonnade might include one of the many sets of deities who are listed in ritual texts, such as Shiva in his form as the hundred and eight *lingas*, or in south India the twelve Vaishnava saints (the *alvars*). Amongst these shrines, trees or smaller plants may be located – in a Shaiva temple an oak-apple tree (*bilva*), or in the case of a Vaishnava temple a basil plant (*tulsi*). Sprigs of both are used in the respective temple rituals. The cult of the *tulsi* plant has developed to the point where many Vishnu temples will have a special container in which it is held. These may be of terracotta or stone, and they display considerable regional variation.

Once the worshipper has processed around the outer area of the temple, and the subsidiary shrines have been visited, the group of buildings around the central shrine is approached. These include halls where the god is taken at specific times of the day or year – for his washing, sleeping or entertainment by dancers and musicians. Some of these halls, or *mandapas*, are attached to the sanctuary and here the progression from open, light space to enclosed, dark space becomes pronounced. The columned halls attached to the main shrine offer an intermediary space, as they are open at the sides, though possessing a roof; they offer shade as well as an entrance to the sanctuary. They are entered by staircases built against the platforms on which the temple superstructure is built; overhanging eaves provide shade. In the cooler, darker interior, space is available for visitors to congregate, waiting for the *darshan* of the deity, perhaps passing the time singing hymns in honour of the god (these are known as *bhajans*). Recitations of stories taken from the massive compilations of mythological information contained in texts such as the *Puranas*, or the *Ramayana*, are also given here. The didactic character of this activity is underlined by the mass of legendary and religious information which is contained in the sculptures and paintings (where they survive) which decorate the walls of the *mandapas*.

From the *mandapa*, in the simplest temples, the pilgrim comes to one last chamber before the sanctuary; this is a vestibule. It is unlike the *mandapa* in that it is walled, and thus more enclosed. Light, however, still penetrates because typically there are entrances from the courtyard on two sides, as well as the doorway from the *mandapa* on the third side; on the fourth side the entrance is dark and leads to the sanctuary. The two entrances from the courtyard often have porches with benches constructed in them. The interior of the vestibule is often columned, with each column decorated with sculpture of the symbols or forms of the deity. In the centre of the chamber a stone or bronze sculpture of the animal mount of the god is frequently located. He is shown gazing into the sanctum in rapt adoration. In some temples this image is one of a series axially aligned and located from the outer entrance right to the edge of the sanctuary. In yet other temples the *vahana* of the god has its own shrine, located on this same axis.

35 Garuda, the hawk mount of the god Vishnu. Wood and beaten metal. In use today in the Venkataramana temple at Tadapatri, Andhra Pradesh. 19th/20th century. The image of the god is placed on the back of the Garuda sculpture during parades at festival time. This example is marked with the distinctive facial indicator (a vertical stripe) used by worshippers of Vishnu; this is the *naman*. The connection between the hawk and the god Vishnu (or his Vedic prototype Vasudeva) is documented in the Helio-dorus column inscription at Vidisha, dated to *c*.120 BC. (See p. 50)

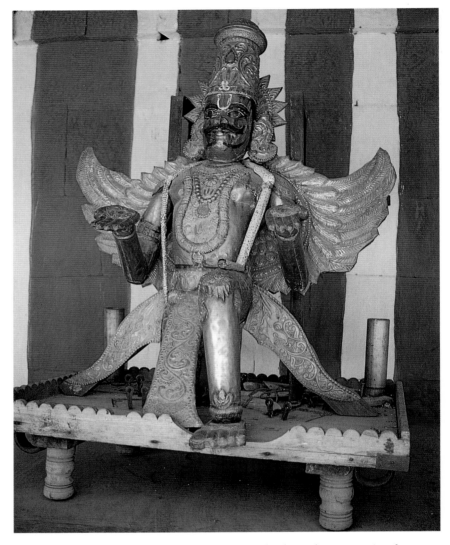

As the worshipper moves across the vestibule the *vahana* or animal mount will be acknowledged by the placing of flowers or coins on the animal or close to it. When the visitor passes back through this chamber following *darshan*, the bell which is suspended from the ceiling here is rung. This indicates that the encounter with the god is completed. The transition to completely enclosed space thus progresses from the courtyard to the *mandapa*, and then to this penultimate vestibule chamber.

The entrance to the shrine is through a door, the lintel of which is usually carved with the image of an auspicious figure – Ganesha or Lakshmi are the most common. Even at this point there is in many temples a last opportunity to perform a further auspicious clockwise walk around the central shrine – *pradakshina*. In such temples a dark passageway leads the devotee around the outer face of the sanctum (*garbhagriha*). This, like the interior of the sanctuary itself, is small, low and devoid of decoration.

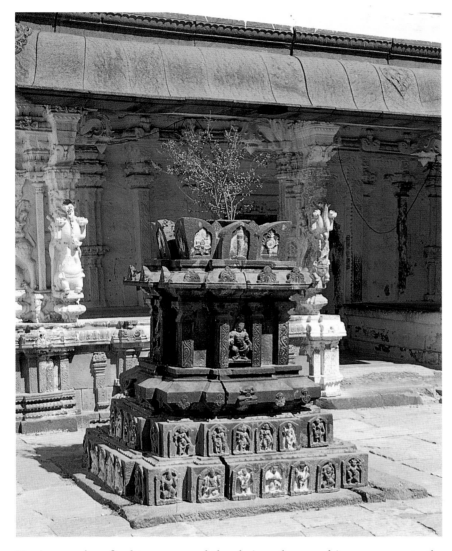

36 Container for a *tulsi* bush at the Venkataramana temple at Tadapatri, Andhra Pradesh. Temple constructed mid-16th century and later. The *tulsi*, or sweet basil plant, is sacred to Vishnu, and above all to the god in his Rama incarnation. This specially constructed container is of a type found in Andhra Pradesh and Orissa, distinguished by its crenellated top. The containers are found both at temples (as here) and as part of domestic shrines.

Having made a final turn around the shrine, the worshipper comes to the seat of the god itself.

The inner sanctuary is invariably rectangular in shape, dark and undecorated. Its appearance is in striking contrast to most of the rest of the temple compound, where colour and decoration are present everywhere. In the sanctuary nothing distracts from the presence of the god from whom the worshipper will receive *darshan*. Entrance to the sanctum is restricted to the brahmin officiant in whose family the care of the temple has been entrusted. The living of a temple is traditionally passed from father to son, and the brahmin seated at the entrance to the *garbhagriha* will only be helped by other male members of his family. They act as intermediaries between the devotee and the god. Increasingly today, and doubtless due to egalitarian Gandhian ideas, the inviolability of the sanctuary to any but the brahmin is being eroded. Frequently, though, there is still a rail

37 Funnel (*pranala*) on the exterior wall of the Brihadishvara temple at Tanjore (built *c*.1010 – see p. 224). This example has an elaborate support in the form of a pot-bellied dwarf blowing a conch. He is one of the *ganas*, the mischievous attendants of the god Shiva. Inscriptions recording the construction of the temple run around the moulded base of the structure.

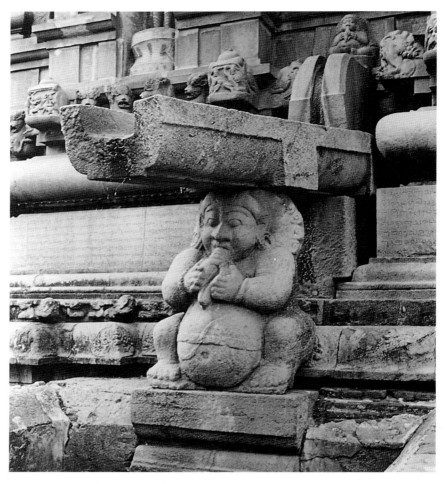

which sets the deity apart from the faithful, thus restricting access.

The icon of the deity is usually a standing, seated or lying figure, though cults which have tribal origins may still have a non-figural, or only partly figural icon – a rock with eyes embedded in it, for instance. Depending on both the time of day and the time of year, the figure will be more or less visible on account of the clothing worn, and the quantity of offerings (such as garlands), which have been placed around the image. The interior of the shrine is often only lit by oil lamps, thus producing a dim or flickering light. This, along with the quantity of flowers, clothes, coloured powders and other offerings heaped on, or in front of the image, often makes it difficult to see the precise contours of the image. In this massing of shapes and colours, it is possible to see the Indian interest in pattern and design, rather than clarity and naturalism. In a temple where the image has been worshipped for centuries, the visual confusion will be compounded by the gradual abrasion of the facial features of the statue through the continual application and smoothing of *ghee* (clarified butter), and other liquid offerings on to the statue. Realism is not an important element in the imaging of the divine in Hinduism.

When the worshipper first arrives at the steps which separate the public from the sanctuary, the basket of offerings is handed to the brahmin. He then offers them to the deity. If a coconut is included in the offering this is broken and the juice gathered. Such liquid offerings may be used to anoint the image. When this is done, the liquids will gradually drain from the image, and be channelled away through the wall of the sanctum. On the outer side of the shrine wall a decorated spout, *pranala*, funnels the juices into a small tank from which devotees can anoint their foreheads as they walk around the shrine in *pradakshina*. The offering at the sanctum, besides coconuts, invariably includes flowers and a few of these are placed on the image, which will already be garlanded and decorated – sometimes in elaborate patterns. The brahmin may then pick up some flowers from the existing mass of offerings in front of and on the deity. These are added to the original offering of the devotee which is then returned, along with the container. This returned material is *prasad*, which has been sanctified through contact with the divine image. At this point, water, or coconut juice from offerings, is served to the worshipper with a distinctive spoon; the vessel for the liquid is also of a specific type. The liquid is taken in the hands, the right hand uppermost, and then drunk with any remaining drops smoothed over the hair.

A further element in the worship of the image (*puja*), is the honour paid to it with incense and with lights – both are considered pleasing to the god.

38 *Mandapa* in the court of the Tiruvengalanatha temple at Vijayanagara, Bellary District, Karnataka. First half of the 16th century. This ruined *mandapa* demonstrates the typical post and beam construction of these columned halls. They are open and light at the front, but enclosed and dark at the back. Steps flanked by balustrades (here missing) lead up over a moulded course to the platform of the *mandapa*.

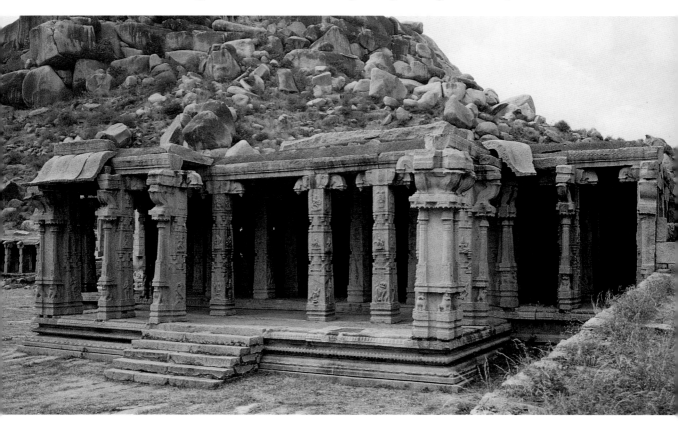

The brahmin first censes the image and then, taking a lamp – anything from a single-wicked tray to a candelabrum – holds it before the god, 30 turning it in a clockwise direction; this is known as *arati*. He then brings the light to the gathered worshippers and they pass their hands quickly through it and over their heads as if to shower themselves with the light which has been close to the deity. Many take the opportunity to place a coin on the lamp tray. Just as there are particular times of day for the performance of *puja*, so are there specific times for *arati*. While this activity is going on, the devotee has the occasion to make personal contact with the deity, through *darshan* (see p. 57). Standing with hands folded palm to palm in the position of acknowledgement and adoration (*anjalimudra*), eye contact can be made with the god, and prayers and requests can be silently addressed. The worshipper understands that, at that moment, the deity is residing within the image. The correct rituals conducted at the enshrinement of the image, and the correct sacred utterances spoken at the outset of the worship by the brahmin, ensure that the god will grant his beneficent presence.

It is possible for wealthy individuals to commission elaborate *pujas*, the fees for which are determined by the quantity and quality of offerings, and the time taken by the brahmins to perform the ceremony. Some *pujas* imitate royal rituals, such as *abhisheka*, while others such as the *panchamrita* are characterised by the image being lustrated by the 'five nectars' of the *puja*-name – water, milk, curds, sugar and clarified butter.

From this description it will be clear that the congregational worship familiar in the Islamic and Christian traditions is not a feature of Hindu worship. Group singing may take place outside in the temple compound, or on pilgrimage, but the interior of the temple remains a place where the individual, through the intercession of the brahmin, comes close to the godhead. A temple which has royal or wealthy patrons will perform more elaborate and costly rituals. However, in most temples today, whatever the caste position of the individual (some shrines do however still exclude non-Hindus), Hinduism encourages a personal and one-to-one relationship between the devotee and the god. This is carried out through *darshan* in the temple.

Conclusion

The temple is the most ubiquitous and recognisable context for Hindu art. 18 Its construction, beautification and ritual have been elaborated and changed over two thousand years of continuous development. It has grown from the small apsidal shrines of Mathura and Nagarjunakonda, to the immense and labyrinthine structures of Rameshvaram and Madurai. As an architectural form it continues to grow, making use of modern forms of construction, though still invoking the ancient texts as indicators of tradition.

Despite the change in building techniques, the purpose of the temple has remained constant, for in the sanctum, the deity may take up temporary residence. This happens partly on account of the skill of the craftsman who produces the icon of the god, but above all because of the learning of the

brahmin who invokes the divine presence at the beginning of *puja*. The connection between brahmins and temple activity is fundamental. A shrine without a brahmin officiant cannot be considered orthodox. Despite this though, there are countless shrines in rural and tribal communities which are not controlled by brahmin families. This fact provides a constant tension, an interface of both challenge and acceptance on both sides, as orthodoxy bends to heterodoxy and *vice versa*.

The lure of the divine presence causes pilgrims from all over the sub-continent to attend at temples. It is for these visitors who are eager to be blessed by the presence of the god, as well as for the everyday visitors, that the didactic programmes of sculpture and painting have been produced for Hindu temples; in wealthy temples these programmes may be extended by recitations, and performances in music and dancing. Such presentations of the legendary cycles of the deity, and the varied equipment used in the shrines of the god, call into being temple art in the service of Hinduism.

3

SHIVA



39 'The Holy Family' – Shiva, Parvati and their children on Mount Kailasa. Drawing from the Punjab Hills, Kangra style. *c.*1800. In this exquisite drawing, the dissolute and androgynous figure of Shiva is shown centrally, typically naked, with dreadlocks and a snake as a garland. His consort Parvati, to his right, offers him liquid refreshment: perhaps his favourite, *bhang,* an hallucinogenic drink made from cannabis. The *vahanas* of Shiva (bull), Parvati (lion) and Skanda (peacock) are included; elephant-headed Ganesha is merely 'attended by' his pile of sweetmeats.

Three major groupings of deities can be recognised in Hinduism as was discussed in Chapter 1. One of them revolves around the god Shiva, and we now consider the varied imagery and rich mythology associated with this powerful and popular god.

The origin of Shiva is unknown. However, a 'prehistory' for a few of the features of his cult can be found in the artefacts of the Indus Valley civilisation (see p. 20). Many of the other characteristics which make up the personality of Shiva can no longer be traced back to any one source. Certain elements apparently attached themselves to his character from the wild god Rudra who appears in the Vedas, but whose independent cult did not survive into the historical period. Shiva himself does not, however, figure in the Vedas. The period between the worship of the Vedic Rudra, and the appearance of the first sculptures of the god Shiva in the first centuries AD, is a nebulous phase in the history of this great god. The considerable variation in his personality is no doubt due to the number of different cults which have eventually become absorbed into his worship during this period of uncertainty between Vedic Rudra and historical Shiva.

Shiva is a deity who often inhabits the farther limits of accepted activity. He delights in stepping outside the norms of human behaviour, and stories abound of his outrageous conduct and moral ambivalence. It is therefore not surprising that he is frequently disconcerting and unpredictable, yet despite this he is considered beautiful, and is the object of intense devotion. Possessing such a complex character, Shiva is understandably known by many different names. He is Mahadeva (the Great God), Nataraja (the Lord of the Dance), Mahakala (the Great Black One), and Sundareshvara (the Beautiful Lord).

Shiva is also the genius of fertility, as is clearly implied by the most common form in which he is worshipped – the standing phallic pillar, or

137

x

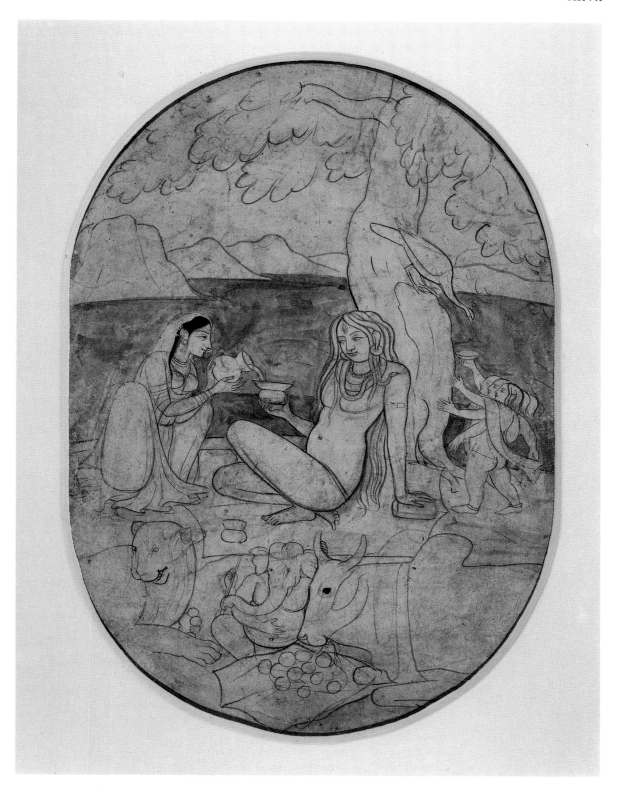

linga. The presence in the Vedas of passages which decry the worship of 40
the phallus by the people whom the Indo-Aryans encountered when they
entered India, has been used as an argument for the pre-Aryan origin of at
least the part of the cult of Shiva which is concerned with the veneration of
the *linga.*

The mythology of Shiva is full of illusion, magic and paradox. He is
both the wandering and chaste ascetic who gives up the comforts of
everyday life and the ideal family-man. It is not unusual in paintings to see
him either as a ragged and dispossessed mendicant, or seated in his
mountain home with his family seated demurely around him. In these
'Holy Family' paintings what appears curious to the western eye is not
considered remarkable in India. The paintings show a male figure wreathed 39
in snakes (Shiva), with beside him his wife (Parvati) seated on a tiger-skin
with an elephant-headed baby (Ganesha), while close by a six-headed boy
(Skanda) feeds a peacock.

Shiva as *linga*

In the historical period, the earliest surviving images of Shiva are probably
those in the *linga* form. This method of depicting Shiva as the erect phallic
pillar is still the commonest in India. However, it is important to state
immediately that such an apparently sexual image is not intended to offend
sensibilities. For many the upright standing pillar is not a sexually-charged
image. The reverse does, though, appear to have been the case originally.
For instance, an enshrined *linga* today will be lovingly garlanded and
attended by young women and elderly matrons alike, but without any
overt suggestions of sexuality. In traditional Indian society, the *linga* is
rather seen as a symbol of the energy and potentiality of the god.

The most famous of the early images of Shiva in the *linga* form is still wor-
shipped at Gudimallam in southern Andhra Pradesh (see map on p. 229).
The temple building is of the later Chola and Vijayanagara periods, though
most scholars now accept that the image enshrined here should be dated, on
stylistic grounds, to the second or first century BC. The phallic nature of this
image is made obvious in the carving of the uncovered *glans*, while the god
in human form is shown standing in front of the shaft of the pillar. In this
remarkable depiction there is therefore a combination of the aniconic and
the iconic forms of the deity – all within the same sculpture. The muscular
young god stands on the shoulders of a crouching dwarf – perhaps one of
the nature spirits (*yakshas*) whom he has tamed, or one of the dwarfs (*ganas*)
who make up his retinue of badly-behaved and irreverent followers. In one
hand Shiva holds a water-pot, while he rests an axe on his shoulder; in the
other hand he holds a ram or perhaps an antelope. The latter identification
is perhaps more likely, for the antelope is recorded in the later iconography
of the god, both as an attribute springing from one hand, and as a skin flung Front
over the shoulder. This wild animal at Gudimallam also recalls one of the
epithets of Shiva, 'Lord of the Animals', a name which has often been
remarked upon by archaeologists in connection with the seals from Indus
Valley sites where a 'proto-Shiva' figure is shown surrounded by wild
animals (see p. 21). Any direct link between the iconography of Gudi-

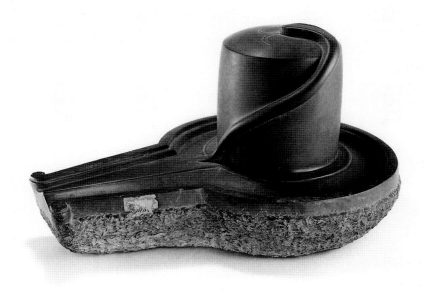

40 *Left* Stone sculpture of the aniconic image of Shiva, the *linga*, set in the female symbol, the *yoni*. Probably eastern India and 18th century. The uncarved and rough base of this image would have been buried below floor-level in the shrine for which it was made. The cobra coiling around the shaft of the *linga* acts as a protective guardian.

41 *Below* Print of decorated *lingas*. Probably Maharashtra. 19th century. The dressing of a *linga* for worship is often elaborate. The *lingas* are set in *yonis*, and some bear the face or whole figure of Shiva. Multi-headed cobras and garlands of lotuses are also used to beautify the image.

42 Decoration on a six-sided pillar from the Buddhist site of Amaravati, Guntur District, Andhra Pradesh. 1st century BC/1st century AD. A tree-shrine, symbolic of the enlightenment of the Buddha, is here depicted with an enclosure at its base, similar to the fragmentary one discovered around the base of the *linga* at Gudimallam.

mallam and the Indus Valley should, though, be treated with caution, for both the geographical and the cultural distance between the two is very great.

The Gudimallam icon is also important because of the physical features of the standing figure of the god. They are not the features associated with gods of orthodox Hinduism. Shiva is shown as squat and broadly-built, and with the thick, curly hair and the pronounced lips still seen amongst tribal populations in Central India. Extrapolating from this image we can suggest again that the early cult of Shiva owed as much to the ideas of the indigenous populations of India as it did to the gods of the Indo-Aryans as recorded in the Vedas. Finally at Gudimallam, the image of the god is placed within a rectangular enclosure. Such structures are known from early Buddhist sites and sculpture, where a railing is shown enclosing the tree beneath which the Buddha gained enlightenment. This suggests how Shaiva practice in the second/first centuries BC may have been absorbing elements which were probably commoner amongst non-Shaiva groups. It is also notable that unlike many later *lingas*, the Gudimallam example is not set into a *yoni*, the vulva-shaped female symbol of power (the feminine version of the *linga*), but is merely socketed into two circular stone elements. When the *yoni* is depicted in later sculptures, it is usually carved from the same piece of stone as the *linga* and thus acts as a base from which the *linga* rises. It is possible that the use of *linga* rising from *yoni* is a late development based on tantric teachings where sexual imagery is used symbolically to represent the union of opposites. When the *linga* is anointed in worship with water, milk or ghee, the *yoni* also acts as a conduit from which the sacred offerings can be collected and distributed to worshippers.

43 Brass cover for a one-faced *linga* set in a *yoni*. Made in the family workshop of Bishnu Chand of Vrindaban. Contemporary. This example is modelled on one in use at a shrine on the *ghats* at Mathura close to Vrindaban, where the metalsmiths' workshop is located. The face of Shiva is shown protected by two rearing cobras, while a third one is shown in the path of the *yoni*. Around his neck, Shiva wears *rudraksha* beads, while across his forehead and divided by his third, vertical eye, are the three distinguishing stripes of Shiva worship

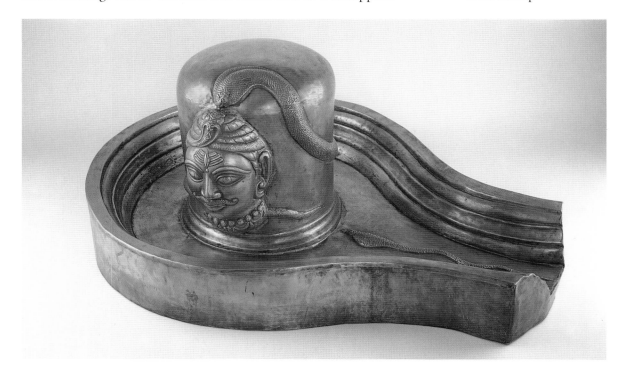

44 *Opposite* Four-faced Shiva *linga*. Schist. From eastern India. *c.*800 AD. At each of the cardinal points a face of the god is carved. The three shown in this illustration are, from left to right, Shiva as incarnate terror (Bhairava), as withdrawn and serene ascetic (note the rosary beads around his neck and the crescent moon in his hair) and as feminine power (Parvati).

The image at Gudimallam has been described in some detail because it is one of the earliest surviving and unequivocal images of the god Shiva. It also deserves attention, however, because Shiva in the form of *linga* is the commonest way in which the god has been shown, from the earliest times to the present. It is also suggestive of how the *linga* with the figure of the god standing in the shaft – or later and more commonly, only the face of the god in the shaft – acted as an iconographic 'bridge' connecting the human depictions of Shiva (the iconic) with the *linga* (the aniconic).

Lingas with the single face of the god let into the shaft or with his four or five heads in the shaft are common types. Another of the earliest known surviving *lingas*, that at Bhita, is of the five-faced type. Each head is presumed to convey a particular characteristic of the deity – wrath, beauty, ascetic power etc. This emphasises the all-inclusive nature of the character of the god. He is not only a wrathful, or a beautiful or an ascetic god – he is all of these, and more. One head is placed at each of the cardinal points, while the fifth is placed on the top surface of the *linga*. If such a well-developed doctrine is recorded from one of the very first icons which survives, it suggests that ideas about multi-headed *lingas* were developing at a yet earlier time.

Usually the *linga* is fashioned as a plain standing pillar. It is circular in section, except towards the base where most examples are octagonal; at the very base they are square. They are usually carved of stone, yet they can be made of almost any material. Some examples are merely lumps of rock protruding from the earth, or stalagmites or other natural features. In legend they can be of sparkling crystal or of flaming light. They can also be temporary – made of sand on the sea-shore, and washed away by the waves once worship is completed. A group of *lingas* considered remarkable are those which are self-manifest (*svayambhu*) – that is, not made by any human activity, but divinely engineered through the grace of the god. Others are miraculously discovered through the intervention of animals. The varieties of *lingas* are enormous, and texts, prints and paintings list them in detail. Another type of *linga* is the one which comes from the valley of the Narmada river in northern Central India (see map on page 228). The local stone is a highly banded metamorphic rock. When this is broken up and then tumbled in the river, the action of the water causes erosion into distinctive pebbles which resemble *lingas*. The banding of the rock sometimes appears like a serpent coiling around a *linga*, or like the triple ash-stripes which the devotees of Shiva smear across their foreheads. Because three stripes on the forehead are known as the mark of Shiva, *lingas* are often found with metal plaques in the form of three stripes tied to the upper part of the shaft – as it were, to the forehead of the *linga*. A yet further variation has hundreds of small *lingas* sculpted in rows around the shaft of the main *linga*. By worshipping one image, the devotee worships many.

Like most images of the gods when under worship in India, a *linga* in a temple will frequently be swathed in cloth, or covered with the flower offerings of worshippers. During the time it is viewed by the public, it is often difficult to see the shape and markings of a popular image because of the mass of garlands and vermilion powder showered on it. If the image is also 'dressed', then very little will be visible. Even the humblest Shiva

47

43

44

41

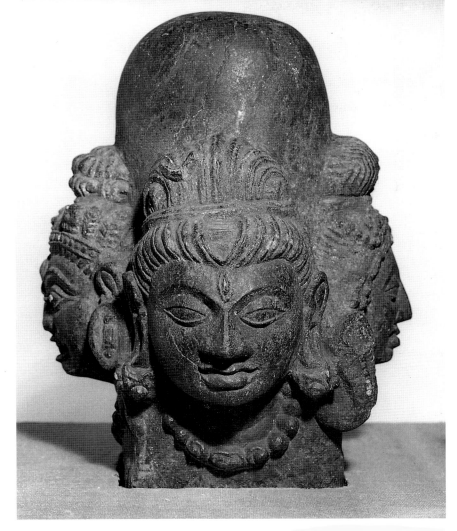

shrine will have placed on the *linga* a leaf from the *bilva* tree, which is sacred to Shiva, or a blossom from the hallucinogenic *datura* plant, which is also closely associated with Shiva. The *linga* in an important shrine will at times 43 be concealed by a metal cover which is frequently decorated with the face of Shiva. Such covers, made by the repoussé technique, are commonly made of brass, though silver and gold examples are also known.

In the sanctuary of a Shiva temple, a single *linga* will generally be located. However, in subsidiary shrines it is not uncommon to find rows of *lingas* sometimes in groups of 108, a number sacred to Shiva. Other varieties of massed *lingas* include a central major *linga* with rows of smaller ones set around, forming a square. The Lingayats, a Shaiva sect now mostly restricted to Karnataka, acknowledge no human icon of Shiva, but instead 45 always carry with them a small *linga* in an amulet box which is hung around the neck.

It has often been assumed in the past that the *linga* is not only a symbol of fertility and thus prosperity, but also a symbol of sexual union and even lubricity. This is by no means necessarily the case, for in Shaiva doctrine concerned with *yoga*, great emphasis is laid on the importance of chastity and the retention of seminal fluid, rather than its expulsion. The erect

46 Three gold Kushan coins. From the northwestern subcontinent or from Afghanistan. All show images of a god who is probably Shiva; ii) and iii) with labels naming the god as 'Oesho'. Top to bottom: i) gold double stater of Wima Kadphises c.AD 75–100, showing Shiva holding a trident, and accompanied by a bull. In the Kharoshti inscription on the reverse, Wima is given the title 'Maheshvara', an ephithet usually associated with Shiva. ii) gold stater of Kanishka I c.AD 100–126, showing four-armed Shiva holding a trident, thunderbolt, water-pot and elephant goad, and an antelope. iii) gold stater of Vasudeva I c.AD 164–200, showing three-headed Shiva holding a trident and a diadem, accompanied by a bull. All three images show the god ithyphallic

phallic pillar thus symbolises the denial of merely sexual energy, and the transmuting of this into a divine and transcending energy. Even the combination of *linga* with *yoni* is less obviously sexual than might be assumed, for the *linga* actually rises up from the *yoni* rather than penetrates down into it as one would expect if the imagery was primarily sexual.

Early figures of Shiva

The earliest figures of Shiva which show him in purely human form come from northwestern India, the area of ancient Gandhara (see map on p. 228). From the first centuries AD the figure of the deity is recorded in sculpture. The importance of these few surviving, though rather small, images of the human Shiva is difficult to gauge. They may be no more than subsidiary figures in larger, though now broken up, Buddhist compositions. While certain features of the iconography identify the figure as Shiva – his trident and his erect phallus – others seem to point to the deity who eventually emerges as Vishnu. Yet other elements are borrowed from the contemporary, and by then well-developed, Buddhist scheme. Despite this variety, the identity of a Shiva-type is beyond doubt. In Chapter 1 the link between Shiva and the Bodhisattva Avalokiteshvara was mentioned (see p. 30), but elements such as the water-pot which Shiva carries in some of these early Gandhara images connect him also with the Bodhisattva Maitreya. In Buddhist iconography, Maitreya always carries his own water-pot – being a brahmin he could not run the risk of drinking polluted water. Shiva shown in Gandhara carrying a water-pot – as also in the Gudimallam figure – implies that he too is a brahmin. This is an interesting detail for, if some aspect of Shiva-worship has a non-Vedic origin, to deliberately show the god as a brahmin is perhaps an attempt to present Shiva as orthodox.

Also from northwestern India come coins of the second century AD 46 issued by the kings of the Kushan dynasty. Some of them bear the image of a figure who is captioned 'Oesho', a name which philologists still argue over, but which is often equated with that of Shiva. The coins with this figure are not rare, suggesting that Oesho was well-known and popular. Further, the attributes seen on the coins such as the multiple heads, the erect phallus and the bull mount, make it clear that this deity, whether or not he is truly Shiva, contributed to the complex mix from which emerged the personality of Shiva. The ancestry of the god is undoubtedly intricate and continues to be discussed by scholars. Meanwhile, in present-day India, his mythology and his iconography still develop.

The human forms of Shiva

We have seen that Shiva as *linga* is the most common form of the god in India. While this is true, depictions of Shiva in human form are nevertheless very well-established in the canons of Hindu art. In a Shiva temple, the icon under worship in the sanctuary will usually be a *linga*. However, the sculptural programme employed for the outer walls of the temple is more 144 likely to show the god in human form.

47 Shiva appearing within the cosmic *linga*, as *lingodbhavamurti*. Tamil Nadu, South India. Chola period, *c*.900 AD. The sculptural programme of Chola-period temples often includes this popular image of Shiva, within a niche, on the exterior wall of the shrine. Another favourite image of Shiva for an outside position is the god as *dakshinamurti* (see fig. 51). Although the South Indian images of this scene of Shaiva supremacy are the most well-known, a 10th century fragment preserved in Benares shows the *linga* of light surrounded by flames and with the figures of the astonished gods on either side of it. Unlike the Chola version, the god does not actually appear within the shaft of the *linga*. It is tempting to connect the imagery of a fiery pillar with an earlier, but Buddhist, image which refers to the appearance of the Buddha as a pillar surrounded by flames. A representation of this scene, where such a pillar is enthroned and venerated, is recorded in the sculpture from the Buddhist site of Amaravati and is dated to the 2nd/3rd century AD.

A variety which spans both the *linga* and the human form of the god, and which is visually akin to the Gudimallam icon, is the image of Shiva as *lingodbhava*. Here Shiva demonstrates his superiority over all other gods. 47 He stands resplendent in an oval opening within the *linga*, while above and below him grovel two gods who had not acknowledged his power – Vishnu (shown as a boar – the fourth incarnation of the deity) and Brahma (shown as a goose – the bird on which he rides). These two gods had disputed which of them was the greatest of the deities. While they argued, a *linga* crowned with flame appeared, which neither of the astonished gods could delimit. Attempting to do this, the Vaishnava boar dug deep into the ground while Brahma, as a goose, flew to the highest reaches of the atmosphere, both without success. At this point Shiva manifested himself in human form within the *linga*, and confounded the two other gods, who then acknowledged his supremacy. Such overt competition between the deities is uncommon in Hinduism, and increases the interest of this icon.

Turning to the fully human forms, Shiva as Lord of the Dance – Nataraja – is one of the best known. Shiva seen dancing, either in a wild ecstatic frenzy or in a withdrawn yogic state, has a long textual and sculptural history. Several striking manifestations of this iconographical type evolved in south India during the early medieval period. The famous 137 form of Shiva Nataraja, known as *anandatandava*, is worshipped pre-eminently at Chidambaram in Tamil Nadu (see map on p. 229). In this version the gyrating, four-armed god is shown within a ring of flames, his unkempt ascetic's hair flying out around his head as he performs his dance. Nestling within his matted dreadlocks is the small figure of the goddess of the river Ganges. The Chidambaram icon depicts Shiva bringing one time-cycle to an end and ushering in the next. It is thus an image connected with both destruction and creation. Shiva reconciles at this moment of cosmic history these oppositional activities, along with all other contrasts – love and hate, day and night, good and bad. This image reminds the devotee that true reality is beyond all contrasting opposites. In his dance, he tramples underfoot the demon Apasmara. The dwarf demon is a personification of the ignorance of the teaching that all opposites are illusion. Shiva carries in his hands both the fire of destruction and the double-sided drum whose beat summons up creation, thus illustrating his position on the very margin between the end of one epoch and the beginning of the next. Of his two other hands, one is held in the position which signifies that the devotee should not fear (*abhayamudra*) – the hand held up close to the shoulder with the palm facing the viewer. The fourth hand points downwards to the god's foot, beneath which the worshipper may take safe refuge. In this image Shiva again demonstrates his occupancy of the outer limits of behaviour, and of time. True to form he is uninterested in the countless aeons which pass during the cycle, ignoring it while engrossed in meditation. Ends and beginnings are, however, his concern, and this image of the ascetic god exactly encapsulates this aspect of his character.

Shiva as Nataraja in part draws on imagery which, in India, is strongly associated with ascetics, such as matted hair and garments made of tiger skin. This is not unexpected, for Shiva is regarded as the greatest of all

48 Detail from a sculpted stone arch, depicting an ascetic. Schist. From eastern India. 11th/12th century. Ascetics are traditionally depicted as emaciated, for they have abandoned the pleasures of regular family life. Similarly they have straggling beards and long matted hair, often tied up on top of their heads. This detail is from an arch, probably from the exterior wall of a temple. A figure would have been positioned within the arch.

mendicants and itinerant seekers after truth, and is indeed their patron. Despite his role as a husband and father, and contrary to the accepted norms for established family life, he is renowned for his abandonment of settled life and his success in meditation and ascetic practices. This paradox is typical of his character. As an ascetic he is depicted with a thin, emaciated body, wrapped in a tiger- or elephant-skin. He carries the ascetic's water-pot and perhaps a staff. Around his neck is the rosary of 108 *rudraksha* beads. He has uncombed hair, frequently tied up on the top of his head; his body is

smeared with ashes from the cremation ground where he sits focusing on the unreality of phenomenal existence. Across his forehead are the three stripes of ash which are the hallmark of the Shaiva practitioner. Hindu, and especially Shaiva, mendicants adopt most of these iconographic elements themselves and are seen wandering the length and breadth of India, or in large numbers at the great festivals in the important centres of Shiva worship, such as Benares (in the Ganges valley) and Amarnath (in Kashmir; see map on p. 228). Although mendicants come from across the sectarian divide, it is true that the solitary and non-conformist nature of ascetic life means that Shaiva devotees are more likely to take up this practice than are Vaishnava ones. Shiva is himself the supreme ascetic and thus the great role model. The existence of ascetics – individually or in bands – provides a valuable safety-valve in traditional Hindu society. Those who do not wish to, or cannot, conform to society's demands, can find an outlet in the life of the wandering mendicant, free to ignore the strictures of one of the world's most conservative and family-oriented cultures. The common terms in India for mendicants are *sadhu* (a wanderer), yogi (an adept of physical and spiritual exercises) and *sannyasin* (a renouncer who abandons home and family for the ascetic life).

Yogis frequently gather disciples around them who benefit from the

49 Shiva as Bhairava. Punjab Hills, Kangra style. *c.*1820. The placement of the wild figure in a beautiful landscape of exquisitely flowering trees is typical of the paradox seen in the mythology and philosophy of Shiva. The presence of the skull-cup (*kapala*) in his right hand recalls the Shaiva ascetics, the Kapalika, who used skull-cups for the collection of alms, and who deliberately indulged in contrary behaviour to demonstrate their passage beyond the difference of opposites.

కాలభైరవమూర్తి శుక్లవాహనం.

teachings and experience of their teacher, or *guru*. This activity brings to mind another aspect of the character of Shiva, the god as wise and generous teacher. Iconographically Shiva is known in this form as Dakshinamurti. This emphasises a more pacific side to his personality in comparison with 51 the wild-eyed yogi and the cosmic dancer Nataraja. As Dakshinamurti Shiva is a young ascetic with matted locks tumbling down over his shoulders and with his hands in a position of teaching. Behind him a tree is usually represented while around him are assembled the sages to whom he is imparting his teachings. The presence of the tree is a fascinating detail

50 *Previous page* Album painting of Bhairava. South India, Tanjore or Tiruchira-palli. On European paper watermarked 1820. In this beautifully composed painting, Bhairava, accompanied by his dog *vahana*, is depicted as a wandering ascetic, with matted dreadlocks and a garland of skulls. South Indian painting in the 18th and 19th centuries developed a highly stylised formula for portraying the gods. Faces are circular, with large, staring almond-shaped eyes; bodies are idealistically proportioned with (for males), large chests and small waists. The inscription is in the Andhra script and language of Telugu, used by some brahmins in central Tamil Nadu in the early 19th century.

51 *Right* Shiva Dakshina-murti. South India, probably central Tamil Nadu. *c.*960 AD. The young, four-armed god delivers his teachings in this serene Chola-period stone sculpture. The figure trampled underfoot represents ignorance.

because the teaching figure seated beneath a tree has a longer and earlier history in Buddhist iconography. The Buddha at the time of his first sermon sat beneath a *pipal* tree at Sarnath. This iconographic type, a shorthand version for the imparting of wisdom, gained very wide currency in India, and it seems likely that this small element of Buddhist convention was used by the Shaivas just because it was the time-sanctioned way of depicting teaching figures. The figure of Shiva is seated with one leg hanging down, and with the other one crossed over it, in an attitude of relaxed informality. The name for Shiva teaching (Dakshinamurti) is made up of two elements, *dakshina*- and -*murti*. The latter merely means 'image', while the former, meaning 'south' or 'right-handed' perhaps refers to the direction which the god faced as he delivered his teachings. Seated in the mountains of his Himalayan home, he turned towards India (south), and addressed his followers.

Closer in character to the Nataraja type is Shiva as Bhairava. The Shiva cult in this form is a celebration of the unconventional. Bhairava is

49, 50 accompanied by the inauspicious dog. Even more reprehensibly, though, Bhairava is renowned for the most heinous of crimes – the beheading of a brahmin. This was no ordinary brahmin, but the god Brahma himself. The story is told that Bhairava was generated miraculously from the anger experienced by Shiva as he was forced to listen to the vain boasting of Brahma. Immediately created, Bhairava sprang forward and cut off one of the five heads of Brahma. Ever since, Brahma has been recognised by his four, rather than five, heads. As penance for his crime, Bhairava was condemned to endlessly wander with the fifth head of Brahma stuck to the palm of his hand. Only when he reached Benares, the great confessional where all sins are washed away, did the head of Brahma fall from his hand, freeing him of his crime. He is frequently shown as a young ascetic with wild hair, a staff and with erect penis. He is ambivalent, excitable and dangerous in character, reflecting the emotions aroused at his birth. The fact of his fantastic penance and the horrific nature of the skull attached to his palm, endeared him to the extreme Shaiva sect, the Kapalika. They emulated the requirement on him to wander, secure in the knowledge that, like Bhairava, they too would reach liberation through the grace of Shiva. Like Bhairava, they also carried with them a skull (*kapala*), which they used as a begging bowl, and from which they took their name. The unconventional character of Bhairava has not detracted from his popularity, 25, 52 especially in Nepal and northern India, where he is known as Bhairon.

A further form of the fierce and unpredictable type of Shiva, is Virabhadra. His birth was, like that of Bhairava, brought about by Shiva's anger towards one specific figure, Daksha, his father-in-law, the father of his first wife, Sati. When Daksha, disgusted with the behaviour of his mendicant son-in-law, declined to invite him to a major sacrifice, Virabhadra was created by Shiva to avenge the insult. Arriving unannounced, he destroyed the sacrifice, symbol of conventional religiosity, and killed Daksha. Later, relenting, he returned Daksha to life – but with 53 a goat's head. In this form, Daksha is frequently seen standing diminutively at the feet of the terrifying Virabhadra. Overcome by shame, Sati died and her dismembered body was distributed across India by the grieving Shiva. The worship of Virabhadra is recorded throughout the Deccan and also south India, and his myth may reflect some historical process where the established cult of sacrifice was overthrown by local gods.

The worship of Shiva exists throughout India in forms which are recognised everywhere. Some of these are detailed above. However, he is also worshipped in an immense variety of local forms which have currency only amongst one regional or occupational group. For instance, in the valleys of Himachal Pradesh, Shiva and his consort are worshipped in the 54 form of cast bronze masks when brought out of their temples in parade. During the festivals of the deity, these masks are mounted in wooden palanquins and paraded through the town. Devotees honour them with music, dancing and incense, and by offering them cloth, money and balls of clarified butter. During the festivals at some of the hill temples, oracles go into trances and the god speaks through them.

Another example of a local Shaiva cult comes from Maharashtra, where

52 *Next page* Gilded metal mask of Bhairava, the Terrifying One. Kathmandu valley, Nepal. Between 17th and 19th centuries. The wild and uncontrollable nature of the god is demonstrated by the wide-open, staring eyes. Typically Shaiva elements are the serpent imagery (earrings, necklace and in the head-dress); the upstanding ringlets of matted hair; the third eye set in the forehead; the crescent moon in the hair and the skull imagery (in the hair and headdress).

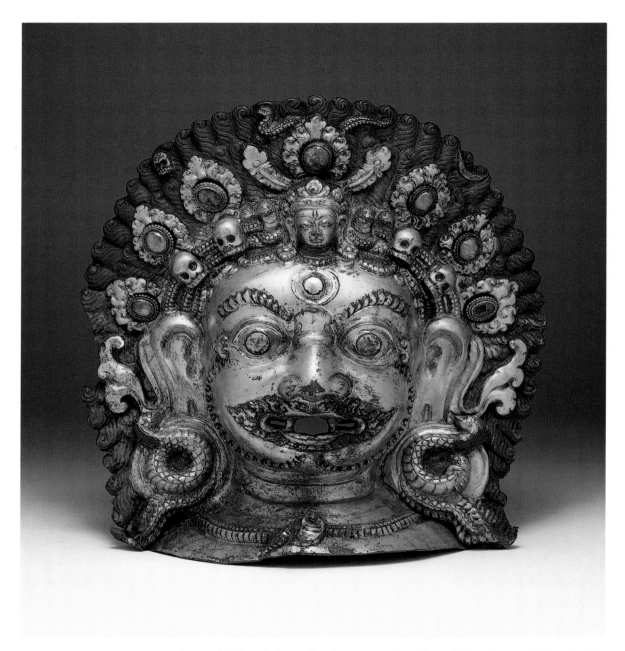

the god Khandoba, who is none other than Shiva, is worshipped. His foremost wife is Parvati, but here in the uplands of the Deccan he is given a second wife who is considered to be a girl from one of the local pastoral communities. It has been suggested that tribal or itinerant populations would find Shiva as Khandoba more accessible because of his marriage to one of their own people. Consistent with his distinct personality, seen in his own myth-cycle and ritual practices, Khandoba has his own iconography. He invariably rides a horse – suitable for the deity of a pastoral people – and

53 *Prev. page top left* Metal plaque of Virabhadra. Southern Deccan, perhaps from Mysore District. 18th century or earlier. This plaque was acquired before 1810, when it was published by Edward Moor in his pioneering work *The Hindu Pantheon*. This book was one of the first to attempt a systematic presentation of the gods of the Hindus to an English audience. The Shaiva nature of the imagery of the plaque is emphasised by the engraved *linga* and bull on either side of the head of Virabhadra, and the rearing cobra above.

54 *Prev. page top right* Mask or *mohra* of a deity. Himachal Pradesh, probably from the Kulu Valley. Perhaps 16th century. It is difficult both to identify the deity depicted in a *mohra* and also to establish a date for it. In recent years many copies of *mohras* have been made, which adds to the chronological complexity. The third eye shown in this example, and the presence of snakes on the chest of the deity, do at least suggest a Shaiva affiliation.

55 *Prev. page bottom* Panorama of Benares. North India. First half of the 19th century. This painting is one of a group of twelve which, when joined, show the length of the waterfront at Benares, as seen from the far bank. In the centre, the bathing steps (*ghats*) are clearly visible. Pilgrims and daily worshippers throng these areas eager to bathe in the purifying waters of the Ganges. Some of the *ghats* are reached by long stairways which stretch back into the city. On the left, two temples with tall *shikharas* of red sandstone are seen.

is depicted with his consort tucked in beside him. Small bronze figures of Khandoba and his consort are common. The symbiotic relationship between the pan-Indian tradition of Shiva worship, and the local tradition of deities such as Khandoba, is difficult today to untangle. 56

While Shiva is thought of as being omnipresent, tradition provides him with several particularly favoured homes. The most renowned of these are Mount Kailasa in the western Himalayas and the north Indian city of Benares (see map on p. 228). Both are the foci of mass pilgrimage, though each is very different in character. Mount Kailasa is remote and difficult to reach, situated amongst the highest mountains in the world. Benares, a city with a long history of urban settlement, is located on the banks of the river Ganges, the most sacred of the rivers of India. In one of the Sanskrit texts 55 which record the pilgrim places of Benares (Kashi), it says —

> Are there not many holy places on this earth?
> Yet which of them would equal in the balance one speck of Kashi's dust?
> Are there not many rivers running to the sea?
> Yet which of them is like the River of Heaven in Kashi?
> Are there not many fields of liberation on earth?
> Yet not one equals the smallest part of the city never forsaken by Shiva.
> The Ganges, Shiva and Kashi: where this trinity is watchful, no wonder here is found the grace that leads one to perfect bliss.

> (Kashi Khanda 35.7–10)
> Eck, D., *Banaras. City of Light.* 1983.

River of Heaven = the Ganges; The city never forsaken by Shiva = Benares.

We have mentioned in passing some of the hand-positions (*mudras*), which are seen in the images of Shiva. He also carries a specific weapon — the trident (*trishula*). As this is so intimately connected with Shiva, his 144 devotees, especially mendicants, often carry one with them. This immediately identifies them as Shiva's devotees. A trident is frequently stuck into the ground at the entrance to a shrine to indicate the presence of the god within. Subsidiary offerings can be made to the trident before continuing into the temple. As we have seen, Shiva also carries a drum (*damaru*). The 137 way it is made is entirely in keeping with Shiva, the god who resides in the cremation ground. It is formed from the top part of two human skulls joined back to back, with a thong and a pellet which, when rotated, beat against a leather membrane stretched over the two skulls.

The consort of Shiva

Not surprisingly, the consort of Shiva has many names. Most commonly, though, she is known as Parvati, and is considered to be the child of Himalaya, the deified mountains. As Parvati her influence is benign, or at the worst neutral, and she has no major cult of her own. However, under different names and personalities, she is the Great Goddess, Devi, who will be discussed in greater detail in Chapter 5. When she is worshipped in this

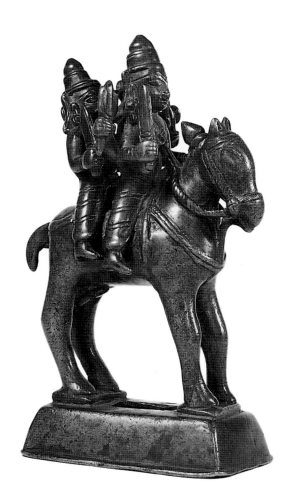

56 Small bronze group of the god Khandoba and his consort on horseback. Maharashtra. 18th or 19th century. A prominent feature of the Vijayanagara period (14th to 16th centuries) in the Deccan, was the way in which the cults of folk deities such as Khandoba, and Narasimha at Ahobilam (see p. 125) were accommodated within orthodox Hindu practice.

way it is often difficult to differentiate Parvati as spouse of Shiva, from the Great Goddess. Many people would, indeed, regard the fertility aspects of Shiva and the Great Goddess as merely the male and female sides of the same cult. They are both inextricably linked.

The blending of these cults has suggested to scholars that as the worship of Shiva spread through India, it tended to usurp the locations where the goddess was previously worshipped. In several historically-attested examples, the subjugation of the ancient mother-goddess cult by the male-oriented and brahmin-served cult, was through the medium of a divine marriage. For instance, the cult of the goddess Minakshi is of greater antiquity at Madurai, than that of her spouse, Shiva – here known as Sundareshvara. Their divine marriage, which is celebrated in the temple each year, probably commemorates a usurpation of the original goddess shrine by the cult of Shiva. A similar situation is recorded at Hampi, in Karnataka. Here the primal deity on the banks of the Tungabhadra was Pampa – a goddess as one would expect in India for a river divinity. Indeed, the earliest shrines at Hampi are dedicated to forms of the goddess. Only later does the shrine of Shiva as Virupaksha take the central stage, and the

57 *Next page* Painting of Ardhanarishvara. Perhaps from Rajasthan. Late 18th/early 19th century. In this distinctive Shaiva image, the male (Shiva) and female (Parvati) are combined. Shiva is shown with his consort on his left, the side always reserved for women. The river Ganges flows from the dreadlocks of Shiva, while Parvati is crowned; he carries the trident and drum, while she carries a lasso. This painting probably belonged to Charles Townley, and is thus among the first to have entered the collections of the British Museum.

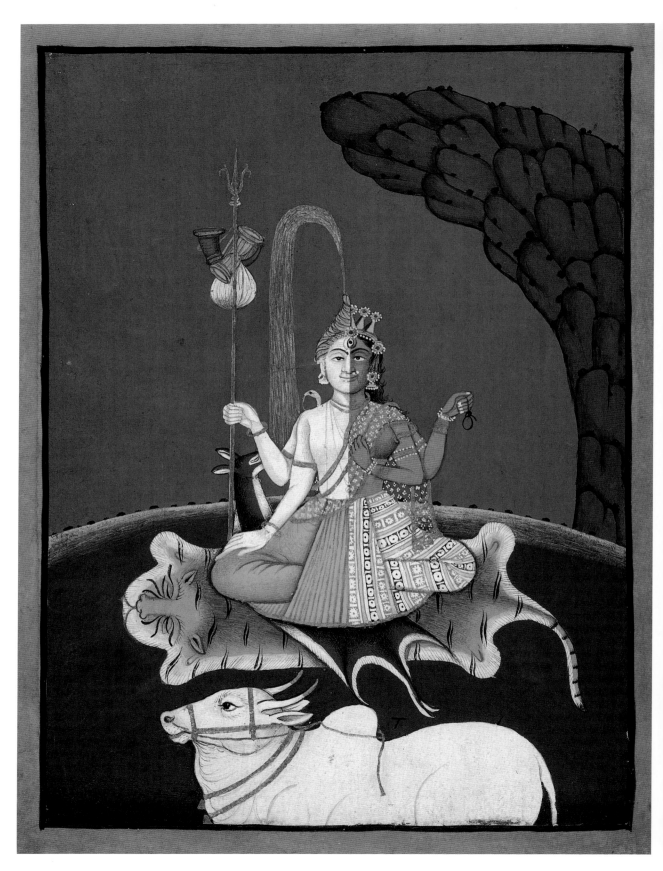

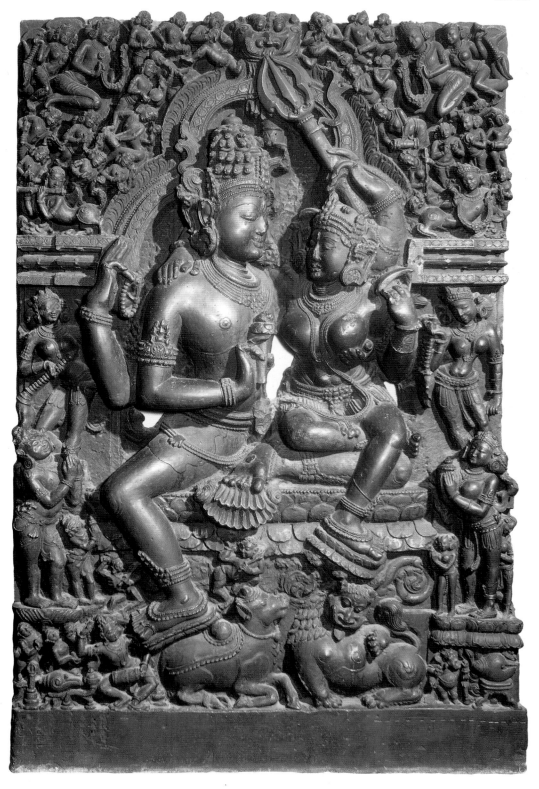

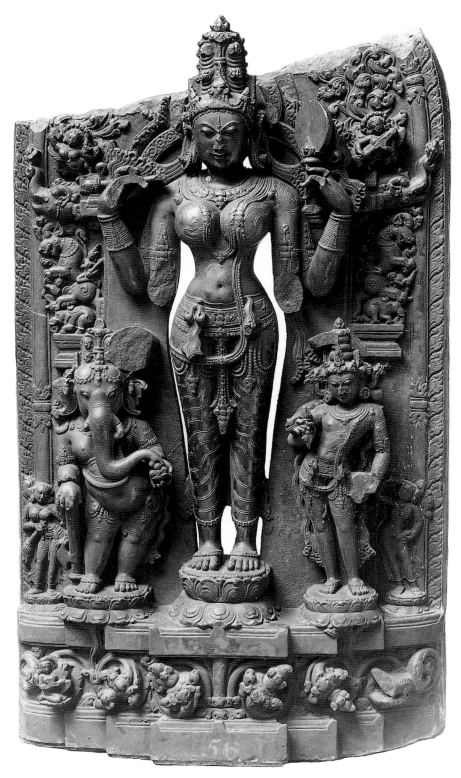

58 *Previous page* Shiva and Parvati seated at ease. Schist. From coastal Orissa. 12th/13th century. One of the finest and most magnificent Indian sculptures in the collection of the British Museum, this representation of the divine couple depicts them seated lovingly together. This grouping is known as *umamaheshvara*. Surrounding the figures are heavenly musicians and garland-bearers, while below are not only the *vahanas* of the two deities, but also a row of ritual equipment: two conch-shell trumpets on stands, a lamp and a bell.

59 *This page* The benign goddess Lalita. Basalt. Eastern India. Pala period, 11th century. The iconography of this goddess is a matter of debate, but it has recently been suggested (Maitra 1989) that the object held in her upper right hand is a stick for applying eye make-up, an identification entirely in keeping with the mirror which she holds in her other hand. The goddess stands in front of a typically elaborate eastern Indian throne-back.

original goddess become his consort. Today the ancient sacred area is dominated by the large late medieval temple dedicated to Virupaksha. The concept of the union of the two deities is taken to its logical conclusion in the image of Ardhanarishvara. In a single body both deities are combined – Shiva on the right side and Parvati on the left.

57

In her role as a benign deity, Parvati is popular as a goddess of abundance – both of food and of life itself. A particularly popular image of her is as Annapurna, who is recognised by the ladle she carries; unlike so many other goddesses she carries no weapons. Other benign forms of Parvati are Lalita – identified by the mirror she carries – and Gauri, whose name means 'the Fair'. Parvati has a substantial mythology, though most of it is bound up with that of her husband Shiva. This is particularly so in relation to the legends dealing with their courtship and marriage. In a manner so unconventional as to be entirely worthy of Shiva, Parvati pursued him relentlessly, determined to secure him as her spouse. Such pursuit by a woman of a man is quite against the accepted norms of Indian behaviour. Shiva was, as so often, interested solely in his meditation and would have nothing to do with her. Thus after various failed ruses, Parvati decided that the only way to secure his interest was to become equally as adept in meditation and the practising of austerities as he, thereby gaining his admiration. This is what eventually happened and the betrothal was

109

59

60 Bronze processional image of *somaskanda* – S(hiva), Uma (=Parvati) and the child Skanda. South India, Tamil Nadu. Chola period, *c*.1100 AD. Magnificent bronze sculptures are a hallmark of the Chola period. This example was originally framed by a tall surrounding arch attached to the two prongs seen at the sides. The leaping antelope shown in the upper left hand of the god recalls the forest abode of Shiva as an ascetic; the other upper hand (now broken) would once have held an axe.

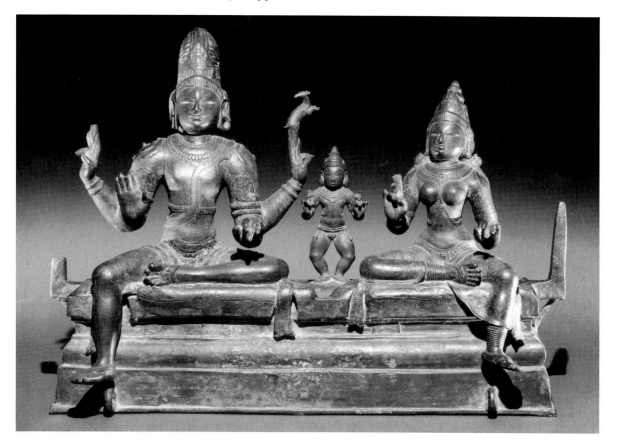

arranged, though not without some disquiet expressed on the part of the parents of Parvati. Who, after all, would want to be linked with such an unsavoury and unstable character? Despite this, the wedding took place, and this is frequently shown in both sculpture and painting. A concomitant image of them seated together in the pose of 'royal ease' has also been very 58 popular. Parvati is depicted seated in the lap of Shiva, who supports her with one of his four arms. They look at each other with tenderness, reminding us that Shiva and his consort are not only the terrifying deities of the cremation grounds, but also the ideals of human, physical love. Suitably, Parvati is shown as young and beautiful, and is indeed even referred to, on occasion, as a virgin. The beasts upon which they ride (their *vahanas*) – his bull and her lion – are seen at the base of the sculpture. Another common iconographical example showing the family of Shiva is the south Indian type, *somaskanda*. Here Shiva and Parvati are shown seated 60 at ease, with their young child Skanda between them.

Ganga

Parvati is without question the most important form of the wife of Shiva. However, the goddess Ganga, the deified river Ganges, is also considered his consort. The argument for this is as follows. The river Ganges is an agent of fertility as it brings with it not only water but also rich silt from the mountains. This silt is deposited on the river banks when the monsoon rains have departed, providing productive soil for the new crops. The river, whose goddess is Ganga, therefore has the fructifying qualities which are associated with the Mother Goddess, whose consort is Shiva. Therefore, Ganga is the consort of Shiva – either as a form of Parvati, or as a second spouse. In some legend-cycles, Ganga and Parvati are also sisters. There are many other connections between Shiva and the river deity, such as the presence at Shiva's home, Benares, of the river Ganges lapping seductively 55 at its walls. Rivers in India are invariably personified as female, with the result that the identification of Parvati with Ganga is repeated a thousand times throughout India wherever there is a shrine to a river goddess.

The Ganges rises in the western Himalayas at Gangotri. It flows southwards out of the mountains, and enters the plains at Hardwar, flowing eastwards across the northern plain made up of silts which the river itself has laid down over the millennia. While flowing eastwards it gathers various tributaries, the most important of which is the Jumna which joins it at Allahabad. Finally, barred from continuing eastwards on account of the hill-country of eastern India, it turns south and eventually debouches into the Bay of Bengal. Throughout its length its passage is marked by a series of important places of pilgrimage: Gangotri, where the source of the river from a glacier is recorded; Hardwar, where it is loosed from the constriction of the mountains; Allahabad, where the junction of the Jumna and the Ganges – the *sangam* – is considered auspicious; Benares, where Shiva resides; and Sagar island in the delta of the Ganges where the waters of the river and the ocean mingle. With so many propitious locations along its route, it is not surprising that the river is the most sacred of the rivers of India. As a result, to die on the banks of the river Ganges, above all at

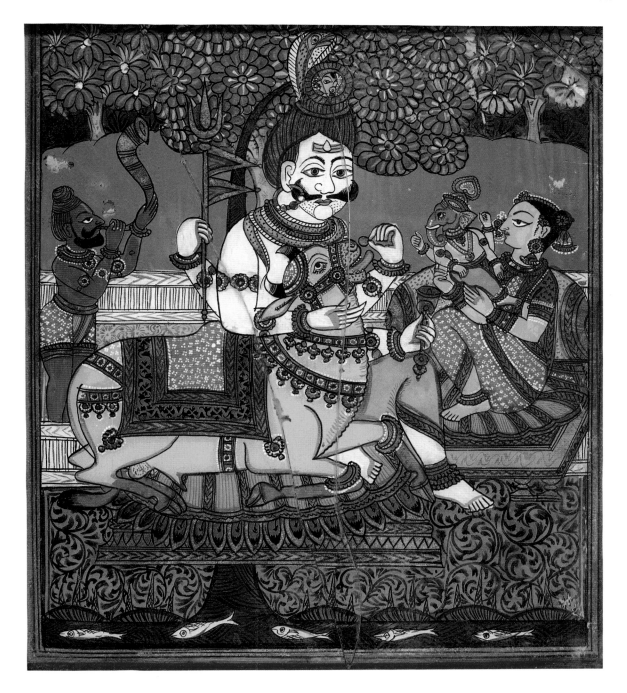

Benares, and to have one's ashes consigned to her waters is considered to be the best of deaths for a Hindu. This ensures release from the endless round of rebirth – or at least, the achievement of a better birth in the next existence.

The commonly-told story of how the river Ganges came to flow on

earth is repeatedly shown in sculpture. Originally the river flowed through the heavens and the earth was deprived of its benefits. However, the sage Bhagiratha, through the practice of severe penance and yogic exercises, amassed sufficient merit for a boon to be demanded of the gods. He asked for Ganga to be allowed to flow on earth for the advantage of men. This the gods were bound to grant, in acknowledgement of the accumulated merit. Before the departure of the river from the heavens, however, Shiva agreed to break the crashing fall of her descent to earth by catching her in his hair. It is for this reason that the goddess Ganga is frequently shown in the matted locks (the *jatamukuta*) of Shiva, with the river spouting from her 61 mouth. There is a certain logic to this story, for Gangotri (the source of the Ganges) is not far from Mount Kailasa, Shiva's Himalayan home. The foothills can thus be imagined as the locks of Shiva.

Because of the attention shown to Ganga in this episode of her arrival on earth, Parvati is popularly thought to have suffered pangs of jealousy. In sculpture she is portrayed turning away from Shiva as he welcomes the descending/arriving goddess. A magnificent panel depicting this scene is located in the cave temple dedicated to Shiva on the island of Elephanta, in Bombay harbour. This rock-cut temple, probably to be dated to the sixth/seventh century AD, is one of the finest single artistic creations in the cult of Shiva.

As we saw in Chapter 2, Ganga and her sister river Yamuna, are often placed at the entryways to temples, conferring their blessings on those who 33 enter the temple compound. The mounts on which they ride are the fish or water-monster (Ganga) and the turtle (Yamuna). This iconography is recorded from the early centuries AD onwards.

The children of Shiva – Skanda and Ganesha

Skanda and Ganesha are generally considered the children of Shiva and Parvati. However, their birth myths reveal an unorthodox generation whereby Skanda is the son of Shiva, but not of Parvati, and Ganesha is the son of Parvati, but not of Shiva. The worship of Skanda is of greater antiquity than that of Ganesha, but both of them have important cults, independent of Shiva and Parvati.

Skanda was born from the love-making of Shiva and Parvati. However, their prolonged sexual activity caused such cosmic upset and distress that the semen of Shiva was not eventually deposited in Parvati, but in the river Ganges. Despite the fact that the goddess of the river, Ganga, is closely associated with (some would say is identical to) Parvati, Parvati is not considered the mother of Skanda. Notwithstanding her cooling properties, Ganga was unable to bear the heat of the divine seed, with the result that it was, eventually, nurtured and born to the six Krittikas (the constellation known in the west as the Pleiades). The child born to the six mothers was Skanda, who on account of their name is also known as Karttikeya, and because they were six in number, is frequently shown six-headed.

The earliest surviving figures of Skanda are of second/third century AD date, and come from the northwest of India. Like his father Shiva, Skanda is depicted on the coins of the Kushans – the rulers of north and northwestern

India during the first centuries AD. This tradition of showing Skanda on coins was continued in the Gupta period (fourth–sixth century AD), when one of his names – Mahasena – was adopted by members of the Gupta royal family. The Kushan period sculptors of Gandhara (see map on p. 228) probably only depicted Skanda within the context of larger compositions which were predominantly Buddhist, for no large scale sculptures of the god survive from this period. Even at this early time he is the young god of war and is shown wearing plate-armour. He is further recognised by the spear he carries in one hand and the cock in the other. The other centre of early figural sculpture in the Kushan period was Mathura (see map on p. 228), and figures of the martial god have also come from this site, made of the typical mottled red sandstone of the locality. Mathura was the Indian capital of the Kushan dynasty who ruled much of northern India, Afghanistan and central Asia during the first two centuries AD. It is from Mathura and Gandhara that, with only one or two exceptions, the earliest figures of Hindu deities have been recorded. Skanda fits into this pattern, emerging in a way similar to other Hindu deities, such as Shiva and Vishnu, from the mainly Buddhist and Jain sculpture of these two important centres.

As is the case with the cult of his father Shiva, that of Skanda is probably an amalgam of different cults. This is reflected in his numerous other names – Kumara, Mahasena, Karttikeya, Subrahmanya and Murugan. The last two are the names of south Indian deities who still have somewhat different characters to the northern deity. Murugan has a lively and popular cult in Tamil Nadu, with a major pilgrimage centre at Palni, northwest of Madurai (see map on p. 229). He is usually depicted as a young boy and, like his northern counterpart, he carries a spear and is often shown with a cock. His spear is also the recipient of devotion, and is sometimes anthropomorphised as a subsidiary goddess. Like many other deities, he has a specific *mantra* or sacred syllable which is associated with him. Sometimes it is shown in the palm of his hand, held up towards the devotee in the position indicating fearlessness (*abhayamudra*), or seen decorating his spear. As a god within the Shaiva ambit, he wears across his forehead the triple ash-stripes (see p. 82). As Subrahmanya, he is a more adult deity, frequently shown riding a peacock, sometimes shown with his six heads, and accompanied by his two wives Devasena and Valli. While Skanda and Murugan are invariably single-headed, Subrahmanya is sometimes represented two-, four-, six-, or even twelve-headed. In Shiva temples in south India sculpted representations of him are found decorating the columns of the halls leading to the shrine. Temples dedicated to Skanda are regularly located in the courtyard (*prakara*) of Shiva temples, and receive the attention of devotees on their way to the main temple.

Ganesha is immediately recognisable on account of his elephant head joined to a childlike human body. His unusual anatomy is traditionally explained by a myth concerning his birth. However, although a legend is told today to account for his animal form, it is likely that he was originally a tribal animal totem who was absorbed into the larger Shaiva tradition. In the myths he is beheaded, before being acknowledged by Shiva as his son. This sequence may reflect an ancient defeat of either a cult, or a people who worshipped an independent elephant deity, who were then included into a

62 *Next page* Popular print of Murugan. Published in Madras, Tamil Nadu. Contemporary. The peacock mount of the boy god is prominent in this modern print, and is emphasised by the title, Sri Mayurpriya (mayura = peacock). In the background, to the right, is his temple with a *gopura* and red and white striped walls. His *mantra* is also shown, in white, supported on a spear (like the one he holds) and rising up above the temple enclosure wall. Stylistically popular prints such as this look back to the pioneering historicist paintings of Ravi Varma.

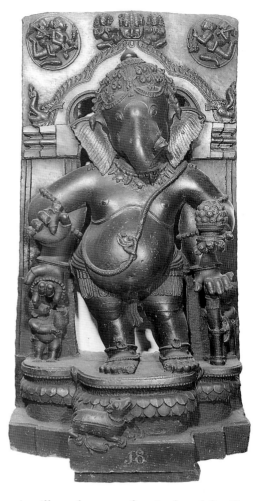

63 *Above right* Ganesha, the elephant-headed god. Schist. From Orissa. 13th century. Typically corpulent, and holding a bowl of sweets, the god is shown standing on a lotus pedestal at the base of which crouches his rat *vahana*. His anklets are of snakes, as is the sacred thread wound across his chest. The arch within which he stands is of a standard Indian decorative type with a lion mask (*kirttimukha*) at the top, and aquatic monsters (*makaras*) at each end.

Shiva-worshipping group. There is still an element of agricultural fertility attached to him, perhaps a legacy from these earlier periods. Unlike Skanda, who was born only to Shiva, Ganesha was born from Parvati. Throughout the myths of the two sons, this opposition continues. Skanda is the god of hasty and unconsidered action, while Ganesha has a reputation for being wily and acting only after thought. Especially propitiated as the Remover of Obstacles, Ganesha is also, when angered or ignored, the Placer of Obstacles.

In the most common story, Ganesha was created by Parvati alone from the mixture of unguents and dirt rubbed from her legs as she washed. By her own energy she empowered the small model of the male figure she had made, and brought it to life as her son, Ganesha. That it was necessary for her to 'give birth' to her son in this way, perhaps reflects the yogic requirement for Shiva to retain his semen (see pp. 83–4). She had previously been denied a child, and had thus had recourse to this stratagem to ensure she bore a son. It is thus true that Parvati, although a form of the Great Goddess, the apogee of fertility itself, does not produce children in the accepted sense. However, her great power is indicated by her ability to bring life to the child image which she made from the dirt scraped from her body as she washed. As a woman who never bears children, she retains the

beauty and seductive figure of a young woman, able to satisfy the advances of her husband.

At the time of Ganesha's 'birth', Shiva was away from the family home. On returning, and finding an unknown young man standing guard outside the bathroom of his wife, he naturally challenged him. Ganesha was equally unknowing of his father, and the two came to blows. The result was never in doubt, for Shiva is the greatest of the gods, and the father killed his own son, by cutting off his (human) head. When Parvati found out what had happened and explained the circumstances to Shiva, the god undertook to restore Ganesha to life. This he did by ordering one of his retinue to bring him the head of the first being he met. This was an elephant, and Ganesha was thus returned to life with an an elephant's head. Further, as compensation for the loss of his human head, Ganesha was entrusted by Shiva with the leadership of the members of his rowdy and dwarfish retinue (the *ganas*). Ganesha's name means no more than 'Lord of the Gana'. In recognition of his courage in the defence of his mother's chamber, Ganesha is also given custody over all doorways. This post is remembered in the thousands of examples seen throughout India of an image of Ganesha placed in or above the lintel of an entryway.

An extension of his position as guardian of entrances is his epithet of Lord of Beginnings. Before any new undertaking is commenced, his name is invoked. Appropriately, weddings are occasions when it is important to gain his blessings. The New Year is another time he is prominent – new

37

64 Crowned Ganesha. Punjab Hills. Basohli style, *c.*1720. This painting, with its strikingly restricted palette, is unusual in that the god is shown crowned and without *laddus*. The elephant goad (*ankusha*) and axe are more typical attributes of Ganesha; the horizontal stripes on his body indicate the Shaiva ambit of his worship.

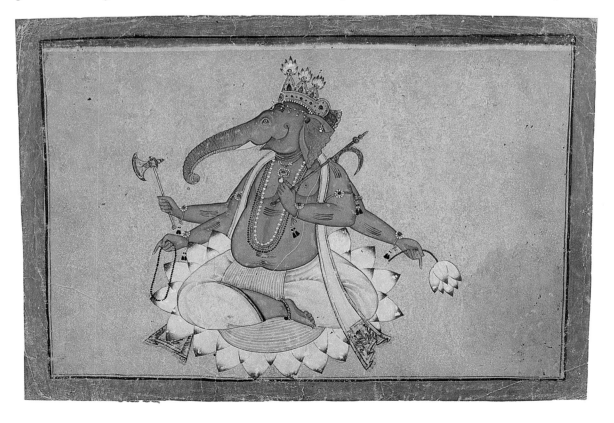

calendars often bear his image. On entering a temple, a visitor will acknowledge Ganesha before any other god. His shrine will be located at the entrance, and before homage is paid to the main deity of the shrine, Ganesha must be satisfied. Because he can control the positive or negative outcome of beginnings, he is also the Lord of Obstacles (Vighneshvara). It is not only the removal of obstacles over which he has control, but also their imposition. Hence the importance of acknowledging him at the outset of all ventures. Although largely jovial and benign, Ganesha is known to be able to place problems in the way of the smooth running of everyday activity. As a result he has devotees in almost every household in India, irrespective of their sectarian affiliation. Like his father he dances, but considering his weight and his character, he dances only a comic jig.

With few exceptions he has an iconographically limited range. He is always depicted elephant-headed, and with a large pot-belly bound around with a snake. His limbs are usually rather chubby and childlike – he never becomes fully adult. In sculpture he is often shown with a head of curly hair, indicating the ascetic's dreadlocks. This he inherits from his father, Shiva. He is himself, though, too genial a deity, and too interested in his sweetmeats, to be otherwise concerned with asceticism. His attributes are an elephant goad and a noose and, most important of all, a bowl of 64 sweetmeats from which he lifts delicacies to his mouth with his trunk. His 63 appetite for these sweets is proverbial, and offerings of them left at his shrine are accepted with favour. The bowl containing the sweetmeats (usually of the specific type known as *laddus*) is commonly seen in his left hand, though occasionally it appears in the right. If he is shown four-armed, he carries the three attributes listed above, and has his fourth hand in the gesture of fearlessness (*abhayamudra*). Another variant is for him to carry his broken tusk. This, according to legend, he detached from his mouth to use as a pen, when called upon to act as scribe for the sage Vyasa, when he recited the epic story of the *Mahabharata*. The mount which Ganesha rides is the rat, a beast whose diminutive size merely adds to the already comical picture of the god. The proximity of rats to food offerings made to the god in temples, suggests a practical connection between Ganesha and his *vahana* – perhaps the rats who take the offerings of *laddus* are in fact delivering them to the god?

The standard iconography is listed above, but in central India Ganesha is not only singularly popular, but he also receives attention at eight specific shrines where he is worshipped as one of the Eight Ganeshas (the *ashta-ganeshas*). There is a recognised pilgrimage route which takes in all the eight shrines. In central India he is also worshipped in a more basic fashion, with the result that almost any large stone, if sanctified with vermilion powder, can become the object of a Ganesha cult. This type of worship perhaps reflects a rural, non-temple and non-textual origin of the elephant-headed god, as may be the case with other animal-headed deities such as Hanuman 79 and Narasimha. These deities have an iconography which is laid down in 75 the texts, and which is seen in the brahmin-served temples, but they also have a more elemental imagery which reaches far back into tribal and agricultural prehistory. One of the very important features of these non-temple shrines are the silver and enamel eyes that are placed on the image.

Because making eye-contact is the major reason for a visit to a shrine (this is how supplication is directed), these alone of his characteristics have to be included. Until the eye installation ceremony has been performed, the image will have no efficacy. Other distinctive features such as his trunk or his chubby legs may or may not be added.

Animals associated with Shiva

The various animals connected with Shiva have been mentioned in passing. Two of them, the cobra (*naga*) and the bull, will be examined briefly below.

The cobra (*naga*) is linked with Shiva not least because of its ambivalence. It is deadly, but it also acts as a guardian of the *linga*, rearing up over it, and covering it with its hood. The latter image is recorded in the metal figures of a cobra which fit around the base of the *linga*, with the head

41 (or heads) of the snake rising up protectively. Shiva wears snakes as

65 Stone plaque with a five-headed cobra, *nagakal*. Deccan. Date uncertain, between 1000–1900 AD. This beautiful relief, with its suggestion of pent-up energy and power, is of a type usually found placed beneath trees throughout the Deccan. It is almost impossible to date, belonging to the most potent and ancient substrate of Indian religion. Worship of *nagas* already features in the earliest surviving Indian sculpture.

67 *Opposite* Bhairavi Ragini. Page from the Manley *Ragamala*. Painted in Rajasthan, perhaps in Amber. *c*.1610 AD. This exquisite painting comes from a series which illustrate musical modes as described in verse. These are known as *ragamalas*, and often survive today bound in albums. In this example, the rapt concentration of a beautiful young woman seen at her devotions evokes the emotion of the music. She is seated in a small pavilion in the middle of a lake which is filled with lotuses and wildfowl. She is venerating a Shiva *linga* by placing garlands on it and chanting, keeping time with the cymbals she holds in her hands. At the base of the *linga* are various ritual vessels, while a diminutive bull is shown curled up on the pavilion steps.

jewellery, and ties them around his body in that deliberate juxtaposition of 39 opposites which is his trademark. In the *linga* form of the god, snakes are often shown carved around the shaft, or are seen swimming up the path of the *yoni*. The phallic imagery behind such usage is clear. A corollary of this 43 fertility characteristic of snakes is that small *naga* shrines are often located around ant-hills. These are especially visited by women eager for the birth of male children. Old ant-hills in India are frequently used by snakes for their burrows, and Shiva devotees will leave food or milk offerings, or conduct special *pujas* there to supplicate them. Votive offerings at these shrines include glass bangles (stacked one above the other on the branches of an overhanging tree) and miniature cradles.

Images of snakes – often a pair entwined – are common sights in rural India. Frequently, stone slabs bearing images of the sacred animals are set 65 under a tree, anointed with vermilion, and have offerings made to them. In Rajasthan, at the town of Molela, clay plaques of the gods are made and used as votive gifts, or placed in domestic shrines. Sometimes they are painted, sometimes left plain. Cobras are common subjects for these plaques.

The bull is the mount of Shiva. He is popularly known as Nandi, though 66

66 The bull mount of Shiva. Granite. Southern Deccan. Vijayanagara period, 16th century. The humped bull mount of Shiva, garlanded and decorated with bells, is popularly known as Nandi. In the southern tradition he is usually shown seated with his legs tucked beneath him. Also, the body – as here – is often foreshortened in comparison with the head and front parts.

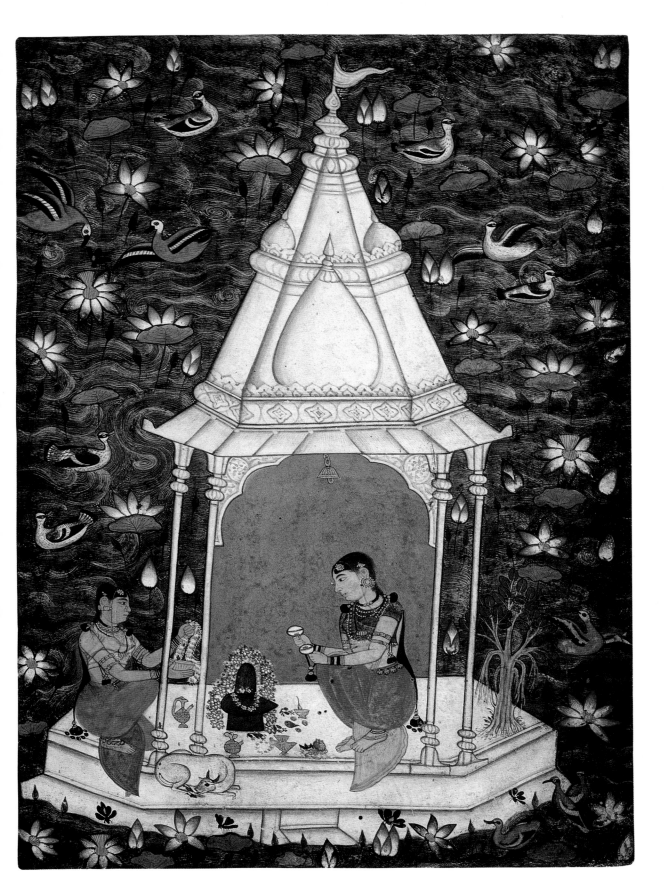

it may be that the use of this name has resulted from the misreading of a text. Cattle are also associated with the god Krishna (see pp. 133–4), but in his case the association is more with the maternal and pastoral side of their character. It is the strength and fertility of bulls which are the qualities connecting Shiva with his mount. He and Parvati are often shown either riding on the back of, or in the company of, the bull. At the Chola-period temple at Tanjore dedicated to Shiva Brihadishvara, a massive stone representation of Shiva's bull occupies a pavilion separate from the main temple. More usual in a Shiva temple, though, is a sculpture of the bull-mount at the juncture between the court-yard and the built structure. The placement of the animal sculpture here indicates the entrance. The figure of the bull faces directly towards the enshrined icon of the god. Stationed outside the shrine, the bull is not only a guardian but is also the first and most constant of all the devotees of Shiva. He is always there and is lost in rapt adoration of his lord. This aspect of the bull *vahana* of Shiva makes him a popular focus for the subsidiary attentions of worshippers at a Shiva shrine.

Conclusion

The name Shiva, 'the Auspicious One', has usually been interpreted as an ironic nickname reflecting the mercurial nature of the deity. This may well be so, but it also reminds us that Shiva can, truly, be beneficent. He is, without apology, full of paradox and his worshippers see in this a symbol of the truths which go beyond descriptions. He may be auspicious or inauspicious, static or full of movement, in this world or beyond it, iconic or aniconic, male or female. He is all of these things, though none of them describe anything but part of the whole because he passes beyond all distinctions. In him all opposites are reconciled. The images with which his followers have struggled to depict him inevitably fall far short of including all of these philosophical possibilities. However, some attempt at approaching the indefinable quality of the god is doubtless to be seen in the use of aniconic images. Although the *linga* was certainly originally phallic, today it has for most worshippers become almost entirely aniconic. It does not 67 stand any longer for the erect male member of the god, but for all divine potency of whatever description. This device allows the deity to be all things to his worshippers, allowing the imagination complete range. This ineffable quality further allows enormous social variety in a system where there are crushing mores which usually enforce uniformity of behaviour, including religious behaviour.

The worship of Shiva can be powerful, dangerous, beautiful, exciting, mystical, exultant and solitary. It satisfies one substantial sector of humanity. Another large group looks for security, certain knowledge and the strength of community. In India this second group turns towards the worship of Vishnu, who is the subject of the next chapter.

4

VISHNU

If the worship of deities can be charted in the form of 'careers', then that of Vishnu must now be at its height. Today there are probably more devotees of Vishnu in one or other of his different forms than there are of either Shiva or Devi. The reason for this lies in several characteristics of the god which have been evolving over the last millennium. These can be summarised, as follows.

Firstly, Vishnu is the preserver and the maintainer of the established order. Just as Shiva is the Lord of the Beginning and of the End, so Vishnu holds sway over intervening time. He oversees the centre ground of behaviour and avoids extremes, and this gives him great popularity. In a conservative society such as India's, the maintenance of orthodox standards against the pollution of intruders is highly important. This situation has ensured that the god who oversees stability and the continuity of standards has become one of the most notable in the pantheon. It is significant that this aspect of the cult of Vishnu began to increase in popularity during the Mughal period, at the time that Hindu society was challenged by the effects of increased Muslim power. It is also significant that these cults have continued to hold the attention of Hindus throughout the period of the next intruders – the British. The form of devotion to Vishnu that this has taken, has primarily been the worship of the seventh and eighth incarna- 1, 132 tions of the god – Rama and Krishna (for the concept of incarnations, see Chapter 1 p. 34 and below p. 112ff.). Since the fifteenth and sixteenth centuries, these two cults have been the most important ways of wor-shipping Vishnu. This does not preclude, however, the continuing impor-tance of other Vaishnava cults, where the deity is worshipped as one of the other *avataras* or indeed only as Vishnu.

Secondly, Vishnu represents all the qualities which are most valued in an orthodox Hindu household, where the good of the family unit and of the caste is considered more important than the well-being of any individual. It

is not surprising that Vishnu is rarely conceived of as an ascetic; he is the god of accepted behaviour and the home – not its abandonment. Rama and Krishna between them exemplify all the highly valued and desired traits of settled, male-dominated life – regal bearing, generosity, patience, single-mindedness (Rama), and love, childish winsomeness, ineffable power and control of natural forces (Krishna). Rama is considered the ideal husband, while Sita his wife is the perfect spouse. To the western viewer, the sweet and often self-indulgent nature of these two forms of Vishnu is sometimes uncomfortable; they lack the quixotic vigour of the cult of Shiva. However, Vaishnava cults with their emphasis on home-life, children and continuity, remain extremely popular throughout India. It is entirely in keeping with Vaishnava ideals that it was Krishna, the eighth incarnation of Vishnu, who laid down in the *Bhagavad Gita* the requirement that Hindus should accept, rather than fight against, their *dharma* – their position in life, determined by inherited caste.

Thirdly, Vishnu is the god of love and of emotion. This love flows both from the god to the devotee and *vice versa*. The love of God for his worshippers is emphasised for the first time in the same text – the *Bhagavad Gita* – that contains Krishna's exhortation to accept one's *dharma*. The emotional love which the Vaishnava devotee feels for God is not the wild emotion associated with Shiva, but the unselfish and adoring love of the unworthy devotee for his Lord. It is, at least on the surface, asexual in character. This altruistic love, which flows in both directions, is at the very core of the *bhakti* cults (see pp. 36–9). In the case of Vishnu, this two-way outpouring of love is especially connected with the name of Krishna, part of whose 'prehistory' probably goes back to the cult of a young erotic hero-god, whose overtly sexual character has been eroded by the effect of devotional cults. The erotic element now only survives in a religious symbolism which is explained as demonstrating the yearning of the soul for God.

Vishnu is one of the most popular Hindu gods today, and is usually looked on as the preserver deity. This characteristic has not always been part of his personality, for it seems as if the *bhakti* cults have had the effect of softening the fierce aspect of the earlier god, and reducing the importance of the ferocious side of his character. This will become clear in the sections which deal, for instance, with the Narasimha and Parashurama incarnations of Vishnu (see below, pp. 123–5 and 127–9). However, before coming specifically to the various incarnations, there is a further general comment to be made about Vishnu. This concerns him as a saviour god – a feature perhaps inherited from the cult of the bodhisattvas of Mahayana Buddhism, where saviour gods enjoyed great and understandable popularity (see p. 30). The qualities of Vishnu as a saviour are manifested in a continuing series of appearances on earth as incarnations (*avataras*). His devotees believe that at times of spiritual and political decline, he appears on earth as a saviour, guiding erring mankind, benefiting them with an outpouring of his love. According to the generally accepted canon there are ten incarnations, the *dashavataras*. These are Matsya, Kurma, Varaha, Narasimha, Vamana, Parashurama, Rama, Krishna, Buddha and Kalki. Variant lists exist, drawn up according to regional or sectarian requirements. For instance, some devotees consider that Krishna is the

supreme God, and consequently do not feature him in the list at all; in such cases Balarama, the brother of Krishna, is substituted. The individual character of these ten incarnations is discussed and illustrated below.

This system of incarnations is probably the way in which other cults have been absorbed into that of Vishnu. In the worship of Shiva, we have noted 'the Divine Marriage' as a means of achieving the same result. Also in Shaiva practice, the use of both iconic and aniconic representations of the god has enabled quite different personalities to be amalgamated. In Vaishnava cults, this same mechanism of absorption, so common throughout Hinduism, is mainly carried out through the agency of incarnations. This is a system which continues into modern times. Vaishnava teachers

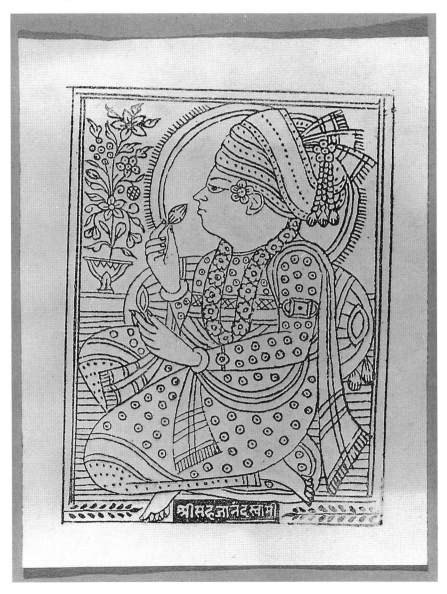

68 Woodblock print of the founder of the Swaminarayan movement. Western India. 19th century. The Swaminarayan sect consider their founder, Sahajananda Swami (the name appears in *devanagari* script at the base of the print) to be an incarnation of the very highest godhead, or of Krishna. He lived in Gujarat between 1781 and 1830. Western India, especially Gujarat and places such as East Africa and the UK, where Gujaratis have settled, are the main centres of this new Vaishnava cult.

who found sects, such as Swami Narayan, may be considered incarnations 68
of Vishnu by their followers. This both increases the importance of the new
cult, and also ensures that new sects do not pass outside the Vaishnava fold.
Also, just as Vishnu is infinite, so theoretically are the numbers of his
incarnations which can appear on earth. There is an endless possibility for
new names and new cults to be added to the incarnations of Vishnu. The
Buddha has already been accepted as one, just as Christ is sometimes today.
Jain figures have, however, somehow resisted the Vaishnava embrace, and
they do not figure in canonical lists of the incarnations. The ability to
incorporate other devotions is one of the ways in which Vaishnava – and
indeed, most Hindu cults – survive so well. The incorporation of other
cults, some of which may be associated with specific locations or have very
specific characteristics, explains the wide range of personalities which have
become assimilated into the overall personality of Vishnu.

Besides the incarnations of Vishnu there are also many other, less
systematised forms of the god, just as in the cult of Shiva. Some of these
other forms are in series, like the group known as 'the twenty-four images'
(*chaturvimshatimurtis*) which are all four-armed, and are distinguished one
from the other merely by slightly differing hand positions, or attributes
carried in the hands. Yet other forms of Vishnu owe their existence to
particular episodes in the mythology of Vishnu, or are deities thought
to be Vishnu though bearing different names, such as Vitthoba or 93
Venkateshvara.

The early history

The name of Vishnu does appear in the Vedas, but only in the later parts. In
the Vedic period, Vishnu was clearly not an important deity and his
personality then seems to have been somewhat different to that which we
know from the historical period. It was not until the first centuries AD that
his character developed and he was depicted in sculpture. Along with other
Hindu deities – especially Shiva and Skanda – the depiction of Vishnu
seems to have evolved more or less simultaneously in the Gandhara area of
northwestern India, and the region around Mathura to the south of Delhi
(see map on p. 228). The imaging of these deities may well have been
influenced by the appearance in sculpture in corporeal form of divine
figures during the same centuries in Mathura (Buddhist and Jain) and
Gandhara (Buddhist). The extent to which this use of realistic forms was
due to the influence of Hellenistic and Roman provincial sculpture in
Gandhara is still a matter of debate. However, any such influence would
have been less in Mathura, given its still greater distance from Hellenistic
centres. It is in Mathura that the earliest unequivocal iconography of
Vishnu developed. The Mathura icons, sculpted from the distinctive
mottled red sandstone of the area, depict the god as a young and regal
figure. He already wears the royal headgear (*kiritamukuta*), which still
identifies him today. One of these early images shows him in multiple
form, demonstrating similar ideas to those which produced the multi-faced
linga in the cult of Shiva. In the multi-headed and multi-bodied images of
Vishnu (Vishnu Vishvarupa) artists attempted to portray the god as the

Universe incarnate. In these early centuries AD Vishnu was conceived of as a deity whose sphere of activity was nothing more nor less than the Absolute – the whole of creation. In this context it is notable that the first incarnations of Vishnu – Matsya, Kurma and Varaha – are all concerned with creation myths. In Kashmir in the later centuries of the first millennium AD Vishnu was worshipped as single-bodied, but still multi-headed (usually four-headed), again indicating the all-pervasive and cosmic nature of his personality. The three heads seen by the devotee (the one at the back was generally not visible) were usually arranged with a human head in the centre, flanked by a boar and a lion.

Other deities who are later regarded as forms of Vishnu, such as Varaha and Krishna, begin to be imaged for the first time in the early centuries AD. Most remarkable are the Gupta-period images of these two gods (fourth–sixth century). Varaha, the boar form of Vishnu (today regarded as the third incarnation) was clearly popular in Central India, whence come a 139 group of images of great power and presence; these will be discussed further below. Images of Vishnu in human form are found in the same group of excavated caves, at Udayagiri, as one of the most potent sculptures of boar-headed Varaha. The most important image of Krishna to have survived from this early period comes from Benares, and is now in the museum of the Bharat Kala Bhavan in the same city. Sculptures of both these two forms of the god exude forthright and undisguised physical power, unlike the more pacific character associated with Vishnu today.

The attributes of Vishnu

The standard depiction of Vishnu is four-armed and standing upright. His crown we have mentioned, but it is worth reiterating that it is different from the headgear of Shiva. Shiva invariably wears his hair in matted 69 dreadlocks, in the manner of an ascetic. Vishnu, however, wears a crown as befits a deity who personifies all the regal qualities. In his four hands he 74 usually carries a conch shell and a lotus, and his two distinctive weapons, the club (*gada*) and the discus (*chakra*). These attributes do not always appear together, and it is quite common for one hand to be empty and to be shown either in the position of boon-granting (*varadamudra*) or fearlessness (*abhayamudra*). One of the common epithets of Vishnu is Varadarajaswami – the Lord who grants boons. The two weapons – club and discus – have themselves become the focus of specific cults; they are also sometimes shown in human form. This is particularly noted in Kashmiri sculptures of the deity, where the god holds the weapons, which are themselves supported on the heads of small figures who are the weapons in anthropomorphic form. It is also common for the attributes of the god to be carried in procession at times of festival and also to be carried by the guardian figures at the entrances into temples dedicated to Vishnu. These immediately indicate the sectarian affiliation of the temple.

The marks of the discus (*chakra*) and of the conch (*shankha*) are always associated with Vishnu. In front of the images of Vishnu in a temple the motif of the discus and the conch are repeatedly used in the decoration of the metal implements and vessels used in the temple ritual. A very specific

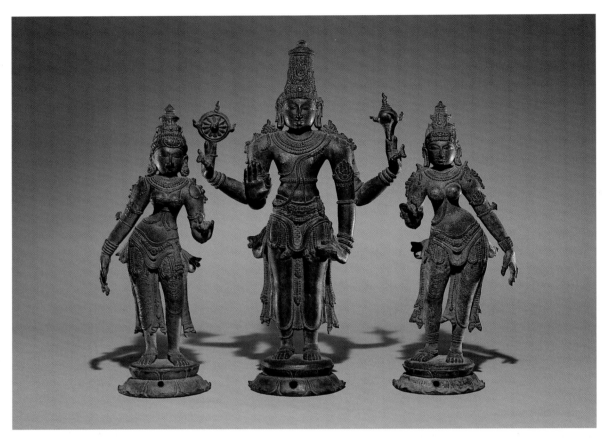

69 *Above* Vishnu with Shri and Bhu. Bronze. South India, central Tamil Nadu. *c*.1000 AD. Vishnu is depicted as uncompromisingly regal. He wears anklets, bracelets, armlets, earrings, necklaces and – snaking its way across his chest – the sacred thread of the brahmin caste.

70 *Right* Metal Vaishnava stamps. Probably all from Bengal. 19th century or earlier. These stamps are used by devotees to mark their bodies or their clothing. The outer examples are of script only. The large central example is filled with the symbols (*lakshanas*) of Vishnu, his footprints, conch (lying on its side) and wheel. On either side of the footprints are a club and a lotus blossom – all connected with Vishnu.

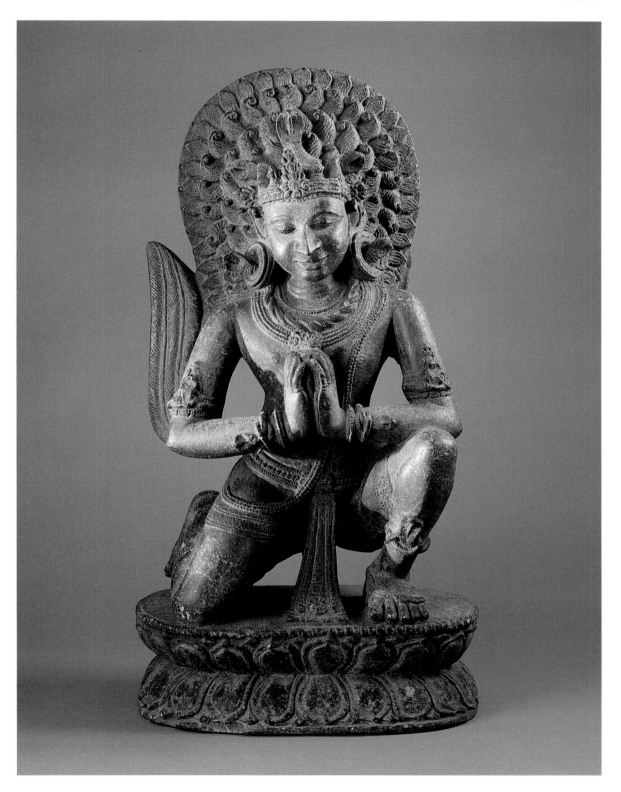

instance of their use as indicators of the presence of Vishnu is when a replacement icon is being prepared for the temple dedicated to Krishna as Jagannatha at Puri in Orissa (see map and pp. 135–8). This takes place periodically. The tree which is chosen to provide the wood for the image is determined by the natural markings on the trunk. These must resemble the discus and the conch attributes of the god. Their presence indicates the immanence of the deity, and the suitability of the tree for the making of the new image. Another example of the importance of the *chakra* as a Vaishnava symbol is noted in the small ammonite fossils, *shalagramas*, which are used in the worship of Vishnu. These fossils, found in the gorge of the Kali-Gandaki river in Nepal (see map on p. 228) are sacred to him because the concentric rings of the fossil are looked on as a naturally-occurring form of the discus of the god. Such natural examples of the presence of the deity can be seen as the Vaishnava equivalent of the *svayambhu linga* (see p. 82), the self-manifest Shiva *linga*. Finally we can note that pilgrims visiting Vaishnava shrines will decorate themselves with stamps bearing the discus and the conch shell, or will wear clothes block- 70 printed with the same devices. The body stamps may also display other symbols connected with Vishnu, such as his feet, or epithets written out in lines of text.

Another important attribute of Vishnu is the animal on which he rides. We have already noted that Shiva rides on a bull; in a similar fashion Vishnu has his own mount (*vahana*). This is the bird, Garuda. Some 71 scholars have seen an original solar imagery in the bird *vahana*, which, added to the similarly solar imagery of Vishnu's discus weapon and the legend of Trivikrama (see below p. 127), have suggested that the Vedic Vishnu may have been in some way connected with the main sun god Surya. Vishnu's bird mount is sometimes described as an eagle, sometimes a kite. From the painting and sculpture record it is impossible to tell – not least because Garuda is usually shown part-human in form. He is most commonly represented with a bird's wings, and with a human head which 35 only displays his bird nature in the prominently curved beak.

The incarnations of Vishnu

Today some of the incarnations (*avataras*) are more popular than others; such changing variety has doubtless always existed. One result of this, however, is that the surviving myths vary considerably in their complexity. Those stories which deal with the first incarnations as given in the canonical list – Matsya, Kurma and Varaha – are today reduced almost to a single episode each. This is, though, quite unlike the mythology of the later incarnations such as Rama and Krishna, who today boast an elaborate web of legend. Given the probable popularity in the past of the earlier incarnations as suggested by the sculptural record (especially in the case of Varaha), it seems logical to assume that a large body of legend once existed, but has not survived.

In the canonical listing of the incarnations, these first, and today least popular, ones are concerned with creation and with the beginning of time. These are aspects of the modern character of Vishnu which are not today so

71 *Previous page* Garuda. Schist. From Orissa. 13th century. The hawk *vahana*, Garuda, is depicted in a position of adoration before his lord, Vishnu. His hands are placed in the position of salutation, *anjalimudra*. The snakes in his earrings and headdress recall that, since at least the early centuries AD, he has been considerd the arch-enemy of all serpents. Indeed, he is often shown with a snake in his beak. The double lotus pedestal on which he is placed is a noted eastern Indian feature.

apparent. The first four are also animal or part-animal in form. The middle group are more epic and heroic in character, while the last two emphasise the saviour-qualities which we have already mentioned as specific to Vishnu.

1 Matsya

72 The fish incarnation. The surviving myth concerning Matsya tells how Vishnu took the form of a fish to save mankind from a consuming flood in the earliest period of creation. Not only did he save primeval man, but also the sacred texts, the Vedas. Noteworthy in this account of the first *avatara* in the list is the emphasis placed on the saving of mankind by the deity.

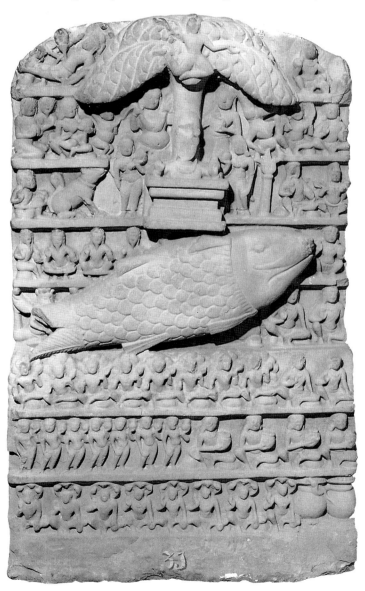

72 Sculpted sandstone slab depicting Matsya. Central India. 9th century. In this large and striking sculpture of the first incarnation of Vishnu, the fish form of the *avatara* occupies the central ground. His saviour qualities are suggested by the shrine he carries on his back, which he has rescued from the all-consuming waters. It has recently been suggested (Joshi, 1991) that many of the visual references are specific to Prayaga (modern Allahabad), sacred on account of the juncture of the Ganges and the Jumna. If so, the devotee who took *darshan* of this image may have thus obtained benefit partly equivalent to a pilgrimage to Prayaga itself.

74 *Opposite* Varaha rescuing Bhu from the ocean. Perhaps from Chamba, *c.*1740. Dramatic colouration, including the use of silver, is a hallmark of the painters from this region. Such paintings probably come from series showing all the *avataras* of Vishnu; here the boar incarnation is shown defeating the sea-demon, while carrying up the earth, balanced on his tusks. Varaha holds in his hands four of his expected attributes – wheel, conch shell, lotus and club.

2 *Kurma*

The tortoise incarnation. Vishnu is remembered today also in connection with a creation myth – one which has a distinctively pastoral quality. The image used to describe the bringing forth of creation was the churning of milk to produce butter. In this myth the cosmic ocean (the 'milk') from which creation (the 'butter') emerges, was churned using the sacred mountain, Mandara, as a churning pole, set on the stable back of the divine tortoise, Kurma. The snake Vasuki was used as a churning rope, pulled backwards and forwards around mount Mandara by divine figures on either side. Amongst the objects produced by the churning were the heavenly nectar (*amrita*), which the gods ate, thus ensuring their continuing immortality. Another product of the churning was the goddess Lakshmi (see p. 176). It is because of this legend that Kurma is envisaged as the base upon which the world is placed, a position depicted in traditional Indian cartography.

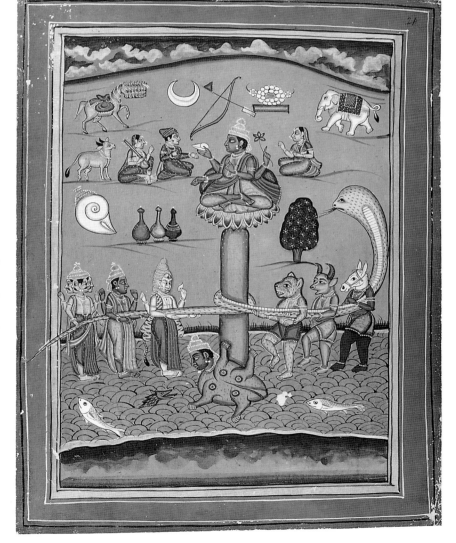

73 Painting of the Churning of the Ocean of Milk. Perhaps from Maharashtra. 18th or 19th century. Vishnu appears here at the base of the cosmic churning pole as the tortoise Kurma. The gods (to left) pull on the rope made of the serpent Vasuki, while demons pull on the right side. Some versions of this story refer to a poison thrown up by the churning, along with the gifts seen in the upper part of the painting. In order to prevent the poison causing universal destruction, Shiva quickly swallowed it, thus saving mankind, but so burning his throat that it was permanently discoloured. This event is remembered in his epithet, *nilakantheshvara*, the Lord with the Blue Throat.

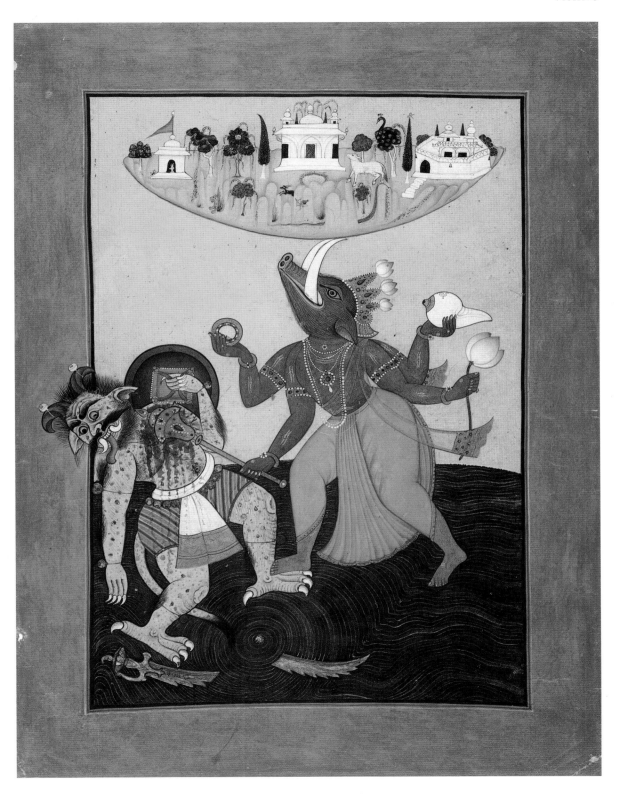

Kurma is not now a major deity, and does not receive important veneration independent of Vishnu. However, there are still tribal groups in India, such as the Gonds, who offer particular worship to Kurma. Tortoises are, of course, still found in the forest habitats of these tribal populations. Such specific worship of Kurma would be unusual in the settled, urban Hindu tradition. Its existence amongst forest groups, though, indicates the greater emphasis on animal deities which one would expect from a society yet dependent upon hunting and gathering for its food supply. One can perhaps see all of the first four incarnations of Vishnu – the animal forms – in the same light. They may provide a clue as to the way in which independent traditions and cults have become channelled from rural and tribal life into mainstream Hinduism.

3 Varaha

The boar incarnation. This *avatara* is also remembered today on account of 139 a myth concerned with creation. At a time when the whole world was flooded, Varaha rescued the earth from the bottom of the ocean where she had been imprisoned by a sea-demon. The earth is personified as the goddess Bhu. Varaha, usually shown with a human body and an animal head, is most frequently depicted at the moment when he emerges from the ocean, bearing the goddess with him. Bhu, who is also considered one of 74 the consorts of Vishnu, is shown as a diminutive figure, either hanging on to one of his tusks, or seated in the crook of his elbow as he strides forcefully up out of the waters. The vanquished sea-demon is sometimes shown crushed beneath the foot of the conquering deity. The powerful physique with which Varaha is usually endowed, and the nature of the story, with its connotations of brutal abduction and equally brutal rescue, lend the images of Varaha a vigorous resonance in keeping with the early personality of Vishnu. It is noteworthy, however, that even in this myth which is so full of crude animal forcefulness, Varaha is the god who re-affirms the status quo. He brings back the goddess Earth to her rightful position, reversing the attack made upon the cosmic order by the action of the sea-demon.

During the Gupta period (fourth–sixth centuries AD), the cult of Varaha was popular, especially in Central India, if we can judge from the surviving sculpture. Several remarkable depictions of him survive from the sites of Udayagiri and Eran, dated to the fifth century AD. In these versions he appears in both purely animal and part-animal forms, and again demonstrates the primeval power and virility of this incarnation of Vishnu. At the seventh/eighth century site of Mahabalipuram, south of Madras (see map on p. 229), Varaha was also honoured from an early period. In two of the rock-cut shrines, large sculpted panels of majestic proportions depict Varaha rescuing Bhu from the ocean. Only a few centuries later the same scene, immediately recognisable, is known in Kashmir, at the other end of the subcontinent. This provides striking evidence of the widespread use of similar iconographies.

Although in recent centuries the boar and, above all, the pig have for most people in India been considered unbearably polluting, it is clear that in the first millennium AD the boar was honoured and admired as a symbol of potency. It was even adopted as the royal mark by the south Indian Chola

and Vijayanagara dynasties. The later change of attitude towards swine in general is doubtless connected with Muslim influence from the twelfth century onwards.

74 In later Indian painting, the iconography of Varaha changes, and the god is shown literally carrying part or all of the earth in his tusks. Sometimes he carries a mountainous stretch of landscape, in others it is the whole globe which he balances on his tusks.

4 Narasimha

The lion incarnation, whose canonical position as an *avatara* of Vishnu is mentioned already in the *Mahabharata*. This part-human, part-animal incarnation is unlike the previous three zoomorphic forms in that he is unconnected with creation or with the beginning of time. Also unlike the first three incarnations, Narasimha still has an independent, though small, cult in his own right. His cult is not widespread, but is known throughout Orissa and the eastern Deccan, especially in and around the temple-town of Ahobilam in Andhra Pradesh (see map on p. 229). Here the main events of his legend are said to have taken place, and a series of temples dedicated to him are the centres of pilgrimage, attracting devotees from all over the Deccan. From this area of the southeastern Deccan has come one of the earliest depictions of Narasimha – the fourth century AD relief panel from Kondamotu.

The major surviving legend concerning Narasimha recounts his vanquishing of king Hiranyakashipu. Most representations of the *avatara* depict him at the climax of this story as he destroys the unbelieving king. This is the god in his *ugra* or fierce form, and he is thus technically known as Ugranarasimha. This distinction between pacific and horrific forms of the same deity is common throughout the Hindu pantheon. The Narasimha legend recounts how a devotee of Shiva, Hiranyakashipu, was granted a boon in recompense for penances performed. The boon was the gift of immortality – but with one proviso. Hiranyakashipu was to be safe except from a being who was neither man nor beast, at a time when it was neither day nor night, and in a place which was neither inside nor outside the king's palace. Understandably confident in his glorification of Shiva, the king even forbade his son Prahlada to worship his chosen deity, Vishnu. However, in response to the supplication of the son, and in order to answer the pride of the father, Vishnu manifested himself in his Ugranarasimha form (neither fully man nor fully beast) and humbled the king. Coming upon him at sunset (neither day nor night) and bursting out of one of the columns of the palace verandah (neither inside nor outside the palace), he killed the intolerant king. It is this moment of triumph which is usually

75 shown in sculpture and painting. Narasimha throws the king across his lap, and tears out his entrails.

This myth is interesting on two counts. Firstly, it documents explicit competition between the devotees of Vishnu and those of Shiva. This is quite unusual, though there is a sequel in the story of Sharabheshvara, in which Shiva takes on the form of a mythical animal (*sharabha*) and overcomes Narasimha. The second feature of interest about the story of Narasimha and Hiranyakashipu is its bloodthirsty nature. As the intestines

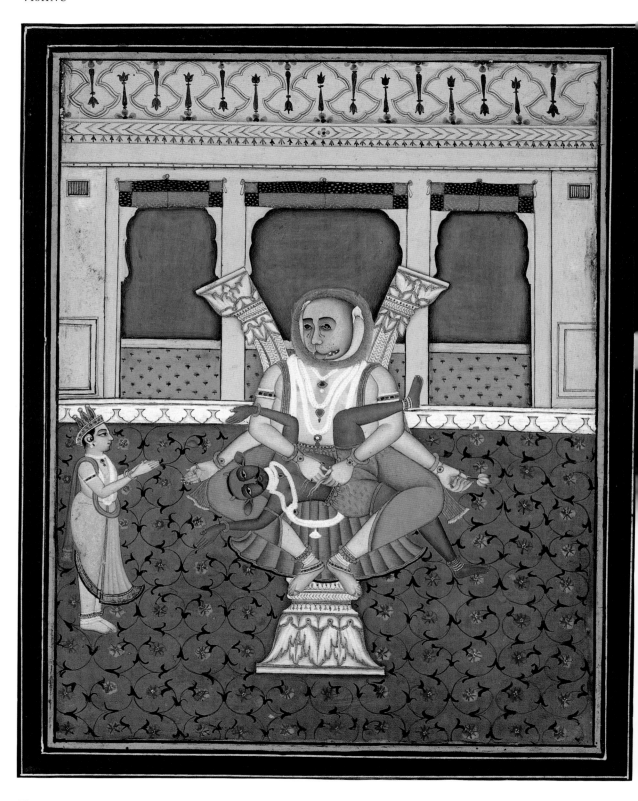

of the king are ripped from his body by the lion's claws, blood flies in every direction. The thought of such bloodshed to orthodox Vaishnavas – many of whom are strict vegetarians – is horrific, and is only understandable by viewing the god as a defender of religion.

The fierce and gruesome way in which Hiranyakashipu is despatched obviously also reflects the lion character of the *avatara*. The story probably also indicates the way in which an originally forest deity, with many non-Sanskritic features, was absorbed into orthodox Hinduism. Throughout the Deccan and also in Orissa (see map on p. 16), there is a long history of the worship by tribal populations of a lion god in completely animal form. The cult of Narasimha today is an amalgamation of this local aboriginal cult with its oral traditions, and the orthodox Vaishnava cult based on pan-Indian texts and practices. The reason behind this amalgamation, or even 'take-over' by orthodox Hinduism of a non-orthodox tradition, is to be sought in the attempt to include all religious activity within the bounds of Vaishnava control. This instinct to reduce immense variety to a single system is very strong throughout Hinduism. It can, however, work in both directions. Thus tribal cults can be taken over by traditions based on texts and orthodox practice, as in this example of Narasimha, and orthodox practice can be completely changed by non-textual practice, such as the change in worship from sacrifice to the devotion seen in the *bhakti* cults.

The tribal deity Narasimha was, and remains, a god of the Central Indian jungles. As the Indian lion is now only found in a small area of Saurashtra, far from the Deccan (see map on p. 228), the specifically leonine features of Narasimha are now somewhat compromised; he also appears today as a tiger, or as some other feline. However, what is beyond doubt is that in his non-orthodox, tribal form, he requires blood sacrifices. The gory end of Hiranyakashipu is an intimation of the original cult. In the temple-town of Ahobilam in southern Andhra Pradesh, blood offerings of goats and rams are made to Narasimha at a specified time of the week. For an orthodox Vaishnava devotee, this is an extraordinary activity. The idea of flesh-offerings in any context is abhorrent, but presented to an incarnation of Vishnu, it is doubly disgusting. Given the conflict this produces, it is noteworthy that at Ahobilam, Narasimha only receives blood offerings at a strictly regulated time of the week, thus suggesting an attempt to curb the practice. This type of offering is not uncommon in India, especially at the shrines of the goddess Durga (see p. 168), and at low-caste and tribal sanctuaries, though it is very rare at Vaishnava shrines. Narasimha at Ahobilam seems to be in the transitional state between a wild and unregulated tribal deity and an orthodox form of the god Vishnu.

Although Narasimha in his *ugra* form is the commonest way in which this incarnation is shown, he is also sometimes depicted as a yogi. When shown in this way he wears strapped around his knees the *yogapatta* or band, which ascetics tie around their legs while engaged in ascetic austerities. Another variant shows him with his consort, Lakshmi, upon his lap. In this we may see a deliberate move to show this originally wild deity in a more acceptably peaceful manner. For this form mirrors a common image of Vishnu, known as Lakshmi-Narayan (see p. 151), where Lakshmi sits in the lap of Vishnu as she does in the depiction of Narasimha.

94

75 *Opposite* Narasimha kills Hiranyakashipu. North-western Deccan. *c.*1800. The painting shows the climactic point of the Narasimha myth (see p.123) when the god, emerging from the column, rips apart the body of the proud king. One hand of the god reaches towards the figure of the devotee Prahlada in the hand-position of boon-fulfilling, *varada-mudra*; Prahlada meanwhile adopts the position of *anjalimudra* (adoration). The architectural backdrop, including the section inlaid with coloured marbles, suggests a provenance in the Deccan not far removed from Rajasthan.

5 Vamana

The dwarf incarnation, and the first completely human *avatara* in the 76 sequence. Vamana is instantly recognisable because of his small stature and because of the water-pot he holds in one hand and the umbrella he holds in the other. The pot identifies him as a brahmin, carrying his own undefiled water supply with him. Again this incarnation is only remembered widely today in one legend. This describes him in two quite different guises – as a dwarf and as a giant – demonstrating the ability of the god to transform himself at will.

In the myth Vishnu appears on earth as the dwarf Vamana in response to the activities of the king Bali. Bali had become so powerful that he threatened the gods themselves, and thus the whole cosmic order. Following accepted tradition for a brahmin, Vamana petitioned the king for a boon of land, a time-honoured way for the settling of orthodox brahmins in previously unpopulated regions. Vamana merely asked for the land which could be circumscribed within his three steps. Responding just as a righteous and powerful king should do, Bali granted the boon. Once

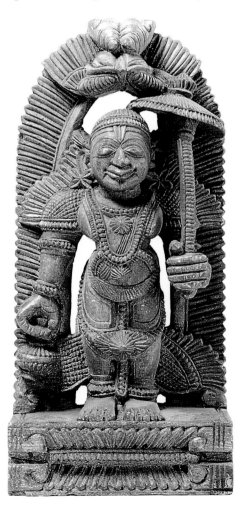

76 Vamana, the dwarf incarnation of Vishnu. Soapstone. South India. Probably 18th century. This small sculpture belongs to a series which illustrate the incarnations of Vishnu. Such sets of images were probably produced for sale at important Vaishnava temples. Today distinctive sets of sculptures are still found for sale in the bazaars attached to major temples.

the boon was granted, however, Vamana transformed himself into a giant, taking on the form of Vishnu Trivikrama, the Lord of Three Worlds. He then took his steps, and with them encompassed the earth and the skies. In this myth the power of Vishnu outside accepted human constraints is demonstrated. In some forms of the myth, Vishnu also demonstrates his charity and magnanimity by granting control of the Underworld kingdom to Bali – almost as a consolation prize. This version suggests the survival of information about a pre-Vaishnava cult which is first conquered, and then incorporated. If so, it is yet a further example of a very common feature in Indian religions; it is recorded in Buddhism as well as Hinduism. Typically an enemy, once vanquished, becomes a devotee and is granted a subsidiary position in the new hierarchy.

The myth of Vamana/Trivikrama is of a type found repeatedly in Hindu literature. Here, as in the case of Durga defeating Mahisha (see pp. 168–9), or Karttikeya defeating Taraka, the gods find themselves under fierce attack from the demons. All seems lost, with the order of the cosmos itself at stake. These evil forces are only eventually controlled by calling on some supernatural being who, almost by trickery (as in the case of Vamana and Bali) subdues the demon. Another repeating element which is also sometimes mentioned in this legend concerns the way in which the demon has amassed power. This is invariably through the espousal of the very actions which the gods defend – the correct performance of ritual and the practice of penance with ascetic vigour. Through this activity figures like Bali accumulate such merit that they are able to challenge the gods themselves. Perhaps in this demonstration of the fallibility of the divine figures, we see a reminder of the laws of *karma* which underpin all activity, human or divine (see p. 29).

6 Parashurama

The incarnation of Vishnu as 'Rama with the Axe'. This *avatara* is the first in the group of martial heroes. They are clearly differentiated from the group who come before.

Parashurama does not now have a substantial cult, and today he is undoubtedly overshadowed in popularity by the seventh incarnation of Vishnu, Rama. The connection between these two heroic archetypes, who after all share the same name, is far from clear. According to the texts Parashurama is the son of Jamadagni and Renuka. The main myth in which he figures is of great interest because it recalls a time of conflict between the two most prestigious of the caste groups, the brahmins (the priestly class) and the *kshatriyas* (the warrior class); see p. 25. The ordering of the castes which we know today has, in its basic outline, been in place for many centuries, founded on the ancient texts. However, its complexity and the number of its subdivisions has greatly increased. The ancient texts, however, were compiled by the brahmins. Not unnaturally, they presented their own point of view with their position, as most important of the four major caste groups, clearly stated. For instance, they are often referred to as earthly images of the gods; the divide between them and the rest of society was consequently very great.

However, it is clear that there has always been some mobility through

the system – it could not have survived to the extent it has without some elasticity. Theory and practice did not, therefore, always agree, and reading between the lines of brahmin-written history, one can surmise that there have been a series of attempts to actually change the order of the system, or even to abolish it altogether. The most frequent area of conflict was between the brahmins and the *kshatriyas* for the senior position. The incarnation of Vishnu as Parashurama perhaps recalls such a time of conflict. The legend tells how, in revenge for the killing of his brahmin father, Parashurama slaughtered the members of the guilty *kshatriya* family – not only in this generation but for the following twenty generations. The actual scene of massacre is the one usually depicted in Hindu paintings of 78 this *avatara*. In sculpture this scene is not shown, though a male figure standing with an axe is sometimes seen in temple relief sculpture and is clearly intended to represent Parashurama. Although the bloody carnage of this *avatara* is somewhat out of sympathy with Vaishnava aspirations today, it is significant that Vishnu as Parashurama champions orthodoxy. It is he who restores the status quo, and returns the human order to its

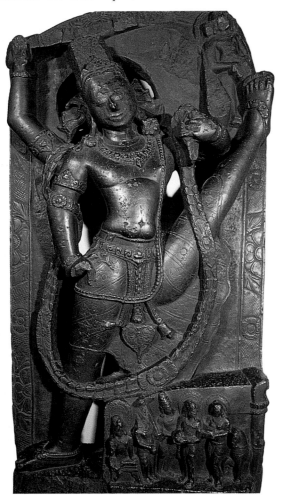

77 Vishnu as Trivikrama. Basalt. From eastern India. 10th century. In this powerful, though damaged, sculpture the god takes one of his immense strides through the cosmos. His left foot is raised high up to the border of the sculpture. The previous scene in the story is shown at the base. As in the Varaha *avatara* sculpture in fig. 139 the heavy garland – indicative of the god's high status – is clearly represented.

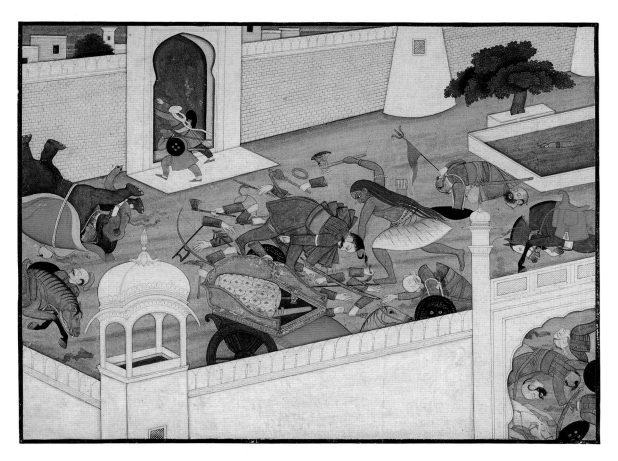

ordained position with the brahmins assured of their place at the centre of society. The prototypical Parashurama may once perhaps have been no more than a north Indian chieftain who excelled in battle against his caste opponents. However, he has come to be used as a defender of the divinely-sanctioned structuring of society.

7 Rama

The incarnation of Vishnu who is the hero and main protagonist of the epic, the *Ramayana*. According to legend, the acts of Rama (recorded in the *Ramayana*) were set down, in Sanskrit, by the sage Valmiki. The object of intense devotion, Rama is today the most popular form of Vishnu worshipped, along with Krishna. Indeed, Rama's very name, especially in northern India, and in its Hindi form Ram, has become synonymous with the word for God. His legend, particularly in more recent centuries, has offered great scope to Indian artists – poets, painters and sculptors. His deeds are known in countless variants in all the regional languages of the subcontinent, through the works of poets such as Kamban, who composed a Tamil version, and Buddharaja who elaborated the *Ramayana* in Telugu. Versions are known from all over southeast Asia, where episodes from the epic frequently provide the basis for the shadow puppet theatre. Some parts

78 Parashurama kills Kartavirya. Punjab Hills, Guler style. *c.*1765 AD. The wild *avatara* with his eponymous axe, blood-tinged, is depicted slaying the multi-armed Kartavirya, leader of the *kshatriyas*. His obsessive search for vengeance is emphasised by his unbound hair and fixed, steely expression. All around are dramatic scenes of death, set within a typical north Indian palace court.

of the *Ramayana* are even recorded in the literature of Mongolia. However, today the version most widely known, especially in northern India, is that written by the sixteenth century poet, Tulsi Das. A brahmin settled in Benares, he wrote not in Sanskrit, but in the vernacular of his day, Hindi. His much-loved account of the story of Rama is the *Ramacaritamanasa* (the Holy Lake of the Acts of Rama). Dramatic performances and public recitations of the text have ensured that this version of the story of king Rama, of his beautiful wife Sita and her abduction and rescue, continue to be widely known.

Probably Rama was originally an historical figure, perhaps a chieftain taking part in the slow penetration of India south of the Ganges plain by the Indo-Aryans in the late centuries BC. His legend can be explained in a quasi-historical way to illustrate the vanquishing of indigenous peoples, represented by Ravana, his southern foe. He has, however, long been forgotten in any such conquering context, and his legend of heroic deeds and adherence to family values has made him an ideal candidate for inclusion as an incarnation of Vishnu. Here his qualities of ideal king and husband have fitted completely with those of Vishnu as preserver and keeper of the established order.

The *Ramayana* is today of great length. However, the story can be told in brief, as follows. King Dasharatha ruled from the city of Ayodhya in the Ganges valley (see map on p. 228). He had four sons, Rama, Lakshmana, Bharata and Shatrughna, by his three wives. One of the wives, Kaikeyi, was granted two boons by Dasharatha on account of her bravery during a celestial battle. The first boon she used to ensure that her son, Bharata, was anointed king rather than the rightful Rama; with the second she demanded that Rama should be banished to the forest. Dasharatha was forced to agree, and the unwilling Bharata was anointed king while Rama and his faithful wife Sita had to leave the city. In this action Rama acts in a way which is typical of his conduct throughout the rest of the epic. He obeys his father's order without demur, even though it is patently unjust, for he personifies the traditional filial virtues. In exile Rama, Sita and Rama's brother Lakshmana lived in the forest, where in preparation for what was to come, they waged war against demons. One of the demons 80 they encountered was Shurpanakha, the sister of Ravana the king of the island of Lanka. She fell in love with Rama, who, true to form as the guardian of family morals, rejected her advances. In a jealous rage Shurpanakha attacked Sita, who was only saved through the intervention of Lakshmana, who cut off Shurpanakha's ears and nose in retaliation. When she returned to Lanka, her brother Ravana swore he would avenge her disfigurement, and humble Rama. Initially he was successful, as by a trick he managed to abduct Sita, carrying her off in his aerial chariot to his palace in the south. The majority of the rest of the epic is concerned with the many adventures of the two brothers as they firstly discover the whereabouts of Sita, and secondly succeed in rescuing her from her prison on the island of Lanka. This part of the epic ends with the victory of Rama and Lakshmana over Ravana and the destruction of his kingdom. In many of their activities they were greatly aided by the chief of the monkey army, Hanuman and his allies in the animal kingdom, such as the bear Jambavan 79,

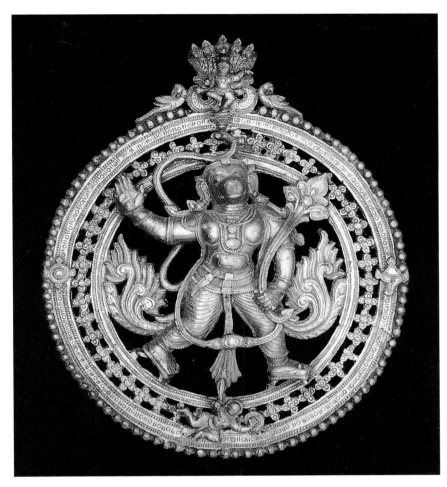

79 Circular plaque depicting striding Hanuman. Karnataka or Tamil Nadu. 16th century or later. This very lively depiction of Hanuman shows him carrying in his left hand the magic plant which will cure Lakshmana (wounded on the field of battle). The flaming wheel and conch shell seen at the edges of the circular surround, and the dancing figure at the top (either Krishna or Balarama), reinforce the Vaishnava context of the scene depicted.

and the vulture Jatayu. There are many miraculous and sometimes amusing episodes which eventually bring the epic to its conclusion. They have provided artists – especially painters and sculptors – with countless scenes to be used for the elaboration of the exteriors of temples or the decoration of manuscripts.

In many respects the figure of Rama, though obviously central to the whole action, stands back, and it is his lieutenants – especially Hanuman – who come centre-stage. The position of Sita is also important. Although mostly inactive and incarcerated in Lanka for much of the duration of the epic, it is, of course, a truism to say that without her, none of the events of the epic could have unfolded. Ravana is humbled and Rama glorified entirely because of her.

Once Sita is freed and reunited with Rama, they prepare to return to Ayodhya. However, first, Sita has to undergo a trial by fire to prove that she was not unfaithful during the period of her separation from Rama. She is vindicated by surviving the fire without harm and they leave for Ayodhya and the coronation of Rama. Rama is the archetypal householder and king, wise, faithful to his *dharma* – and watchful of the reputation of his wife.

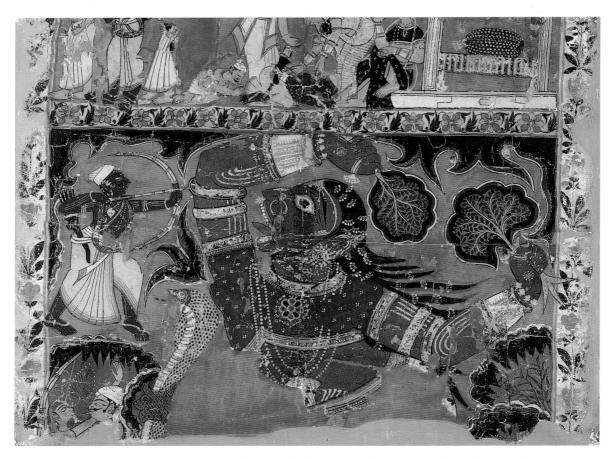

80 Rama battling with the demoness Tataka. Register from a scroll-painting, *pat*. From Kandi, Murshidabad District, Bengal. *c*.1800. In this panel the ogress Tataka fights with Rama, who is shown firing at her, to the left. Scrolls like this were used by travelling bards to illustrate their recitations. The large slab of scarlet for the background, and the agitated way in which the sky is shown, point to the survival here, far away both socially and geographically from the painting of the courts, of pre-Islamic painting styles.

A final episode, added at a later date, records how faithful Sita was forced to go into exile from Ayodhya once more. It was whispered in the city that while a prisoner of Ravana her honour had been impugned, and because of the requirement for the consort of the king to be above suspicion, she was abandoned in the forest on the orders of Rama. It was while there that she gave birth to twin sons, Lava and Kusha. They were both eventually reunited with their father, but Sita, whose name means 'furrow', was never completely reconciled, being eventually swallowed up by the earth goddess herself, from whom she was born.

8 Krishna

Today Krishna is the most widely worshipped of all the *avataras* of Vishnu, (save perhaps Rama) and often the subject of an intensely emotional cult. Indeed, he is so popular that many of his devotees would not even count him as one of Vishnu's incarnations, but rather think of him as God without equal. On account of his pre-eminence amongst the incarnations, it is not surprising that his mythology is highly developed today with a wide range of sectarian and regional variation.

Like the cults of Shiva, Skanda, and Surya (the Sun god), the cult of Krishna probably reaches back to the early centuries AD. His personality

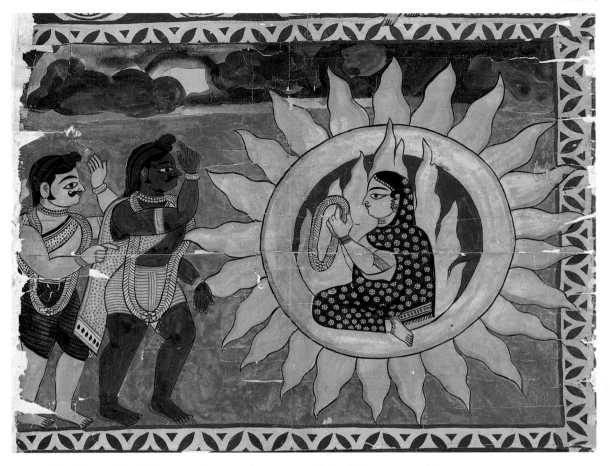

has evolved considerably since then, with a series of doubtless originally different cults, from distinct parts of India, merging to form the deity known today. We can trace many different strands in the rich personality of this deity, including:

a) A god-child who is constantly involved in practical jokes. Often he is shown stealing butter or curds, or playing pranks on unsuspecting adults. Like most male children in India, he is doted upon and spoilt. This and the succeeding early parts of the life of Krishna are associated with the town of Vrindaban on the river Jumna, to the south of Delhi (see map on p. 228).

b) A cowherd god who is renowned for his erotic dalliance with the milkmaids (*gopis*). Originally this sexual element in the worship of Krishna may have been overt, and possibly connected with a fertility cult. However, the relationship of longing from afar that exists between the milkmaids and Krishna has now for many centuries been seen as a metaphor for the pining of the soul for union with its Lord. This has been especially developed in the case of Radha, the chief of the *gopis*, and the particular object of Krishna's fickle desire. A popular subject for artists at the courts of the Punjab Hills of the eighteenth and nineteenth centuries was Radha depicted at night, waiting for her flighty lover who might or might not come to meet her. The devotional literature which is highly

81 The Trial of Sita. Register from a scroll-painting, *pat*. From Bishnupur, Bankura District, Bengal. Mid-19th century. Like fig. 80, this painting is a register from a Bengali storyteller's scroll. The evocative, yet totally unrealistic, way in which the fire is depicted is in keeping with the other-worldly tenor of the event portrayed – Sita's ordeal and her miraculous escape. Rama and Lakshmana, to the left, salute her.

extended in the cult of Krishna, is full of images drawing on this relationship. The language of the sixteenth century poet Sur Das emphasises the sharp discomfort at the separation of god and devotee (see p. 153).

One of the scenes from this adolescent period of the life of Krishna which is often depicted in painting, shows the milkmaids bathing at the river Jumna. Unseen by them, Krishna approaches, secretly gathers up all their clothes and hides them in a tree. When they return to the banks to dress, he taunts them from the safety of the tree. This element of mockery is typical of Krishna's relationship with the milkmaids – they love him with an enduring passion, but all he does is tease them. Another common motif in this erotic iconography is the circular dance, the *rasamandala*, in which he is 82
shown dancing with each of the *gopis* at the same time. Through his divine power he can convince each of them that they are the only object of his desire.

c) A pastoral deity who plays the flute with magical effect, luring the unwary from the certainties of settled life. Merely to hear his flute playing in the distance is enough to completely unsettle Radha. This pastoral strand in the personality of Krishna may explain the distinctive blue skincolouring of the god. It has often been assumed that his dark-coloured skin is indicative of a non-Aryan, tribal past. This is based on the premise that the Aryan invaders of the second millennium BC were paler of complexion than the populations with whom they came into contact in India. The peacock feathers which he invariably wears in his crown also suggest a forest – and thus a non settled – origin for the god. The tribal ancestry is further implied by the use of the flute; the pastoral Bhil tribesmen of Rajasthan, Gujarat and Madhya Pradesh are justly famous to this day for their skill in playing the bamboo flute.

One of the most famous stories of this aspect of his character provides a fascinating insight into the way the gods of Hinduism usurped power from the older sacrificial gods of the Vedas. In this case Krishna is successful against the Vedic god Indra, as he is able to protect his followers from Indra's anger, which is caused by their abandonment of his cult. When the inhabitants of Mathura first became devotees of Krishna they made food offerings to him as Lord of Mount Govardhan. Indra, the previous recipient of their offerings, was angered and, as the weather god, attacked them with a fierce storm. Calling on their new god to aid them, the herdsmen of Mathura were protected by Krishna when he lifted up Mount 3
Govardhan and used it as an umbrella beneath which his followers could take refuge. One of the earliest surviving sculptures of Krishna – now in the Bharat Kala Bhavan in Benares and dated to the sixth century – shows him as a powerful adolescent figure, wearing a tiger-claw necklace and lifting up the mountain to protect his devotees. This form of the god had a wide currency from an early period, as is proved by a monolithic sculpture from south India which dates to the seventh/eighth century. In this example the scene is represented at more than life size, on the face of a huge boulder at the port of the Pallava kings at Mahabalipuram (see map on p. 229). 83
Although much of the mythology of Krishna is today connected with the region of Braj (the country around Mathura and Vrindaban), the south of India undoubtedly also contributed to the development of the cult.

d) A god who controls the snake deities (*nagas*), and is especially
remembered in the battle with the snake king Kaliya, at Mathura. This
episode is recalled at the annual Nagapanchami festival. Auspicious prints
and paintings are produced for this festival and hung outside doorways.
They show Krishna overcoming Kaliya by dancing on the outstretched
hood of the cobra king. In the same way that we have discussed in the cult
of Vamana (see p. 127), Kaliya, once defeated, becomes a devotee of
Krishna. The wives of Kaliya acknowledging Krishna are frequently
shown on either side of the god as he dances on the head of the serpent king.

The association of Krishna with *nagas* is one that is probably inherited
from the deity Balarama, whose serpent-related cult was popular in the
early centuries AD in the same region around Mathura, known as Braj,
which is today the centre of Krishna worship. The closeness of the two gods
is still acknowledged, in that Balarama and Krishna are considered to be
brothers. Balarama is still worshipped; indeed, he is sometimes listed as an
incarnation of Vishnu, and is then shown carrying a plough, suggestive of
an agricultural purview. In two magnificent eastern Indian bronzes in the
British Museum dated to the tenth and twelfth centuries, Balarama is
depicted carrying a plough and is also shaded by the rearing hood of a great
cobra. At this period Balarama was still a popular deity, whereas today his
independent cult is not significant. He does, however, figure in the Krishna
cult of the sect founded by Vallabhacharya (see pp. 142–3); they call him by
the nickname Dauji. In this form he is considered to be an *avatara* of the
snake Shesha, upon whose coils Vishnu reclines (see p. 147). Thus even as
Dauji, the brother of Krishna, the connection with snakes first recorded in
the early centuries AD is maintained.

e) A philosopher who, in one section of the great Indian epic the
Mahabharata, provides council on the duty of the individual, and his
relationship both with society and with God. This section of the immense
text is the *Bhagavad Gita* (see p. 28), and it is in these teachings that Krishna
reveals himself as the Lord who is not only worthy of love, but who loves
all his followers in return. Although this scene is often depicted in popular
prints, Krishna as teacher does not have his own cult.

f) An urban ruler who justly legislates from his city of Dvaraka on the
west coast of India, in Saurashtra (see map on p. 228). By this connection,
and because of its geographical position on the far west coast, the city is
counted as one of the four *dhamas*, the places of pilgrimage which delimit
the extent of sacred India (the others are Badrinath, to the north; Puri, to
the east; and Rameshvaram, to the south; see maps, pp. 228–9). In the
legend Krishna rules from Dvaraka accompanied by his consort of later –
and more sober – life, Rukmini. Dvaraka is the location of his mature years,
removed from the dalliance and herding adventures of Braj. The temple of
Dvaraka remains an important, and also a beautiful, location. It has un-
doubtedly become a more important pilgrimage centre within the last 150
years, due initially to the peace imposed by British control, and later by the
provision of modern transport. The town boasts a number of fine homes
for pilgrims (*dharmashalas*), and has a well-organised temple schedule.

g) An almost non-representational image from Orissa, worshipped at
the eastern of the four *dhamas*, Puri (see map p. 228). Originally an image of

82 *Next page* Krishna dancing
with the *gopis*. Mewar,
Rajasthan. 1630–40. In this
manuscript page, the
rasamandala of Krishna is
illustrated. The flute-playing
god in the centre magically
causes each of the *gopis* to
imagine that he is dancing
with her alone. Drum and
cymbal players at the bottom
left accompany the wild
gyrations of the besotted
milkmaids. The element of
intense emotion is emphasised
by the use of a scarlet
background for the *gopis*.
A very similar painting is
today housed in the Rajasthan
Oriental Institute of Jodhpur.

83 *Page 137, left* Krishna
holding up Mount
Govardhan. Mahabalipuram,
northern Tamil Nadu. 7th or
8th century AD. With one
hand Krishna holds aloft the
mountain; the other is held in
the grant-fulfilling posture,
varadamudra. The pastoral
quality of the scene, which is
sculpted with an impressive
simplicity, is demonstrated
by the herded animals and
the woman carrying stacked
pots on her head.

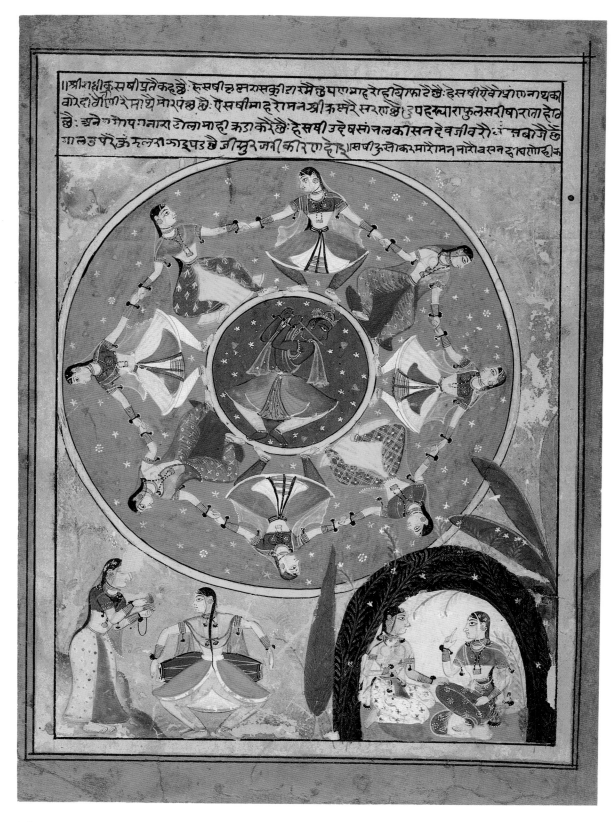

the jungle tribes of the interior of Orissa, the deity at Puri, Jagannatha, has now been incorporated within orthodox Hinduism, despite its only partly anthropomorphic shape. At Puri, Krishna is worshipped with his brother Balabhadra (Balarama) and his sister, Subhadra. Scholars have made the distinction, which certainly seems to hold true for Orissa, that gods of orthodox Hindu cults are usually worshipped in the form of anthropomorphic images (*murti*), while tribal deities are not. Tribal gods seem more likely to be recognised in a standing post, a pile of stones, or a similar non-anthropomorphic form. Iconographically, Krishna/Jagannatha at Puri seems to be half-way through the process of changing from a tribal to an orthodox image. The aniconic 'standing post' ancestry of the Puri image is still apparent, though he has been granted some elementary human characteristics, such as facial features and stumpy arms. Another attribute probably inherited from the tribal past of this image is its periodic replacement by a newly sculpted icon. This takes place within different intervals, but usually at least once every twenty years, with a ceremonial process of considerable elaboration.

Because the town of Puri has been a centre of pilgrimage for centuries, the production of sacred souvenirs for pilgrims has become highly developed. Pilgrims can not only purchase paintings and models of the deities, but also paintings of the temple. Puri is also the scene of one of the

84 *Above right* Krishna subduing Kaliya. Northern India, perhaps Benares. 19th century. Ephemeral paintings such as this one were made for prophylactic display during the days of the snake festival of Nagapanchami. *Naga* kings (*nagarajas*) are frequently shown multi-headed; five (as here and in fig. 65) and seven heads being the commonest variants. The swift but sure execution of the painting is shared with other religious paintings such as those from the Kalighat temple in Calcutta.

85 The approach to the Krishna temple at Dvaraka, Saurashtra, Gujarat. 14th century and later. The 'Chapan Seedi', the 56 steps by which pilgrims approach the shrine at Dvaraka. At the top is the *svarga-dvara* (the heavenly gate) through which they pass to the temple, the *shikhara* of which towers over the steps. The flag flying from the top is changed according to the season, and the provision for the raising of a new flag, including all the costly rituals which accompany it, is an act of great merit. Behind the viewer is the Gomti River in which devotees bathe beforehand, thus preparing themselves ritually for receiving *darshan* of Krishna in the temple. They leave the temple by another gate, into the town of Dvaraka itself, appropriately known as the *moksha-dvara* (the gate of liberation).

most remarkable of the famous Indian 'chariot festivals'. Once a year the image of the god is brought out of the temple and mounted in a many-storeyed carved wooden chariot on the top of which the god is enthroned; here he is attended by brahmin priests. Above the throne platform is a colourful superstructure of swaying bamboo and textiles. The whole immense vehicle, like a ship under sail, is then dragged through the streets by devotees. Tens of thousands of worshippers line the streets eager for a beneficial view of the god.

These are some of the forms in which Krishna is worshipped. His mythology is extraordinarily rich, and there are a large number of texts which detail aspects of his life. The basic text, and perhaps the earliest, is the

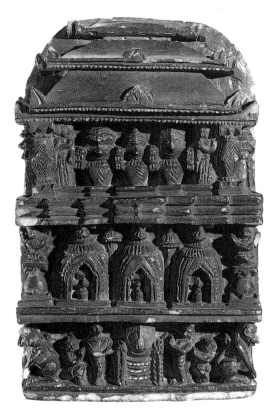

86 and **87** Two small plaques, probably both from Puri, Orissa. Fig 86 of stone, H. 11.5 cm, 87 of bronze, H. 3 cm. Both probably 18th century or earlier. These two small plaques show the three images worshipped in the Jagannatha temple at Puri. Both are of a size that could easily be carried away by pilgrims following a visit to the sacred location; they could then be used in a domestic shrine. The stone example is of further interest because of the architectural setting, representing the temple, within which the figures are placed.

10 *Bhagavata Purana*, though mention should also be made of the *Gita Govinda*, written by the twelfth century Bengali poet, Jayadeva. The latter has been particularly influential in the development of eastern Indian devotion to Krishna, especially those sects which trace their lineage back to Chaitanya (see pp. 140–42).

Krishna was probably already an important pastoral deity in the first centuries AD, with the cults of a number of different gods beginning even then to merge with his. However, it was not until the second millennium

88 Bronze image, inlaid with silver, of Balarama. Eastern India. 12th century AD. Sophisticated icons such as this one stand at the end of a long line of metal craftsmanship in eastern India. In this series are both Buddhist and Hindu examples from the 8th to the 12th centuries. The stepped base with donor figures, the double lotus pedestals, and the elaborate architectural surround are all features of the Bihar/Bengal schools of bronze-casting.

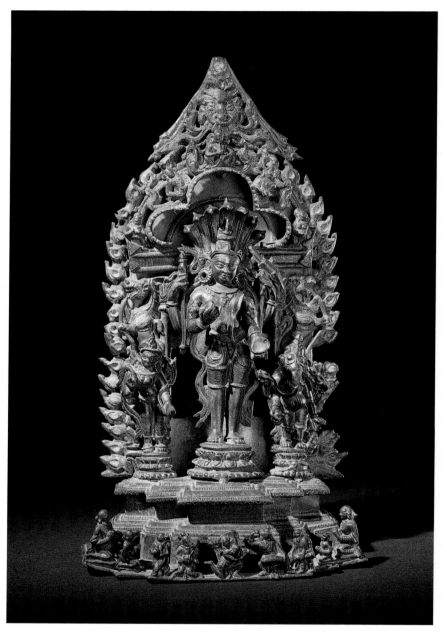

AD that the worship and the depiction of Krishna became very important and began to dominate the religious activity of large numbers throughout India. This was due in part to the work of two important saints, whose devotion to Krishna has become legendary. Their love for the god was so intense and impressive that cult activities specific to their visions of the god grew up amongst their followers, and continue to this day. These two saints were Chaitanya (1486–1533) and Vallabhacharya (1479–1531). Chaitanya was born in Navadvip, in Bengal, while Vallabhacharya was a

native of southern India. However, despite their very different backgrounds, they both followed the same path of total devotion to the deity – *bhakti*. They considered that the selfless love and honour given to the god was of equal or even greater importance than religious knowledge or the mechanical following of correct practice.

The worship which has developed from the mystical experiences of Chaitanya includes the frequent singing of hymns in praise of Krishna. These songs are known as *kirtanas*, and are often accompanied by dancing. Also of importance to the followers of Chaitanya (known today as the Gaudiya Vaishnava) was the repeated singing of nothing more than the name of Krishna, usually in the form of 'Hari Krishna, Hari Ram'. To sing the name alone is considered sufficient to honour the god and to gain merit for the devotee. His followers still practise these distinctive devotions to this day. One of the episodes of Chaitanya's mission, which was to have a profound effect on the geography of pilgrimage, was his insistence that

89 Painted cotton hanging, *pichhwai*, of the Vallabhacharya Sampradaya. Probably from Nathdvara, southern Rajasthan. 19th century. Both paintings on cloth and appliqué textile hangings are a prominent part of the Nathdvara tradition. In this example, the humps, horns and lower legs of the cows are coloured with vermilion, indicative of the auspicious nature of the Gopashtami festival.

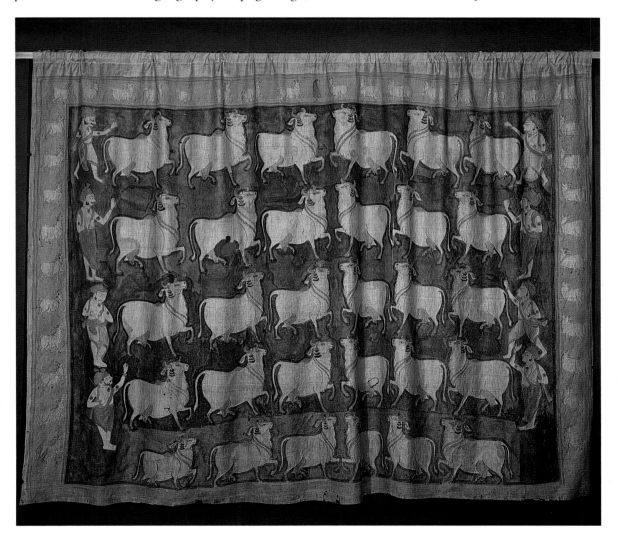

Vrindaban and its environs were the historical scene of the early life of Krishna. Vrindaban and the neighbouring town of Mathura, to the south of Delhi (see map p. 228), are located on the banks of the river Jumna. Chaitanya's identification of this region with the land of Krishna's childhood and adolescence has ensured that the two towns and countless villages in the surrounding landscape have become totally imbued with the complex mythology of Krishna. This is especially remarkable since during the early centuries AD this region was overwhelmingly connected with Buddhism and Jainism, as is clear from the archaeological record. The history of the change from the old cults to the new ones is only now being untangled.

Today Mathura/Vrindaban (they have become almost a continuous settlement) make up the single most important location in India for the worship of Krishna. Similarly, the countryside around is well-travelled by pilgrims who follow a fixed route to view the sacred locations. All the scenes of the legend of Krishna have been matched with specific places in and around Mathura. From the sixteenth century onwards, temples (*mandirs*), retreats (*ashramas*), pilgrim accommodation (*dharmashalas*) and other religious buildings have been constructed in Braj by the faithful. Old people, especially from Bengal, come to the city to die in the hope of securing a better rebirth. This is particularly true for lower caste widows who, being inauspicious, are sometimes cast out by their families, and have nowhere else to go.

The Krishna cult which stems from the other great saint, Vallabhacharya, is essentially similar in its absolute devotion to the god. However, it has differed markedly in two ways. Firstly, there is not the same element of ecstatic and spontaneous experience which is strong in the cult of the Gaudiya Vaishnava. Indeed, an insistence on this world and the enjoyment of all it has to offer has been a strong element in the teachings of the followers of Vallabhacharya, the Vallabha Sampradaya. Secondly, it has always possessed an elaborate organisation, in both the cult and the teachings. The latter have been passed down through the family of Vallabhacharya himself. The leaders of the cult preside over some of the larger of the sect's temples, and are known as Maharaj. The most important of their temples (strictly speaking, these are called 'mansions' [*havelis*], and not 'temples' [*mandirs*]), is at Nathdvara, in southern Rajasthan. Although Vallabhacharya himself originally came from south India, it is in the western parts of India that his teachings, the *Pushti Marg* or Way of Grace, have prospered. Consequently, their temple and painting traditions closely follow those of Gujarat and Rajasthan.

It is for its paintings and textile hangings that the sect is best known 89 outside India today. This is particularly so with paintings from their major temple, located at Nathdvara ('the Door of the Lord', see map on p. 228). Here Krishna is worshipped as Shrinathji. In this temple, more than in any other of the sect, very elaborate rituals have developed around the worship of the specific icon Shrinathji. This image has a long history extending back to the time of Vallabhacharya himself, who was instrumental in first establishing it as the major icon of the sect. His successors have installed a calendar of worship of enormous complexity, celebrating all the events in

the life of both Krishna and of Vallabhacharya. For all these different feasts, different paintings or hangings were required for the service of the deity. For instance, the textile hanging illustrated on page 141 was probably produced for the festival of Gopashtami, which recalls Krishna becoming an adult cow-herd. During this festival cows are especially venerated. Nathdvara has become a centre for the production of paintings which depict the life of Krishna and of Vallabhacharya. This is not only because of the requirement for different paintings to be hung in the sanctuary of the temple for all the different festivals, but also because it was assumed that the god always wanted elaborate and luxurious decorations in his shrine. Just as the god is imagined to desire all available comforts, so it is the aim of the members of the Sampradaya to live as full a material life as possible. Unusually for an Indian sect, asceticism has no place in this scheme.

Not only have these paintings been produced for the very elaborate sequences in the temple at Nathdvara, but they have also been taken away from the city by pilgrims to be used in domestic shrines. Further, during the last century, amongst the many rich merchant families who flourished in the new British-founded cities such as Calcutta, were a substantial number from Mewar. This is the region of southern Rajasthan where Nathdvara is located, and which has provided the prosperous middle-class families who make up the members of this cult, the Vallabha Sampradaya. Wherever they settled they took with them their cult of Shrinathji. The result has been that this icon is now also widely known outside Mewar.

In a more speculative vein, it is worth mentioning that the image of Krishna as Shrinathji shares some of the basic features of the Jagannatha image at Puri (see p. 135ff.). Both of them, in their lack of well-defined physical features, share a closeness to aniconic forms of the god. We have a much clearer indication of a transition from tribal to orthodox icon in the case of the Puri image. The lineage of the Shrinathji icon is less clear. However, we do know that when Vallabhacharya first came upon the image it had previously been worshipped by the shepherds of Mount Govardhan, near Vrindaban, as a snake (*naga*) deity. Also, it had received offerings of milk in the open air, not in a built sanctuary attended by brahmin priests. This combination of low-caste pastoralists, a *naga* deity, and the cult activity not taking place in a temple or shrine, suggests that the cult of this icon may have in its ancestry some tribal elements now completely absorbed within the elaborations of the Sampradaya.

Nathdvara is the most important of the temples of the followers of Vallabhacharya. However, other important temples include those at Dvaraka (see map and p. 135), where the icon is of similar form to the Shrinathji image. Another important centre is at Dakor to the east of Ahmedabad where the image clearly also belongs to the same group as the Nathdvara and Dvaraka images.

9 The Buddha

Unlike the preceding incarnations of Vishnu whose existence is only guaranteed in the mythological or heroic past, the Buddha is known as an historical figure. We also know that he founded his own philosophical

90 *Next page* The Buddha incarnation of Vishnu. Perhaps from Maharashtra. 18th or 19th century. An exact provenance for this painting – and the other paintings of the *avataras* bound in the same volume – is difficult to pin down. Certain features such as the oval face and the stepped crown look southern, but the treatment of the landscape and the sky are more northern in character.

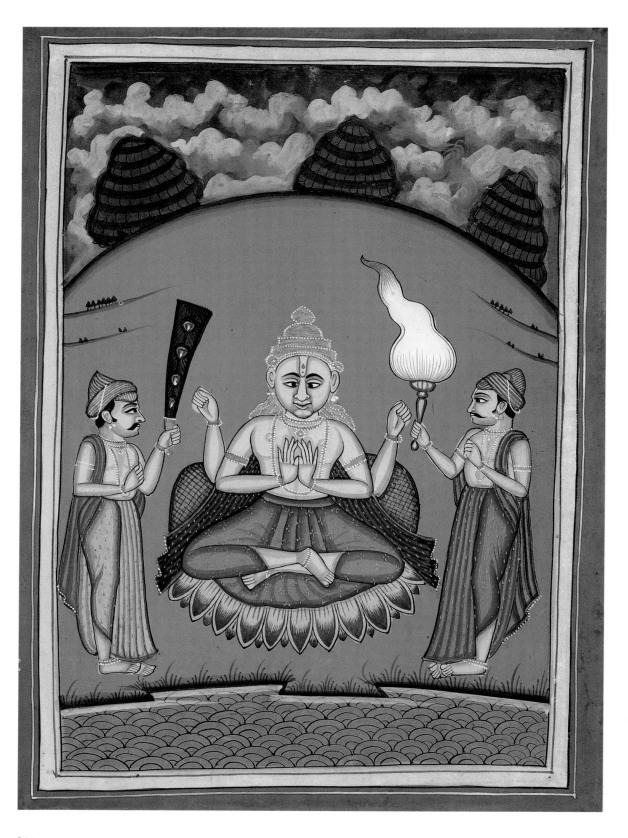

144

system which rejected the effectiveness of the gods. It may therefore seem curious to a non-Indian to see the Buddha listed amongst the *avataras* of the god Vishnu. However, syncretism is a feature of all Indian religions. Cults easily absorb features from other groups, especially if these outside features are powerful and would add to the lustre of the borrower.

The Buddha as an *avatara* of Vishnu has no substantial cult. Even at Bodh Gaya where the Buddha achieved his Enlightenment the shrine, although until recently still in Hindu control, was a Shaiva, rather than a Vaishnava place of worship. The cult of the Buddha was probably included as an *avatara* as the influence of Buddhism in India began to decline. During the

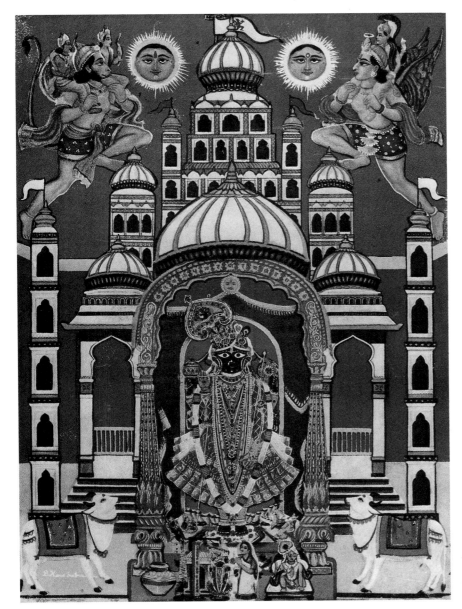

91 Popular print from the Krishna temple at Dakor, Gujarat. Modern. This print belongs to the long tradition of place-specific images sold at temples visited by pilgrims. As in the painting from Puri (fig. 14) which is of the same genre, the temple is shown both in section and in elevation. The icon of the god is located beneath the central tower of the temple, with the eyes depicted proportionately large, and of silver. This ensures the blessing of *darshan* for all who attend at the temple.

145

last phases of Indian Buddhism an elaborate theistic structure evolved in Buddhism. It was during this last period (tenth–twelfth centuries) that the interaction between the two religions became very close with similar practices and doctrines, such as the *tantras* (see p. 30), appearing in them both. It was probably for this reason that the historical Buddha became listed amongst the *avataras*. It is probably no coincidence that one of the earliest surviving lists of the *avataras* of Vishnu to include the Buddha, appears in Jayadeva's *Gita Govinda*, an eastern Indian Vaishnava text of the twelfth century. Its provenance and date are entirely in keeping with the marked degree of syncretism which was a feature of eastern Indian religion at this time. Both the Buddha and Vishnu are seen as benign saviour-figures; in this they are unlike Shiva.

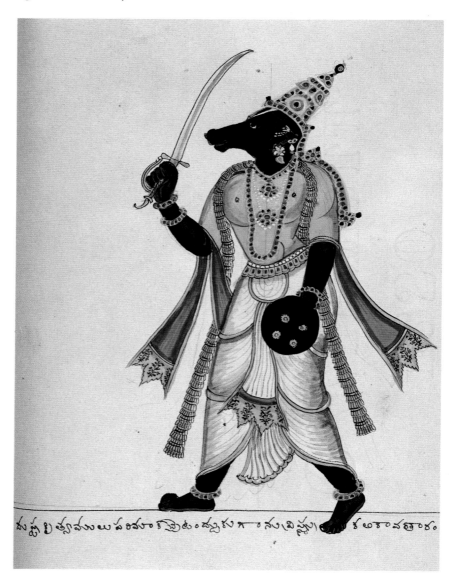

92 Kalki, the incarnation of Vishnu yet to come. South India, probably Tanjore. On European paper watermarked 1820. This depiction of horse-headed Kalki comes form an album of 91 paintings, the subject matter of which is mostly iconographical; this example is from a *dashavatara* series. However, also included are 9 paintings which show the major temples of South India, including Rameshvaram, Madurai and Shrirangam, the last of which is illustrated in fig. 19.

10 Kalki

92 The last of the *avataras* of Vishnu, and the one whose incarnation is still to come, is Kalki. He is depicted either as a horse-headed human figure, or as the horse itself. The texts say that his appearance in the world will come at a time of dissolution when the old orders of caste certainty have been overthrown, and inter-caste marriage has become a commonplace. Kalki will herald the end of our present time-cycle (the *kali-yuga*) and the sequence of time-cycles will once more begin their remorseless round, starting again with the first (the *krita-yuga*). Kalki is not an important incarnation of Vishnu, and does not have his own cult activity.

This list of the ten incarnations provides a canonical grouping of some of the different aspects of the god Vishnu. It is by no means a complete list of all that is recognised as Vaishnava, nor are the *dashavataras* necessarily the commonest forms of Vishnu that are worshipped today. It is, however, a listing which, despite slight regional variation, has time-honoured sanction.

Other common forms of Vishnu

Because they are so frequently seen, it is important to mention briefly the following further images of Vishnu.

Vishnu Anantashayana

28 In a popular creation myth Vishnu is described as lying in a deep trance before the dawn of creation. He sleeps on the coils of the cobra Ananta or Shesha, whose hood curls up above him, providing a protective covering. From the navel of the recumbent Vishnu rises up a lotus blossom on which sits the god Brahma. It is he who then brings creation into being.

Vishnu Varadarajaswami and Venkateshvara

When worshipped as Varadarajaswami, Vishnu is shown with one hand held parallel to the thigh, while the other is held with the palm outwards. This hand position is the *varadamudra* (hand position of wish-fulfilling) mentioned in his epithet. Vishnu has been worshipped in this form at the major religious centre of Kanchipuram, in Tamil Nadu (see map on p. 229) from at least the twelfth century to the present day. Vishnu is also worshipped as Varadarajaswami at Tirupati in southern Andhra Pradesh. This temple is plausibly described as the richest and most visited of all pilgrimage temples in India today. Here, the main icon is known and worshipped under the name of Venkateshvara, though the iconography, with one hand in *varadamudra*, is also in keeping with the title Varadarajaswami; Vishnu is worshipped thus in a subsidiary shrine. The popular name Venkateshvara is important historically because it hints, through its use of the Shaiva ending 'ishvara' (Lord), that this great Vaishnava shrine may once have been not so exclusively Vaishnava. The image of the god is today wreathed in garlands, and its entire surface is encrusted with jewellery of the most extraordinary richness. It is, therefore, difficult to make any definite statement concerning the iconography of the sculpture. Further, because of the constant press of the thousands of pilgrims who visit the

shrine daily, it is impossible to look closely at the details of the sculpture. However, the temple, located amongst the Seven Hills of Tirumala, may perhaps have once been dedicated to Harihara, the deity who is half-Shiva and half-Vishnu. This might account for the unusual nomenclature.

Vithoba or Vitthala

In this form, Vishnu is worshipped in Maharashtra, most famously at the temple of Pandharpur. This town is particularly associated with the singer-saint Jnaneshvara, whose hymns in honour of Vishnu are fondly remembered by Marathas. The temple draws pilgrims from all over the uplands of 93

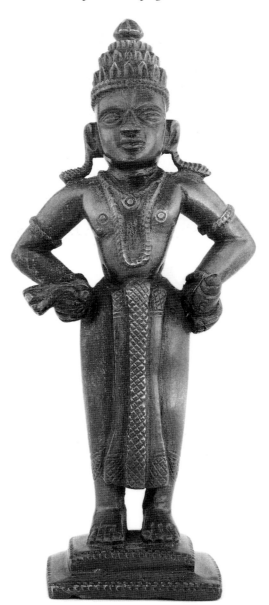

93 Small bronze sculpture of the god Vitthala, also known as Vitthoba. Maharashtra. 18th century or later. This deity, associated so closely with the town of Pandharpur in Maharashtra, is also well-known further south on account of the construction at Vijayanagara of the great royal temple dedicated to his worship, built in the mid-16th century.

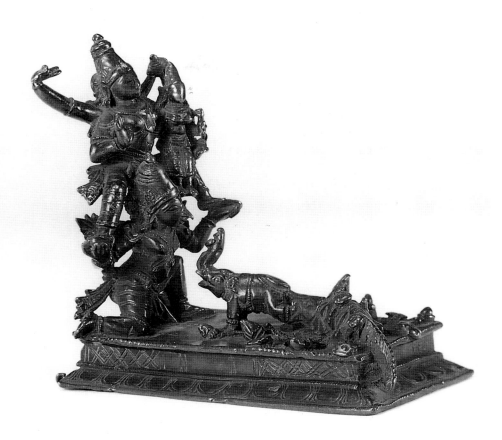

the western Deccan. Again this depiction of Vishnu shows him standing, but with both hands on his hips; usually one of the hands is turned out towards the viewer.

Vishnu Gajendramoksha

94 This vision of the god again depicts him as a saviour. The legend tells of a devotee of Vishnu, who through the curse of a sage, was turned into an elephant. Forced for many years to wander throught the forests, he came one day to drink at a lake. There a crocodile caught hold of him, causing the elephant in his distress to call on the name of Vishnu. The god, mounted on Garuda, flew to his rescue and killed the crocodile, thus saving his devotee and returning him to his original, human form.

The consorts of Vishnu

The various consorts of Vishnu have so far only been mentioned in passing. The most usual name of the spouse of Vishnu is Lakshmi. She is the embodiment of prosperity, and is worshipped to ensure the blessing of affluence for her followers. Because of the universal desire for wealth, she

94 Small bronze sculpture of Vishnu as Gajendramoksha. South India. 18th century. While paintings of this subject are common, bronze images are unusual. The very moment that the elephant is saved is depicted here, with Vishnu and Lakshmi, seated on Garuda, approaching the elephant. In the foreground is the crocodile in whose back the *chakra* weapon of Vishnu lies embedded.

has a definite cult of her own. She is particularly worshipped and invoked at the New Year when businessmen open fresh ledgers and accounts. It is common at this time to see calendars bearing her image, standing with her hands outstretched in the posture of boon-fulfilling (*varadamudra*), and with gold coins flooding down from her open palms. Often shown together as an indication of specially potent good luck are the Eight Great Lakshmis (*ashtamahalakshmis*), who are all responsible for slightly different aspects of the character of the one Lakshmi. As a group of deities, the Lakshmis demonstrate the feature of replication which is commonly found in Hinduism. Just as there are the Eight Lakshmis, there are also the Nine Durgas, the Twelve Lingas of Light, and the Seven Mothers. The idea, perhaps, is to maximise the possibility of successful intercession by the

106

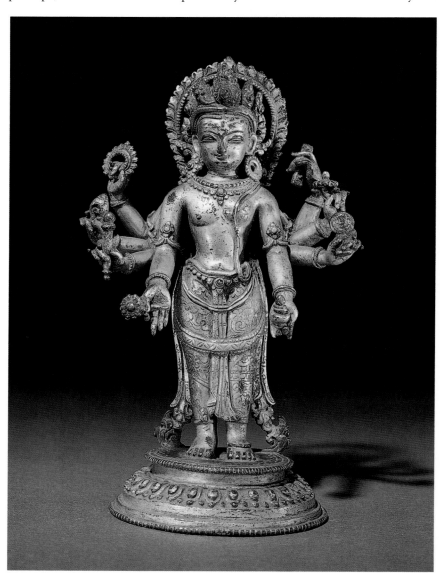

95 Lakshminarayan. Kathmandu valley, Nepal. 17th century AD. In matters of religion, the Nepalese have often displayed a remarkable degree of syncretism. This conjoined image – Vishnu to the right and Lakshmi to the left – is in keeping with this spirit. While making a complete and satisfying icon, the bronzesmiths have subtly indicated the differing characteristics of the god in details such as the single female breast, the different earrings left and right, and the differential pleating of the *dhoti* –the male side (right) terminates with a zig-zag motif, while the female side sweeps away gracefully from the centre line.

devotee. It may also reflect the originally fragmented nature of some of the now unitary cults. Listing once-different deities as a group may have been a way of incorporating many deities into one.

73 When Vishnu is shown with one consort alone, it is invariably Lakshmi who accompanies him. One of the most frequently related stories of her birth occurs as part of the creation legend of the Churning of the Ocean of Milk (see p. 120). Lakshmi was one of the products of the churning. Because she is the embodiment of royal authority it is appropriate that she is attracted to Vishnu and is regarded as his consort; royal power is one of his

94 most prominent characteristics. Lakshmi is often depicted seated in his lap; this form of the two deities is known as Lakshmi-Narayan. In a form which is now rarely seen outside Nepal, this proximity is taken to its logical conclusion. Vishnu and Lakshmi are depicted combined as a single figure,

95 one side male and the other side female. Probably the development of this concept of the two gods came about as an imitation of the more widely

57 known Shaiva deity Ardhanarishvara, who is similarly half male (Shiva) and half female (Parvati). (See p. 99.)

Lakshmi as the goddess of good fortune and abundance has a long history, reaching back to the late centuries BC. She is seated on a lotus and is

, 112, showered with water by two elephants who empty pots of water over her
113 head. The lotus in India has had a long association with ideas of both fertility and purity – it grows with both power and beauty from the mire of ponded water. The water poured over the head of Lakshmi is symbolic of plenty, for in a land of such great seasonal variety in the water supplies, the idea of a constant stream of water is full of luscious promise. As the seated figure bathed by elephants she is known as Gajalakshmi, and her image is frequently found carved on the lintels of Vaishnava temples. On entering, the visitor not only bows their head before her, but also receives, in return, her grace as the bringer of good fortune.

The other names of the consort of Vishnu include Shri and Bhu. The name Shri is synonymous with prosperity. Bhu is the same earth goddess

74 who was rescued from the depths of the ocean by the Varaha incarnation of Vishnu (see p. 122). As the earth goddess, her cult has obvious connections with that of the Mother Goddess, Devi, who is the subject of the next chapter. During the Chola period in south India (ninth–twelfth centuries

69 AD), Vishnu was frequently shown flanked by Shri and Bhu.

Conclusion

From Kashmir in the north to the Tamil country in the south, the cult of Vishnu has been elaborated in sculpture and painting since the opening centuries of the Christian era. In the texts his name can be followed from the late Vedic period to the present. During the time in which he has been imaged, his character has developed and changed, and it continues to do so. During this process, spread over two thousand years, the numbers of different cults which have become absorbed into that of Vishnu are very many, and some of them have survived as independent entities to be included in the list of ten canonical *avataras*. This has had a profound effect on the way the god is imagined and depicted.

Despite this diversity, there are certain qualities which are incontrovertibly Vaishnava, and not Shaiva. Vishnu personifies cosmic order, he oversees the certainties of life, he maintains age-old traditions, especially those based on the family and domesticity. He is not concerned with fertility, mysticism or asceticism. He is the god to whom many have turned during times of national stress because it is he who acts as protector – as is demonstrated in the ancient legend of Krishna lifting up Mount Govardhan (see p. 134). It is Vishnu who has evoked some of the tenderest religious lyrics in Indian religion. Typically, he is addressed in terms of longing and of selfless devotion; merely to utter the god's name is sufficient

83

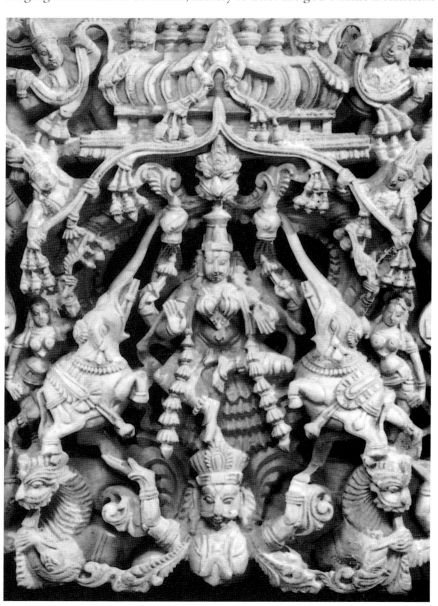

96 Gajalakshmi, the goddess Lakshmi lustrated by elephants. Wood. Chettinad, southern Tamil Nadu, South India. 19th century. This detail, which depicts Lakshmi being bathed by two elephants, is from the lintel of an elaborate mansion door. The goddess is invariably shown above the doorways of the great houses of the wealthy Chettiar banker families, many of whom made fortunes during the colonial period, particularly in British Southeast Asia.

for him to know that his devotee approaches him. The personal love of the god for his follower, and the reciprocal love of the devotee for Vishnu, presents an archetype for all Vaishnava activity. It is therefore appropriate that this chapter should end with a quotation from the work of one of the great Vaishnava *bhakti* poets, Sur Das. He possessed a striking ability to demonstrate in his poetry the all-embracing nature of the love of God – even God's love for him, the greatest of reprobates. His distinctive voice has endeared him to generations of Hindus:

> I, only I, am best at being worst, Lord.
> It's me! The others are powerless to match me.
> I set the pace, forging onward, alone.
> All those other sinners are a flock of amateurs,
> but I have practised every day since birth,
> And look: you've abandoned me, rescuing the rest!
> How can I cause life's stabbing pain to cease?
> You've favoured the vulture, the hunter, tyrant, whore,
> and cast me aside, the most worthless of them all.
> Quick save me, says Sur, I'm dying of shame:
> who ever was finer at failure than I?

(Hawley, John Stratton, *Sur Das. Poet, Singer, Saint*, p. 151, Seattle and London, 1984)

5

THE GREAT GODDESS, DEVI

Approximately 70 per cent of the population of India is rural and non-industrialised, and dependent on settled agriculture or pastoralism for its livelihood. In the past this figure has been even higher. Tied so vitally to the land, people have always needed to understand the natural cycle of the seasons. It is also necessary, in this predominantly rural society, to appreciate the connection between the monsoon rains, good soil and fertility on one hand, and the lack of rains, aridity and consequent famine on the other. A sympathy with the earth and its essential fertility comes as second nature to most of the inhabitants of the subcontinent. The lore of the earth has been handed down from generation to generation, and continues to be elaborated.

Because of the importance of the fertility of the earth, it is not surprising that the earth, deified, has been invoked by Indians for many centuries. On account of the analogy between the earth producing crops, and the fertility of a female bringing forth offspring, the earth has invariably been worshipped in India as a goddess. This connection between agricultural fertility and the feminine principle is by no means reserved to India, and is recorded in many other cultures. However, in India it is especially developed, and in Hinduism, a vast number of different goddesses are worshipped, particularly in the countryside. They are generically known by the name of Devi, which means no more than 'goddess', though in the temple tradition of the Sanskrit texts, the earth goddess is usually referred to as Bhu (see p. 122). Because of the connection between the fertility of the 74 earth and female reproduction, the goddess is often referred to as 'Mother' – Mata in north India (common variants include Ma and Mataji), and Amman in the south.

In her manifestation as fertile mother, Devi is recognised by many Hindus as incarnate in the life-providing rivers of the subcontinent. Without river water and fertile sediment deposited on river-banks, much

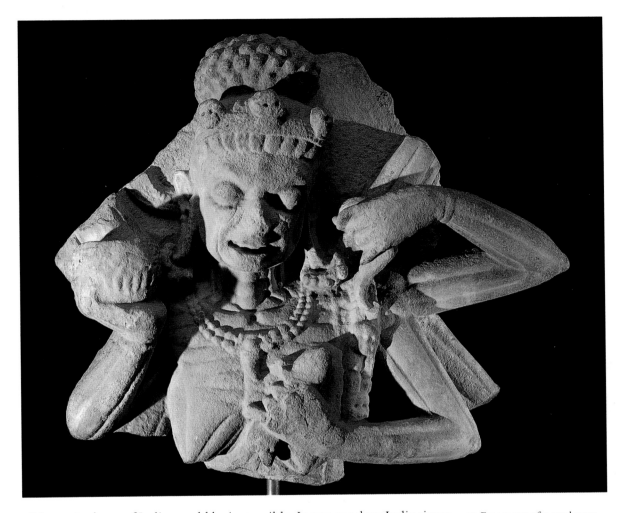

of the agriculture of India would be impossible. In pre-modern India rivers and tanks were one of the absolute prerequisites for life. Most of the major rivers of India are the recipients of worship – important examples, from south to north, are the Kaveri, Krishna, Narmada, Jumna and above all, the Ganges (see pp. 100–2). Rivers are also seen as purifying, both ritually and indeed literally, for the scouring action of the monsoon rains cleans away polluting deposits. The image of the goddess of a river is often conceived of as the river itself. Garlands are thrown on to the surface of the water to honour the goddess, in the same way that devotees place garlands around the neck of an image in a temple.

 The idea of the Goddess as Mother, as the life-providing waters, and indeed as the Earth itself, leads on to the idea of the soil of India being literally the body of the goddess, and the features of the Indian landscape – such as the mountains and rivers – being her own physical features. The frequent occurrence of the names of Devi as toponyms is another indicator of the close connection between the land and the goddess: Calcutta is named for Kali, Ambala for Amba, Chandigarh for Chandi. From this

55, 61

97 Fragment of a sandstone sculpture of the goddess Chamunda. Orissa. 12th century. This terrifying vision of the goddess as a skeletal hag, wearing a garland of skulls, represents the opposite notion of the divine feminine as beneficent (see figs. 102 and 113). In both icons, however, she is fertilising – either through blood (as here) or through water (as in Gajalakshmi). Unlike Vishnu, *devi* encompasses all polarities.

perspective the land of India thus becomes sacred – it is the realm, and the body, of the goddess herself. Such ideas have sometimes been translated into potent political forces, as in the years leading up to Independence in 1947. The freeing of Mother India – *Bharat Mata* – from foreign rule became the rallying point for patriots.

The identification of the goddess with the landscape of India is further emphasised in the legends concerning the first consort of Shiva, Sati and the dismemberment of her body (see p. 91). Traditionally wherever the fragments of her body landed on the soil of India, there was established a shrine to the goddess. These are the *pitha*, literally 'benches', the places where the goddess has taken up her seat. The *pitha* are often situated in naturally impressive or beautiful locations – at the junction of two rivers, near a cave or deep in a forest – thus emphasising the connection between the power of the deity and the actual landscape.

In Hinduism there has for a long time been a belief in a female goddess whose charge is fertility and, by extension, prosperity. However, there are also other goddesses whose role is more specific, and less obviously concerned with productivity. All goddesses though, of whatever mien, possess a common thread which can usually be traced back to concepts of fertility. For example, the powerful goddess who is invoked against smallpox – Shitala – protects supplicants from the disease, and thus ensures their future reproductive capabilities. Sita, the wife of Rama, is another interesting case for in the *Ramayana* (the epic of the legend of Rama – see pp. 129–32), she appears compliant, the embodiment of wifely devotion, and apparently unconnected with fertility. However her name, which literally means 'furrow', suggests an agricultural component in her past, and at her death she is swallowed up by Mother Earth from whom she was born. Further, it is her existence which causes the whole story of the *Ramayana* to unfold – she is productive of the story. Without her, the whole epic would not exist. Although the male characters act out the main events of the story, it is Sita who forces the whole saga along. Here we see another feature common to Hindu goddesses. Not only are they specifically conceived as fecund, but also as active, immanent and productive. In contrast, male deities are mostly considered passive, otherworldly and transcendent.

Another characteristic common to most goddesses is their connection with life-giving blood. In the first instance, many goddesses require blood-offerings, and are frequently depicted drinking the life-enhancing liquid from a skull-cup; secondly, the cycle of the seasons is equated with the menstrual cycle of the goddess; thirdly, the group of terrifying goddesses who haunt battlefields are often shown smeared with the fructifying blood of their enemies; fourthly, the similar group who inhabit cremation grounds are either placated with blood or flesh offerings, or as in the graphically immediate case of the goddess Chinnamasta, drink their own blood from their own self-severed necks while striding over a copulating couple. This connection between blood, flesh offerings, fertility and the Mother Goddess is one that today causes some discomfort amongst educated, especially high-caste Hindus, many of whom are now vegetarian. As a result, the worship of the bloodthirsty goddesses is to some

105

110

extent today confined to lower-caste groups. Within this context, it is possible to chart the change of religious customs amongst groups of worshippers as they imitate higher castes. This is seen today at some Devi temples, where the goddess still delights in drinking fresh animal blood, but where the animal is killed not by any of the Hindu devotees who believe (following higher-caste prescriptions) that they would be polluted by such an action, but by a Muslim butcher. The caste distinction in the worship of Devi is further emphasised because she is also honoured with offerings of alcohol. Since the moral crusades associated with Gandhi and his urban, middle-class disciples, the consumption of alcohol has also been frowned upon.

Blood, fertility, alcohol and action are all the hallmarks of the goddess; she who is sometimes benign, though more usually fierce. We have noted this ambivalent nature in other deities, and Devi is no exception, providing a devotee with a complete gamut of emotional responses, from blood-curdling horror through to gentle and maternal love. As a rule the goddess when worshipped alone is fierce, but when the consort of a male deity, she is benevolent. All human experience is contained within her worship.

The great male gods are usually attended by a goddess, though Hanuman, and in most representations, Ganesha and Karttikeya, are exceptions. Divine consorts such as Parvati and Sarasvati (see pp. 94–100 and pp. 174–5) are in some way considered versions of the same vital female force which is Devi. Their names are often and bewilderingly interchangeable. In previous chapters we have noted the characteristic in Indian religions for many deities to merge into one. This is also noted in the worship of Devi. In the sixth century text, the *Devi Mahatmya*, which recounts the deeds of the goddess, textual authority is provided for the concept of a single, all-powerful female deity: Mahadevi, literally the 'Great Goddess'. Mahadevi is regarded by her devotees as encompassing all the thousands of local *devis*, as well as the pan-Indian goddesses of the orthodox tradition. This line of development, whereby all the independent female deities are subsumed into the one great goddess, has continued to the present day. However, the many different versions and aspects of the Great Goddess are so varied and interesting that a few are individually listed below, following a brief description of the evolution of the Mother Goddess cult.

Early history and function

The earliest evidence of images of a female goddess comes from the western borderlands of India, from sites such as Mehrgarh and Sheri Khan Tarakai during the sixth and fifth millennia BC (see p. 23). From the same region, later examples are recorded from the sites of Rehman Dheri and Lak Largai, both dated to the fourth/third millennium BC. The function of these prehistoric figurines made of baked clay is not known for certain, as they have not survived in an obviously sacred context. Neither do we have any textual evidence for their use, of course. However, they were made in such large quantities, and often with the regenerative organs so exaggeratedly displayed, that most scholars would accept their identification as

98 *This page* Clay figure of Kali striding over recumbent Shiva. Bengal. Late 19th century. Probably contemporary when it entered the museum in 1894, this image of the bloodthirsty goddess is of the type fashioned for Kali-*puja* and then paraded through the streets, before being immersed in a tank or river at the end of the festival. Her necklace is of severed heads, while in her hand she carries a further gory trophy. Her crown is of a specifically Bengali type.

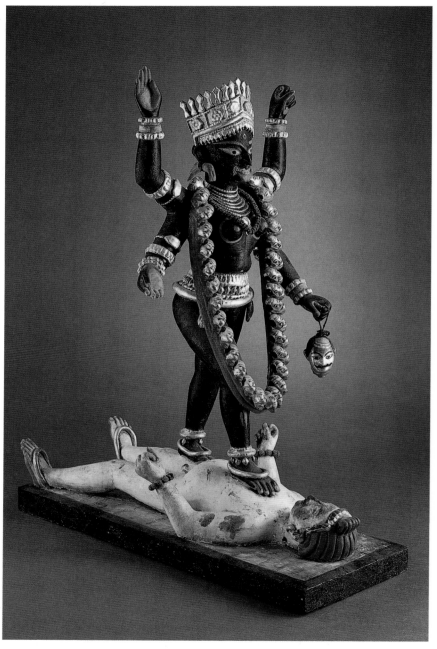

99 *Opposite* Popular print of the goddess Bahuchraji. Gujarat, Western India. Contemporary. This poster, purchased from the shrine of this popular local goddess, would have been bought by a pilgrim and then used in a domestic milieu. The goddess is depicted in a clinging *sari*, suggestive of the influence of film imagery on the producer of the original painting. In her lower right hand she holds a book with on it the word 'Shri' (auspiciousness). She rides a cockerel *vahana*, at whose feet is her powerful mystic diagram or *yantra*.

images of a Mother Goddess. The clay that these images are made from is entirely appropriate for depicting the goddess, for as we have seen, the goddess and the earth are considered as one.

During the second and first millennia BC, terracotta figurines continued to be produced; those from the important urban site of Mohenjo-daro (c.2500–2000 BC) are perhaps the best-known. The emphasis on fertility is, however, less pronounced in these examples than was the case in the earliest

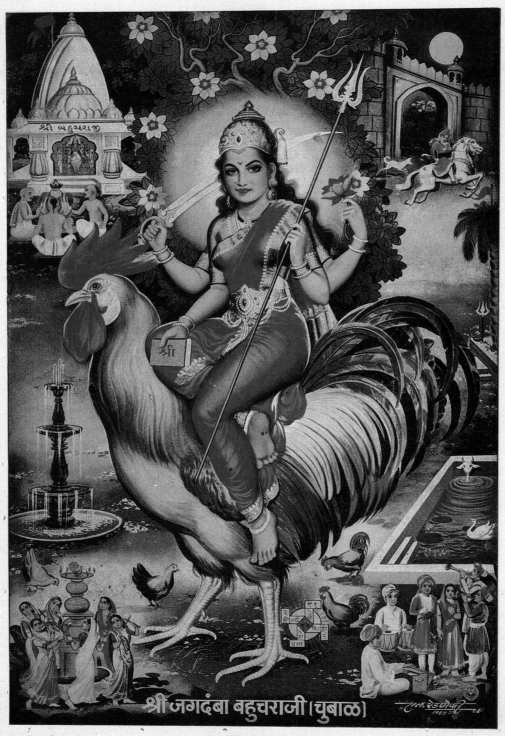

श्री जगदंबा बहुचराजी (चुबाल)

BAHUCHARAJI (Chubal)

S. S. Brijbasi & Sons.

period. All the prehistoric examples are hand-formed, and are decorated using appliqué, as well as being painted and incised. Yet later examples are recorded from sites in peninsular India, such as Inamgaon (see map on p. 229) where a female figure in an oval box was recovered. Both the box and the figure were made of clay and have been dated by the excavators to c.1400–1000 BC. It is presumed that they had some cult significance. Later, the making of female terracotta figurines is documented from the early historic periods (late centuries BC/early centuries AD) in northern India. From the northwestern regions (modern Pakistan) elaborately decorated female figures have been recovered from excavations which are dated to this period. Meanwhile from Rajghat, the ancient site at Benares, come ringstones dated to the Maurya period (fourth/third century BC) which are decorated with goddess-type figures.

The function of the prehistoric and historic terracotta goddess figurines is not clear. However, evidence collected in the last two or three centuries in remote parts of India can perhaps suggest how they might have been used. Even today terracotta figurines are offered as gifts in rural, and especially tribal, shrines. Over the years these may build up into deposits of many thousands. The immense number of figurines recovered from archaeological excavations suggest a parallel. Such a coincidence would also explain why in the archaeological record they are not found in an obviously sacred context, such as a built shrine. However, there is one major difference between the archaeological and the ethnographic evidence. The prehistoric terracotta figurines – especially the very early ones – seem to be images of the goddess, while the figurines left in shrines today are, for the most part, left as gifts and do not usually represent the deity. Thus horses (symbols of royalty), buffaloes (representing wealth), clay domes (for a residence) and other desirable items are left in the shrines, in the hope that the worshipper's requests will be met. However, so many examples exist from all over the ancient world of small images of the deity being deposited in shrines as votive offerings, that this slight distinction between ancient and modern practice in India should not be considered too problematic.

Another type of clay offering made today is a depiction of a part of the body. These are left when the equivalent part of the human body requires healing. Thus you find clay feet, testicles, arms and heads, all deposited in the hope of a cure. Similar practices have entered into the orthodox tradition, with the result that silver plaques which depict parts of the body are sold and presented at shrines.

The Vedas, the sacred texts of the Indo-Aryans (see p. 24) are dominated by powerful male gods. Goddesses such as Ushas (the Dawn) and Prithvi (the Earth) are mentioned, but their importance is slight, and their power is not great. It is significant that these Vedic goddesses do not have the same strong links with blood and fertility which are so noticeable in the character of Devi. The elemental and terrifying quality of some of the later Mother Goddesses is not apparent in the Vedas. Consequently it is likely that this side of the personality of the goddess is not one brought into India with the intruding Indo-Aryans, wherever else it may have come from. Meanwhile at the level of the indigenous population it seems likely, even though the

100 *Above* Female figurine of terracotta. Northwest Pakistan. Late centuries BC/ early centuries AD. Typical of figurines of this period is the combination of highly schema-tised representation, along with great elaboration of coiffure and neck jewellery.

101 *Opposite* Forest shrine with deposited terracotta figurines. Eastern part of Baroda District, Gujarat. Contemporary. Common throughout rural India, such shrines represent the continuity of some of the oldest traditions in the subcontinent. Here horses and domes are piled up around quasi-anthropo-morphic posts, whose silent witness give these shrines a potent and surreal quality.

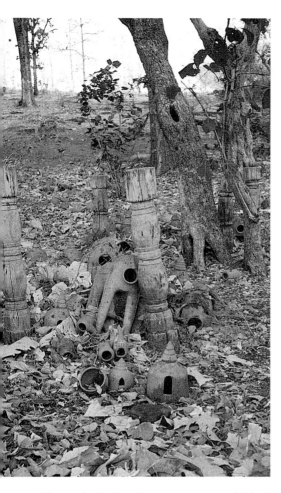

evidence is slight, that some sort of Mother Goddess worship continued from the earliest times. This assumption is based on the reappearance of a substantial cult of female deities in the first half of the first millennium AD.

It is only with the first surviving Buddhist and then Jain monuments (second century BC onwards) that divine female figures are seen in the artistic record outside the terracotta repertoire. Their position is, however, clearly subsidiary. Although the Buddhist teachings inveigh against the sacrificial religion of the elitist brahmins, it is clear that neither Buddhism nor Jainism made any attempt to supplant the popular cults, especially those connected with the fertility cult of the forest spirits, the *yakshas* (male) and *yakshis* (female). In Buddhist teaching there is the understanding that one can worship the gods or not – it made little difference as they were subject to the same laws governing behaviour (*karma*, see p. 29) – as were humans. It is for this reason that sculptures of robust and beautiful young women are depicted at early Buddhist sites such as Bharhut and Sanchi, and Jain sites at Mathura. Invariably they occupy subsidiary, though architecturally supporting, positions. Frequently they are shown hanging on to the branches, or entwined around the trunk, of an ashoka or pipal tree.

103

102 Above right Mother Goddess. Tanesara, southern Rajasthan. Mid-6th century AD. This standing figure of a Mother Goddess or *matrika* comes from a series, like the *saptamatrikas* (fig. 106). However, unlike them, in this group there is no identification as to the deity, for neither mount nor recognisable attributes are part of the design. The maternal tenderness with which the goddess turns towards the child is most unusual in early Indian sculpture and is seen in at least four other sculptures in the series.

The erotic nature of the embrace is often pronounced. One such female tree-spirit (*yakshi*) from the Buddhist site of Bharhut (second century BC) has one leg around the tree trunk, one hand hanging on to a branch, and the other pointing to her exposed genitals. In folk-myth such figures of fertility are supposed to be able to bring a tree to blossom merely by kicking it with the foot as they hang from its branches. The illustrated example, from Sanchi, is of this type. The idea behind these images of sensuous fecundity seems to be that they not only physically support the structure, but that they also, metaphorically, support the teachings of the creed. A further aspect of these figures is less easy for us to grasp today. However, in their very perfection of physical form in a world of imperfection, they act as charms and as the embodiment of auspiciousness. Their placement at entrances – again as seen at Sanchi – ensures the fortunate character of the space they encircle. This auspiciousness is connected with their fruitfulness, and is made abundantly clear by the near nudity of the figures. Barring a hip girdle (which yet leaves the pubic area exposed) they wear almost nothing except jewellery. This recalls later images of the goddess discussed below, where the deity squats, legs thrown wide apart, displaying her life-producing pudenda.

Unlike the cults of Shiva and Vishnu, that of Devi did not develop substantially at the level of temples and texts during the early centuries AD. As seen in the previous chapters, the two male deities began to appear in bodily sculpted form in northern India during the period of the Kushan kings (see pp. 84 and 114). The goddess Lakshmi is recorded on coins of the second century BC, while Durga is definitely imaged from the early Gupta period (fourth century AD) onwards; there is some dispute over depictions which may be of an earlier date. However, the first text to lay out the deeds of Devi systematically – the *Devi Mahatmya* – is dated to the fifth/sixth century AD, though it is now embedded in another text, the *Markandeya Purana*. In the *Devi Mahatmya*, however, her myth is already well-established, and doubtless draws on much earlier material. Certainly in the next century she is well enough known as Durga, the vanquisher of the buffalo demon, to be represented in the impressively powerful relief panel in the Mahishasuramardini cave at Mahabalipuram.

Aniconic forms of Devi

Devi is worshipped in the form of symbols just as is Shiva and, to a lesser extent, Vishnu. The major aniconic symbol of Shiva is the standing pillar, *linga* (see p. 78), while that of the Goddess is the *yoni*, the stylised representation of the female genitals. As she is frequently considered the female and immanent power of Shiva, it is logical that the *linga* and the *yoni* are often shown together, the former rising up out of the latter. Also, the *yoni* is an entirely suitable symbol for a fertility goddess, representing the fruitfulness of the divine womb, which is the earth.

The *yoni* is rarely worshipped alone, though examples are known. Perhaps the most famous of these is located at Kamagiri, near Gauhati in Assam, where the goddess is worshipped as Kamakhya. This famous *pitha* (see p. 156) is situated at the spot where, according to tradition, the *yoni* of

103 *Opposite* Supporting bracket from one of the gateways of the *stupa* at Sanchi. Central India. Late 1st/early 2nd centuries AD. Although from a Buddhist monument, this sculpture illustrates a constant theme found in Hindu – indeed all Indian – architectural sculpture. The combination of a beautiful, jewelled, near-naked woman with a flowering tree, and the use of the whole ensemble as a structural element, ensures a protective auspiciousness for the building (see also fig. 33).

104 A *yantra* or metal plaque covered wth *mantras* and used in the worship of the goddess. North India. 18th century or earlier. *Yantras* combine the power of the written word and that of sacred designs. The potent individual words or syllables are *mantras*, associated with specific deities. The goddess connection of this example is also demonstrated by the prominent central positioning of a triangle within two circles.

Sati was thrown by her distraught husband (see p. 91). It is thus logical that the deity is worshipped here primarily as *yoni*. The rituals attached to this image specifically invoke the menstrual cycle of the deity, through the application of red colouring to the image. Other, though slightly different, examples of the worship of the *yoni* alone come from various locations in the Deccan, including the seventh/eighth century temple site of Alampur. Sculptures of the goddess in partly-human form with her thighs widely spread and displaying her genitals are recorded. The fertility aspect of the iconography is further emphasised by the appearance, where her head would be expected, of a lotus blossom; she is part-human and part-plant, and in both the human and vegetal worlds, is fertility incarnate. It is noteworthy that on these sculptures, the pubic area has often been smoothed away through the touch of countless devotees as they hope to acquire the power of the fruitful goddess through contact with the most powerful part of her icon.

Another symbolic image used in the worship of the Great Goddess is the *yantra* or geometric diagram. *Yantras* are usually produced as metal plaques, or appear in paintings or prints of the deity to whom they are appropriate; rock crystal *yantras* are also common. They are the visual versions of the aural *mantra* (see p. 18), and thus embody supernatural power. They are primarily, though not exclusively, associated with Devi, and amongst those employed by devotees of the goddess there is a considerable variety. Thus there is the Shri-*yantra*, the Kali-*yantra*, and the Bhuvaneshvari-

yantra, amongst others. They are named for different forms of the goddess, and use different designs. *Yantras* used in the goddess cult are generally based on a combination of triangles and circles, sometimes with a series of triangles superimposed, making the shape of a star. The triangle is the abstract sign of the goddess because of its approximation to the shape of the vulva. Besides the set(s) of triangles, they usually bear on them painted, engraved or cast sacred syllables – *mantras*. To complete the powerful symbol the triangular elements of the design are often set within circles, with the smaller and inner of the sets of triangles raised up above the others, again probably indicative of the shape of the vulva. The history and use of *yantras* is linked with other sacred diagrams in Indian religions, such as *mandalas*, many of which have a cosmic connotation, as does the *yantra*.

Attributes of the Great Goddess

Different forms of Devi have different characteristics. Despite this, there are certain common features which are found repeatedly in connection with the goddess. We have already mentioned the affinity between the goddess in many of her forms and blood, alcohol, and fertility, and the idea that she is active, approachable and concerned with the well-being of her devotees. She is also renowned as fickle and dangerous – she is both the epidemic, and the saviour. She inflicts harm and yet also protects from it.

A tendency to condense the myriads of deities down into specific lists is another aspect of the personality of the *devi*. Examples include the Navadurga (the Nine Durgas), the *ashtamahalakshmis* (the Eight Great Lakshmis) and the Chaunsatha Yogini (the Sixty-four *yoginis* or female ascetics). However, probably the most prominent example of listed goddesses is the group of female deities known as the *saptamatrikas* – the Seven Mothers. These are a group of goddesses whose names vary slightly from list to list, but which, by the middle of the first millennium AD, are usually seven, and mirror (with the exception only of the last) the names of male deities. They are Brahmani (Brahma), Maheshvari (Shiva), Kaumari (Kumara = Skanda), Vaishnavi (Vishnu), Varahi (Varaha), Indrani (Indra) and Chamunda. In the sixth-century cave temple of Elephanta there is a panel where they are shown seated in a row, attended at either end by Ganesha and Karttikeya. This becomes the standard way to portray the Seven Mothers. They are feared rather than loved and they are renowned as the devourers of young children.

Added to these standard features of Devi are certain iconographical similarities which are also particularly associated with her. One of the most obvious of these is the animal on which she rides, her *vahana*. Most frequently she is seated upon, or is attended by, a lion or a tiger. The former is more usually associated with Durga and the latter with Amba, but both are to some extent interchangeable. This confusion is compounded today because the lion only survives in India in one small protected location in Gujarat, and is therefore not now frequently seen. Both these animals are also found as the *vahana* of the *devi* under names other than Amba and Durga. In parts of India today it is not uncommon for the lion *vahana* to appear more like a British Imperial lion. Another animal identified with

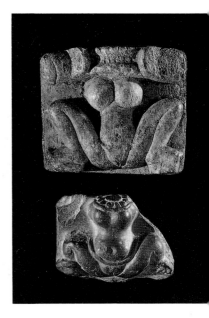

105 Two small plaques showing a displaying fertility goddess, known as *nagna-kabandha* or *lajja-gauri*. Top: Deccan, stone, sixth century AD and, bottom: Ter, Maharashtra, clay, 3rd century AD. These plaques, one of stone and one of clay (the very earth itself), show small images of the goddess. Her fertility aspect is emphasised not only by the displayed pubic region, but also by the blossoming lotus which takes the place of a human head.

106

106 Stone panel of the Seven Mothers, the *saptamatrikas,* Central India, perhaps Madhya Pradesh. 9th/10th century. Probably from a lintel above a temple door, this grouping of the Seven Mothers is unusual in that they are only accompanied by one male figure (to left); also, Chamunda (far right) is shown with a snake head-dress. Varahi, boar-headed, is immediately recognisable.

Devi, especially in her beneficent guise as Shri-Lakshmi, the bringer of good fortune, is the elephant (see p. 176).

Also commonly seen in the iconography of the Great Goddess is the array of weapons with which she is depicted. Most frequent of these are the sword, the sacrificial chopper and the trident. However, as she is regularly shown multi-armed, she can carry a number of frightening weapons with which she protects her devotees and fights the demons who threaten cosmic stability. Her range of weapons is especially elaborated in the mythology of Durga (see p. 168).

The goddess as *shakti*

The idea of the goddess as active and immanent has already been mentioned, but this concept is worth examining in greater detail, because of the effect it has had on the development of the *devi* cult. Philosophically Devi was regarded as action incarnate, and of this world, rather than beyond it. Conversely, the male deities are assumed to be operating outside the web of constraints which characterise human existence. They may only be described by negatives, as their qualities are beyond imagining. One of the results of this is that they are sometimes viewed as distant figures, unconnected with the activities of this world which, though it is illusion, is nevertheless of forcefully apparent reality to those within it. The god Brahma is a case in point. The connection between his name and the concept of *brahman*, Ultimate Reality, suggests the difficulty of approaching such a deity. How could such a remote deity, who cannot even be described, be concerned with the everyday events of human life?

This type of transcendent male deity is also exemplified in one major strand of the worship of Shiva. He is described mythologically as spending

113

110

aeons of time sitting in the high Himalayas, lost in meditation and unthinking of the needs of his devotees. It is only when disturbed and then engaged by his wife Parvati that his attention focuses on the more mundane features of life. If the divine as male is solitary and aloof, then surely it is appropriate that the divine as female should be seen as active and energetic? The earth, which is the body of the goddess herself, is clearly a force of regenerative action and energy. On the earth the work of the goddess is apparent to see. She is not obscure, nor does she have to be reached through complex meditation or the following of arcane rules. This is the reasoning behind the popularity of the goddess: she is approachable and is of this world. As a corollary, it is true that ultimately she partakes also of the illusion which is human life; one of her epithets is Mahamaya (the power of illusion). However, she listens to the entreaties of her worshippers, who can reach out to her as a maternal and immediate divinity.

102

The idea of the goddess as powerful, energetic and close at hand was greatly developed during the latter part of the first millennium AD. This change was based on the elaboration of texts which are collectively known as *tantras*. These texts propagated the idea that the goddess, usually in a terrifying and energetic form, was the centre of all power (*shakti*); also that her power could be experienced by the adept through a combination of ritual actions and the recitation of texts. Some of these texts became no more than formulae, ritually chanted to produce the requisite magical sounds, rather than on account of any inherent meaning. The actions required in these rites were often extreme and deeply shocking to the

107 Durga in battle with the Buffalo Demon. Relief panel from Mahabalipuram, Tamil Nadu. Mid-7th century AD. This panel illustrates the extraordinarily high standards of Pallava sculptors. In the rock-cut shrines of Mahabalipuram, the central sanctum is surrounded by large panels of relief sculpture, framed by pilasters, all of it carved from the living rock.

orthodox. They included sexual intercourse, the eating of meat (sometimes the flesh of unclean animals – or even human flesh) and the drinking of intoxicating liquors. These actions had to take place in the most polluted, or inauspicious of locations: the cremation ground, or at the cross-roads. It seems that the notion behind these drastic actions is that true reality is a landscape with no opposites, where all divergences are reconciled. To demonstrate the ability to be beyond the distinctions of this illusory world, the skilful practitioner must demonstrate that neither good nor bad, auspicious nor inauspicious, has any power. The sexual union which was a part of these rites was seen in the same light – a joining together of the transcendent (male) and the immanent (female) in a juncture which went beyond sexual distinctions. Scholars today debate the extent to which the texts describe what actually happened in tantric rites. Some have suggested that they were only ever used as a means to encourage visualisation during meditation. Most of the historical evidence of the last two or three centuries would, however, suggest that in Hinduism, tantric rituals literally took place. In these rituals the Great Goddess as the reservoir of Supreme Power was invoked. When Devi is depicted as a tantric deity, she is shown as bloodthirsty, and carrying horrifying weapons in her many arms which 110
ring her like a halo. As a tantric goddess she acts alone, unfettered by the attentions of a consort.

Forms of the Great Goddess

The following seven *devi* cults provide an indication of the variety in the personality of the Goddess.

Durga

Durga is invariably depicted as the goddess who kills the Buffalo Demon. 107
This is probably the single most popular and long-lasting image of Devi. It 108
is in this form that she is described in the early text composed in her honour, the *Devi Mahatmya*.

Her legend is of a familiar type and is as follows. The demon Mahisha gained his power by conducting such severe penances that he threatened the stability of the gods themselves on account of the good *karma* he accumulated (for similar myths, see p. 127). Mahisha, who took the form of a buffalo, became so overweening that the gods begged Durga to subdue him; they were helpless against him. In the commonest version of the story she is created from the combined energies of the angry deities, endowed with a weapon from each of them – the javelin of Agni, the trident of Shiva, the disc of Vishnu, and so on. She is multi-armed to carry all her weapons, and riding a lion. She is the fearfulness of the (male) deities, 116
combined. She is usually depicted, after many battles, at the moment of triumph and having just decapitated the buffalo. She places one foot upon the neck of the recumbent animal, and delivers the final blow, spearing Mahisha (seen in human form) as he emerges from the neck of the dying 15
buffalo. Her *vahana* – a lion – aids her by attacking the rump of the buffalo, which is often shown with the disc of Vishnu embedded in it. Meanwhile, Durga, beautiful and serene, maintains an almost detached calm, as if the 108

outcome of the contest was never in doubt. By her action, however, she restores the cosmic equilibrium, as well as demonstrating her superiority over the other gods. Not surprisingly, this story is given in great detail in the *Devi Mahatmya*, one of the most important texts in the literature of Devi. Characteristically, this story, the important event of her myth, is one full of drama, indicating again the close connection between Devi and action. She is not renowned as an ascetic meditating alone and in silence; her field is the active one of overcoming demons.

The cult of Durga is of considerable antiquity, and along with other important deities of the post-Vedic Hindu pantheon, her earliest images are to be found from the first centuries AD, in the country around Mathura to the south of Delhi. The cult of the victorious warrior goddess spread widely, and she is shown killing the buffalo demon at Ellora, in Central India, in the sixth–eighth century sequence of rock-cut cave temples. In the mid-seventh century, we find her portrayed with complete confidence at 107 the south Indian rock-cut complex at Mahabalipuram. The relief panel at the latter site is one of the greatest examples of narrative sculpture from India. We see the buffalo demon and his cohorts repulsed by Durga, who is shown riding on her lion *vahana*, and surrounded by her victorious troops. In south India, as in this example, the demon takes a different form to that in the north; he is buffalo-headed but human-bodied. In north India he is usually shown human, but appearing out of the severed head of the buffalo demon. A further regional difference is found in southern India from at least the Chola period (tenth–twelfth century) onwards, when the goddess is portrayed in sculpture standing triumphant upon the decapitated head of the buffalo; the rest of the body of Mahisha is not depicted.

A remarkable indicator of the currency of the worship of Durga is the find of fragments from a shattered cult statue of the goddess at the site of Tapa Sardar at Ghazni, in Afghanistan. Here, in an important Buddhist complex situated on a major trade route, fragments have been excavated from a sculpture which, without doubt, once formed part of an impressive clay sculpture of the goddess and her demon adversary. It is dated to the eighth century AD. It is especially remarkable to find this image in a Buddhist (albeit highly syncretic) sanctuary; evidence of fire-worship is also recorded from this site. From a similar period and also from Afghanistan is a small marble group depicting the same legendary story; it comes from Gardez. It is clear, therefore, that by the eighth century the cult of Durga was known throughout the subcontinent, from Afghanistan in the northwest, to the Tamil country in the southeast.

Today Durga is still popular throughout India, but in Bengal she enjoys a special position, with Durga-*puja* in the autumn being her most important festival. This holiday period in Bengal has a family character not dissimilar from that of a western Christmas. At this time, not only is Durga's victory over Mahisha remembered, but a further, and poignant element in her mythology is recalled. Durga, to many of her devotees, is none other than the fierce form of the benign Parvati (see pp. 94–100). Parvati is the consort of Shiva, and once a year at Durga-*puja*, when all family members return to the ancestral home to celebrate the triumph of Durga, even the married daughters come back, briefly, to the bosom of

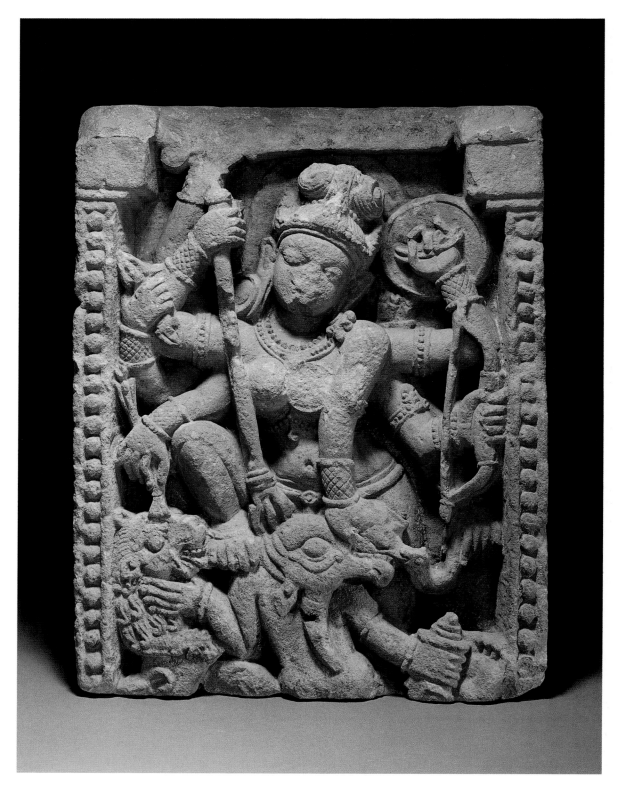

their families to be fed and pampered in a manner often all too dissimilar from the lot of an Indian wife in the house of her parents-in-law. This return is mirrored in the mythology of Parvati/Durga, who is wedded to the austere and anti-social Shiva. For, at Durga-*puja* she is welcomed back home by her devotees, when she returns from the mountain fastnesses of the Himalayas where she lives with Shiva. For the short period of the holiday, she escapes from the quixotic behaviour of her husband, and returns to the loving care and comfort of her family – that is, her devotees.

For the festival, special icons of the goddess vanquishing the demon are made in clay by a specific subcaste of artisans. These brightly-decorated images are often several times life size and are housed in temporary shrines; they are venerated throughout the festival. At the end, sorrowful goodbyes are said to them – recalling the way in which real-life Bengali girls leave their families and return to their in-laws, and Parvati/Durga returns to Shiva in the Himalayas. The clay images are, at the end of the festival, taken to the river or to a pond or tank and submerged, thus returning them to the elements from which they came.

Annapurna

While Durga is a fierce goddess of the battlefield, Annapurna represents a contrary view of the the personality of Devi. Her name literally means 'She who is full of food' and, not surprisingly, she is considered the goddess of plenty, especially where grains and the preparation of food are concerned. Her personality is pacific, fertile and bountiful. Her symbols are the over-flowing pot of rice, and the brimming vessel of milk. She is worshipped in both iconic and aniconic forms. As the latter she is represented as a full-bellied pot; in Central India she is depicted seated and with a ladle across her lap. The small domestic bronze shrines of Maharashtra, shaped like diminutive thrones, usually contain her image carrying her ladle, along with the others of the family of Shiva or ritual items associated with his cult. These include Ganesha, *lingas*, Nandi, offering cakes (*pindas*) and *nagas*. All are crowded on to the small flat top surface of the altar. These small shrines are invariably Shaiva in affiliation. Unlike most other goddesses, Annapurna carries no weapons.

Her most famous and popular shrine is in Benares, the city sacred to Shiva (see p. 94). Here, as one would expect, the connection with Shiva is especially emphasised, and in the coloured lithographs depicting her story which are sold in the streets of the city, the homely qualities of the preparer and dispenser of food are contrasted with the wild and unkempt characteristics of her yogi consort, Shiva. She provides food even for him, just as she does for her devotees. In Bengal during the month of Chaitra (March/April) there is a tradition of producing clay images of the goddess ladling out food to Shiva, who is shown as a begging mendicant. This perhaps recalls the story of his expiation of the sin of killing a brahmin, when he came to Benares as a penniless and hungry wanderer (see p. 91). At the harvest festival of Annakuta, the 'Mountain of Food', which takes place in the autumn, Annapurna's Benares temple becomes the focus of elaborate activity. This festival is usually associated with Krishna, but in Benares it is Annapurna whose temple is filled by her devotees with quantities of rice

108 *Opposite* Durga killing the Buffalo demon, Mahisha. Sandstone. Orissa. 8th century AD. Although now damaged, this sculpture clearly indicates the ferocity of the goddess's attack on the demon. The neck of the beast is forced back on itself to fully expose the throat, into which the trident weapon of the goddess is being thrust. Throughout the medieval period different forms of goddess worship – especially tantric cults – were popular in Orissa.

109 Small bronze image of
the goddess Annapurna.
Northeastern Deccan. 18th
century or earlier. Identified
by the ladle which she carries
across her lap, this little icon
of the beneficent goddess
Annapurna probably came
from a domestic shrine.
Evidence of worship over a
long time is seen in the
amount of wear across the
face.

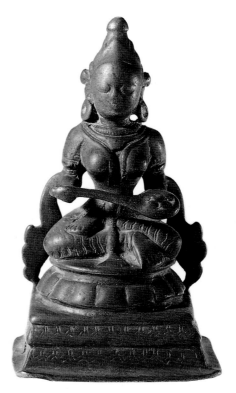

and other foods which are then given away to the needy as *prasad*, food
sanctified through contact or association with the deity.

Kali

She is perhaps the most terrifying of all the manifestations of the Great
Goddess. In some myths she is actually the personified anger of Durga as
the goddess attacks the Buffalo Demon. Despite these seemingly unattrac-
tive characteristics, she is nevertheless the object of often intensely
emotional devotion. In the poetry of the eighteenth century Bengali poet
Ramprasad Sen, for instance, we read of her addressed as 'Mother', a
paradoxical feature which is difficult to square with her image. This
unusual connection was further developed by Sen's fellow-Bengali the
mystic and teacher Ramakrishna.

The name Kali, 'the Black (female) One', perhaps provides some clue to
her ancestry. It may suggest a tribal deity, rather than one rooted in the
beliefs of orthodox Hindus, obsessed with their pale-skinned Indo-Aryan
progenitors. Such arguments have also been advanced with respect to the
skin-colour, for instance, of Krishna, part of whose origin is again to be
probably found in an indigenous tribal cult (see p. 134). This origin of the
cult of Kali is further suggested by the fact that, while Durga is a deity of
the battlefield, Kali haunts the cremation ground, the most inauspicious of
locations, which is usually situated on the outskirts of any settlement. The
outskirts are also the place where non-caste populations — untouchables
and, of course, tribal groups — are required to live. This location also

provides some other important information about the goddess, for she is an outsider and has no social relations which fit into conventional patterns. In this respect she is the true female equivalent of Shiva; both of them are to be found in the cremation ground, both are anti-social and both are the focus of the religious activity of individual adepts who seek great powers through the mastery of dangerous techniques. They both represent the antithesis of classic Vaishnava *bhakti*, full of love and tenderness. They are rarely sweet and cloying, but sharp, independent and astringent, egging each other on to orgies of ever wilder behaviour.

110 Kali, who is often indistinguishable from the goddess Chamunda, is shown as gaunt in appearance and with sagging breasts. She is made to look even more horrific by her necklace of skulls, her skirt made of severed arms, and above all her lolling tongue which is shown oversize, red and dripping with the blood of sacrificial victims. In some images the gruesome tongue is by far the largest single element of the iconography, and acts as a shorthand symbol for her. The continual presence of sacrificial blood reinforces her connections with the two most polluting elements to the orthodox Hindu, blood and death. These are the paradoxical realities in the worship of Kali, perhaps intended to force an awareness of the essential link between life, blood and death and the eventual unreality of all phenomenal existence. In southern India, a variation of this unremittingly horrific vision of the goddess Kali is recorded. She appears as a beautiful and seductive young woman, the only clue to her true personality being her protruding fangs.

One of the most famous temples dedicated to Kali is located on the river steps (*ghats*) of the river Hooghly in Calcutta; the area is today known as Kalighat which, in its turn, has provided a popular etymology for the name of the city. This temple has in the past been a major source of painted icons of the goddess. Also in Calcutta is Kumartully, the centre for the production of the clay images already referred to in connection with

98 Durga-*puja*. In the same workshops similar life-size images of Kali are produced. Like Durga, Kali is especially popular in Bengal.

Another popular icon of Kali depicts her striding over, or sometimes

98 dancing upon, the recumbent body of Shiva. In some depictions he even appears to be dead, or anyway in a trance. In this image Kali demonstrates the extent to which the transcendent power of Shiva can only be made immanent through interaction with the dominant goddess – here shown literally through the impress of the trampling feet of the goddess. This scene was one which found favour with painters of the Pahari schools, and it frequently appears in their paintings.

Kali shares with Durga the thirst for blood sacrifice, and at her temples animals are frequently offered to slake her insatiable desire for blood. Durga, because of her association with the buffalo-demon, is frequently honoured with sacrifices of buffaloes. David Kinsley (1986) has suggested that this recurring emphasis on the requirement for blood is to be seen as the other side of the coin to the bounteous and fecund goddesses, such as Annapurna (see pp. 171–2) and Lakshmi (see p. 176). Without replenishment (sacrifice), there can be no continuing outpouring of fertility; death provides blood which is nourishment, which in its turn produces life.

110 Sandstone panel of the eight-armed goddess Chamunda. Orissa. 9th century. The powerful nature of the goddess is demonstrated by the thunderbolt (top left) and also the weapons – trident (now damaged) and sword – that she brandishes. She also carries a skull-cup and a severed head. This picture of terror, emphasised by her skeletal anatomy and her jewellery made of bone, skulls and snakes, is completed by the cowed human figure on which she sits.

Sarasvati

A benign goddess who is known and worshipped throughout India today, 111 yet whose cult is of great antiquity. She figures prominently in the Vedas, though her character has changed substantially during the intervening period. She has been honoured by both Hindus and Jains, and amongst the former is acknowledged by all sectarian groups.

In the Vedas, Sarasvati is worshipped as the river of the same name, which today for most of its original course is nothing more than a dried-up water channel. However, during the second millennium it was still a major river of the Punjab, the region of northern India in which the Indo-Aryans first settled after their arrival in the subcontinent. The banks of the Sarasvati were considered ideal locations for Vedic sacrifices to be performed. In the worship offered to the deified river, we see the first example of a feature which becomes standard in Hindu India – belief in the sacred quality of a great river. The later worship of the Ganges builds on this first example. The fact that at Allahabad, the Ganges and the Jumna are thought to meet the Sarasvati (magically transported from the Punjab), acknowledges the effect which this ancient river has had upon the Hindu imagination.

Today, however, the river aspect of the goddess is not generally remembered, the only exception perhaps being the lotus (a freshwater blossom), on which she is often shown seated. Since the end of the Vedic period she has become increasingly associated with the spoken word, and as

III The goddess Ambika. Marble. From Gujarat or Rajasthan. Dated by an inscription on the base to 1091 in the Vikram era (= 1034 AD). In the inscription the goddess is also referred to as Vagdevi, the goddess of speech. This suggestion of intellectual activity is reinforced by the stylus she carries in her upper right hand. Crouching at her feet is her vehicle, a lion, an animal associated with a number of powerful and strong goddesses. Exceptionally, the inscription at the base records the name of the sculptor, Manathala, son of Mahira.

such is known also by the epithet Vagdevi, 'goddess of speech'. Given the central relevance of the spoken word in Hindu ritual in the form of reading aloud from texts, and the recitation of *mantras*, the importance of Sarasvati as Vagdevi becomes apparent. This early historical connection between the goddess and the spoken word was later elaborated so that her purview came to include poetry, music and indeed all intellectual pursuits. This side of her character explains her enduring popularity amongst students who invoke her name, especially at exam time. The musical side of her personality is indicated by the stringed instrument, *vina*, which she often carries. In Bengal she, along with Lakshmi, is popularly thought to be the daughter of Durga. They are shown together on scroll-paintings and clay images, along with their 'brothers' Ganesha and Karttikeya.

Brahma is considered her consort, and they are sometimes depicted together. Both are shown with the same *vahana*, the swan or goose. Unlike many other goddesses, however, her connection with her spouse is tenuous; neither is she especially linked with fertility. Sarasvati has enjoyed great popularity amongst the Jains. This has been explained by some scholars by invoking the time and money which Jains have lavished on libraries and the commissioning of manuscripts, for by producing further copies of the sacred texts, merit is acquired. Such activity is the natural arena of Sarasvati, and her depiction in many Jain temples becomes understandable set against these interests.

Shri Lakshmi

This beneficent goddess, the embodiment of agricultural abundance, auspiciousness and royal authority, is one of the earliest to be unequivocally identified in the artistic and textual record; her name appears in a late Vedic text. Though now widely thought of as the consort and *shakti* of Vishnu, (see pp. 149–151), she still has her own independent cult. This separateness was probably more definite in the past, particularly in the period prior to the Gupta dynasty (fourth-sixth century AD). Her iconography is today varied, but the earliest images all show her seated on a lotus and being lustrated by elephants, one on either side; this is Gajalakshmi. Coins from Gandhara of the first century BC show Lakshmi in this way. As 112 Gajalakshmi she sits, four-armed, on a lotus. The flower is symbolic of purity, opening its brightly coloured petals above the dirt of ponded water. The lotus is also symbolic of fertility. Lakshmi is sometimes shown carrying lotus blooms, or even dressed in a garment made entirely from lotus petals. The elephants who lustrate the goddess are the animals which in India are always linked with royalty – only kings could afford to keep 96 such beasts. In a hot country where water supplies are often inadequate, lustration is a powerful image. This act mirrors the royal coronation ritual of the *abhisheka*, when the head of the monarch is anointed with water. The use of this multivalent imagery reinforces the connection between the goddess and royal power. Elephants in Indian folk-lore symbolise rain, their huge grey shapes being equated with rain clouds.

The ubiquity of the cult of Lakshmi is demonstrated by the wide geographical spread of her images over a very long time span. At Mahabalipuram, the two seventh century rock-cut shrines dedicated to Varaha contain large relief panels of Gajalakshmi. By contrast, paintings from the Punjab Hills of the eighteenth century, also showing Lakshmi 113 lustrated by elephants, are common. Her image is often carved on the door lintels of Vaishnava temples. By her presence at the entrance she guarantees the auspiciousness of the shrine. Most temples somewhere will have an image of Lakshmi, irrespective of their dedication or overall sectarian affiliation.

Lakshmi is also considered the granter of financial reward. She is particularly worshipped at the time of the New Year, when businessmen open fresh ledgers and accounts. Special *pujas* are conducted and reverence is paid to all the articles – pens, ink, paper – which will guarantee success in the coming year. New business undertakings will be embarked on under the patronage of Lakshmi. This aspect of her character is celebrated at the festival of Diwali in the autumn. Lamps are lit in all houses so that misfortune – Alakshmi – will be chased away.

Manasa

The worship of this goddess is mostly confined to northern India. However, her particular area of operation – the control of snakes and protection from snake-bites – is one with which other goddesses throughout India are also concerned. Manasa herself is immediately recognisable by the snakes which form a canopy above her head. Various 114 legends record her birth and the reason for her connection with serpents. In

the Bengali text the *Manasakavya* of Vipradas, it is recorded that her poison and that of venomous animals is the same poison which Shiva swallowed at the Churning of the Ocean (see p. 120), and then spat out again. Like some other goddesses, such as Shitala, her character is ambivalent – she is both the goddess who directs and is surrounded by snakes, as well as being the goddess who protects against snakes.

Her festival, as celebrated in Bihar, was documented in detail by W. G. Archer in 1938. He recorded that the festival takes place in August, though in Bengal it is in the early summer months; however, in both areas it is celebrated for the same reason. When the monsoon rains come, snakes are flushed out of their burrows and present a serious threat to workers in the fields. More than ever at this time it is necessary to propitiate the goddess. In the Purnea District of Bihar, where Archer was the District Magistrate and Collector, Manasa is also known by the name of Bishahari, and in western Bengal as Jagadgauri.

The early history of Manasa is not clear, though she was probably worshipped by both Hindus and Buddhists in the early medieval period; today she is also worshipped by Muslims. From at least the first centuries AD, there is evidence for the worship of male snake deities – the *nagarajas*. They have a subsidiary, yet important, place in early Buddhist sculpture. Female snake deities, *naginis*, also appear in the sculpture of this early period. They are, though, subsidiary to the *nagarajas*, and are in no way indicative of the important position which the female deity Manasa is later to assume. It is perhaps only under the influence of the more systematised Devi-worship which is reflected in the *Devi Mahatmya* from the sixth century onwards, that the female snake goddess becomes the object of a distinct cult. Manasa does not, however, appear in the *Devi Mahatmya* itself.

However, her cult was certainly well-established by the eighth century, as is testified by a series of fine bronzes of the goddess which comes from Bihar and Bengal. The important early bronze figures of Manasa show her enthroned with one foot pendant – the position known as *lalitasana*. Unlike snake deities from southern India, Manasa is depicted as fully human. Her connection with serpents is only indicated by the multi-headed cobra hood which rises above her head. Her own right hand is held in the position of grant-fulfilling, *varadamudra*, while with the other she often cradles a small child figure with a snake (*naga*) headdress, which mirrors the larger and more elaborate one with which she is endowed. In common with other goddesses who are at least partly beneficent, she is shown full-bellied, with a slim waist and ample bosom. Around her, smaller figures, also sporting cobra-hoods rearing up over their heads, are frequently seen.

The cult of a snake deity, such as Manasa, has connections with many other cults. We have already mentioned the *naga*-stones (see pp. 68 and 108) which are a notable feature of the Deccan, and the cult of the *nagaraja* and the *nagini* found in early Buddhist sculpture. The legend of Krishna and Kaliya (see p. 135), provides another example of the ubiquity of snake cults. In eastern India, the connection between Manasa and the Kaliya episode is emphasised by the fact that the festival of Manasa is called Nagapanchami – the name which elsewhere commemorates the triumph of Krishna over Kaliya. Manasa is also connected with fertility, which links her with Shiva.

112 Two coins depicting Lakshmi being lustrated by elephants: i) bronze 'Lakshmi plaque' coin. Sri Lanka. 1st century AD. ii) silver four-drachm of the Shaka king of Gandhara, Azilises. *c.*30 BC. These coins are remarkable because they show that knowledge of the goddess Lakshmi, in her Gajalakshmi form, was current from at least the first century AD at the opposite ends of the subcontinent.

113 Painting of Gajalakshmi. Punjab Hills, Kangra style. *c.*1775 AD. The connection between Lakshmi and the lotus, symbol of fertility and prosperity, is well represented in this painting. The goddess holds two blossoms and is seated on a third, which in its turn rises out of a pond of lotus flowers. Her two lower hands are held in *varadamudra* (boon-granting) and *abhayamudra* (reassurance).

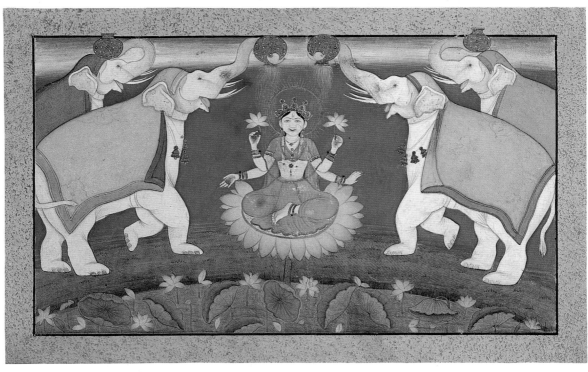

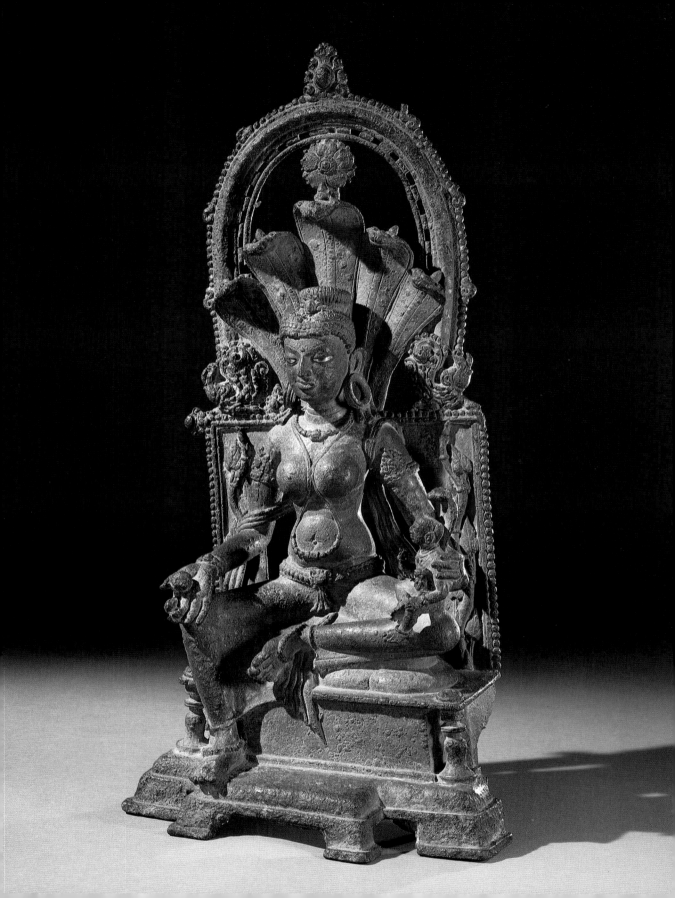

Women supplicate her for the favour of children – especially male children. The phallic shape of snakes is an obvious link between her cult and that of Shiva.

Manasa is still widely worshipped in northern, and particularly eastern, India. An earthenware pot decorated with appliqué snakes is frequently the object of worship in her rural shrines. Her legends have also come down to us via the scroll-paintings (*patas*) used by the itinerant bards of eastern India. These wandering performers popularise her cult by singing the Manasa legends while unrolling a painted scroll which illustrates her story. In these lively paintings, the lengthy narrative is recounted of how the Shiva devotee Chando eventually acknowledged the supremacy of Manasa. In this myth, and also in the story of her birth, there is an undercurrent of rivalry with Shiva, which probably reflects an historical challenge between the two cults. This is further accentuated by the fact that snakes are prominently connected with both Shiva and Manasa. Her birth, however, seems to make her subsidiary, or at least secondary to Shiva, for according to myth it occurred when Shiva's sperm accidentally leaked into a lotus pond. This, through the agency of the wife of the serpent Vasuki (see p. 120), was transformed into the beautiful goddess Manasa. There is a similarity between this myth and the one which records the birth of Karttikeya (see p. 102). In both instances the sperm of Shiva leaves his body without reference to its final destination, is deposited in water, and is then brought to fruition by a female fertility deity. The aftermath of the story of the birth of Manasa returns to the theme of rivalry between the goddess and Shiva. The legend tells of Shiva's displeasure when he is unable to fully enjoy his lotus pond because of the snakes – Manasa's snakes – which now live in it. In his anger he instructs the hawk-headed Garuda to attack the snakes. Eventually the issue is resolved when Manasa exerts her wiles upon Shiva, charming him into submission. The involvement of Garuda invokes a much older Indian myth which records the antagonism between the *vahana* of Vishnu, Garuda, and snakes. This theme is known at least from 71 the second/third century AD, appearing in sculpture from the Buddhist site of Amaravati, in Andhra Pradesh.

Village goddesses

We have already mentioned the continuingly rural nature of much of India. Throughout the subcontinent, where the population depends on the vagaries of agricultural production in an uncertain climate, local or wayside shrines to the goddess of the specific locality are frequently found. The extent to which they are independent, or are but part of the cult of some greater female deity, is now rarely possible to determine. Sometimes the names are the same, but the characteristics are different, with the goddess called by the name of one of the major deities, but possessing a legendary cycle which is entirely place-specific having no connection with the world beyond the locality. An example recently studied in great detail is that of the goddess Draupadi. Her name is famous throughout India for her part in the epic, the *Mahabharata* (see p. 28). However, in the region around Gingee in Tamil Nadu, she is worshipped as a powerful local goddess. Sometimes such local village goddesses are of tribal origin and are

114 *Previous page* Manasa. Bronze inlaid with silver. Eastern India. 8th or 9th century AD. The Buddhist bronzes of eastern India have been thoroughly studied, with the result that comparative material for this wonderful image of the snake goddess must be sought in that corpus. The elongated halo, for instance, connects it with the metal workshops at the major Buddhist monastery at Nalanda in Bihar. Bronzes were produced in large quantities there from c.8th to 12th centuries AD.

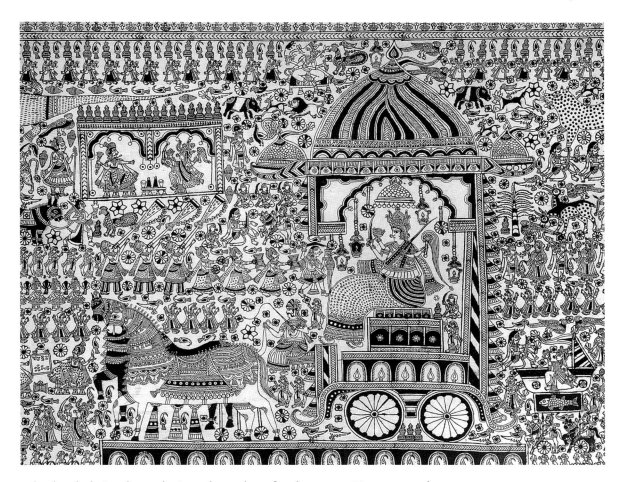

only slowly being brought into the realm of orthopraxy. However, when this occurs they frequently bring with them all sorts of extra ritual and legendary 'baggage' from their tribal past. As a type, guardian deities of the village are known as *gramadevata*, and are most usually female.

Many goddesses of this type are closely associated with the yearly round of agricultural activity and are supplicated for good rains and full harvests. They are seen as embodying fertility, and yet they are invariably unconnected with a male consort; they are fertility personified despite male presence. Indeed, when they receive blood offerings, it is often a male animal whose life-blood is offered and it is invariably a male devotee who makes the offering; goddesses worshipped by women are not usually of the bloodthirsty variety. The accent on the power of the unmarried goddess and her vicious relationships with the males in her legendary cycle is important in understanding the cult of Devi. After all, these male figures are mostly either demons whom she conquers, or sacrificial offerings whose blood she consumes. Such a vision represents the exact antithesis of the norm in Indian society. In India, especially in the countryside, women are required to marry young, leave the parental home and be subservient to the husband and his family, not the reverse. Some scholars have seen in the

115 Detail from a large textile with a block-printed and hand-drawn design. Ahmedabad, Gujarat. Contemporary. Hangings such as this are used in the worship of Devi throughout Gujarat. The most active production centres today are in the Mirzapur district of Ahmedabad. The background is usually a deep maroon red – this example is an exception, having been purchased prior to dyeing to better demonstrate the process of production. The sacrificial animal, led by a figure carrying a knife, is partly visible, halfway up the left-hand side.

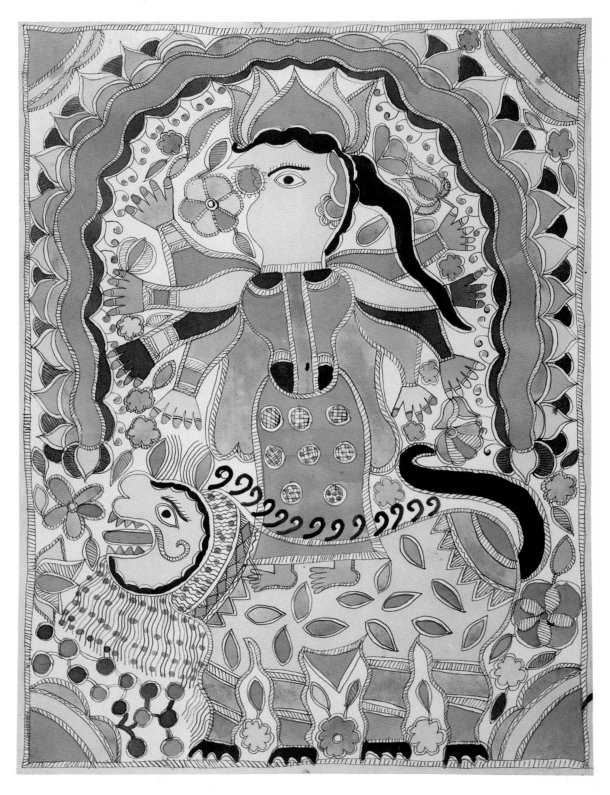

cult of the terrifying and powerful virgin goddess, a reflection of the idea of the potency of the unfettered and uncontrolled female; only when brought under the control of a male-dominated family can the power inherent in the female ability for productive action be safely channelled.

Many village deities require alcohol or blood offerings (*bali*), the latter in the form of chickens, goats or occasionally buffaloes. Their cults are rarely in the charge of brahmin families, and indeed some of them specifically require a tribal or other low caste member of village society to act as intercessors. Their 'seats' (*pithas*) are frequently found in the open – perhaps in the fields for which their protection is sought. A shrine with established buildings dedicated to the cult of these types of goddesses is less usual. Frequently they are unimaged, or are only recognised in the form of a pile of stones or a standing pole. This is again in contradistinction to orthodox practice. Some anthropologists have suggested that the appearance of the deity imaged, is in itself an indicator of the beginning of the process by which a cult is absorbed into orthopraxy. Ritual before a village goddess is often not a matter of the established practices of offering, lustration and the recitation of Sanskrit texts, as one would expect in a temple cult. More usual are blood and alcohol offerings followed by noisy invocation of the deity and then the arrival of the goddess herself. The theophany may take

116 *Opposite* Painting from Madhubani, Bihar. By the artist, Kapuri Devi. Contemporary. Painting in Madhubani (the term Mithila is also sometimes used) has developed substantially in the last fifty years from the local custom of wall-decorating. As in many parts of rural India, the walls of houses in this part of Bihar are traditionally enlivened with commemorative and prophy-lactic images and designs painted straight on to the smoothed wall plaster. In this example – on paper – the goddess Durga rides on her lion *vahana*.

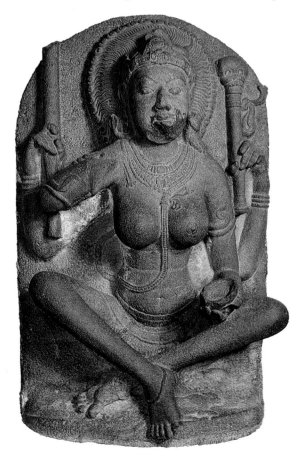

117 Mother Goddess or *matrika*. Granite. Northern Tamil Nadu, perhaps Kanchipuram, 9th/10th century AD. This image of the four-armed goddess was probably part of a series in the manner of the *saptama-trikas* (see fig. 106). However, our knowledge of Pallava religion is still not sufficient to name and exactly characterise this deity. Her wild ascetic's hair, skull-topped staff and skull-cup all suggest an horrific rather than a pacific personality. The uncluttered background and the large areas of the image which bear no decoration are typical of the directness and power of early South Indian sculpture.

the form of her appearance in some natural phenomenon, or in the possession of her chosen priest, who acts as a medium. Sometimes the medium will be questioned by the worshippers, and will then provide answers from the goddess. These displays of possession are often characterised by loss of bodily control on the part of the (usually male) medium.

Agricultural and human fertility are probably the major areas of operation for the *gramadevata*. However, this bounteous and pacific side is balanced by a grimmer face, for the *devi* is also the bringer of catastrophes, especially epidemics. Many believe that the heat of her anger is being visited on a settlement when smallpox breaks out. At such times it is necessary to placate the goddess Shitala with offerings – blood and alcohol if possible, but if not, terracotta figurines of horses or buffaloes for her to ride upon at night. The village goddesses possess a worrying ambivalence. 8 They can both bless and curse and, like the climate in which they may also manifest themselves, they are quixotic in their change of mood.

Some western Indian goddesses are worshipped in portable shrines, the walls and ceilings of which are made of coloured cotton hangings. On these are depicted the legends of the particular deity. These hangings are known by a variety of names depending on their size, and precise use: *chandarvo*, 115 *pachedi* and *tukada* amongst others. These portable shrines are used by different groups of low-caste devotees, some of whom follow a nomadic existence in search of agricultural or other temporary work. Their goddess and her shrine travel with them. Elsewhere in Gujarat the textiles find their way into small village shrines, or are deposited at centres of the Mother Goddess cult. An example is the popular hill-top *devi* shrine of Chotila, in Saurashtra, where a *pachedi* is displayed in front of the sanctuary.

These religious textiles are made by a subcaste who, when commissioned to produce textiles to honour a *devi*, purchase the cotton, the paints and the dyes, as well as any necessary new woodblocks for use in printing. Technically the design is produced by a combination of hand-drawing, block-printing, dyeing and washing. The goddess is depicted centrally, riding on her lion *vahana* and placed within a quasi-architectural surround, or on a chariot. Approaching her is her priest, who in turn leads a sacrificial animal – a goat or a ram – which will be offered to her when she is invoked. All around this central section of the hanging are registers containing scenes from the *Puranas*, the texts which detail the vast accumulation of Hindu mythology.

Although usually used to enclose the space within which the *devi* is honoured, these textiles can also be used in a more talismanic fashion. The priest/medium, while still in a trance, will sometimes wrap himself up in the *chandarvo*, thereby partaking of some of the power of the goddess through contact with her depiction on the textile.

Conclusion

The worship of the Mother Goddess under one of many different guises has been a feature of Indian religious life for almost two thousand years. If the prehistoric terracotta figurines are also to be included in this category, the continuity reaches back into the fifth or sixth millennium BC. The vigour

of her cult is demonstrated by the emergence, even now, of new *devi* cults. These, borrowing from existing traditions, and adding new elements, produce iconographies so that the new *devi* can be imaged and thus receive the devotion of her worshippers. The most obvious of these new cults of recent years has been that of Santoshi Ma (the Mother who is Satisfaction), whose rapid rise to prominence has already received the attention of scholars. Another example can be found in the case of a loved – but also feared – politician who has suffered assassination, Indira Gandhi. Within a few months of her sudden death, posters and paintings showed her as an associate of the gods.

Finally, in a century of great nationalism and searching for a truly Indian identity following colonialism, it has been to a female concept – *Bharat Mata* (Mother India) – that many Hindus have turned for solace. The idea that the very landscape of India itself, the hills, the rivers, and the forests, was throwing off the yoke of the outsider for the first time for a thousand years has been a potent idea for Hindus. This is reflected in the very wide range of their depictions of the *devi*. It is therefore not surprising that in Benares, seen by devout Hindus as the most important place of pilgrimage and the residence of Shiva, there is a temple dedicated to *Bharat Mata*. The icon enshrined here is a relief map of India itself.

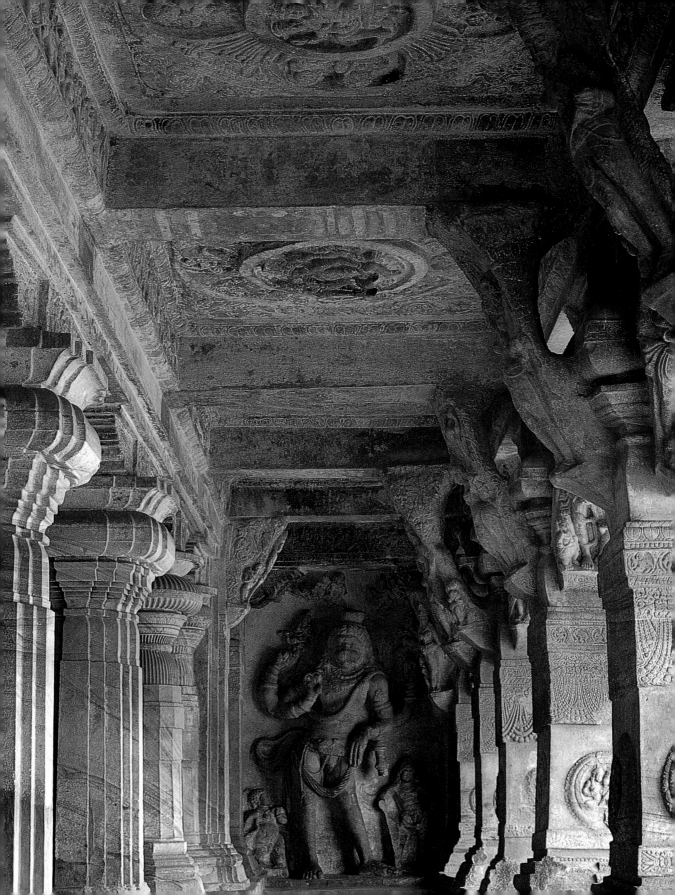

6

REGIONAL AND CHRONOLOGICAL SURVEY OF HINDU ART

We conclude this study of Hindu art by considering it in historical and regional perspective. This is in contrast to the approach adopted in the previous chapters, where greater emphasis has been placed on function, iconography and the history of cults. However, reference will frequently be made here to sculpture and painting already illustrated and discussed.

Much basic record work on Indian art is still to be done. However, general statements are possible, and this is the function of this chapter. A standard format is adopted, with India subdivided into five regional areas to provide a framework:

North India, from Kashmir to Uttar Pradesh, and including the foothills of the Himalayas; also, when dealing with pre-Islamic India, the northwestern parts of modern Pakistan;

Western India – the modern states of Gujarat and Rajasthan;

Eastern India – the states of Bengal, Bihar and Orissa;

Central India and the Deccan – the modern states of Madhya Pradesh, Maharashtra, Karnataka and most of Andhra Pradesh;

South India – southern Andhra Pradesh, Tamil Nadu and Kerala.

Within each of these regional divisions, histories of temple architecture, sculpture, and painting will be found, though these are only summary due to the size of the subject and scope of this chapter.

118 *Opposite* Cave 3 at Badami, Karnataka. Dated by an inscription to 578 AD. This impressive sculpture of Vishnu as Varaha appears at one end of the porch to the rock-cut sanctuary. The columns are elaborately decorated with figures as well as with strings of jewels and floral bands. The ceiling panels contain figures set in medallions.

North India

This vast region is made up of two basic units: the Himalaya mountains, and the flat, fertile plains produced by the rivers which flow out of them. To the west is desert, to the east the delta country of Bengal. Most foreign invaders have entered India through the mountains of the northwest, attracted to the fertile river plains of the Ganges and Jumna. North India has often experienced the imposition of radical change through conquest. Invaders have included the Indo-Aryans (firstly in about the twentieth century BC, but continuing for several generations), the Kushans (first centuries AD), the Huns (sixth century), the Afghans (eleventh century), and the Mughals (sixteenth century). No other part of India has been so fiercely fought over as the plains of the Ganges and the Jumna. The cultural effect of this has been dramatic. Some traditions have been suddenly extinguished; others have been enlivened and given new impetus. The civilisation of northern India has, therefore, repeatedly experienced interruption, change and renewal.

Most important for the development of Hindu art in this region is the location here of many of the most sacred pilgrimage sites in India. Benares (Varanasi), the city of Shiva and the place which devout Hindus wish to 55 visit at least once during their lifetimes, is located on the banks of the Ganges. At Benares the river makes a short detour towards the north (the most auspicious direction) as it flows eastwards across the north Indian plain towards the Bay of Bengal. It brings with it the fertilising sediment which ensures a dense agricultural settlement along its banks. To bathe in the river at Benares cleanses the soul of impurity, and to die and be cremated there offers the soul the opportunity of liberation. Also on the Ganges, at the point where this river and the Jumna join, is Allahabad. Here the mythical river Sarasvati is also said to join the Ganges. This triple junction – Ganges, Jumna and Sarasvati – is the auspicious Triveni. At Allahabad every twelve years the *kumbh mela* is held. At the most recent celebration of this festival between twelve and fifteen million people are estimated to have taken part. Other important pilgrimage centres in north India include Amarnath, Kedarnath and Badrinath in the Himalayas, and Mathura on the Jumna. Mathura, once a major centre of both Buddhism and Jainism, is now closely linked with the cult of the god Krishna. This cult has had a significant effect on the development of the artistic traditions 84 of northern India.

Temple architecture

Due to the frequent fighting over the northern Indian plains, few structures of the earliest periods still exist. Almost the only one is the ruined Hindu temple at Bhitargaon in the plain between the Ganges and the Jumna, dating from the fifth century AD. It is a brick-built shrine with a pyramidal tower in which many have seen one of the first instances of the later *shikhara*, the tower-like superstructure of many, particularly north Indian, temples. The exterior is decorated with panels of terracotta sculpture in the Gupta style. Further north is Kashmir, today mostly Muslim, though at one time the location of flourishing Buddhist and Hindu communities. This region, in architectural terms, acted as a conduit through which

artistic ideas from Gandhara and farther west entered India. Thus northwestern architecture retained features such as classical Roman style columns and pediments long after the disintegration of the Gandhara style in the fourth and fifth centuries. These features are often combined with another typical Gandhara, though Indian, feature: the trefoil arch. The fragments of wood from the Kashmir Smast cave, in the Peshawar District of the Northwest Frontier Province of Pakistan, clearly illustrate these elements. Even today in the mosque architecture of nearby Swat, columns with exaggerated Ionic-style capitals are found, suggesting some element of continuity from the Roman-inspired columns of Gandhara shrines. One of the major Hindu temples in the Kashmir valley is the now-ruined temple at Martand dedicated to Surya, the sun god. It is set in its own courtyard, which is articulated by classical-style columns and is dated to the eighth century. From the next century are the temples (also ruined) at Avantipur, where a similar arrangement of a shrine on a platform flanked by porches is recorded. Later still and built in the twelfth century is the small Shiva temple at Pandrethan, near Shrinagar, where elements of classical architecture are still visible.

Moving south from Kashmir, but still within the foothills, we find the styles of architecture are largely determined by local resources. In the valleys of the western Himalayas (see map on p. 228), buildings were mostly constructed of wood. Few ancient examples have come down to us, but parts of temples can be assigned to the eighth/ninth centuries, and the metal sculpture located in some of them point to yet earlier dates. In

119 Wooden architectural fragment from the Kashmir Smast cave, North West Frontier Province, Pakistan. 9th/10th century. This decorated beam element, in the shape of a trefoil arch, depicts a dancing ascetic – perhaps Shiva – accompanied by musicians. The central figure is shown in the traditional *tribhanga* pose, with the body bent in three different directions: i) head and neck ii) trunk iii) legs. The small dentils at the base are western classical features which have survived from earlier Gandhara styles.

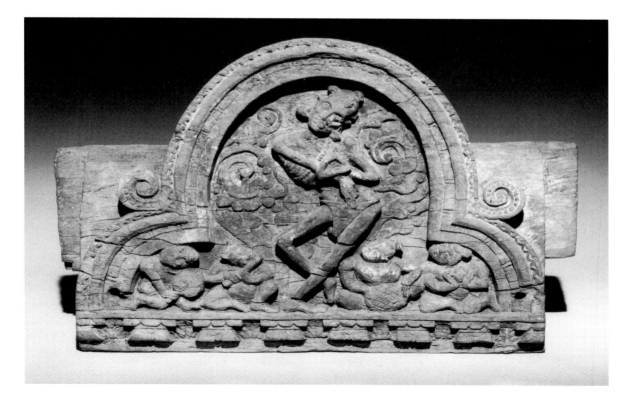

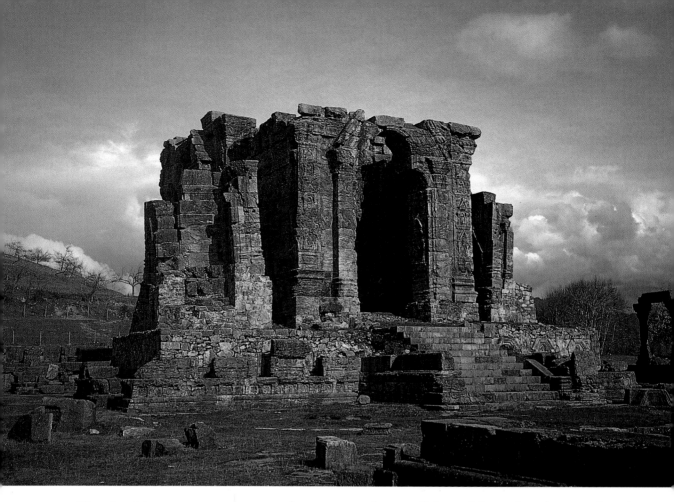

120 The ruins of the sun temple at Martand, Kashmir. Mid–8th century A.D. Striking in its location, the Martand temple stands as a witness, in its use of indigenous and classical architectural elements, to the ability of Indian architects to successfully draw upon different traditions. The main shrine building stands within a large court, the edges of which are demarcated by a classical colonnade, the remains of which can be seen at the far right. A gateway (not visible) provided access to the court.

response to the severe weather conditions of the region, deep overhanging eaves are frequent. Another common feature is the pagoda-type *shikhara* reminiscent of the better-known Nepalese styles. Stone temples with tall *shikharas* are also found, as at Bajaura in the Kulu valley. This example dates from the late ninth century, and seems to be an extension northwards of then current Central Indian styles. A rare example of rock-cut architecture in this area is located at Masrur; here again the influence of styles further to the south is presumed.

In the Ganges plain, the heartland of northern India, only a small quantity of Hindu architecture survives from the first millennium A.D. However, during the Mughal period, a group of temples dedicated to Krishna was constructed at Vrindavan on the Jumna, and several of these are still standing. Built in the local red sandstone during the sixteenth century, they include the Govindadeva, striking on account of its use of both the traditional post and beam architecture, and the Islamic style of arched and vaulted architecture. This degree of architectural syncretism may perhaps be seen in the light of early Mughal policies of religious reconciliation associated with the Mughal king, Akbar. The *shikhara* of this temple does not survive, though an impression of how it may have looked can be gained from other temples in the town of approximately the same date, such as the Madan Mohan.

During the period of Mughal decline and the subsequent emergence of the British colonial power, the tradition of temple building re-asserted itself, especially amongst the regional princely houses, such as the Holkar family of Indore and the Maharajahs of Jaipur. Although both these houses ruled from outside the Gangetic plain, they lavishly endowed temples and pilgrim homes respectively at Benares and Vrindavan, two of the most important religious centres of northern India in the medieval and modern periods. During the British paramountcy, and indeed onward into modern independent India, temple designs have become more eclectic, and during this time north India has experienced a renewal of temple building. Revivals of medieval plans are common, though modern construction techniques and materials are used.

Sculpture

The sculptural record in stone, terracotta and bronze from northern India is more complete than is the architectural one. The very earliest sculpture is of nature spirits, *yaksha* (male) and *yakshi* (female). Their cults developed later in both Hinduism and Buddhism. The earliest icons of the Hindu deities – with the exception of those on coins – come from Mathura and from the northwestern regions of Gandhara (see map on p. 228). Some examples have already been mentioned in connection with the emergence of individual deities (see pp. 84 and 114). Small images from Gandhara of a figure who appears to be Shiva (though the iconography, let alone the function of these figures is far from clear) are dated to the fourth century AD, and show him multi-armed, with erect phallus. They are produced in the typical grey schist of the region. From Mathura in the first centuries AD have come Shiva-*lingas*, as well as sculptures of Vishnu, and also of Devi; the local sandstone is the usual material, and sculptures are mostly small.

It is not until the Gupta period (fourth to sixth centuries) that substantial sculptures of Hindu deities appear in the artistic record, and independent of Buddhist sculpture. The most striking examples come from Central India (see below), but from northern India there is a fine example of Krishna carrying Mount Govardhan, which is now housed in the Bharat Kala Bhavan, in Benares. Typical of the Hindu sculpture of the Gupta period are the massiveness and force of the conception, which nevertheless has an idealised and still naturalistic beauty despite the damaged state in which it survives. Terracotta has always been an important medium for the production of sculpture in India. During the Gupta period, however, it advanced beyond the merely rustic. As Bhitargaon indicates, temple façades were decorated with panels of figures, or with sea-monsters (*makaras*) with writhing tails. Large standing figures, as well as small figurines, are also known from northern India at this period: the former from the excavations at Ahichchatra, the latter from Rajghat, the ancient site at Benares.

In the succeeding periods and up to the advent of Islam, Kashmir witnessed a period of great religious and artistic activity boosted by an economy with substantial Central Asian connections. As mentioned already in connection with temple building, both Buddhism and Hinduism flourished in the northwest throughout most of the first millennium AD.

Bronze and stone sculpture of Hindu deities were produced to a high level of accomplishment. One of the particular iconographic features of Kashmiri Hindu sculpture, in both media, is the interest shown in multi-headed images of both Shiva and Vishnu. Three- or four-headed images are frequent; Vishnu is often depicted with a lion head on one side, and a boar on the other, with a demonic face at the back facing through the halo. The two animals are associated with Vishnu as the *avataras* Narasimha and Varaha (see pp. 122–5). This type of multi-headed image of Vishnu from Kashmir is known as Vaikunthanatha, the Lord of Vaikuntha, the dwelling of Vishnu. Four-headed images of Vishnu are assumed by Pal, who has studied the corpus of Kashmiri sculpture, to be later than the three-headed ones. He further writes, 'As [the *shastra* text] the *Vishnudharmottara Purana* explains, the heads represent Vasudeva, Sankarshana, Pradyumna and Aniruddha, symbolizing respectively, strength, knowledge, sovereignty and energy' (Pal, 1975). The main figure is usually nimbate, and is accompanied in many instances by small figures representing the personified weapons of the god, *chakra* and *gada* (see p. 115). Shiva is less often represented in the bronze sculpture of Kashmir, but a similar interest in multi-headed images is seen in the stone image of this deity, now in the British Museum.

Southeast of Kashmir in the foothills of the Himalayas, metalsmiths produced brass icons of striking power and presence throughout the medieval period. The earliest probably reach back to the sixth century. Sometimes these local hill styles were closer to Kashmir (to the north), while at others the styles of the plains (to the south) were more influential; this dual influence is also mirrored in architecture, as already described. One of the major centres for the production of metal images was Chamba, where examples of large brass sculptures of both Vishnu (eighth or ninth century), and Shiva and Parvati (known in this temple by their names of Shankara and Gauri, and dated to the eleventh century) are still worshipped. The former is stylistically close to Kashmiri examples, being of the multi-headed Vaikunthanatha type, with personifications of the weapons of Vishnu at the base. The Shankara and Gauri icon, on the other hand, reflects greater contact with the plains; the figures are elegantly tall, with comparatively small heads, and the jewellery of the goddess is of the sophisticated type more associated with lowland styles.

A distinctive tradition in this region of small hill-states is the production in brass of busts or masks (*mohras*) of the deities. These usually depict either 54 Shiva or Devi. Their chronology is inexact and many have been copied, adding to the confusion. They are usually crowned, and appear with large smiling faces; snakes often appear draped across the chest. The earliest are dated to the second half of the first millennium AD, though many more are known from later centuries up to the present day. Some are inscribed with the names of donors. Kept within the temple for much of the year, they are brought out for festivals, such as Dussehra, and paraded in palanquins or on special wooden supports. In this way all devotees can see the gods on the auspicious festival days.

Returning to the plains, the important city of Kanauj, capital of king Harsha in the seventh century, and fought over in later centuries by both

Hindu and Muslim dynasts, has been the source of much sculpture. The ancient city is now ruined. Particularly notable are large sandstone panels carved with stiffly frontal figures of deities surrounded by a plethora of smaller divine beings.

Painting

The record of religious painting in north India is even more depleted than is the tally of temple architecture, and for the same reasons. Indian painting of the first millennium AD barely survives anywhere on account of the deleterious climate, and in northern India there has been the added problem of Muslim iconoclasm. From surviving texts, however, and by analogy with what is known of later periods, we can infer that there has always been a substantial tradition of painting on wood and above all on cloth. This must have been the case throughout the subcontinent, not just in the north. Some fragmentary notion of this north Indian painting tradition can be seen from the paintings recovered by Sir Aurel Stein from Central Asia. Of these a small number reflect a very clear Indian influence, or were perhaps produced in northwestern India. Most of these are Buddhist in subject, but they include a small number of images of Hindu deities such as Ganesha and Shiva. One panel painting shows Shiva in a form instantly recognisable from the corpus of Kashmiri sculpture of the god, being three-headed, four-armed and ithyphallic. Elsewhere on the southern edges of Central Asia (for instance in Ladakh) religious paintings survive to give some idea of northern Indian styles. They are, however, invariably Buddhist in subject matter.

Examples of Hindu painting are hardly known in north India until the late sixteenth century, and then in a quite different guise. During the period of religious tolerance associated with the Mughal emperor Akbar, the greatest of the Indian epics, the *Mahabharata* and the *Ramayana*, were translated into Persian at his order. These manuscripts were illustrated in the court ateliers. Examples can be seen in the British Library (*Razmnama* [the *Mahabharata*]) and the Metropolitan Museum in New York (*Hari-vamsa*). The most remarkable example, however, is of the *Ramayana*, now in the Man Singh Museum in Jaipur. In these manuscripts the paintings are full of brilliant colour and compositional expertise. Remarkably, these painters (many of whom were Hindus) could illustrate manuscripts of Persian fables or the lives of the Mughal emperors, just as they could the Indian epics. This unusual situation of a non-Hindu ruler (Akbar) commissioning Hindu subject paintings is interestingly paralleled during the rule of the successors to the Mughals – the British – in some of the so-called Company paintings.

The later Mughals showed less interest in the religion of the majority of their subjects, with the result that most of the rest of the body of great Mughal paintings are products of the Muslim courts as far as subject matter is concerned. Religious painting remained at a consequently lowly level throughout the break-up of the Mughal empire and during the British period. Examples include items such as the paintings made for the Naga-panchami festival. The lack of princely powers in the Gangetic plain meant that in these recent centuries, there has not been a central powerful system

84

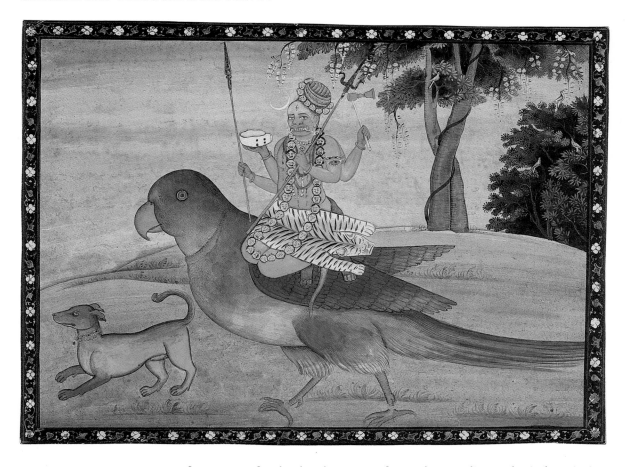

121 Painting of Shiva riding on a parrot. Punjab Hills, Kangra style. *c.*1820 AD. While his parrot mount is unusual, there is no doubt as to the identity of the deity. This is Shiva as an ascetic, with matted and coiled-up hair decorated with the crescent moon and with skulls around his hair and neck. He also carries a skull-cup in one hand. The ascetic character of the god is emphasised by the dog which, being the most inauspicious animal, is usually associated with the wandering mendicant Bhairava (see fig. 52). The twining and flowering trees in the background are a trademark of Kangra painters.

of patronage for the development of a northern Indian and Hindu painting school. In this respect, the situation in western India has been different.

Only in the hill-states of northwestern India, such as Basohli, Guler and Kangra (see map on p. 228) did non-Islamic painting continue at a courtly level (for the substantial corpus of Rajasthani painting, see below under western India). This tradition is collectively known as Pahari, or Punjab Hills, painting. As court life at the Mughal capitals decayed throughout the eighteenth century, painters were increasingly left without patronage. Consequently, artists began to move away from the great city courts, to the small, mostly Hindu, highland courts of the northwestern foothills. In these regions Islam had never deeply penetrated. The refugee artists brought with them great technical skill which, married to the vigour and exciting colour sense of local taste, produced a magnificent flowering of courtly Hindu painting during the late seventeenth, eighteenth and early nineteenth centuries.

The earliest examples are from courts such as Basohli. While different from the Early Rajput style of western India (see below), they are clearly close to it, given the striking psychological use of colour and the lack of interest in perspective which is seen in both styles. Devi is frequently the subject of the Basohli paintings. In contrast, the later Pahari paintings, for

instance from the court at Kangra, are much more svelte; the throbbing vitality of the earlier paintings is now subdued. There is a greater interest in perspective, doubtless brought about through the acceptance of Mughal techniques which in turn had come into Indian painting from European paintings and prints. The royal patrons encouraged the production of series of paintings to illustrate texts such as the *Ramayana*, and the *Krishna-lila*, as well as individual scenes such as Shiva with his family on Mount Kailasa.

Western India

Approximating to the present-day states of Rajasthan and Gujarat, this area has a more substantial history of Hindu art than can be reconstructed for northern India. Despite individual acts of desecration, such as the sack of the temple at Somnath by Mahmud of Ghazni in 1024, the vicissitudes of war have been less destructive here. In fact, Nathdvara in southern Rajasthan actually benefitted from the Muslim incursions into northern India, for the image of Krishna as Shrinathji which had previously been enshrined near Mathura, was brought to southern Rajasthan and lodged in Nathdvara because it was considered a safe haven. It has remained there ever since, making the city one of the most important Hindu pilgrimage centres in western India (see pp. 142–3).

122 Detail of the exterior decoration of the Harihara temple at Osian, Rajasthan. 8th century AD. The lower part of the *shikhara* (seen here) is carved with a series of niches containing figures; Vishnu as Trivikrama (see p. 127) is shown in the centre. Above these niches are pediments made up of groups of horseshoe-shaped arches, *gavakshas*, placed one above the other. The Harihara of the temple dedication is a deity half Vishnu (Hari) and half Shiva (Hara).

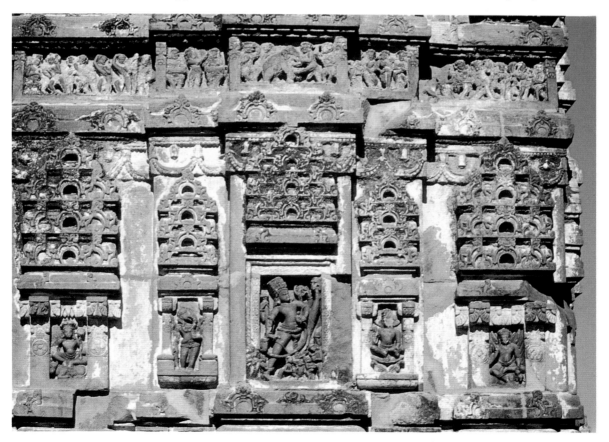

Geographically, western India contains areas of high fertility based on rivers draining into the Arabian Sea, as well as large tracts of very dry, desert landscape. The long coastline has enabled overseas contacts to be maintained with the Persian Gulf, the Red Sea and East Africa. Such contact was probably exploited from very early on in the history of the region; this is suggested by finds of seals of the so-called Persian Gulf type from the Indus Valley site at Lothal not far from the Bay of Cambay. Certainly the exposure and proximity of the western subcontinent to the Islamic heartlands meant that Islam arrived early in this area – in Sind (now in Pakistan) and Kutch, Arabs were present by the early eighth century as traders, rather than invaders.

The Hindu cults of this area have, over the last millennium, been substantially Vaishnava, and this has had a profound effect on all the arts of western India. The cult of Krishna (the eighth incarnation of Vishnu – see pp. 132–43) has been particularly important, as is demonstrated by the presence of the major Krishna temples at Dwarka, Dakor and Nathdvara, 85, 91 to which devotees from many parts of India come for *darshan*.

Temple architecture
Although there are remains of Jain and Buddhist rock-cut architecture in the Saurashtra peninsula, the earliest evidence of Hindu temple building dates from the sixth century AD. The foremost example is the temple at Gop, also in Saurashtra. It is built upon a high platform and with a tall rectangular tower crowned with blind windows of horseshoe-shape (*gavaksha*); a covered passageway for circumambulation of the shrine has now collapsed. Eighth century temple constructions are known from sites such as Osian and Roda, where the towers over the sanctuaries are built in 124, 1 the northern (*nagara*) style. They are covered in a decoration of *gavaksha*, 122 and ribbed elements similar to the flattened circular element (*amalaka*), which caps the superstructure. The square shrines of these temples are still small, and are usually only preceded by a columned porch or a small pavilion (*mandapa*). The outer walls of the sanctum are carved with niches containing figures of deities. Dated to the tenth century are the group of temples at Badoli, and the *devi* temple at Jagat, both in Rajasthan. The latter is noteworthy on account of the high stepped moulding on which it is constructed, the deeply overhanging eaves of the porch, and its fine state of preservation.

The greatest temples of the medieval period in western India, however, are associated with the Solanki dynasty – above all the temple dedicated to the Sun at Modhera, dated to the eleventh century. Although now ruined (the *shikhara* has collapsed), the overall conception is clear. The scale has 123 expanded, and the number of elements making up the total assemblage has increased compared with the earlier and smaller shrines of Saurashtra or Rajasthan. These factors suggest an increasingly complex ritual activity. The sanctuary is surrounded by the same passageway for the performance of *pradakshina*, but a large columned *mandapa* is located in front of it, though on the same elaborately moulded base; the column base illustrated 17 is of the same type. On a separate stepped base to the east is another, but slightly later, *mandapa*, originally roofed with a corbelled dome. The

columns in the *mandapa* at Modhera demonstrate a distinctive feature of Solanki-period temple architecture in that they have capitals from which spring repeatedly cusped arches, while yet further up the column is another capital which supports the superstructure; there are thus two capitals, one above the other. The interior of both the *mandapas* are covered with a mass of figural and foliate relief sculpture. Beyond the outer *mandapa* at Modhera are two columns which once formed a ceremonial gate, *torana*, to give access to the large rectangular tank which completes the assemblage. This tank has four major stepped descents (one on each side), but has many other series of steps, each one arranged symmetrically around small shrines, along all the sides. This produces a geometric display of great elaborateness.

Although outside this survey of Hindu sacred architecture, the Jain temples at Mount Abu in Rajasthan should also be mentioned, for the earliest is dated to the same Solanki period. As they are intact, they provide an indication of how temples such as Modhera might have appeared, and indeed it is likely that the same craftsmen worked on Jain structures as on Hindu ones. The deeply cut sculpture of deities as well as decorative devices covering every surface, gives an illusory impression of insubstantiality. This is compounded by the use of glistening white marble. The corbelled domes noted at Modhera are similarly deeply and profusely sculpted at Mount Abu. The later Jain pilgrimage centre of Shatrunjaya Hill, near Bhavnagar and the temple at Ranakpur (see map on p. 228), continue this tradition.

123 Ground plan of the temple at Modhera, Gujarat, dedicated to the Sun God, Surya. Like many of the greatest Indian temples, it was constructed over a long period. Recent scholarly work (Lobo 1982) suggests the following sequence: the tank, beginning of the 11th century; the temple, after 1026; the *mandapa* used as a dancing hall, the third quarter of the 11th century. (See also fig. 31.)

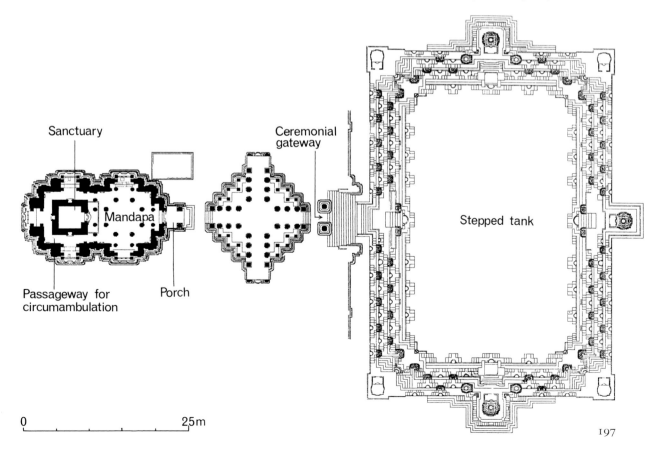

Sanctuary

Ceremonial gateway

Mandapa

Stepped tank

Passageway for circumambulation

Porch

0 25m

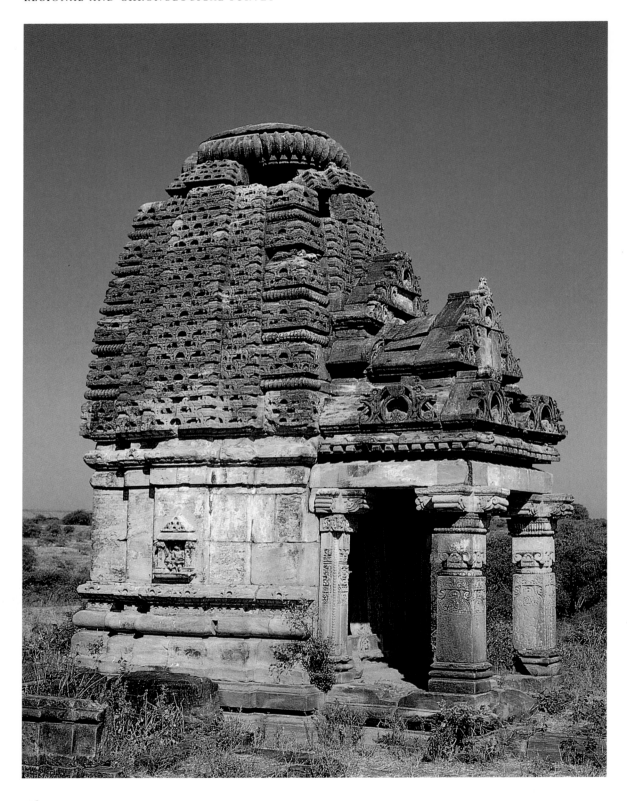

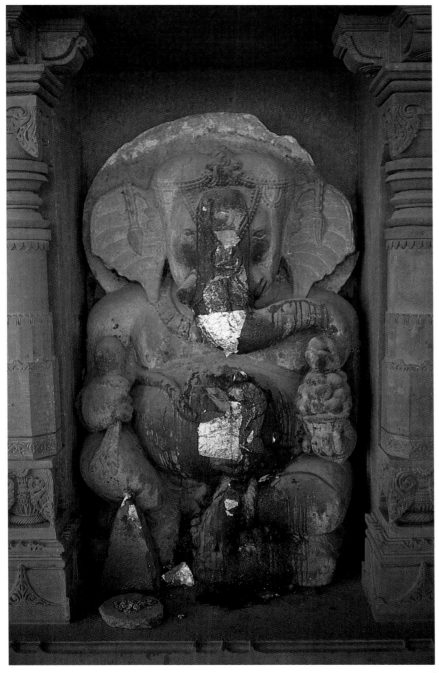

125 *This page* A niche containing an image of Ganesha. From Osian, Rajasthan. 8th or 9th century. As the securer of good beginnings and outcomes, Ganesha is honoured with flowers and coloured powders in almost all Hindu temples. In this photograph his image is seen within a niche on the exterior wall of a temple. This arrangement – deity within pilastered niche – is found throughout the subcontinent wherever Hindu gods are worshipped.

124 *Opposite* Temple 5 at Roda, Gujarat. 8th century AD. A group of five early temples still stand at this site. The *shikhara* in this example is covered with carving made up of small circular arch elements which are repeated many times. Meanwhile, at the corners, these are separated by flat ribbed sections which mirror the large flat circular capping stone seen at the top of the *shikhara*; this is known as the *amalaka*.

Another feature of temple architecture typical of western India is the *haveli*, a large house-temple, without *shikhara* or other of the traditional characteristics of a Hindu temple, but complete with the structures of a secular domicile. These are especially noted amongst the followers of Vallabha and of Swami Narayan (see pp. 142ff. and 114).

Sculpture

The most important early group of Hindu sculpture in this region comes from the site of Shamalaji in northern Gujarat. These fine sculptures, with both Shaiva and Vaishnava subjects, have been dated to the middle of the sixth century and are now displayed in the museums at Baroda and in Bombay (Prince of Wales Museum); a few pieces remain in worship at the site in northern Gujarat. They are executed in a late Gupta style full of naturalistic but idealised beauty. Also included in this group are powerful sculptures of Vishnu as Vishvarupa; the multi-headed god is shown surrounded by emanatory figures indicative of his many-sided character. Related to the Shamalaji sculptures, is the group of mother goddess images from Tanesara in southern Rajasthan, one of which is in the collections of the British Museum. They display a quality of maternal tenderness 102 otherwise rare in Indian sculpture, where the character of the Goddess is usually considered more robust, if not downright terrifying.

Later stone sculpture all comes from temples where, throughout the medieval period, exterior wall surfaces were increasingly covered with pedimented niches containing figures, the niches often in series, one above the other. The sculptural repertoire is enlivened by the inclusion of many mythical animals. Sculpture here repeatedly becomes subsidiary to architecture, with the Indian *horror vacui* becoming an obsession. Naturalism gives way to increased stylisation, especially as far as facial features are concerned, with the eyes, eyebrows and nose conventionalised, and the limbs manneristically attenuated.

Bronze sculpture of the Gupta and later periods of western India is dominated by examples of Jain figures, some of the most notable being from Akota, near Baroda. These are dated to the sixth century, and include not only images but also ritual equipment such as censers. A similarly dated bronze sculpture of Vishnu, with one surviving weapon-personification, is now in the collections of the British Museum. Later bronze sculpture includes many small domestic icons; Vishnu and Durga are frequent subjects, with features picked out in silver, and dedicatory inscriptions on the reverse of the backplate in *devanagari* script. These later bronzes share a distinctive way of depicting the thrones upon which the deities are seated.

Painting

These western regions of the subcontinent provide, in the form of manuscript illustrations, some of the oldest surviving examples of Indian painting. Most of these paintings are to be found in Jain texts, the earliest of which are dated to the twelfth century, though most are later. Examples of manuscript painting dated to the fifteenth century accompany Hindu texts such as the *Gita Govinda* of Jayadeva, and the *Bhagavata Purana*. These texts 10 detailing the life of Krishna were of great importance in the development of the cult of the god during the period of Muslim control throughout the north of India. These illustrations show many of the basic and apparently innate characteristics of Indian painting, which frequently occur in other regions and at other times. Such characteristics include the background slabs of a single, bright, vibrant colour, the lack of concern with perspective, and the interest in the decorative possibilities of illustration, at

the expense of the possibilities of realism. One scholar (Topsfield in Gray 1981) has named this style the Early Rajput style. On the southern edge of the Rajput kingdoms, in Malwa, this flat, decorative and brilliant style continued into the latter part of the seventeenth century. Elsewhere in Rajasthan, however, Mughal stylistic conceptions entered the canons of court painters almost a hundred years earlier.

During the Mughal period (sixteenth to eighteenth centuries) western India, and especially Rajasthan, was ruled by princely houses, many of whom maintained painters at their courts. The paintings from these courts, such as Jaipur, Bikaner and Udaipur, show a mixed inheritance. Stylistically they looked both to the Early Rajput style, and to the contemporary imperial style of the Mughal courts, where the Rajput princes were often obliged to spend time as courtiers. Through this contact with Mughal life, features of Persian painting practice entered the Rajput style, for the artists of the Mughal court were particularly beholden to Persian techniques, especially in the sixteenth century. In subject, the range of Rajput painting was wide, and included portraiture and genre scenes. Also included were series of paintings known as *ragamalas* (literally, a garland [*mala*] of music [*raga*]) which embody the idea that the emotions experienced in music could be portrayed in painting. These musical paintings sometimes used religious subjects to illustrate the emotions. Such subjects included both scenes from the epics and the Puranas, but above all stories from the legendary cycles of the life and deeds of Krishna. Finally, scenes of devotees at their worship were also produced from the courtly atelier, and provide fascinating detail of religious activity at the western Indian courts.

As Mughal power declined following the death of Aurangzeb in 1717, the Rajput states became increasingly unable to continue independently, and within a hundred years had entered into treaty agreements with the new British power. While the courts continued right up until Independence in 1947, only a few of the painting ateliers, such as the one at Udaipur, survived the initial surrender of power.

A quite different type of western Indian painting is the style which has developed around the pilgrimage centre of Nathdvara, in Rajasthan (see above and also p. 142). Here in an *haveli* temple, the image of Krishna as Shrinathji is enshrined. Two categories of painting are particularly associated with the shrine: the small paintings produced for pilgrims to carry away with them and the much grander paintings and hangings (*pichhwai*) which were placed behind the image in the central shrine. The sacred calendar of the followers of Vallabhacharya at Nathdvara is full of festivals and days commemorative of different events in the life of Krishna. For each of these, a different *pichhwai* was displayed in the temple. At other Vallabha *haveli*, similar paintings are also displayed. They are notable for the delightfully realistic way in which animals and plants are shown, while humans – and above all the totemic image of Krishna – are depicted with an hieratic and impressive stiffness.

A final category of western Indian painting is the type of narrative painting associated with story-telling. Although long scrolls similar to the more famous Bengali examples are known from western India, the most renowned type of story-telling paintings are those prepared on large

126 *Next page* Jagat Singh I worshipping Krishna. Mewar, Rajasthan. *c*.1700 AD. Despite his elevated position in all other activities, the ruler here appears before the god barefoot and in the posture of obeisance. His costume, with its diaphanous over-garment, his turban and the weapons which he carries in his belt all illustrate the influence of the Mughal court at which many rulers were obliged to reside. The colouration, however, with its dramatic alteration of dark and bright background, is far away from the aesthetic of the Indo-Persian court culture.

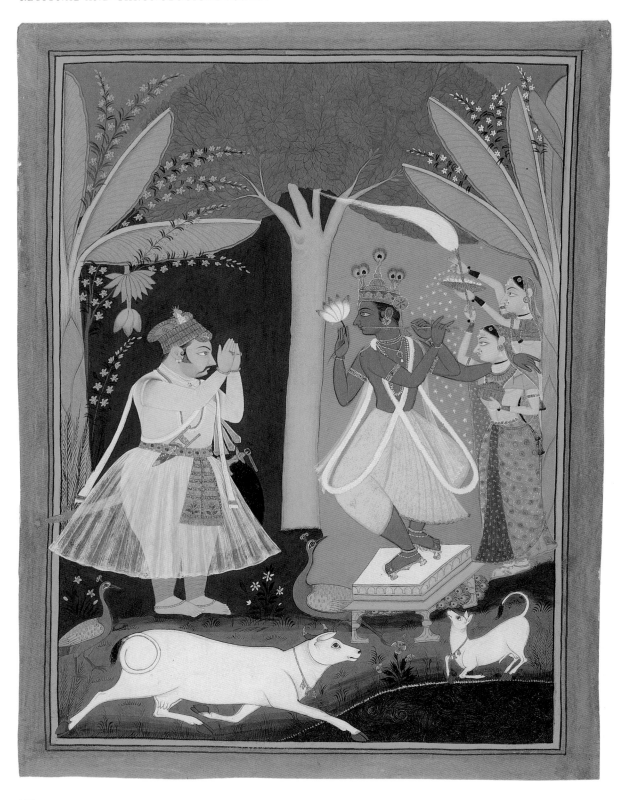

rectangular sheets of cloth, which use a bright palette with scarlet pre-dominating. These recount the exploits of the hero, Pabuji, and are used at night-time performances when the individual sections of the painting are illuminated as the epic unfolds in that age-old Indian combination of sung recitation and pictorial representation.

Eastern India

This is the area which today consists of the states of Bengal, Bihar and Orissa; also the now separate country of Bangladesh, today mostly Muslim. Undivided Bengal is dominated by the immense delta of the Ganges, and higher upstream, the juncture of the Ganges with many other rivers, the most important of which is the Brahmaputra. The region is flat, fertile, and densely populated, but liable to flooding. To the north (the Himalayas and Tibet) and east (Burma) lie territories inhabited by non-Indo-Aryan populations. Bihar extends on both sides of the east-flowing Ganges, reaching the modern frontier with Nepal to the north. South of the river in Bihar, the dusty riverine plains eventually give way to the broken and ridged country of the Santal Parganas, and yet further south to the forested hill tracts of Chota Nagpur. This area also extends into Orissa, which broadly speaking is made up of a hilly, forested and sparsely inhabited interior, and a broad coastal belt of fertile and more densely populated land which extends inland along the main river valleys. An

127 Painting of the Hiranya Garbha (the Golden Egg). Punjab Hills, Basohli style. *c.*1730. AD. Bharat Kala Bhavan, Benares. Although so much Indian art is figural, dealing with the gods in human form, there has always been a strong element in Indian religious art which glories in abstract forms. In this spectacular painting illustrating a creation myth in the text, the *Bhagavata Purana*, the beginnings of life are conjured up – the universal embryo appears amongst the swirling clouds of inchoate matter.

important, though often unremarked, feature of the whole eastern region is the large part of the total population which has its origins in tribal and not orthodox Indo-Aryan traditions. This is especially marked in the hill country of southern Bihar, western Bengal and western Orissa.

Nevertheless, eastern India has a tradition of urbanism which goes back to the middle of the first millennium BC, and is renowned throughout Asia as the land where the Buddha was born, taught and, in c.480 BC, died. In Bihar south of the Ganges, is situated Bodh Gaya, the place where the Buddha gained enlightenment. This remains an important worldwide focus of pilgrimage. To the north, situated on the river is Patna (ancient Pataliputra), the capital city of Ashoka Maurya, the champion of Buddhism in the third century BC. Buddhism flourished in this part of India throughout the first millennium AD, and the region was famous for the monasteries and religious universities located at sites such as Nalanda (Bihar) and Paharpur (Bangladesh), especially under the patronage of the Pala kings of the eighth to twelfth centuries. Towards the end of this period, popular Buddhism and Hinduism became increasingly inter-meshed (see p. 30). However, when Muslim invaders from further west sacked the monasteries in the twelfth century, Buddhism collapsed as a major force in India. Hinduism, which had also had its royal patrons (the kings of the Sena dynasty, amongst others), did survive the Muslim onslaught. Scholars have suggested that this was because, unlike Buddhism, it did not attach so great an importance to the institution of monasticism with its specialist buildings and cults which separated it from the majority of the lay population. In Orissa – protected from Muslim penetration by the inhospitable country of the Chota Nagpur – traditional religious life continued. Hinduism eventually became the dominant system, with its important pilgrimage centre at Puri (see pp. 137–8). Buddhism was probably extinct by the sixteenth century, though the memory of its cults survives, even today, in the names of local Hindu deities such as Tara, which recall the goddess of the same name.

From the twelfth to the sixteenth centuries, Bengal and Bihar were ruled by Muslims of non-Bengali origin; in the second half of the sixteenth century the whole eastern region was incorporated within the Mughal empire of Akbar. It remained under the nominal control of the Mughals until, under pressure from European traders settled in the lower delta, especially at Calcutta, it passed into the hands of the British. For them it acted as a bridgehead from which the rest of north India was subdued.

Temple architecture
Rock-cut architecture in eastern India is known from the Maurya period (third century BC), and can still be seen at the caves in the Barabar Hills. Slightly later in date is the group of rock-cut Jain shrines at Udayagiri in Orissa (this site should not be confused with the site of the same name in Central India [see p. 122]). However, probably the two most important groups of Hindu structural temples in eastern India are the stone-built shrines of coastal Orissa, exemplified by the temples at Puri and Bhuvaneshvar, which represent a long local tradition, and the late medieval and modern temples of Bengal which are built of brick and decorated with

back cover

129 terracotta panels. These are exemplified by the group at Bishnupur in Bankura District.

The city of Bhuvaneshvar contains many examples of the Orissa style of temple construction. One of the earliest of these is the Parashurameshvara temple, built in the seventh century. Its arrangement of a small hall with a roof of stone slabs laid below a clerestory level connects it with Deccan architecture of the Chalukya period, as does the *shikhara*. Comparative structures are found in the Deccan, at Aihole (see below, under Central India). Typical of the later temples in the Orissa series is the combination of columned enclosed hall (often with a tiered pyramidal roof) attached to a back cover tall *shikhara*, with above a massive ribbed element (*amalaka*), crowned by a pot. The earlier examples (eighth and ninth centuries) are small, and densely covered with both figural and vegetal relief sculpture; the inventiveness and elaboration of the latter is especially well-developed in the mature Orissa style. An oddity amongst the earlier temples at Bhuvaneshvar is the Vaital Deul (eighth to ninth century) with a rectangular shrine, above which is a vaulted tower. The sculpture within the shrine chamber also sets this temple apart from the rest. Usually undecorated, this space is here filled with Shaiva deities in terrifying forms.

The finest examples of the later Orissa style are recorded again at 14 Bhuvaneshvar (the Lingaraja temple, founded eleventh century), at Puri 143 (the Jagannatha temple, twelfth century) and Konarak (the Surya temple, thirteenth century, but now ruined). All of these share the common architectural vocabulary of the earlier temples, but the elements are expanded to accommodate increased ritual activity. This is the case not only in the horizontal dimension (there are more *mandapas* before one reaches the sanctum) but also in the vertical dimension. Indeed, the *shikhara* of the Sun temple at Konarak was of such an immense size that it has long since collapsed to leave only the preceding structures. Even in this truncated form the temple is impressively large, with the bulk of what remains designed as the very sky-chariot of the Sun-god, with the wheels and horses of his chariot faithfully recorded.

Brick structures decorated with panels of carved terracotta are the hallmarks of the late medieval sacred architecture of Bengal. They first came to prominence in the sixteenth century, but their construction continued well into the nineteenth century. The use of building materials all derived from clay is entirely in keeping with the delta location of these temples. They are usually square or rectangular in plan, with shallow arcades let into the entrance side. The superstructure is generally composed of one or more roof elements which are curved in two dimensions. Frequently, this superstructure is crowned with symmetrical arrangements of one or more small towers capped by domed elements. The arched façades of the lower storey are covered with panels of carved terracotta; 129 scenes from the *Ramayana* and above all from the legends of Krishna are the most popular. Every space at the lower level is covered, often with purely decorative devices such as garlands, lotuses, musicians, birds etc, while the arches above and around which the panels are located are often cusped in a distinctively Islamic fashion. Some of the friezes have depictions, amongst the riot of other human activity, of figures in European dress. These were,

128 *Next page, top* Detail of the mural painting at Lepakshi, Andhra Pradesh. Mid-16th century. The temple complex at Lepakshi was built and decorated at the order of the two brothers Viranna and Virupanna, local rulers in southern Andhra Pradesh at the time of Achyutadeva Raya, the penultimate of the Vijayanagara kings. The two figures shown here with hands in the position of adoration have been identified as the two brothers.

129 *Next page, bottom* Terracotta panel from the exterior of a temple in Bishnupur, Bengal. 17th century. The exploits of Krishna provide the subject matter for many of the carved terracotta panels which adorn the exterior of Bengal temples of the 17th to 19th centuries. Here the story of Krishna's theft of the clothes of the *gopis* is shown (see p. 134). Krishna plays his flute mockingly from the safety of the tree, while the *gopis* helplessly call on him from below.

doubtless, copied from the traders seen in Bengal from the time of the first Portuguese visitors (late sixteenth century) onwards. These images of Europeans bring to mind the similar rows of European figures seen on the famous Bengali *baluchar* saris. Thus, decorative elements used in these temples, are drawn from Islamic and European traditions as well as Hindu.

Sculpture

The record of eastern Indian sculpture is rich and diverse. The earliest sculptural material from the region is of terracotta figurines and is associated with sites such as Tamluk (ancient Tamralipti) and Chandra-ketugarh, both in the Ganges delta. These small figures are dated to the last centuries of the pre-Christian era, though terracotta has continued as an important medium for sculpture up to the present day. The ancient images, which are moulded with details added by hand, are often of a Mother Goddess type, and may thus be considered Hindu. The same is perhaps true for the famous *yakshi* from Didarganj now in the Patna Museum, which is assumed to be of Maurya date (third century BC) on account of the high polish given to the stone surface, a characteristic noted on the columns of Ashoka. The date for this remarkable sculpture is, however, still disputed. Eastern India in the following centuries was primarily a land where Buddhist art flourished, and it was not until the convergence of the two religions in the late centuries of the first millennium AD, and the development of Tantrism, that specifically Hindu sculpture appeared again in large quantity.

130 *Below* Exterior of Cave 3 at Badami, Karnataka. Dated by an inscription to 578 AD. (See fig. 118 for interior). The Indian tradition of excavating shrines from the living rock had a substantial history throughout the 1st millennium AD. At Badami, in a strikingly beautiful situation, a series of temples were cut from the cliff-face overlooking a lake. The siting of the cave at the base of the precipice gives an impression of the intense weight and majesty of the natural environment of which the shrine is a living part. The colonnade visible here is followed internally by the actual shrine set into the back wall.

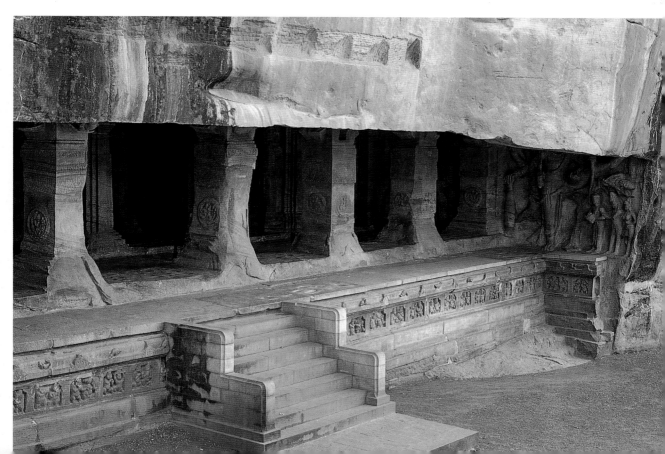

131 Stone sculpture of the Sun god Surya. Schist. From Orissa. 13th century. This sculpture is one of a series which show the nine planets, the *navagrahas*. Surya is the most important of the group and is either depicted carrying two full-blown lotus blossoms (as here) or riding on a 7-horsed chariot across the sky. The niche within which the sculpture is set is itself surrounded by the stepped outline of a temple tower.

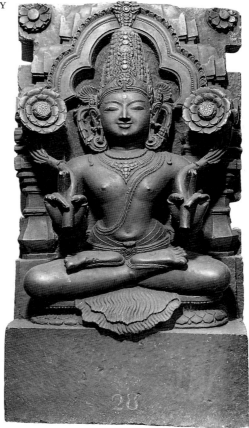

This emergence not surprisingly coincided with the appearance of Hindu temples, the earliest in this region being those of coastal Orissa. For the exterior of these temples and their successors, sculptors provided images 58, 63 of the deities within increasingly sophisticated schemes. Popular subjects included figures of auspicious lovers in embrace. Also frequently recorded from the high point of temple building in Orissa in the medieval period are specific sets of sculptures of deities, sculpted according to textual prescription. This feature of the listing of groups of deities is especially connected with tantric Hinduism, which has been a powerful force in Orissa for many centuries. Thus temples dedicated to the 64 *yoginis* (female yogis), such as the circular temple at Hirapur, include a complete set of these divine beings; other shrines might include a set of all the planets. The 131 stone used in coastal Orissa is a large-grained granitic type of rock.

By contrast, the stone most frequently used in Bengal and Bihar is a black fine-grained stone, technically known as phyllite. On account of its distinctive structure, it takes a high polish and can be used to portray minute detail. In the most important period of sculpture production (ninth–twelfth centuries), both Hindu and Buddhist sculpture follow a similar format. The deity is shown set against either a throne-back or an 59 aureole, both of which arrangements produce a stele, rectangular on three sides, but curved and pointed at the top. The figure either stands or is seated on a lotus; in the case of the latter, the lotus is often supported by luxuriant

scrolls. On either side of the figure, consorts, attendants or minor deities are frequently located, thus producing a distinctively eastern Indian triad arrangement. Dedicatory inscriptions are often carved on the base. Frequently the stone is deeply undercut, thus producing an image which is practically free-standing. Generally the background becomes more elaborate; the twelfth century icons are more densely covered than are those of the eighth century. The latter still clearly show their Gupta ancestry in a greater serenity and lack of elaborate carving. Images of the major gods of Hinduism (Vishnu, Surya, Shiva, Ganesha, Parvati and Durga) were depicted frequently and in many different forms; lesser deities and sages are also included in the repertoire.

The casting of figures of deities in bronze has a long history in eastern India. Icons of the Buddha and of other Buddhist figures are common, though images of Hindu gods are also known. The range closely follows that seen in the stone repertoire. There are several types of distinctive base that are recorded amongst these bronze figures. They include the double lotus and the stepped pedestal. The animal mounts of the deities (*vahana*) and diminutive figures of donors are a feature of the lower parts of the stepped pedestals. A tall, elongated aureole of a single strip of metal which encloses the figure is a feature of Bihar in the earlier periods; further east and later, the aureole becomes a densely filled backplate, often edged with flame elements. The inlay with silver of items such as the eyes is reserved for some of the most elaborate of the icons. Further south, in Orissa, the tradition of bronze casting of images has continued uninterrupted with the production of fine, sophisticated examples. This is not the case in Bengal and Bihar, where bronze casting only continued at a folk level.

Painting

Like western India, the eastern zone has produced examples of manuscript illustration and painted bookcovers dating back to the earliest period of any surviving in India. The subject of these manuscripts are, however, invariably Buddhist. Surviving from a couple of centuries later (sixteenth century) are a group of Hindu manuscripts with decorated cover boards. Examples from Bengal are now housed in London (British Museum, Victoria and Albert Museum) and Calcutta (Asutosh Museum). Scenes from the *Krishna-lila* or of the ten *avataras* of Vishnu are the preferred subjects.

The coastal strip of Orissa has, for a long time, had its own tradition of painting, especially that associated with the cult of Jagannatha at Puri (see p. 137 [under Krishna] and p. 205 [under eastern Indian temples]; see also map on p. 228). Paintings of this popular god, who is now looked on as a form of Krishna, are produced as holy souvenirs for pilgrims to carry home with them. A common type shows the god flanked by his brother and sister – Balabhadra and Subhadra – within their temple at Puri. Small painted images of the god(s), made of wood, are also produced. The tradition of painting on cloth, at its best, displays a use of bright colours combined with a minute and detailed technique. Other subjects illustrated include deities popular in the region: Krishna subduing the snake demon Kaliya; five-headed Ganesha; and the lion-headed *avatara* of Vishnu, Narasimha. The

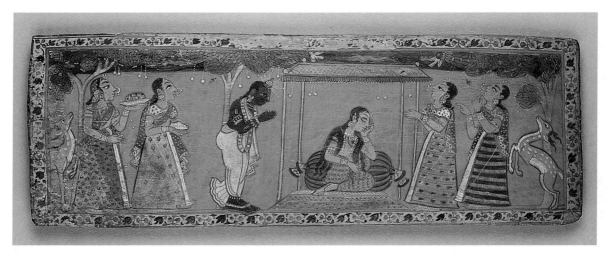

132 Painted wooden bookcover. Bengal. From a manuscript dated 1647 AD. This inner face of the cover shows the love-sick Radha seated in a pavilion. Unnoticed, Krishna approaches.

temple souvenirs showing the gods in the Puri temple again illustrate the important traditional aesthetic of Hindu India which disregards perspective, and orders the painting subject according to an hierarchy of importance, rather than one of realism. Further, architecture is shown in the same painting, in elevation, section and plan. The sacred pattern which all these conventions produce, with the gods in their rightful place at the

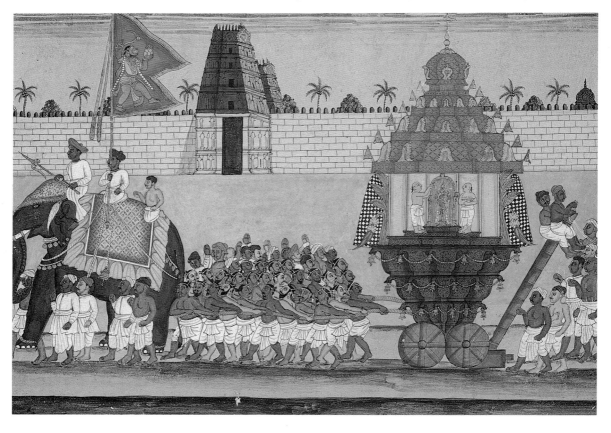

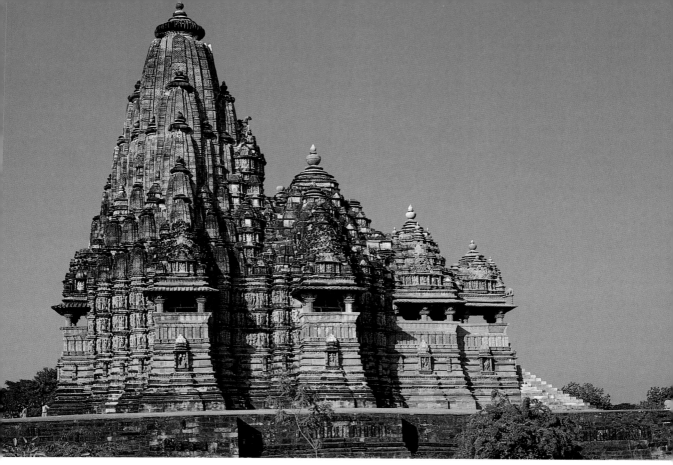

centre, makes the painting successful as a powerful icon of the deity.

Calcutta, the capital city of Bengal, located on the banks of the Hooghly, was the gateway for trade into much of northern India during the British period, and also the location of a school of Hindu painting. This was centred on the temple of Kali, and is known to scholars as Kalighat painting from the district around the temple and its river-bank steps (*ghats*). Here, during the nineteenth century, artists prepared paintings of the gods, especially those popular with the local Bengali population. Often brightly coloured and painted on ephemeral bazaar paper, they fulfilled the same function as today's photomechanical prints. They proved especially popular with a wider, non-Hindu audience in this century, because of the discriminating, though unselfconscious, way in which the artists pared down all detail to a minimum number of lines. They thus speedily produced bright and clear images at a very low price.

The Kalighat artists almost certainly belonged to rural castes who had traditionally been the painters of scrolls used by travelling story-tellers. They set up at the temple, attracted by the wealth of the thriving new city. The function of these story-telling painters has today been taken over by cinema and television, but the recitation of a traditional or local story, accompanied by the showing of the scroll with its many registers, has had a long history in eastern India. Indeed, texts record that this was once a pan-Indian tradition which has now dwindled to rural Bengal and only a few other locations.

134 The Kandariya Mahadeo temple at Khajuraho, Madhya Pradesh. 11th century. The cluster of wonderfully preserved temples at Khajuraho demonstrates many features of the classic medieval Indian temple.

133 *Opposite* Painting of a temple festival procession, perhaps at Shrirangam. Probably from Tanjore. Late 18th/early 19th century. Here the main event of a festival procession – the progress of the god amongst his devotees – is depicted. In the chariot the special image of the god, reserved only for festivals, is located with two attendant brahmins. Devotees gain merit by dragging the im-mense carriage, while at the front of the procession a great pennant bearing the figure of Hanuman leads the way.

Central India and the Deccan

These two terms are used for the hill-country south of the Ganges plain (Central India), and for the high plateau land which stretches out beyond this towards the south (the Deccan). Historically this area has seen frequent warfare, though it never suffered the sequence of devastating invasions which was the fate of northern India. The difficult passage through the hilly country of Central India has acted as a brake on penetration further south. Geographically, it is remarkable for the high table-land of the Deccan which rises steeply from the coastal belt along the Arabian Sea in the form of the Western Ghats, and then slopes gradually to the east. Both Central India and parts of the Deccan were renowned as regions of dense and inhospitable forest.

Throughout the first half of the first millennium AD, Buddhism was a major force in this region. Buddhist sites are recorded in Central India (at Sanchi), in the northwestern Deccan (in the rock-cut temples of the Ghats) 103 and in the southeastern Deccan (at Amaravati, on the Krishna river). 42

From the Gupta period onwards Hindu cults become increasingly apparent in the artistic record in Central India, as is evidenced in the important group of temples and related sculpture from the region (see below). These are the sole indicators of the type of architecture which, on a grander scale, must have been produced under the Guptas in northern India. In the later medieval periods, up to the coming of Islam, this area was ruled by a large number of different dynasties. Amongst them were the Chandellas, to whose patronage we owe the finest surviving group of temples of the medieval period, at Khajuraho. 134

In the post-Gupta period the Deccan was ruled by dynasties, the relationships between which are extremely complex and not now always clear. Their religious affiliations were mostly Hindu, though Jainism remained an important force in the southern Deccan, in the area of the modern state of Karnataka. Here, also, the reforming sect of the Lingayats was based (see p. 83). Further north was the area of influence of the Chalukya kings (sixth to eighth centuries) centred at Badami (ancient Vatapi), where both rock-cut and structural temples record their attach- 118, ment to Hindu cults. Other centres of Chalukya building activity are known at Aihole, Pattadakal and later at Alampur. Their successors in the 21 southwest were the Hoysalas, who patronised architects and sculptors who were, arguably, the most technically accomplished of any in India during the medieval period. The Hoysala kings succumbed to the military inroads 141 into southern India of the Muslim Sultans of Delhi in the fourteenth century. The successes of the northerners were followed by a period of instability in the Deccan because of the difficulty of maintaining long-distance lines of communication between the Muslim courts in the north and the new conquests in the south. Out of this period of uncertainty rose the kingdom of Vijayanagara (fourteenth–sixteenth century), based on the capital city of the same name, in central Karnataka. Frequently at war with the Muslim Bahmani sultans of Gulbarga and Bidar to the north, and later with the five sultanates which flourished after the break-up of the Bahmani kingdom, the Vijayanagara kings have in recent times been seen as the last bulwark of Hindu nationalism before the final influx of Islamic power and

civilisation. The situation was almost certainly a good deal more complicated than this, with political considerations often counting for more than religious ones. The Vijayanagara kings did, however, finally succumb to a concerted attack from the joint forces of the Muslim Deccani Sultans in 1565. Their successors in the Deccan were, firstly, Muslim rulers including the Mughals, to be followed by the Marathas and then the British. Only the Marathas, based at Pune, were Hindu and patrons of local religious architects and artists. The defeated Vijayaragara kings retreated south, first to Penukonda and finally to Chandragiri. Here, their final act of historical significance was to sign a treaty with the East India Company allowing British settlement at Madras.

Temple architecture

It was the Buddhists who were responsible for the majority of the rock-cut shrines of the Western Ghats, such as Bedsa, Bhaja and Ajanta. Within this large central area, but to the north of the Ghats, is situated Sanchi, where Buddhist *stupas* illustrating the achievements of the stone-masons of the first century BC and onwards still stand. Especially notable here is architecture in stone which uses techniques more consistent with architecture in wood; clearly the change from one medium to the other was not far in the past when the Buddhist structures of Sanchi were constructed. Only in the post-Gupta period did dynasties such as the Chalukya at Badami (sixth to eighth centuries), the Kalachuri at Elephanta (sixth century), and

136 *Next page* The Brihadishvara temple at Gangaikondacholapuram, Tamil Nadu. *c.*1025. Built by Rajendra I, this massive temple is all that now stands of the new city which the king built to commemorate his victories in northern India. Indeed, the name of the site means, 'the town of the king who brought water from the Ganges', a reference to his arrival on the banks of the sacred river and his bringing of water for *puja* from the Ganges back to the Tamil lands.

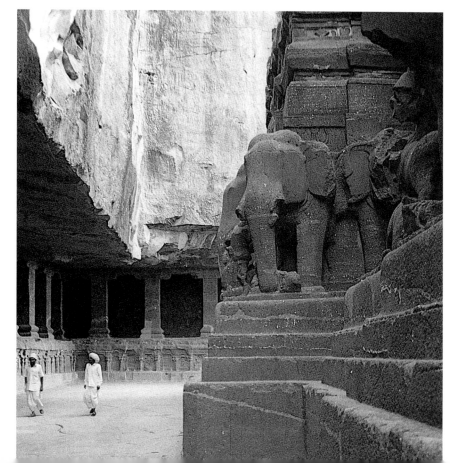

135 Detail of the Kailasanatha temple at Ellora, Maharashtra. 8th century AD. Cut directly into the cliff, this temple (dedicated to Shiva as Lord of Kailasa) sits in a great trough with the sheer cliff-face rising on three sides all around it. In a suitably supporting position at the base of the temple is a frieze of elephants, part of which is seen here. Not only are the main temple and its pavilions cut from the rock, but the precipitous cliff-face is similarly cut into, providing yet further shrines and galleries.

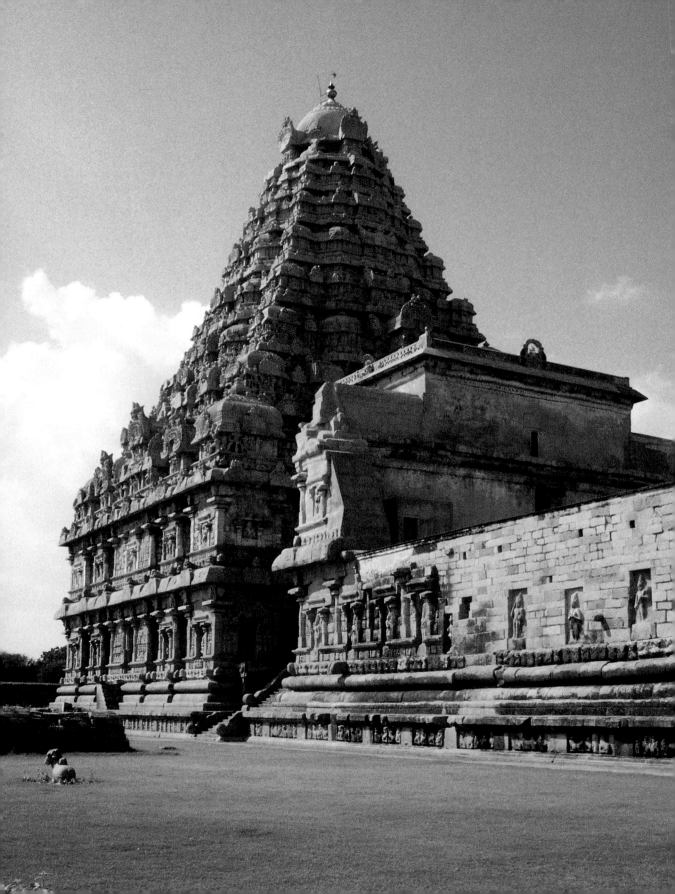

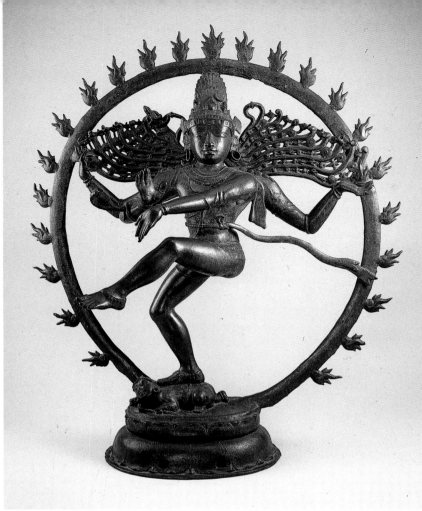

137 Bronze image of Shiva as Nataraja, in the *anandatandava* position. *c.*1100 AD. Probably from Tanjore District, Tamil Nadu. The god is shown at the end of one cycle and the beginning of another. While the *anandatandava* is the most well-known image of the dancing Shiva, the Chola-period bronze-casters also portrayed him in other dancing modes, such as the *chaturatandava*, when his legs are both bent at the knees thus forming an approximate square (= *chatura*).

138 *Below* The Varaha *mandapa* at Mahabalipuram, Tamil Nadu. 7th/8th century. The typical layout of a rock-cut shrine at Mahabalipuram is seen here. The outer face is articulated by a row of columns, often supported on the backs of lions. The interior walls bear large panels of relief sculpture, while in the centre and standing proud is the sanctum, the entrance to which is flanked by door-guardians, *dvarapalas*.

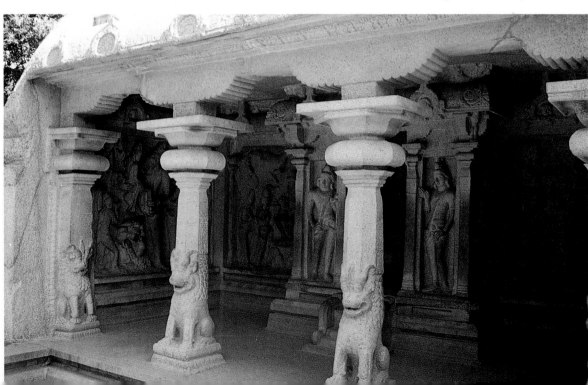

the Rashtrakuta at Ellora (eighth century) demonstrate artistically the strength of the rock-cut traditions of temple architecture in the service of Hinduism. The temple at Elephanta and the Kailasanatha temple at Ellora are *tours de force* in the history of Hindu architecture. Both are rock-cut and dedicated to Shiva. Elephanta is memorable on account of the majesty of 23 the concept, with Shiva being glorified in both human and mysteriously non-human (*linga*) form, a duality emphasised by the two axes of the temple, which bisect each other at 90°. Large panels illustrating the mythology of Shiva are carved in the walls around a massive triple-headed image of Shiva which appears subtle and powerfully otherworldly. It embodies all the qualities of the god, while the equally massive *linga* enshrined nearby embodies all those elements of the god which cannot be qualified.

The Kailasanatha is remarkable in a quite different way. The temple is spectacularly situated at the foot of a scarp and is free-standing, having been 135 quarried from the living rock, from above. The whole structure is in negative, as the now open spaces represent the work of the stone-masons; the structure itself was never built, but is the remnant of the cliff-face. It is dedicated to Shiva as the Lord of Mount Kailasa, the Himalayan home of the deity.

Despite growing from the long tradition of rock-cut architecture of the western Deccan, the temple of Elephanta and the Kailasanatha at Ellora are exceptional. It was the built, rather than the excavated, temple which, in the long run, was to have the longest history in Hindu India. The earliest surviving examples of constructed Hindu temples are located in the hilly country of Central India, south of the Ganges plains. Some of these have been mentioned already in Chapter 2, for they are the earliest built Hindu temples not only in this region, but anywhere in India. They are small rectangular shrines, some with porches, some raised up on plinths. Sculptural decoration is elaborate at the doorways and, in some examples, also at the cardinal points – as at the *dashavatara* temple at Deogarh.

The record of temple architecture in Central India continues to be of interest well into the second millennium, though during the reign of Muslim rulers court patronage was less substantial. Sites of particular importance include the temple at Udayapur dedicated to Shiva as 'The Lord with the Blue Throat', *nilakantheshvara* (for the myth which explains this epithet, see fig. 73). It bears a royal inscription, and is dated to 1080. The *shikhara* is made up of rows of miniature *shikharas* decreasing in size as they ascend. The *mandapa* is corbelled, recalling western Indian designs of the Solanki style (see above). Further to the northeast is Khajuraho, the other major temple site of the medieval period in Central India. Here a 134 group of some twenty-five temples, dating from the ninth to the early twelfth centuries, have survived in a remarkable state of preservation. Although Jain temples are included amongst the structures, the most striking are the Lakshmana, the Vishvanatha and the Kandariya Mahadeva temples, all of them Hindu. They are visually exhilarating on account of the high terraces on which they are constructed, to the top of which the devotee climbs by a flight of steps. This upward movement is combined with the sweeping roof-line from the first *mandapa* up to the topmost point

of the *shikhara*. The sculptural scheme includes depiction of couples in postures of sexual union; these are either explained as auspicious figures or as illustrations of tantric rites. Although the main axis is undoubted, there are also side entrances, which are sheltered by porches in which benches are located. Around the shrine itself is a circumambulatory walkway.

In the Deccan during the medieval period the record is more complicated, but of importance are the Hoysala temples of southern Karnataka (eleventh to fourteenth centuries), which are renowned for complicated ground plans. At Somnathpur near Mysore, a star-shaped plan is used. In the environs of Hassan, the centre of Hoysala power, temples are located at Halebid and Belur. Columns of green chlorite used throughout these temples were lathe-turned, thus producing a distinctive contour which appears to effortlessly swell and contract.

From the fourteenth century onwards in the southern Deccan, temple architecture is predominantly in the Vijayanagara style, owing much to south India proper (see below). This period of the Vijayanagara kings was one of unprecedented temple building, with an increasing emphasis on size and the multiplication of architectural units. Columns in *mandapas* are no longer the squat lathe-turned examples of the Hoysala period, but are of huge pieces of carved stone. They are more elaborate, often made up of animal figures rearing outwards from the main pillar. Meanwhile, in the northern Deccan, Hindu architecture receives royal patronage again only in the Maratha period (seventeenth and eighteenth centuries), following the campaigns of Shivaji and the establishment of a state independent of the Mughals. This style is characterised by *shikharas* in the form of conical towers with cupolas. On the Konkan coast inland from Goa, Hindu temples were built in the early modern period in a hybrid Portuguese and Indian style. At temples such as the Mangesha at Mardol, the combination of indigenous elements and classical columns produces a distinctive local style. European-style belfries, which are used as *dipastambhas* (lamp towers), further add to this complex mixture of architectural styles.

Sculpture

As so much Hindu sculpture was produced for temples, its history closely follows that of temple architecture. In Central India the earliest substantial icons are associated with the Gupta, and post-Gupta, shrines such as the Dashavatara temple at Deogarh. At such shrines, imperfectly preserved as they are, the sculpture is in the true Gupta style of heroic naturalism. Much play is made of the contrast between densely crowded compositions (as around doorways) and blank walls, thus providing a classical balance often lost in the obsessive filling of interstices which is such a feature of much later architecture. The sculptors at these sites not only excelled at figured sculpture, but also at scrolls and other decorative features which combine strength and constraint in equal part. At a number of sites (Udayagiri, Eran, Sagar), the worship of Varaha (see pp. 122–3), the boar *avatara* of Vishnu, is especially recorded in sculptures of primeval power.

In the Deccan in the middle centuries of the first millennium AD, the sculptors of the Chalukya kings developed a distinctive style in both their excavated shrines (Badami) and built temples (Aihole and later at

139 Sculpture of the Varaha incarnation of Vishnu. Red standstone. Central India. 8th century. Following the standard Central Indian scheme of the Gupta period, this *avatara* is depicted with the powerful body of a human figure, combined with the head of a tusked boar. The looping garland, the *vanamala*, with which he is draped is consonant with his position as an incarnation of Vishnu. Here the *vanamala* is still visible where it passes over his right arm and across his right leg.

Pattadakal and Alampur). The sixth century caves at Badami contain fine 21 panels of sculpture cut into the red sandstone and include, in Cave 3, uncompromising and robust depictions of the Narasimha and Varaha 118 incarnations of Vishnu. This Vaishnava cave, unusually, bears an inscription with a date equivalent to 578 AD. Other caves, at Aihole, present sculpture of a more mannered type. The Chalukya structural temples, dated to the seventh and eighth centuries, provided great scope for sculptors. This is especially demonstrated at Aihole where sculpture is seen on ceiling slabs, pillars and bases, and above all set in niches. Stylistically these sculptures show more northern (ultimately Gupta) rather than southern influence. In the realm of sculpture this northern emphasis continues, even at Pattadakal where in the temple dedicated to Shiva as Virupaksha, the architecture owes so much to southern (Pallava) practice.

The Hoysala kings, based in the southwest Deccan, patronised a sculptural style of enormous elaborateness, for although their temples were decorated externally with bands of relief sculpture, the cutting is so deep that the figures of these reliefs are almost free-standing. Figures are covered in jewellery and wear elaborate costumes. Typically, the exterior of the temple below the *shikhara* is covered with niches containing figures and rows of relief sculpture. Frequently the figures are located beneath the broadly spreading branches of flowering trees. The main registers of

sculpture are viewed while the devotee circumambulates the shrine as there is no internal walkway, merely a raised exterior platform. Other, lesser registers were filled with repeated animals linked by vegetal scrolls or depictions of scenes from the epics. For instance, at Somnathpur, panels illustrate episodes from the *Ramayana*, the *Bhagavata Purana* and the *Mahabharata*. A further distinctive feature of Hoysala temples is the decoration of roof-struts which are set at an angle between the outer wall and the lower reaches of the roof. Favourite subjects are dancers or musicians.

The sculpture of the later Vijayanagara period takes this interest in total coverage to a yet further degree. As mentioned above, temple architecture during this period witnessed an emphasis on expansion of elements – more *mandapas*, further courtyards, and yet more *gopuras*. Clarity of conception or quality of execution were perhaps not the first artistic interest: size certainly was. This tendency becomes even more pronounced during the succeeding period in south India, associated with the Nayaka rulers, and their successors (see below, p. 223). Sculpture at the Vijayanagara period sites in the Deccan is, however, full of interest, often displaying lively execution, and a wide repertoire of subjects often local in inspiration and frequently uncanonical. This is clearly seen at the capital city of Vijayanagara, where many temple buildings survive, even though most are not now in worship. The most important are: the Ramachandra, appar-

140 Stone sculpture of Hanuman. Deccan. 18th century. The monkey-headed deity Hanuman may be shown either as the meek devotee of Rama or, as here, as Vira-Hanuman, the heroic and wild god battling with demons. The latter is probably more closely connected to his origins, before his cult was subsumed into the Vaishnava fold.

141 Schist bracket figure of a dancer. Karnataka. Hoysala period. 12th century. Elaborately carved brackets such as this appear as roof-struts in Hoysala temples. The connection between sculpture and dancing was highly developed in traditional India. The positions of the hands and feet, and the emotions engendered by particular facial expressions, sprang from a vocabulary common to both disciplines. Here the dancer is shown using a mirror in her left hand. The visual short-hand of a beautiful woman leaning against a tree is the same as seen at Sanchi many centuries earlier (see fig. 103).

ently the private chapel of the kings; the Virupaksha, a Shiva temple built around an earlier Hoysala-period shrine, and still surviving in worship; and the Vitthala, a temple of highly elaborate sculptural decoration, specialising in large architectural sculpture cut almost entirely in the round, and ceilings of daringly broad span given that they are bridged only with flat slabs of stone. Temple sculpture of this period in the southern Deccan records the inclusion in major temples of previously unorthodox cults.

Hindu sculpture in bronze from the pre-Islamic period survives from the Deccan only in small numbers. A striking example is the bronze group of standing Shiva and Parvati in the British Museum, dated to the twelfth century. The bronze figures produced in later periods have more in common stylistically with South Indian (specifically Chola) antecedents than Deccan ones. *Puja* items from the Deccan are known from the medieval period: tripods, plates and ewers. The production of bronze figures was probably always connected with royal courts, so that during the time when much of the Deccan was ruled by Muslim princes, the casting of large bronze figures was in abeyance. Only with the collapse of Mughal power in the Deccan and the rise of the Maratha rulers in the eighteenth century, did bronze figuring again become widely practised.

Painting

Unlike the architectural and sculptural records, that of Hindu painting from Central India and the Deccan is slight. Undoubtedly here, as throughout India, temples were enlivened from the earliest times with murals as well as paintings on cloth; few have survived from the remote past. At Ellora, in the Kailasanatha temple, a few slight fragments of mural painting have survived, illustrating Shiva in his Nataraja and *lingodbhava* forms (dancing and emerging from the *linga*). However, it is not until the Vijayanagara period (fourteenth to sixteenth century) that murals survive in anything like appreciable units. At the Virupaksha temple at Vijayanagara itself, the painted ceiling of the main *mandapa* has been repainted, yet gives some idea of the effect such murals would have produced in the fifteenth century. More remarkable, though, are the murals in the ceiling of the *mandapa* at the mid-sixteenth century temple at Lepakshi dedicated to Shiva as Virabhadra, in southern Andhra Pradesh (see map on p. 229). A large Virabhadra image dominates the scheme, though it is today difficult to see it. More clearly visible are rows of male and female devotees and an anthology of Shaiva scenes, including the *kiratarjuniyam* (Arjuna fighting with Shiva disguised as a hunter). The style is essentially flat and without any concept of three-dimensional space. Colours are muted, but the great variety seen in the clothing of the figures emphasises again the interest in pattern and design in traditional Indian painting.

This textile variety again brings to mind the importance in Indian artistic traditions of textile manufacture. Indeed, other types of painting which survive from the Deccan are paintings on cloth which were either hung from the ceilings of shrines and *mandapas*, or from the similarly architectural interiors of processional chariots, *rathas* (see p. 61). These are generically known as *kalamkari* (pen-drawn). Although this painting tradition was originally practised in many parts of India, the town of Kalahasti in the southeastern Deccan has, in recent centuries, become associated with it above all others. Usually the cloths show the deity centrally with, all around, registers where the legends of the god or extracts from the epics are depicted. Faces, with the exception of the main deity, are usually in profile, bodies are hieratically drawn, and patterning with abstract designs is common. The cloths inherit all of these features from the mural-painting tradition, as exemplified by Lepakshi. Other paintings on

cloth have survived from the south Andhra coast, including a spectacular hanging of the early seventeenth century, now in the Brooklyn Museum. However, its subject is secular – a king receiving tribute – and thus beyond the scope of this book.

One final type of Hindu-subject painting to be mentioned from this vast central part of the Indian landmass, is the tradition called – erroneously – after the town of Paithan in northern Maharashtra. These paintings usually show mythological or epic scenes, and are of a functional type common throughout India at one time. They were used by travelling bards to illustrate the legends which they narrated to impromptu audiences. Painting on individual pieces of paper, the artists used bright colours to depict figures in profile; scenes of activity – especially battles or individual combat – were popular. They exhibit a high degree of stylisation, with the actions of the story being suggested rather than realistically portrayed.

South India

The history of the most southerly part of the Indian subcontinent (the modern states of Tamil Nadu and Kerala), is in many respects distinct from the rest of India. It is in this region that languages (above all Tamil), and their associated cultures, have survived the onslaughts both of Indo-Aryan languages in the early centuries AD and, more recently, the spread of Hindi. Further, although Islam did reach the far south of India, yet its effect on the general populace and its culture was probably less here than anywhere else. This region is subtropical and invariably fertile, unlike much of the Deccan to the north.

Physically the area is divided into two main sections. The flat and fertile expanses of the Tamil country, drained west to east by rivers such as the Kaveri and the Vaigai, formed the heartland of the ancient realms, north to south, of the Pallava, Chola and Pandya kings. This region has always supported a large population and is only exceeded in this respect by the second section of south India with which we are concerned, the western coastal littoral, divided from the Tamil region by the tail-end of the Western Ghats (see map on p. 16). Here today, in the modern state of Kerala, some of the highest population densities of any on earth are recorded. Agricultural fertility is fortunately also high. Both regions have long traditions of seafaring; for instance, during the Chola period an overseas empire/trading network was maintained in Sri Lanka and southeast Asia. It was from southern India that so much of Indian classical civilization was exported throughout mainland and island southeast Asia. It is on account of these contacts that Indian-script epigraphs are recorded from as far afield as the central Vietnam coast during the early centuries AD. This is also how both Buddhism and Hinduism spread to much of island southeast Asia.

Politically the history revolves around a series of dynasties, the brief outlines of which can be summarised as follows. The earliest dynasty which can be linked with surviving buildings and sculpture is the Pallava, whose kings had their capital city at Kanchipuram and an important seaport at Mahabalipuram (see map on p. 229). The most powerful rulers in the south

138 from the late sixth century to at least the eighth, the Pallavas patronised
Hindu cults and worshipped in both rock-cut and built structures. In the far
south, and based on Madurai at approximately the same time, were the
Pandya kings, few of whose structures remain. Later, the Cholas (ninth–
thirteenth century), considered by many to be the patrons of the greatest
Indian artists, also ruled from the south, based on the city of Tanjore, and
drawing economic strength from the fertility of the Kaveri delta. The
136 Cholas built in stone, and their sculptors excelled in this medium.
However, it is the bronze images of this period which are looked on as the

spiece, greatest of their achievements. Under the kings Rajaraja 1 and his son
137 Rajendra, Chola armies reached the river Ganges itself, and controlled
much of Sri Lanka. The drawn-out end of Chola power in the south
coincided with the first intrusion of Muslims from northern India into the
Tamil lands at the end of the thirteenth century. This initial ingress
eventually came to nothing, and in the succeeding centuries south India
was ruled from Vijayanagara in the Deccan (see above) through a loose
system of alliances. With the collapse of this last major state, smaller units
sprang up in the south, ruled by nobles or Nayaks, based on individual
cities. A further intrusion from the north – this time from the Deccan – saw
the warlike Marathas in southern India and a small but wealthy state
established at Tanjore. This had, however, succumbed to the British by the
end of the eighteenth century.

Temple architecture

The earliest Hindu architecture from south India is rock-cut, and is
associated with the Pallava kings. The most famous location of their early
architecture is at the ancient port site of Mahabalipuram, though other
examples exist (Tiruchirapalli, Mandagappattu) and are also dated to the
138 seventh century. At Mahabalipuram a conspectus of their rock-cut
architecture can be seen. This includes structures built from free-standing
boulders such as the group of shrines called the *rathas*; shrines in the form of
107 artificial caves, such as the Durga cave, with its impressively sculpted
panels; and shrines built up against huge boulders on which vast narrative
83 sculptures were carved. The first two categories share various features in
common: the use of door-guardians (*dvarapalas*); columns supported on the
backs of lions (the earliest columns are, however, plain); and panels of
sculpture inside the shrines which, in terms of the majestic planning of the
compositions, the lack of fussy detail and the suggestions of divine power,
are remarkable. Built temples are also recorded at Mahabalipuram (such as
the so-called 'Shore Temple') and at their capital city of Kanchipuram (the
18 Kailasanatha and the Vaikunthaperumal), all dated to the eighth century.
Seen in the latter two are architectural elements which, starting here,
continue throughout the southern tradition: *gopuras* over the entrance, the
structure located within a court, *mandapas* before the sanctuary, and a
crowning element above the *garbhagriha* in the typically southern form of
the pyramidal *vimana*.

While the Pallavas thrived in northern Tamil Nadu, the Pandya
dynasty, based on Madurai, certainly excavated rock-cut structures,
though their record is much more difficult to trace with few examples now

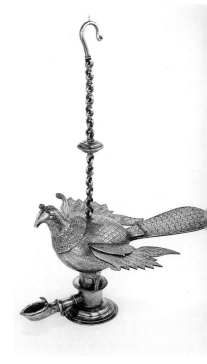

142 Hanging lamp in the shape of a bird. Brass. South India, perhaps Mysore. 18th century or later. Hanging lamps are commonly found in temple sanctuaries. This type, with the body of the bird acting as a reservoir for the oil, is common from Rajasthan in the north to Tamil Nadu in the south. The spout at the bottom is the location for the lamp wick.

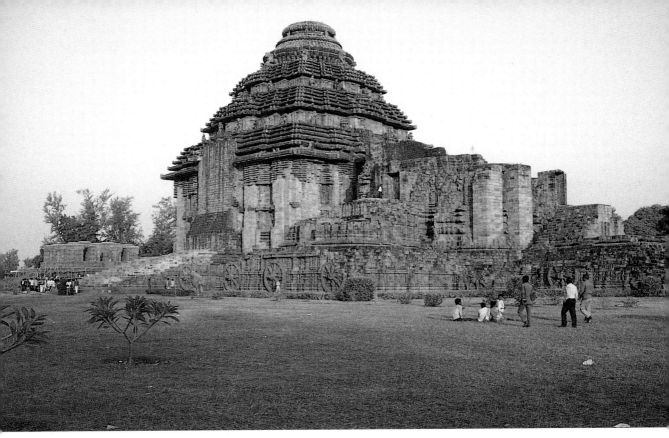

143 The Sun temple at Konarak, Orissa. Built in the reign of the Eastern Ganga king, Narasimha (r.1238–64). Even in its ruined state, with the sanctuary and its great tower missing, the temple at Konarak is one of the great achievements of medieval Indian architecture. It is densely covered with carved decorative friezes and images of divine beings, including some in amorous embrace. It is located in a court in which smaller shrines and *mandapas* are also situated.

known. However, amongst them mention can be made of the Jain cave shrine at Sittannavasal with its fragments of mural-paintings, and the incompletely excavated free-standing Shiva temple at Kalugumalai, with its figures of the bull mount of the god, dramatically located at the base of the dome.

In the succeeding Chola period, throughout the south, rock-cut architecture disappears as a major type. Instead, built architecture develops at an astonishing rate. The number of Chola-period temples, especially in the region of the Kaveri delta, is very large, and ranges from small but exquisite village shrines, as at Kilaiyur (late ninth century AD), to the impressively large temples like the Airavateshvara at Darasuram (twelfth century AD). With their capital at Tanjore, and able to command immense resources, the Chola kings developed a fluent style of architecture which equally blended building with sculpture. The mightiest kings of the dynasty, Rajaraja I and his son Rajendra, were responsible for the two greatest architectural accomplishments of the period – the temples at Tanjore and Gangaikondacholapuram (AD 1009/1010 and c.1025 respec- 136 tively), both dedicated to Shiva Brihadishvara. Both of them were constructed on a previously unimagined scale; still, today, their sheer size is overwhelming. Set within enclosing walls pierced by *gopuras* with impressive sculptures of door-guardians (*dvarapalas*), the towering *vimana* seen from far off, draws the devotee into the temple complex. The two temples are only slightly different, the most obvious distinction being the steeper outline of the tower of the Tanjore temple. At Tanjore, where the temple is also known as the Rajarajeshvara in honour of its founder,

Rajaraja I, the sanctuary itself is raised up on an immense double-storeyed structure in which are niches containing sculptures of Shiva in his many forms. This in its turn is located on a massive moulded basement along which inscriptions run; friezes of mythical animals are also a feature at this level. The sanctuary and its superstructure are preceded by a lengthy *mandapa*. Access is gained by a flight of decorated stairs on the main axis from the *gopura*, as well as on the side at the point that the *mandapa* joins the sanctuary. Other examples of temple building of the Chola period are located at Kumbakonam (ninth/tenth century) and Chidambaram (twelfth/ thirteenth century).

37

The succeeding Vijayanagara and Nayaka styles continued the Chola achievement, expanding elements other than the *vimana*, which curiously tends to decrease in size, just as everything else increases. If earlier temples had one courtyard, the later ones have two or more. *Gopuras* become ever taller, and yet further encrusted with sculpture – especially in plaster which becomes a favourite medium. The subsidiary shrines and, above all, the various *mandapas* increase in size and elaborateness of decoration; some of the pillarwork is made up of groups of three-dimensional sculpture. Examples include the Ranganatha temple complex at Shrirangam on the Kaveri, which is almost a city in its own right, the temple at Rameshvaram and, famously, the temple of Minakshi-Sundareshvara at Madurai.

24

19

Architecture on the Kerala coast has always retained some distinctive traits of its own. Particularly characteristic, is the wide use of structural and decorative wood, which has meant that few structures remain intact from early periods due to the need to replace decayed elements. Another specific element is the favouring of circular or apsidal plans, with conical roofs and overhanging eaves. Examples are located at Nedumpura (ninth/tenth century) and Kaviyur (tenth century with later decorative woodwork).

Sculpture

Many people consider the sculpture of the Chola period to be the greatest production of any south Indian style: perhaps the greatest of any from the whole subcontinent. Chola sculpture, however, grew out of the achievements of Pallava artists. The earliest sculpture in the Pallava corpus is in stone, and is located in rock-cut temples (such as Tiruchirapalli), and the *rathas* at Mahabalipuram, all dated to the late seventh and eighth centuries AD. Here relief sculpture in large panels is recorded from the interior of the shrines; its impressive monumentality is particularly striking, not least because of the absence of cluttering detail and the large size of the main figures. The sense of weighty volume and of impassive solidity is a feature of Pallava-period reliefs. The mass of sculpture on the free-standing boulder at Mahabalipuram, which is identified as either the Descent of the Ganges or the Penance of Arjuna, is one of the masterpieces of Pallava art, renowned for its wonderfully realistic portrayal of animals (the elephants are particularly memorable) as well as the easy familiarity shown in the depiction of human figures. The complex positions in which some of these figures are shown suggests a familiarity with the achievements of the sculptors at Buddhist sites in the southern Deccan such as Nagarjunakonda and, ultimately, Amaravati. Both the *rathas* and the 'Shore Temple' at

107

144 Panel depicting Shiva trampling a demon. Kailasanatha temple at Kanchipuram. 8th century AD. As befits the dedication of this temple, the sculpture on the outer wall of the shrine illustrate the mythology of Shiva. The individual sculptures illustrating the different events of the Shiva story are set within niches (as here). The trident (*trishula*) still today considered the most important weapon of Shiva, is already prominently displayed. This degree of continuity is one of the most satisfying aspects in the examination of Indian art. For the exterior of the Kailasanatha temple complex, see fig. 18.

Mahabalipuram, and the structural temples at Kanchipuram, are enlivened with religious sculpture of great accomplishment. Bronze sculptures from this period are rare, with the few recorded examples probably coming only from the eighth/ninth century; the dating for this group is, however, far from agreed. Figures stand hieratically, and with a distinctive treatment of the knotted sash on the hips.

The surviving sculpture from the Chola period is much greater in quantity, with the result that any survey must inevitably summarise. The monumental, earthy 'pre-classical' aspect of Pallava sculpture slowly gives way to the purest 'classical' style of the Cholas. It achieves a graceful, almost elegant realism, with which is combined an heroic quality, making the Fron

icons – especially those in bronze – appear immediately worthy and acceptable as the focus for adoration.

47 The substantial building programme of the Chola kings ensured that sculpting in stone flourished. Not only did they erect many temples, but the later ones were built on a large scale providing much exterior space for sculpture. However, the earliest in the sequence are small, though the sculpture which decorates them, such as at the Nageshvara at Kumbakonam (tenth century), is of very high quality. As in the earlier Pallava period, Chola figure sculpture is placed within niches on the outer faces of the temple wall. These become increasingly elaborate architecturally, and the figures become more substantial and detached from the wall surface, as can be seen at the two Brihadeshvara temples. The images of the gods are
51 mostly Shaiva, with the Dakshinamurti (teaching Shiva), and the Nataraja (dancing Shiva), being portrayed particularly often.

Mention of the Chola imaging of Shiva as Nataraja, brings us to what is today one of the most well-known images of a Hindu god, both within and without India. The tradition of bronze casting of images in south India using the 'lost wax' process, with detail work added after casting, continues to this day. Its heyday was undoubtedly during the reign of the Chola
137 kings, and the icon of Shiva dancing in the *anandatandava* mode (as Nataraja), ushering out one epoch and welcoming in the next one, is one of the most sublime creations of the southern aesthetic (for further discussion of this important image type, see p. 86). However, other, equally remarkable images were produced in considerable numbers at this time. Those dated between the ninth and the early eleventh centuries are exquisite in their suggestion of a divine realism, be it the poignant affection shown in the scenes of the Marriage of Shiva and Parvati (*kalyanasundara*), or the heroic qualities of the images of Shiva swallowing the destructive
rontis. poison at the Churning of the Ocean (*vishapaharana*). Another favourite is
60 the scene of Shiva and Parvati with their son Skanda, the *somaskanda*. The finest concentrations of South Indian bronzes outside temples are to be found in the museums at Madras and Tanjore; in the latter museum is the spectacular group from Tiruvengadu. Later Chola bronzes tend towards the stylisation which, during the Vijayanagara period, becomes the hallmark of the bronze-casters' art.

Painting

Mural and album paintings from the last two or three centuries survive in some quantity; Hindu painting from the more remote past has survived to a much lesser degree. Pallava period paintings are only known to us from slight fragments recorded in the tiny shrines set into the enclosure wall of the Kailasanatha temple at Kanchipuram (see p. 223). That most frequently depicted Pallava Shaiva image, the *somaskanda* (see p. 100), has been identified as the subject of one of these small murals. Of more substance, though still restricted to one major site, are Chola period paintings – again murals. These have been discovered beneath later Nayaka murals in the circumambulatory walkway of the Brihadishvara temple at Tanjore. Subject matter is again Shaiva (Dakshinamurti and Nataraja), but includes a figural group which has been identified as depicting Rajaraja and his guru.

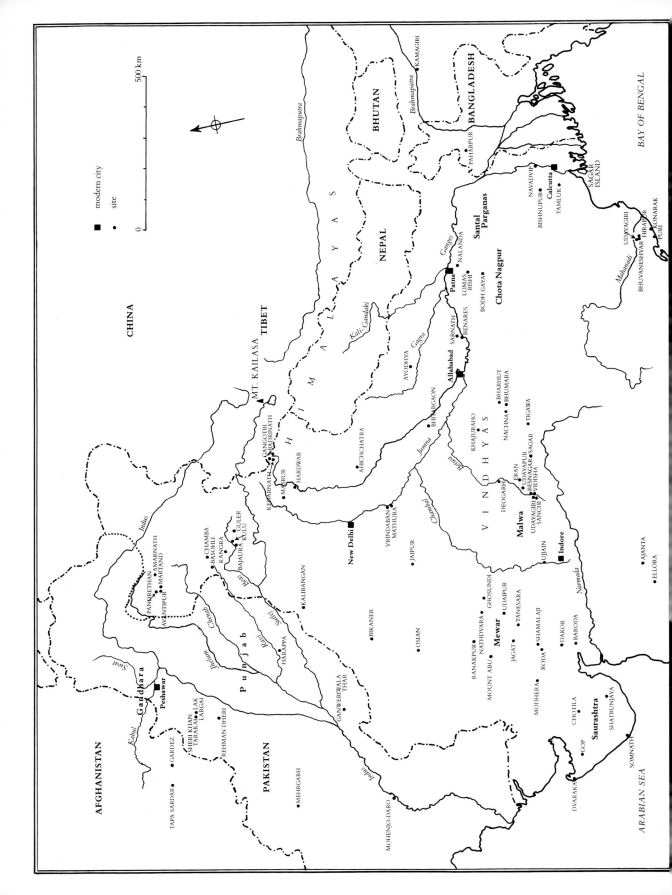

modern city
site

500 km

AFGHANISTAN

CHINA

TIBET

MT. KAILASA

NEPAL

BHUTAN

BANGLADESH

BAY OF BENGAL

KAMAGIRI

PAHARPUR

Brahmaputra

Brahmaputra

NAVADVIP

Calcutta

BISHNUPUR

TAMLUK

SAGAR
ISLAND

Santal
Parganas

Ganges

NALANDA

Patna

LOMAS
RISHI

BODH GAYA

Chota Nagpur

Mahanadi

UDAYAGIRI

HIRAPUR

KONARAK

BHUVANESHVAR

PURI

Kali-Gandaki

Gagra

AYODHYA

SARNATH

Allahabad

BENARES

BHARHUT

BHUMARA

NACHNA

TIGAWA

KHAJURAHO

V I N D H Y A S

GANGOTRI
BADRINATH

KEDARNATH

MASRUR

HARDWAR

AHICHCHATRA

BHITARGAON

Jumna

Betwa

DEOGARH

ERAN

UDAYAPUR

BESNAGAR

VIDISHA

SANCHI

UDAYAGIRI

Malwa

UJJAIN

Indore

AJANTA

ELLORA

Narmada

H
I
M
A
L
A
Y
A
S

Indus

CHAMBA

BASOHLI

GULER

KULU

KANGRA

BAJAURA

New Delhi

VRINDABAN

MATHURA

JAIPUR

Chambal

PANDRETHAN

AMARNATH

MARTAND

AVANTIPUR

Beas

Sutlej

KALIBANGAN

BIKANER

OSIAN

RANAKPUR

NATHDVARA

MOUNT ABU

GHOSUNDI

UDAIPUR

TANESARA

Mewar

JAGAT

SHAMALAJI

RODA

DAKOR

BARODA

MODHERA

Gandhara

Peshawar

SHERI KHAN
TARAKAI

LAK
LARGAI

REHMAN DHERI

Kabul

GARDEZ

TAPA SARDAR

Jhelum

Chenab

Ravi

P u n j a b

HARAPPA

GANWERIWALA

THAR

PAKISTAN

MEHRGARH

MOHENJO-DARO

Indus

CHOTILA

GOP

DVARAKA

Saurashtra

SHATRUNJAYA

SOMNATH

ARABIAN SEA

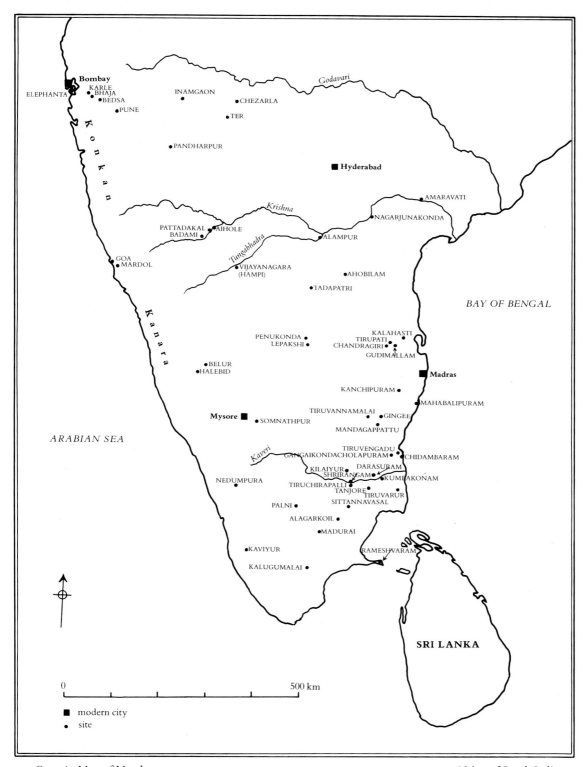

Map showing sites in South India:

ELEPHANTA
Bombay
KARLE
BHAJA
BEDSA
PUNE
INAMGAON
CHEZARLA
TER
PANDHARPUR

Godavari

Hyderabad

Krishna
AMARAVATI
NAGARJUNAKONDA
PATTADAKAL AIHOLE
BADAMI
ALAMPUR
GOA
MARDOL

Tungabhadra
VIJAYANAGARA
(HAMPI)
AHOBILAM
TADAPATRI

Konkan

Kanara

BAY OF BENGAL

KALAHASTI
PENUKONDA TIRUPATI
LEPAKSHI CHANDRAGIRI
GUDIMALLAM

BELUR
HALEBID

Madras

KANCHIPURAM
MAHABALIPURAM

ARABIAN SEA

TIRUVANNAMALAI
Mysore GINGEE
SOMNATHPUR
MANDAGAPPATTU

Kaveri
TIRUVENGADU
GANGAIKONDACHOLAPURAM CHIDAMBARAM
KILAIYUR DARASURAM
NEDUMPURA SHRIRANGAM KUMBAKONAM
TIRUCHIRAPALLI
TANJORE TIRUVARUR
PALNI SITTANNAVASAL
ALAGARKOIL
MADURAI

KAVIYUR
RAMESHVARAM
KALUGUMALAI

SRI LANKA

0 500 km

■ modern city
• site

145 *Opposite* Map of North
India showing sites
mentioned in the text.

146 Map of South India
showing sites mentioned in
the text.

All of these early painting styles are noted for a high degree of naturalism, linking them, at least broadly, with the Buddhist paintings at sites in the western Deccan, such as Ajanta.

It is, however, for the Nayaka and the subsequent Maratha periods that we have by far the greatest amount of evidence for South Indian wall-painting. Many of the Chola-period temples had mural paintings added during these later periods, especially where long stretches of wall space were available, such as in the outer cloisters. Nayaka period painting can still be seen at Madurai, Alagarkoil and Chidambaram. The Brihadishvara at Tanjore boasts a long sequence of paintings, though these are probably to be dated to the succeeding Maratha period, or even later. Yet other examples are to be seen in the Tyagaraja temple at Tiruvarur (see map on p. 229), where well preserved and still brightly coloured ceiling paintings are preserved in one of the later *mandapas*. This style of painting is closely linked with nineteeth century album painting from south India. Paintings on European watermarked paper of deities – almost iconographic manuals – were produced in large numbers during the first decades of the nineteenth century and mounted in albums. Many are captioned in Telugu, suggesting a Tanjore provenance; Telugu-speaking brahmins were settled there during the Maratha period. Many of these albums are now found in European museum collections, which suggests that they were made for Europeans resident in India. If this is so, the use of Telugu captions is unexplained. [9, 19, 50, 92]

Finally, a word is required concerning the rich painting tradition of Kerala. Early examples are almost entirely wanting; the earliest now known probably date only from the sixteenth century and later. Several outstanding sequences are preserved in palaces, such as the exquisite Padmanabhapuram complex south of Trivandrum, once the residence of the Maharajahs of Travancore. Examples are also recorded in temples, though the difficulty of access to temples in Kerala for non-Hindus has long been a stumbling block to their complete evaluation. The schemes tend to fill the entire wall surface and use bright and vibrant colours. Harle (1987) recalls the similarity between this style of painting and the theatre tradition of Kerala – the Kathakali.

Conclusion

In this chapter a regional survey has been presented. In combination with the more iconographical and functional chapters which preceded it, this is designed to demonstrate the great richness and variety of Hindu art. The fact that Hinduism and its art spans millennia and covers so much territory makes its study exciting and vibrant. This is compounded by the fact that the compilation of important original data in India is still being carried out.

The reason that so much record work is still undone is bound up with the history of the understanding of Hindu art, and this, in itself, is an intriguing subject (Mitter 1977). It has too often been denigrated, even by scholars, from intellectual positions which have either been grossly Eurocentric or merely ignorant. In the west when Hindu art has been considered at all, it has undoubtedly suffered in comparison with Indian Buddhist and

specifically Gandhara Buddhist art, with its clear connections with the Hellenistic world. Given this background, it is fitting that many of the objects illustrated in this book come from the collections of the British Museum. For, still the most important single gift of Indian sculpture to this museum came from the collection of a man – Major-General Charles Stuart (known to posterity as 'Hindoo Stuart') – who cared for and understood the concepts behind Hindu art, and appreciated the works of art which attempted to make these ideas manifest. It is hoped that this book, coming from the same museum where the collection of 'Hindoo Stuart' is housed, will be seen as a small continuation of this interest in one of the most original and thriving artistic traditions in the world.

Select Bibliography

Some works appear in many editions; the date of the edition consulted by the author is listed here. Volumes listed in one section of the bibliography often contain information relevant to another section.

General
Archer, W.G., *The Vertical Man. A Study in Primitive Indian Sculpture*, London, 1947.
Barrett, D. and B. Gray, *Indian Painting*, Geneva, 1963.
Basham, A.L., *The Wonder that was India*, London, 1961.
Bayly, C.A., *The Raj. India and the British 1600-1947*, London, 1991.
Brend, B., *Islamic Art*, London, 1991.
Bussabarger, R.F., and B.D. Robins, *The Everyday Art of India*, New York, 1968.
Chanda, R., *Medieval Indian Sculpture in the British Museum*, London, 1936.
Coomaraswamy, A.K., *History of Indian and Indonesian Art*, London, 1927.
Dehejia, V., *Indian Art*, London, 1997.
Dubois, Abbé J.A. and H.K. Beauchamp, *Hindu Manners, Customs and Ceremonies*, Oxford, 1928.
Eck, D.L., *Darsan. Seeing the Divine Image in India*, Chambersburg, 1985.
Elwin, V. (ed. N. Rustomji), *Philanthropologist. Selected Writings*, Oxford, 1989.
Gray, B. (ed.), *The Arts of India*, Oxford, 1981.
Guy, J. (ed.), *Indian Art and Connoisseurship. Essays in Honour of Douglas Barrett*, Ahmedabad and Middletown, 1995.
Guy, J. and D. Swallow (eds), *Arts of India 1550-1900*, London, 1990.
Harle, J.C., *The Art and Architecture of the Indian Subcontinent*, Harmondsworth, 1987.
Harle, J.C. and A. Topsfield, *Indian Art in the Ashmolean Museum*, Oxford, 1987.
Heidelberg exhibition catalogue *Kult und Alltag. Gelbguß in der Volkskunst Indiens*, Heidelberger Akten der von-Portheim-Stiftung, Neue Serie no. 1, 1984.
Huntington, S.L., *The Art of Ancient India*, New York, 1985.
Jain, J., *Utensils. An Introduction to the Utensils Museum, Ahmedabad*, Ahmedabad, 1984.
Jain, J. (ed.), *Picture Showmen. Insights into the Narrative Tradition in Indian Art, Marg*, vol. 49, no. 3, Mumbai, March 1998.
Jain, J. and A. Aggarwala, *National Handicrafts and Handlooms Museum, New Delhi*, Ahmedabad, 1989.
Kramrisch, S. (selected writings of, ed. B.S. Miller), *Exploring India's Sacred Art*, Philadelphia, 1983.
Kramrisch, S., *Painted Delight. Indian Paintings from Philadelphia Collections*, Philadelphia, 1986.
Larson, G.J., P. Pal and H.D. Smith, *Changing Myths and Images: Twentieth-Century Popular Art in India*, Indiana, 1997.
Liebert, G., *Iconographical Dictionary of the Indian Religions*, Leiden, 1976.
London exhibition catalogue (Hayward Gallery), *Tantra*, revised edn, 1972.
London Festival of India exhibition catalogue *In the Image of Man*, 1982.
Losty, J.P., *The Art of the Book in India*, London, 1982.
Maxwell, T.S. *Visvarupa*, Oxford, 1988.
Michell, G., *The Penguin Guide to the Monuments of India*, vol. 1, London, 1989.
Mitchell, A.G., *Hindu Gods and Goddesses*, London, 1982.
Mitter, P., *Much Maligned Monsters*, Oxford, 1977.
Mode, H. and Subodh Chandra, *Indian Folk Art*, New York, 1985.
Nilakanta Shastri, K.A., *A History of South India from Prehistoric Times to the Fall of Vijayanagar*, Oxford, 1966.
Pal, P., *Indian Sculpture*, vols 1 and 2, Los Angeles, 1986 and 1988.
Rao, G., *Elements of Hindu Iconography*, vols I and II, Madras, 1914 and 1916.
Rossi, B., *From the Ocean of Painting. India's Popular Paintings 1589 to the Present*, Oxford, 1998.

Shah, H., *Form and Many Forms of Mother Clay. Contemporary Indian Pottery and Terracotta*, New Delhi, 1985.
Sivaramamurti, C., *The Art of India*, New York, 1977.
Stein, B., *A History of India*, Oxford, 1998.
Washington Festival of India catalogue *Aditi. The Living Arts of India*, 1985.
Welch, S.C., *India. Art and Culture. 1300-1900*, New York, 1985.
Zimmer, H., *Myths and Symbols in Indian Art and Civilization*, New York, 1946.
Zwalf, W. (ed.), *Buddhism: Art and Faith*, London, 1985.

Introduction and Chapter 1: Hinduism
Allchin, B. and R. Allchin, *The Rise of Civilization in India and Pakistan*, Cambridge, 1982.
Bakkar, H. (ed.), *The History of Sacred Places in India as Reflected in Traditional Literature*, Leiden, 1990.
Bhardwaj, S.M., *Hindu Places of Pilgrimage in India*, Berkeley, 1973.
Brockington, J.L., *The Sacred Thread. A Short History of Hinduism*, Edinburgh, 1981.
Dehejia, V., *Slaves of the Lord*, New Delhi, 1988.
Dey, B. and J. Irwin, *Jamini Roy*, Calcutta, 1944.
Fuller, C., *The Camphor Flame. Popular Hinduism and Society in India*, Princeton, 1992.
Jain, J., *Other Masters. Five Contemporary Folk and Tribal Artists of India*, New Delhi, 1998.
Jarrige, J.-F. (ed.), *Les Cités oubliées de l'Indus*, Paris, 1988.
Khan, F., J.R. Knox and K.D. Thomas, *Explorations and Excavations in Bannu District, North-West Frontier Province, Pakistan. 1985-1988*. London, 1991.
Mani, V., *Puranic Encyclopaedia*, Delhi, 1975.
O'Flaherty, W.D. (ed.), *Hindu Myths*, Harmondsworth, 1982.
Oxford exhibition catalogue (Museum of Modern Art), *Gods of the Byways*, 1982.
Pal, P. (ed.), *The Peaceful Liberators. Jain Art from India*, Los Angeles, 1994.
Possehl, G.L., *Indus Age. The Beginnings*, Philadelphia, 1999.
Sen, K.M., *Hinduism*, Harmondsworth, 1961.
Zaehner, R.C., *Hinduism*, Oxford, 1962.

Chapter 2: The Temple
Banerjea, J.N., *The Development of Hindu Iconography*, Calcutta, 1956.
Desai, D., *The Religious Imagery of Khajuraho*, Mumbai, 1996.
Deva, Krishna, *Temples of North India*, New Delhi, 1969.
Evans, K., 'Visual narratives in Indian art. Scenes from the *Mahabharata* on the Hoysala temples', *South Asian Studies* 15 (1999), pp. 25-40.
Jones, D. and G. Michell (eds), *Mobile Architecture in Asia: Ceremonial Chariots, Floats and Carriages*, aarp. vol. 16, London, 1979.
Kosambi, D.D., *The Culture and Civilization of Ancient India*, London, 1965.
Kramrisch, S., *The Hindu Temple*, 2 vols, Calcutta, 1946.
Hardy, A., *Indian Temple Architecture. The Karnata Dravida Tradition. 7th to 13th Centuries*, New Delhi, 1995.
L'Hernault, F., P. Pichard and J. Deloche, *Tiruvannamalai. Vol. 2, Un lieu saint sivaïte du sud de l'Inde*, Paris, 1990.
Markel, S., *The Origins of the Indian Planetary Deities*, London and New York, 1995.
Maxwell, T.S., 'Silpa versus Sastra', in A.L. Dallapiccola (ed.), *Shastric Traditions in the Indian Arts*, Stuttgart, 1989.
Meister, M.W. and M.A. Dhaky, *Encyclopaedia of Indian Temple Architecture*, American Institute of Indian Studies, vol. 1 (1983) and continuing
Michell, G., *The Hindu Temple. An Introduction to its Meaning and Form*, London, 1977.
Pichard, P., *Tanjavur Brhadisvara. An Architectural Study*. New Delhi and Pondicherry, 1995.
Ramaswami, N.S., *Temples of Tadpatri*, Archaeological Series no. 45, Hyderabad, 1976.

Shah, S., 'Water structures in western Indian Vastusastra', in A.L. Dallapiccola (ed.), *Shastric Traditions in the Indian Arts*, Stuttgart, 1989.

Chapter 3: Shiva

Briggs, G.W., *Gorakhnath and the Kanphata Yogis*, Calcutta, 1938.
Brown, R.L. (ed.), *Ganesh. Studies of an Asian God*, Albany, 1991.
Chatterjee, A.K., *The Cult of Skanda-Karttikeya in Ancient India*, Calcutta, 1970.
Courtright, P.B., *Ganesa. Lord of Obstacles, Lord of Beginnings*, Oxford, 1985.
Davis, R.H., *Ritual in an Oscillating Universe*, Princeton, 1991.
Dye, J.M., *Ways to Shiva. Life and Ritual in Hindu India*, Philadelphia, 1980.
Eck, D.L., *Banaras. City of Light*, London, 1983.
Kramrisch, S., *Manifestations of Shiva*, Philadelphia, 1981.
Lorenzen, D.N., *The Kapalikas and Kalamukhas*, New Delhi, 1972.
Meister, M. (ed.), *Discourses on Siva*, Philadelphia, 1984.
Pal, P. (ed.), *Ganesh the Benevolent. Marg*, Bombay, 1995.
Peterson, I.V., *Poems to Siva. The Hymns of the Tamil Saints*, Princeton, 1989.
Ramanujan, A.K. (trans.), *Speaking of Siva*, Harmondsworth, 1973.
Sivaramamurti, C., *Nataraja in Art, Thought and Literature*, New Delhi, 1974.
Sivaramamurti, C., *Ganga*, New Delhi, 1976.
Smith, D., *The Dance of Siva*, Cambridge, 1996.
Taddei, M., 'A new early Saiva image from Gandhara', in J. Schotsmans and M. Taddei (eds), *South Asian Archaeology 1983*, Naples, 1985.

Chapter 4: Vishnu

Allchin, F.R. (trans.), *Kavitavali*, London, 1964.
Ambalal, A., *Krishna as Shrinathji*, Ahmedabad, 1987.
Brockington, J.L., *Righteous Rama*, Oxford, 1985.
Burghart, R., 'Ornaments of the "Great Renouncers" of the Ramanandi Sect', in B. Durrans and T.R. Blurton (eds), *The Cultural Heritage of the Indian Village*, London, 1991.
Champakalakshmi, R., *Vaisnava Iconography in the Tamil Country*, New Delhi, 1981.
Dallapiccola, A.L. (ed.), *Krishna the Divine Lover*, London, 1982.
Dimock, E.C., *The Place of the Hidden Moon. Erotic Mysticism in the Vaisnava-Sahajiya Cult of Bengal*, Chicago, 1989.
Eschmann, A., H. Kulke and G.C. Tripathi (eds), *The Cult of Jagannath and the Regional Tradition of Orissa*, New Delhi, 1978.
Hardy, F., *Viraha-Bhakti. The early history of Krsna devotion in South India*, Delhi, 1983.
Hawley, J.S., *Sur Das. Poet, Singer, Saint*, Seattle, 1984.
Hiltebeitel, A., *The Ritual of Battle. Krishna in the Mahabharata*, Albany, 1990.
Joshi, N.P., 'Prayaga-patta: a slab in the British Museum depicting Prayaga and the Fish Incarnation of Vishnu', in G. Bhattacharya (ed.), *Aksayanivi*, Delhi, 1991.
Miller, B.S. (ed. and trans.), *Love Songs of the Dark Lord. Jayadeva's Gitagovinda*, New York, 1977.
Raghavan, V. (ed.), *The Ramayana Tradition in Asia*, New Delhi, 1981.
Rangachari, K., *Sri Vaishnava Brahmans*, reprinted Delhi, 1986.
Richman, P., *Many Ramayanas: The Diversity of a Narrative Tradition*, Delhi, 1992.
Shapiro, A.A., '*Salagramapariksa* and *Salagramasilalaksanani*', in A.L. Dallapiccola (ed.), *Shastric Traditions in the Indian Arts*, Stuttgart, 1989.
Skelton, R., *Rajasthani Temple Hangings of the Krishna Cult*, New York, 1973.
Sontheimer, G.D., 'Folk deities in the Vijayanagara empire: Narasimha and Mallanna/Mailar', in A.L. Dallapiccola (ed.), *Vijayanagara - City and Empire*, Stuttgart 1985.
Williams, R.B., *A New Face of Hinduism. The Swaminarayan Religion*, Cambridge, 1984.

Chapter 5: The Great Goddess, Devi

Archer, M., *Indian Popular Painting*, London, 1977.
Bolon, C.R., *Forms of the Goddess Lajja Gauri in Indian Art*, Pennsylvania, 1992.
Dehejia, V., *Yogini Cult and Temples. A Tantric Tradition*, New Delhi, 1986.
Dehejia, V. (ed.), *Devi. The Great Goddess. Female Divinity in South Asian Art*, Washington, 1999.
Hawley, J. S. and D. M. Wulff (eds), *The Divine Consort. Radha and the Goddesses of India*, Berkeley, 1982.
Hiltebeitel, A., *The Cult of Draupadi. 1. Mythologies: From Gingee to Kuruksetra*, Chicago, 1988.
Jain, J., *Ganga Devi. Tradition and Expression in Mithila Painting*, Ahmedabad and Middletown, 1997.
Kinsley, D., *Hindu Goddesses*, Delhi, 1987.
Maitra, J., 'The benign Devi and the Puranic tradition', in A.L. Dallapiccola (ed.), *Shastric Traditions in the Indian Arts*, Stuttgart, 1989.

Maity, P.K., *Historical Studies in the Cult of the Goddess Manasa*, Calcutta, 1966.
Rawson, P.S., 'The iconography of the Goddess Manasa', in *Oriental Art*, n.s., vol. I, 1955.
Sinha, G., *Woman/Goddess. An Exhibition of Photographs*, New Delhi, 1999.
Taddei, M., 'The Mahisamardini image from Tapa Sardar, Ghazni', in N. Hammond (ed.), *South Asian Archaeology*, London, 1973.
Véquaud, Y., *The Art of Mithila. Ceremonial Paintings from an Ancient Kingdom*, London, 1977.

Chapter 6: Regional and Chronological Survey

Appasamy, J., *Tanjavur Painting of the Maratha Period*, New Delhi, 1980.
Archer, W.G., *Kalighat Paintings*, London, 1971.
Blurton, T.R., 'Continuity and change in the tradition of Bengali pata-painting', in A.L. Dallapiccola (ed.), *Shastric Traditions in the Indian Arts*, Stuttgart, 1989.
Burgess, J., *The Rock Temples of Elephanta or Gharipuri*, Bombay, 1871.
Crill, R., *Marwar Painting. A History of the Jodhpur Style*, Mumbai, 2000.
Dallapiccola, A.L. and A. Verghese, *Sculpture at Vijayanagara. Iconography and Style*, New Delhi, 1998.
Das, J.P., *Puri Paintings*, New Delhi, 1982.
Donaldson, T.E., *Hindu Temple Art of Orissa*, vols I (1985), II (1986), III (1987), Leiden.
Ebeling, K. *Ragamala Painting*, Basel, 1973.
Fabri, C., *History of the Art of Orissa*, New Delhi, 1974.
Fischer, E., S. Mahapatra and D. Pathy (eds), *Orissa. Kunst und Kultur in Nordost-Indien*, Zurich, 1980.
Fritz, J., G. Michell and M.S. Nagaraja Rao, *The Royal Centre at Vijayanagara. Preliminary Report*, Melbourne, 1984.
Glassie, H., *Art and Life in Bangladesh*, Indianapolis, 1997.
Goswami, B.B. and S.G. Morab, *Chamundesvari Temple in Mysore*, Anthropological Survey of India Memoir no. 35, Calcutta, 1975.
Goswamy, B. N. and Eberhard Fischer, *Pahari Masters. Court Painters of Northern India*. Artibus Asiae Supplementum XXXVIII, Zurich, 1992.
Jain, J., 'Survival of "Yamapattika" tradition in Gujarat', in L. Chandra and J. Jain (eds), *Dimensions of Indian Art. Pupul Jayakar Seventy*, Delhi, 1986.
Jain, J., *Kalighat Painting. Images from a Changing World*, Ahmedabad and Middletown, 1999.
Lobo, W., *The Sun-Temple at Modhera*, Munich, 1982.
London, C.W. (ed.), *The Arts of Kutch*, Marg, vol. 51, no. 4, Mumbai, June 2000.
Marg paperback volumes, Bombay:
 Vol. XXXI, no. 3 *Treasures of Everyday Art - Raja Dinkar Kelkar Museum* [n.d.]
 Vol. XXXIII, no. 4 *Homage to Hampi* [n.d.]
 Vol. XXXV, no. 1 *Heritage of Karnataka* [n.d.]
Michell, G. (ed.), *Brick Temples of Bengal. From the Archives of David McCutchion*, Princeton, 1983.
Michell, G. (ed.), *Living Wood. Sculptural Traditions of Southern India*, Marg, Bombay, 1992.
Michell, G., *Architecture and Art of Southern India. Vijayanagara and the Successor States*, New Cambridge History of India, vol. I: 6, Cambridge, 1995.
Nagaswamy, R., 'Chidambaram bronzes', *Lalit Kala*, vol. 9, Delhi, 1979.
Nagaswamy, R., *Masterpieces of Early South Indian Bronzes*, New Delhi, 1983.
Pal, P., *Bronzes of Kashmir*, Graz, 1975.
Pal, P. (ed.), *Orissa Revisited*, Marg, vol. 52, no. 3, Mumbai, March 2001.
Paul, P.G., *Early Sculptures of Kashmir*, published dissertation thesis, Leiden [1986]
Postel, M., A. Neven and K. Mankodi, *Antiquities of Himachal*, Bombay, 1985.
Schastok, S.L., *The Samalaji Sculptures and 6th Century Art in Western India*, Leiden, 1985.
Seth, P., *Reflections of the Spirit. The Theyyams of Malabar*, New York, 2000.
Settar, S. and G.D. Sontheimer (eds), *Memorial Stones. A Study of their Origin, Significance and Variety*, Dharwad and Heidelberg, 1982.
Shah, H., *Votive Terracottas of Gujarat*, Ahmedabad, 1985.
Sivapriyananda, Swami, *Mysore Royal Dasara*, New Delhi, 1995.
Sivaramamurti, C., *South Indian Bronzes*, New Delhi, 1963.
Sivaramamurti, C., *South Indian Paintings*, New Delhi, 1968.
Skelton, R. and M. Francis (eds), *Arts of Bengal*, London, 1979.
Thomas, J.P., *Tiruvengadu Bronzes*, Madras, 1986.
Topsfield, A., *Paintings from Rajasthan in the National Gallery of Victoria*, Melbourne, 1980.
Varadarajan, L., *South Indian Traditions of Kalamkari*, Ahmedabad, 1982.
Welch, S. C. (ed.), *Gods, Kings and Tigers. The Art of Kotah*, New York and Harvard, 1997.

GLOSSARY OF FREQUENTLY-USED INDIAN LANGUAGE TERMS

Names of deities, epithets and proper names are not included here – see Index.
References to definitions, discussion or illustrations in the text are given in parentheses.

abhayamudra – the hand position indicating 'fear not'; the hand at shoulder-level, palm towards the viewer.

abhisheka – the sprinkling of consecrated water over either a religious image, or the head of a king at his coronation.

ahimsa – non-violence. A central concept of the Jains and a philosophy embraced by Gandhi (p. 32).

alvars – the 12 South Indian poet-saints, renowned for singing the praises of Vishnu (fig. 16; for the Shaiva equivalent, see *nayanmars*).

amalaka – the flat, circular, ribbed element which crowns a north Indian temple tower (back cover illustration).

amrita – nectar of immortality. Used both for the divine food produced at the Churning of the Ocean (p. 120) and for the constituent of elaborate rituals (see *panchamrita* below, and p. 74).

anandatandava – the dance of bliss. Shiva's cosmic dance when he is shown with one foot trampling on the demon Apasmara and with the other lifted up high over it; he dances within a circle of fire (p. 86, fig. 137).

anjalimudra – the hand position of adoration, with the two palms joined, as in prayer.

arati – a temple ritual in which a lamp is respectfully waved in a clockwise direction in front of the god, in order to give pleasure to the deity (p. 74).

ashram – a retreat where spiritual exercises are carried out.

ashtadikpala – the Eight Guardians of the Directions – Kubera, Chandra, Indra, Agni, Yama, Surya, Varuna and Vayu (variant lists occur) (p. 48).

avatara – literally 'descent', but usually applied specifically to the ten incarnations of Vishnu, the *dashavataras* (p. 112).

bali – an offering, often a blood sacrifice.

bhajan – popular hymns sung by pilgrims or devotees at a shrine.

bhakti – emotional and immediate love for the god, often without the intermediary of a brahmin (pp. 36–39).

bilva – the wood-apple tree, sacred to Shiva, and often found planted at his temples. Used in Shaiva ritual (fig. 18).

bodhisattva – in Buddhist thought, a figure who refrains from entering *nirvana*, to aid other living beings; a saviour, ever-present (p. 30).

brahman – Ultimate Reality, beyond all distinctions; the neutral force which underlies the Universe.

brahmana – a member of the priestly caste, the most elevated of the four castes. Anglicized as brahmin (see p. 25).

chakra – the wheel or discus weapon of Vishnu (p. 115, fig. 74).

chandarvo – a large painted and block-printed cloth used in Gujarat in the worship of *devi* (p. 184 and fig. 115).

damaru – a drum, especially the hourglass-shaped one which Shiva carries (p. 94).

darshan – the sight of the deity, the culmination of a visit to a temple when eye-contact is made with the god (p. 57).

dashavataras – the ten canonical incarnations of the god Vishnu (see *avatara* above, and p. 112).

devanagari – the north Indian script used today for Hindi, and generally also for Sanskrit.

devi – generic term for all goddesses. See Chapter 5.

dhamas – the four shrines which delimit the sacred geography of India – Puri (east), Rameshvaram (south), Dvaraka (west) and Badrinath (north).

dharma – personal law, determined by caste and *karma* (see below), which it is one's duty to follow.

dharmashala – a pilgrim home, charitably endowed. Examples are to be found at all the major pilgrimage sites.

dhvajastambha – pillar for flags, usually erected just outside the main shrine in a temple (p. 64).

dipastambha – as above, but for lamps (fig. 22).

gada – the club weapon of Vishnu (p. 115, fig. 74).

gana – the mischievous dwarfs who make up the retinue of Shiva. Ganesha is their captain (fig. 37).

garbhagriha – literally 'womb chamber', the sanctum of a temple (p. 70ff.).

gavaksha – horseshoe-shaped arch, frequently used as a decorative motif in temple decoration (fig. 122).

ghat – steps, especially the flights of steps at river banks, where ablutions are performed (fig. 55). Also the name for the mountainous ridges of the western and eastern edges of the Deccan plateau (see map p. 16).

ghee – clarified butter. Used for oil lamps in Indian temples and also for anointing images.

gopi – the female cowherds who are enamoured of Krishna. Radha is their chief (p. 133ff., figs. 82, 132).

gopura – in South India, the towered gateway leading from the street into a temple enclosure (see p. 64, figs. 19, 29).

gramadevata – the deity of a particular village, frequently a goddess (p. 181).

guru – spiritual teacher.

haveli – temple in the form of a courtyarded mansion. Found particularly in western India (pp. 142, 199).

jatamukuta – the matted and coiled hair of Shiva as an ascetic; often shown in a highly stylised manner as an elaborate head dress (Frontispiece).

kalamkari – literally, pen-work, the term used for drawing and painting on cloth in the distinctive style of southern Andhra Pradesh (p. 221, fig. 28).

kalasha – water-pot. Used architecturally for the topmost element of the north Indian *shikhara* (see back cover).

kali-yuga – the present time cycle, the most degenerate of the four cycles of present creation.

kalyanasundara(murti) – (image or depiction of) the marriage of Shiva and Parvati.

kapala – cup made from the upper part of a human cranium, its use connected particularly with the cult of Shiva (fig. 49).

karma – the law of *karma* is a law of cause and effect. Acts in this life determine status in the next (p. 29).

kiritamukuta – the crown headdress of Vishnu (fig. 69).

kirtana – ecstatic hymn sung by the followers of Chaitanya (p. 140ff.) in which they praise Krishna. 'Hari Krishna, hari Ram' is one of the commonest.

kirttimukha – a decorative device in the form of a lion-mask, frequently used architecturally at the top of an arch (fig. 63 and the drawing at the end of each chapter).

kshatriya – the warrior caste, the second in status in traditional Indian society (p. 25).

kumbh mela – festival which takes place every four years, the location moving between Hardwar, Prayag (Allahabad), Ujjain and Nasik. The Prayag *kumbh mela*, held every twelve years, is the most auspicious, but at each, sins can be cleansed through ritual bathing.

laddu – a distinctive type of spherical sweet made of flour and sugar, frequently offered to Ganesha (fig. 39).

linga – the aniconic form of the god Shiva represented as a standing pillar, and based originally on the male generative organ; often shown united with the *yoni* (p. 78ff., figs. 40, 41, 43 and 44).

lingodbhava – the image of Shiva appearing from within the cosmic *linga* (p. 86 and fig. 47).

makara – mythical sea-monster, frequently used as a decorative motif with scrolls issuing from its mouth (fig. 63).

mandala – sacred diagram of circles and squares representing the cosmos, with a sacred syllable (see *mantra*) or the deity at the centre.

mandapa – columned hall which precedes the shrine-chamber in a temple. It may be more or less open, depending on its location (p. 69, fig. 38).

mandir – temple or shrine.

mantra – spoken invocation specific to a deity – often only a syllable, though sometimes as much as a verse (p. 18, figs. 62, 104).

mohra – cast metal mask of deities, popular in Himachal Pradesh; usually either of Shiva or Devi (fig. 54).

moksha – the goal of Hindu spirituality: liberation, release from rebirths.

mudra – different hand positions which indicate characteristics, such as protective reassurance (*abhayamudra*) or adoration (*anjalimudra*). For both, see above.

murti – 'form'; the image of a deity.

naga, nagaraja, nagini – *nagas* are snake deities, whose cult is of great antiquity and popularity throughout the subcontinent; *nagaraja* is king of the *nagas* and *nagini*, his spouse (pp. 107 and 135, figs. 65 and 84).

navagrahas – the nine planets Ravi, Chandra, Mangala, Budha, Brihaspati, Shukra, Shani, Rahu and Ketu (variant lists occur); often shown in sculpture as a group (fig. 131).

nayanmars – the 63 Tamil Shaiva saints who are renowned for their praises in honour of Shiva (for the Vaishnava equivalent, see *alvar*).

nirvana – extinction, the release from the endless round of rebirths caused by the accumulation of *karma*; Buddhist version of the Hindu *moksha*.

pachedi – see *chandarvo*.

panchamrita – the name of a *puja* in which the image is lustrated with five (*panch-*) 'nectars' (*-amrita*). These are clarified butter, milk, curds, sugar, and water or honey (p. 74).

pichhwai – a large painted textile hanging, usually depicting scenes from the mythology of Krishna. Particularly associated with the followers of Vallabhacharya (p. 142 and fig. 89).

pinda – small balls made of rice, honey and other foodstuffs, used as offerings.

pitha – the 'seat' or shrine of a deity (usually a goddess), particularly those shrines which commemorate the dismemberment of Sati (pp. 91 and 156); also, the pedestal of an image.

pradakshina – honouring an image or a building by processing around it in the auspicious clockwise direction.

prakara – the walled courtyard of a temple. Especially used when courtyards occur concentrically (fig. 19).

pranala – the spout which drains liquid offerings from an enshrined image (p. 73, fig. 37).

prasad – the offering given to a devotee following attendance at a shrine; it is sanctified having been in contact with the god (p. 73).

puja – offering and worship before the image of a deity.

ragamala – literally, a garland of melodies. Used to refer to series of paintings in which the emotions of music are evoked through images and poetry (fig. 67).

rasamandala – the round dance, in which Krishna dances with the *gopis*, magically making each one believe that he is dancing with her alone; a metaphor for his love for all mankind (fig. 82).

ratha, rathapatha – *ratha* is a processional chariot, made of wood, bamboo and cloth, and used at festivals to carry an image of the deity through the streets (p. 61, figs. 26 and 133); *rathapatha*, the street leading to the temple down which the chariot is dragged.

rudraksha – the dried berries from which rosaries are made, especially those used by Shaiva devotees.

sadhu – holy mendicant who has abandoned the constraints of conventional life.

samhita – literally 'collection', but usually referring to the gathering together of the lore known today as the Four Vedas.

sangam – the juncture of two rivers , especially the juncture, at Allahabad, of the Ganges and the Jumna.

sannyasin – a renouncer, a religious wanderer who gives up all connections with family and settled society.

saptamatrika – a grouping of female deities, the Seven Mothers (p. 165, fig. 106).

shakti – the immanent and forceful power of the goddess, Devi (p. 166).

shalagrama – ammonite fossil sacred to Vishnu (p. 118).

shankha – conch-shell, an attribute of Vishnu (p. 115, fig. 74).

shastra – the theoretical texts which lay down the way human activities should be carried out. *Shilpashastras* cover the production of sculpture, *vastushastras* deal with architecture (p. 44ff.).

shaiva – adjective from the name Shiva.

shikhara – the tower which rises up over the sanctuary of a north Indian temple (p. 56, fig. 20, 21, 134 and back cover).

shilpashastra – see *shastra*.

shudra – the lowest of the four categories of the caste system, labourers (p. 25).

somaskanda – iconographical type, common in South India, where Shiva is depicted seated with Parvati, and with Skanda as a child between them (fig. 60).

stupa – the most important Buddhist monument type, commemorative of the Buddha, and probably based on the tumuli thrown up over his ashes after their division.

svayambhu – self-manifest; term frequently used in connection with *lingas* which are believed not to be made by human agency.

tantras – the texts which describe the powerful rituals which adepts use to short-cut the endless sequence of existences. Associated with both Hinduism and Buddhism, especially in eastern India (p. 167).

tirthankaras – literally 'ford-crossers' and thus those who have found the way across. Used to describe the 24 Jain preceptors, of whom the last was Mahavira (p. 32, fig. 12).

torana – arched gate.

trishula – the trident weapon of Shiva (p. 94, fig. 144).

tulsi – the sweet basil plant, sacred to Vishnu (p. 69, fig. 36).

ugra – 'fierce', used to describe the horrific side to the character of various deities, such as Narasimha (p. 123, fig. 75).

utsavamurti – the image of the god brought from the temple for festival processions, usually of metal (Frontispiece, fig. 137).

uttaravahini – the auspicious turning to the north of a river (as at Benares), and thus the ideal location for a temple.

vahana – the mount of a deity, often an animal – the bull of Shiva, the lion of Durga. Often carried in processions (p. 68, fig. 35).

vaishnava – adjective from the name Vishnu.

vaishya – the third category in the traditional division of Indian society, agriculturalists and merchants (p. 25).

varadamudra – the hand position of boon-fulfilling. An epithet of Vishnu is Varadarajaswami, the Lord who grants boons (p. 147).

vastushastra – see *shastra*.

vibhuti – the ash used for smearing sectarian marks on the forehead (p. 61).

vimana – the pyramidal tower which crowns the shrine of a South Indian temple (p. 56, fig. 18).

vina – South Indian musical instrument, not dissimilar from a sitar; the goddess Sarasvati is frequently shown playing it.

vishapaharana – the epithet applied to Shiva 'destroying poison', a reference to his action at the Churning of the Ocean (frontispiece, fig. 73).

yaksha (m) and **yakshi** (f) – the ancient tree and fertility spirits worshipped from the early Historic period up to the present.

yantra – mystical diagram associated mostly with the worship of Devi (p. 164, fig. 104).

yoga, yogapatta, yogini – *yoga*, spiritual and physical exercises; *yogapatta*, a band tied around the knees by ascetics to hold the legs in position while engaged in *yoga*; *yogini*, a female yogi or ascetic who practises *yoga*.

yoni – the aniconic form of Devi, based on the triangular shape of the female generative organ; often shown united with the *linga* – see above (p. 163, fig. 40).

ILLUSTRATION ACKNOWLEDGEMENTS

Abbreviations

BM Courtesy of the Trustees of the British Museum.

TRB Photograph by the author.

GM Photograph by kind permission of George Michell.

AD Photograph by kind permission of Arthur Duff.

Frontispiece BM, OA 1970. 9–21. 1. Brooke Sewell Fund and Bequest.

Figs.
1 BM, OA 1936. 12–9. 3 Given by Mrs Kay.
2 TRB.
3 BM, OA 1960. 7–16. 016. Brooke Sewell Fund.
4 Map by Ann Searight.
5 BM, OA 1947. 4–16. 1 (bull) and 2. Given by the Government of India through the Director-General of Archaeology.
6 From *Explorations and Excavations in Bannu District, North-West Frontier Province, Pakistan (1985–88)*, OP 80, F. Khan, J. R. Knox and K. D. Thomas, London, 1991.
7 BM, OA 1939. 6–19. 207. Given by the Director-General of Archaeology in exchange.
8 TRB.
9 BM, OA 1962. 12–31. 013(42).
10 BM, OA 1958. 10–11. 01. Brooke Sewell Fund.
11 BM, OA 1955. 10–8. 096. Purchased with the aid of the National Art Collections Fund.
12 BM, OA 1872. 7–1. 99. Bridge Collection.
13 BM, OA 1990. 10–29. 04.
14 BM, OA 1880. 304.
15 BM, OA 1919. 11–4. 40. Given by Col. F. H. Ward.
16 BM, OA 1922. 10–20. 6. Given by H. S. Sim, Esq.
17 BM, OA 1880. 20.
18 TRB.
19 BM, OA 1962. 12–31. 013 (1).
20 BM, OA 1880. 4081.
21 TRB.
22 BM Dept. of Oriental Antiquities archives.
23 TRB.
24 TRB.
25 BM, OA 1950. 5–24. 01.
26 TRB.
27 BM, OA 1990. 10–29. 01.

Figs.
28 BM, OA 1991. 3–27. 01. Brooke Sewell Fund.
29 TRB.
30 BM, OA 1880–4058; 1989. 10–27. 4; 1919. 11–4. 53, given by Col. F. H. Ward; 1932. 10–6. 2, given by W. J. Andrew Esq.
31 GM, photo by Snehal Shah.
32 TRB.
33 TRB.
34 TRB.
35 TRB.
36 TRB.
37 GM, photo by Michaela Soar.
38 TRB.
39 BM, OA 1914. 2–17. 011.
40 BM, OA M653.
41 BM, OA 1880. 2370.
42 BM, OA 1880. 7–9. 109. Presented by the Secretary of State for India in Council.
43 BM, OA 1990. 72. 1.
44 BM, OA 1880–24.
45 BM, OA 97. 6–17. 1.
46 BM, C&M (i) 1988. 12–8–533. Cunningham Collection. (ii) 1922. 4–24–64. Whitehead Collection. (iii) 1894. 5–6–92. Cunningham Collection.
47 BM, OA 1955. 10–18. 1. Given by P. T. Brooke Sewell, Esq.
48 BM, OA 1872. 7–1. 72. Bridge Collection.
49 BM, OA 1925. 10–16. 016.
50 BM, OA 1962. 12–31. 013 (70).
51 BM, OA 1961. 4–10. 1. Brooke Sewell Fund.
52 BM, OA 1952. 11–1. 9. Given by Mrs H. G. Beasley.
53 BM, OA 1940. 7–16. 29. Given by Mrs A. G. Moor.
54 BM, OA 1971. 3–3. 1. Given by Douglas Barrett, Esq.
55 BM, OA 1860. 7–28. 675 (07).
56 BM, OA 53. 1–8. 3.
57 BM, OA 1880–2166.
58 BM, OA 1872. 7–1. 70. Bridge Collection.
59 BM, OA 1872. 7–1. 54. Bridge Collection.
60 BM, OA 1984. 4–3. 1.
61 BM, OA 1989. 2–11. 01. Given by Nalin Tomar, Esq.
62 BM, OA 1989. 5–16. 010. Given by T. Richard Blurton, Esq.
63 BM, OA 1872. 7–1. 59. Bridge Collection.

Figs.
64 BM, OA 1966. 2–12. 03. Brooke Sewell Fund.
65 BM, OA 1900. 10–11. 1. Given by W. Frazer Briscoe, Esq.
66 BM, OA 1923. 3–6. 1.
67 BM, OA 1973. 9–17. 03. Brooke Sewell Fund.
68 BM, OA 1880–2539.
69 BM, OA 1965. 10–17. 3 and 4; 1965. 12–13. 1. Brooke Sewell Fund.
70 BM, OA 51. 4–7. 1, given by R. Hawkins, Esq; 96.3–9.15, 16, 20; 1903. 11–17. 36, 47 and 62, given by the Rev. A. W. Oxford.
71 BM, OA 1872. 7–1. 67. Bridge Collection.
72 BM, OA 1872. 7–1. 50. Bridge Collection.
73 BM, OA 1974. 6–17. 014 (13).
74 BM, OA 1966. 7–25. 01. Brooke Sewell Fund.
75 BM, OA 1990. 7–13. 028. Given by Mrs A. G. Moor.
76 BM, OA 1869. 5–3. 7. Given by Henry Pownall, Esq.
77 BM, OA 1872. 7–1. 74. Bridge Collection.
78 BM, OA 1966. 7–25. 03. Brooke Sewell Fund.
79 BM, OA 1853. 1–8. 8.
80 BM, OA 1955. 10–8. 094. Purchased with the aid of the National Art Collections Fund.
81 BM, OA 1955. 10–8. 096. Purchased with the aid of the National Art Collections Fund.
82 BM, OA 1959. 4–11. 07. Given by P. T. Brooke Sewell, Esq.
83 TRB.
84 BM, OA 1880–2407.
85 AD.
86 BM, OA 94. 4–13. 7. Given by Sir A. W. Franks.
87 BM, OA 33. 11–9. 31.
88 BM, OA 1985. 7–19. 1.
89 BM, OA 1983. 5–25. 1.
90 BM, OA 1974. 6–17. 014 (38).
91 BM, OA 1989. 2–4. 027.
92 BM, OA 1962. 12–31. 013 (23).
93 BM, OA 1880–403.
94 BM, OA 1975. 7–30. 1. Given by C. H. Leach, Esq.
95 BM, OA 1956. 12–10. 7. Given by D. R. Hay Neave, Esq.
96 BM, OA 1960. 2–24. 1. Given by John Levy, Esq.
97 BM, OA 1872. 7–1. 81. Bridge Collection.

Figs.
98 BM, OA 94. 2–16. 10. Given by Sir A. W. Franks.
99 BM, OA 1990. 12–17. 010.
100 BM, OA 1951. 12–10. 59.
101 TRB.
102 BM, OA 1963. 11–12. 1. Brooke Sewell Fund.
103 BM, OA 1842. 12–10. 1. Given by Mrs Tucker.
104 BM, OA 1940. 7–16. 329. Given by Mrs A. G. Moor.
105 BM, OA 1976. 4–5. 2, given by T. A. Wellsted; 1958. 10–17. 2, Given by Douglas Barrett, Esq.
106 BM, OA 1880–230.
107 TRB.
108 BM, OA 1872. 7–1. 89. Bridge Collection.
109 BM, OA 43. 7–21. 17.
110 BM, OA 1872. 7–1. 83. Bridge Collection.
111 BM, OA 1880–19.
112 BM, C&M (i) 1888. 12–8. 428, Cunningham Collection (ii) 1970. 5–14. 969, Cunningham Collection.

Figs.
113 BM, OA 1924. 4–1. 02.
114 BM, OA 1969. 1–15. 1. Brooke Sewell Fund.
115 BM, OA 1988. 2–9. 029.
116 BM, OA 1989. 10–7. 02. Given by Professor Dr Anna Dallapiccola.
117 BM, OA 1955. 10–18. 2. Given by P. T. Brooke Sewell Esq.
118 GM.
119 BM, OA 1889. 7–3. 9. Given by Captain A. H. Deane.
120 GM.
121 BM, OA 1925. 10–16. 019.
122 GM.
123 After H. Cousens, from J. Burgess and H. Cousens, *Archaeological Survey of Western India*, Vol. IX.
124 GM.
125 GM.
126 BM, OA 1956. 7–14. 017.
127 By courtesy of Robert Skelton.
128 GM.
129 TRB.
130 GM.
131 BM, OA 1872. 7–1. 100. Bridge Collection.

Figs.
132 BM, OA 1955. 10–8. 06. Purchased with the aid of the National Art Collections Fund.
133 BM, OA 1974. 6–17. 014 (05).
134 Derek Hall/BMV Picturebank.
135 TRB.
136 TRB.
137 BM, OA 1987. 3–14. 1.
138 TRB.
139 BM, OA 1969. 6–16. 1. Brooke Sewell Fund.
140 BM, OA 1984. 7–16. 1. Given by Miss G. Chrystie.
141 BM, OA 1962. 7–21. 2. Brooke Sewell Fund.
142 BM, OA 1919. 11–4. 49. Given by Col. F. H. Ward.
143 GM.
144 TRB.
145 Map by Ann Searight.
146 Map by Ann Searight.

Front cover BM, OA 1940. 7–13. 051. Given by Mrs A. G. Moor.

Back cover TRB.

INDEX